AUDIO ARTS

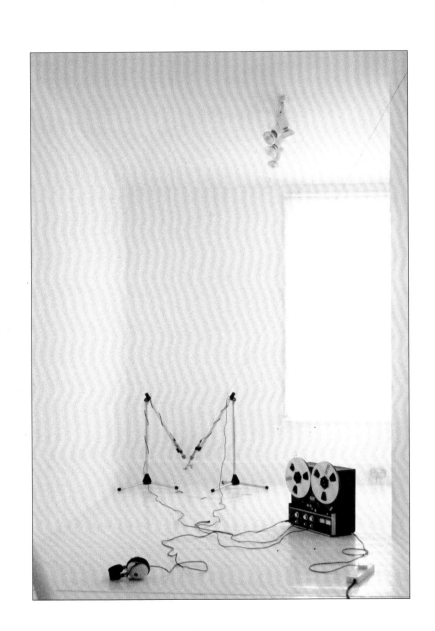

AUDIO ARTS

DISCOURSE AND PRACTICE IN CONTEMPORARY ART

WILLIAM FURLONG

 ACADEMY EDITIONS

ACKNOWLEDGEMENTS

Photo credits: Cover, Mario Bettella; p 9 above, Mick Ford; p 9 below,
Musée National d'Art Modern, Centre Georges Pompidou, Paris, ©
DACS; p 15 above, MIT Press; p 27 above, Pollitzer, Strong & Meyer;
p 42 above, Sue Ormerod; p 49 below, Edward Woodman; p 57 left,
Brian Westbury; p 57 right, Chris Harris; p 64 below, Chris Schwarz;
p 67 centre, Nigel Maudsley; p 75 below, Kate Whiteford; p 111 below
right, Maria-Puck Broodthaers; p 113 above right, Tate Gallery,
London; p 124 below right, Paddy Summerfield; p 125 above centre,
James Peto; p 125 below, Punctum
Previous page: Audio Arts installation, Interim Art, London, 1988

Marcel Duchamp interview pp 16-21 courtesy Estate of Marcel
Duchamp, original recording by the BBC; extract from *Finnegans
Wake*, p 78, courtesy Estate of James Joyce

Thanks also to Judy Adam, John Bewley, Kate Blacker, Iwona
Blazwick, Lucy Coventry, Richard Francis, Heidi Grundmann, Richard
Hamilton, Simon Herbert, Nicola Hodges, Brian Hodgson, Chrissie
Iles, James Lingwood, Vivien Lovell, Declan McGonagle, Bruce
McLean, Maureen Paley, James Peto, Rudolph Remmert, Sarah
Selwood, Nick Serota, Duncan Smith, Elizabeth and Terry Teece, Peter
Townsend and John Walters; also to The Arts Council, London, The
British Council, London, The Institute of Contemporary Arts, London,
Anthony d'Offay Gallery, London, Anthony Reynolds Gallery and
Karsten Schubert Gallery, London.

This is a book of contemporary art at its source and is structured
around the participation of artists. The interviews included in this
book represent only a fraction of the Audio Arts archive. All those
who have contributed to the magazine have generously allowed their
words and ideas to be recorded and disseminated. The book, like the
magazine itself, is not therefore about art; it represents, rather, an
extension into the discourse of art of the practice of those artists
involved in the project.

Special thanks are due to Mel Gooding for his insights and the
inspirational meetings during the preparation of this book.

I am indebted above all to Violet Barrett; without her commitment
and her creative collaboration Audio Arts would not exist.
William Furlong AUDIO ARTS 6 Briarwood Road London SW4 9PX

First published in Great Britain in 1994 by
ACADEMY EDITIONS
An imprint of the Academy Group Ltd

ACADEMY GROUP LTD
42 Leinster Gardens London W2 3AN
Member of the VCH Publishing Group

ISBN 1 85490 363 2

Distributed to the trade in the United States of America by
ST MARTIN'S PRESS
175 Fifth Avenue, New York, NY 10010

Printed and bound in Italy

CONTENTS

THE WORK

Mel Gooding

> Only on condition of a radical widening of
> definition will it be possible for art and activities
> related to art to provide evidence that art is now
> the only evolutionary–revolutionary power. Only
> art is capable of dismantling the repressive
> effects of a senile social system that continues
> to totter along the deathline: to dismantle in
> order to build A SOCIAL ORGANISM AS A
> WORK OF ART. *Joseph Beuys, 1974*[1]

Audio Arts began, as a magazine of a new and special kind, in
1973. It was the invention of two artists in their late twenties,
William Furlong and Barry Barker, and like most brilliant original
ideas, once conceived it seems immediately obvious. It was
made possible by the newly widening availability of a specific
technology, the cassette tape, which had been introduced by
Philips in the early 1960s, and which had revolutionised the
possibilities of the physical dissemination of recorded material.
What it set out to do, and what it subsequently discovered could
be done, were thus consequential upon new possibilities of
sound storage and distribution. Even so, it took time for the
deeper implications of the initial idea to manifest themselves,
and for the creative potentialities of the idea to be realised. What
began as a simple magazine became a work of great originality
and considerable complexity, a work that continues to grow and
ramify, and has extended the scope of sound within the ambit of
art and amplified and augmented the discourse through which
art achieves its meanings.

It came into being almost by accident. Planning to start a
printed art magazine that would invite artists, technologists and
writers as well as critics to contribute to what was at the time a
vigorous international and multivalent debate about the forms
and purposes of art, the editors realised that tapes would be
cheaper to produce and distribute than edited and printed
transcriptions of what had been, and might be, recorded as
intended material. They recognised immediately a virtue in
necessity. Whilst the written word is privileged in the discourse
by its relative permanence, its easy dissemination, and above all
by its history as the code of educated elites in civilised cultures,
speech itself remains a primary mode of human communication,
with its own irreducible features and characteristics, and central
to the living continuum of what Michael Oakeshott called 'the
conversation of mankind'.

Tape recordings contain the actuality of the spoken voice,
the impress of an original reality. Sound recording gives to the
auditor a direct contact with the source; like photography it is
itself a trace of the real, a transformation of the source energy
directly received by the senses. No transcription can do justice to
the true sound of the voice; every transcription involves a
transmutation of the original. What was heard as complex sound,
cognitively replete, affectively inflected, contextualised in time
and by the presence of interlocutors, is received visually in the
solitary silence of reading, screened and neutralised by the
conventions of print. Pace and rhythm, intonation and expres-
sion, emphasis and nuance, all these aspects of speech are lost,
as is its fleeting, fugitive quality. In studying a transcript, however
faithful in its indications of surface feature, we are engaged with
a secondary source, a translation, a mediation; listening to a
recording we encounter actuality. To adapt a vivid passage from
Barthes's *Camera Lucida* (referring there to the photograph) the
sound recording is 'literally an emanation of the referent. From
a real body, which was there, proceed radiations (in our case,
pulsations) which ultimately touch me, who am here; ... the
(sound recording) of the missing being, as Sontag says, will
touch me like the delayed rays of a star.'[2] Sound is a primary
medium; in listening to the recorded voice we hear what was
(and inserted into our real time, still is) the thing itself, manifest,
absolute, poignant. We are touched by it: it enters us by way of
physical sense.

Furlong and Barker quickly realised that this indicated some-
thing different in kind from a printed magazine, that to publish
sound recordings in this format was a means to different ends, to
a more dynamically immediate tapping of the critical and crea-
tive discourse at the point of utterance. Short-circuiting, in
Furlong's phrase, the distancings and framings of the printed
magazine, the cassette magazine could catch the debate at the
living moment, entering directly into the unending discussion
between artists, critics, gallerists and theorists that constitutes
art's circumambient critical culture. Unconstrained by the edito-
rial requirements of the conventional art magazine, or by the
necessity of securing advertisements, and unaffected by compe-

tition from them, Audio Arts could become a component of the creative network as well as an enabling medium of critical transmission. Above all, it could retain aspects of the reality of that culture: it would not merely report on events, it would present experience.

As artists and teachers they had both been involved in the conceptual experimentation that was characteristic of the late sixties and early seventies, in those modes of making which engaged with language and ideas as opposed to representation and expression through material media and actual objects. It was not surprising, then, that they should be excited by the possibilities offered by a primary medium: that a magazine might be the carrier of real works in sound form, as well as a mode of documentation that had the reality of a given time, a particular succession of moments, and the very impress of the voices of participants to an historically located situation.

It took time for the magazine to discover its conceptual identity, and for Furlong to arrive at the compendious and commodious definition of its purposes that is implicit in the work as it continues apace into its third decade. After a promising first number, the issues in the first volume had an air of the makeshift and of critical uncertainty, and a decidedly literary bias. Historic recordings of Wyndham Lewis, James Joyce and WB Yeats were combined with readings from their works, musical items, and interviews with living relatives. In Number 2 items of this kind were coupled with recordings of contemporary concept and performance works, and an interview with Noam Chomsky. Number 3 included an interview recalling the philosopher and mathematician CK Ogden. Interesting as this material is, it gave little indication of editorial direction, or of the real potential of the magazine.

Nevertheless, it was quickly recognised by a number of artists and critics that the magazine was indeed something new and different, something that 'the age demanded', and which could do things that were impossible in other forms. It was not, of course, that recording itself was new; it was that the cassette magazine format enabled the record of the living voice to be inserted into the continuing conversation around and about visual art, to be circulated and disseminated, and, above all, *to be retained*. More than a record or a reflection of art events, it could be an event itself, an actual intervention.

Volume 2 Number 1 was to be a crucially important issue in this respect, coupling edited versions of virtuoso extemporary lectures given in London in November 1974 by Buckminster Fuller and by Joseph Beuys. In each recording the charismatic personality of the performer achieves an immediacy that could never be conveyed by the printed transcript; it is there in the tone and weight of voice, in the urgency and vitality of their speech rhythms, in the manifest ordering of their thoughts in the process

of speaking, reducing intellectual and moral complexities to transparent simplicities of utterance, and in their extraordinary command of the processes of argumentation. With this classic issue Furlong demonstrated for the first time his true potential as an editor, combining critical insight and creative opportunism to lift the operation at once to a higher level. Quite simply, there had been nothing quite like this available before Audio Arts had made it so.

As was his practice from the beginning, in each case Furlong recorded the entire proceedings (Buckminster Fuller's lecture at Art Net lasted for two hours; Beuys's demonstration/lecture/discussions at the ICA continued for many hours over several days) and then edited the material down from copies made tape-to-tape, thereby ensuring the integrity of the original recordings. In addition, Furlong has made over the years many 'supplements' to the magazine, recordings and tape/slide presentations of literary, musical and art performances and events, documentations of exhibitions and conferences, and conversations with artists. Together these materials constitute an art sound-archive the richness and diversity of which must now be unique in the world.

The subsequent career of Audio Arts, documented in this book, is the story of a tireless pursuit of whatever seemed interesting, in the practice and discussion of art, to its indefatigable editor. More than could ever be the case with any conventional magazine, however forceful and determined its editorial direction, Audio Arts became the reflection of an intelligent consciousness, or to put it in another figure, a refraction through an individual response, specifically located in time and space and necessarily limited, of what was happening in art. Most emphatically it has not served as a function of either personal expression or of tendentious rhetoric: Furlong is not interested in journalistic polarities or polemical divisions. If Audio Arts has had any design upon its audience it would be to parallel those aims of Beuys's Free International School for Creativity and Interdisciplinary Research: 'the encouragement, discovery and furtherance of democratic potential, and the expression of this'. Audio Arts has not been concerned with a single point of view so much as with the experienced actuality of contrarieties, the ever-constant reality of variegation. Furlong's approach is in that sense phenomenological rather than analytically critical. Audio Arts is a kind of prism through which the broadest spectrum of artists, performers, critics and all have been projected back into the culture of which it is a part.

Barry Barker left the project early on to pursue an independent career as a remarkably creative gallerist and critic, but it was as much to his intuitive quickness and entrepreneurial energy as to Furlong's foresight and persistence of ambition that the magazine owed its initial success and its ready acceptance in the

most serious quarters of the art world. It might be remarked that Furlong's career has been in some ways parallel to that of his collaborator in those early years of Audio Arts, and that as artists they have continued to work from critical perceptions and imaginative impulses that are closely aligned. In a persistent metaphor, drawn significantly from the world of the visual arts, Furlong frequently refers to the *sound-time* that the magazine's tape-cassette format makes available as *a space* within which artists (and critics and others) might make work or pursue discussion. Whilst Barker has worked with real space and Furlong with audial space, both have utilised a gift for anticipation, for sensing what is in the air, and then made room for things to happen, provided an arena for utterance, a place where work, *authentic and primary*, could be made.

It is implicit in this conception that the role played by Furlong as editor might be seen as equivalent to that of a curator or gallerist. He has been the organiser of presentations and events, not in the mode of the dealer, whose activities, however crucial to the survival of art and the artist in a commercial culture, must be directed to profit, but rather in the function of the imaginative enabler, the creative impresario, that shadowy figure haunting the wings of modern art, the curator as artist. In so far as he has played always a rigorous editorial role, abbreviating, shaping and re-shaping the recorded material as he has felt appropriate, or as the limitations of the cassette format have made necessary, that function has been constrained by what for Furlong has been an unavoidable ethical responsibility: the responsibility, in short, of the artist. The very processes of editing, physical and critical, are for him analogous to those of the artist in the studio: listening, cutting, selecting, splicing, synthesising; always working with the tapes, never with transcripts, his material is the sound itself. It is a composing process: the final work is a construct that must be true to the spirit of its subject.

To succeed as Furlong has done requires an open and generous sensibility and tact of a rare order: these qualities have constituted the fundamental thread that runs through the extraordinary and sometimes arbitrary heterogeneity of material that has gone into the making of Audio Arts. Nothing is excluded on the grounds of *parti pris* or preconception. Contemporary experimental music as well as folk song; discursive art and art polemics; sociological issues in art; interviews and conversations with and between curators, dealers, critics, as well as painters, sculptors, Conceptualists and Minimalists; original soundworks; *actualité* from art fairs and biennales: all these and other elements are part of the project. Wherever Audio Arts has gone it has been recognised as part of the living situation, a constituent of the culture. Predicated upon cooperation and trust between artists, it has exemplified in its own practice the ethics of creative collaboration.

If it seems to the reader that there is some sliding here between the terms *editor, curator* and *artist,* and between notions of the *critical* and the *creative,* then it must be emphasised that in this the language truly reflects those radical redefinitions, or re-negotiations of meaning, that are implicit in the epigraph to this essay, and which find their most extreme and eloquent formulation in the intended tautology of Beuys's most famous statement: EVERY HUMAN BEING IS AN ARTIST. It has always been understood by Furlong that Audio Arts is a creative endeavour; that his work with the magazine, as editor and curator of audial space, is part of his work as an artist, and that this activity was an imaginative intervention in the world whose meaning is, in the profoundest sense, political. There are two entries to be found in a notebook of Lawrence Weiner from 1980 that Furlong would find sympathetic in this respect:

> IT IS/SHOULD
> BE — THE CONTENT
> THAT GIVES THE PERCEPTIONS AND
> OBSERVATIONS OF AN ARTIST
> (WITHIN THE PRESENTATION/ART)
> A USE FACTOR IN SOCIETY

and

> THE CONCEPT (IDEA) OF ENDEAVOUR
> (WORK) WITHOUT COMMITMENT (POLITICAL) IS NOT A REASONABLE ASSUMPTION.[3]

These are broad terms in which to state Furlong's position as an artist; but Audio Arts can be entered under the terms of an ethic/aesthetic more specific than that which identifies all human creative potential within that grand and beautiful idea of art. This is the conception of *social sculpture,* as defined and exemplified in practice by Beuys: 'This most modern art discipline – Social Sculpture/Social Architecture – [which] will only reach fruition when every living person becomes a creator, a sculptor, or architect of the social organism.' What is this aesthetic? It is the beauty of a continuous work that contains many disparate components, with a multiplicity of mental and sensational aspects, held in dynamic dialectical tension within a *conceptual* unity of purpose. It is possible within the terms of the concept for the constituents of this work to maintain their identity, even be separable from that of the work itself. And above all it is possible for such a work of human creativity to assimilate and comprehend within its capacious form elements of *critical* discourse. In the definition of this aesthetic the work (the one great continuous *work*) of Beuys was decisively exemplary. In sound, Audio Arts has worked, moreover, within an over-all unity of *medium*.

This work takes its place in the wider world as a creative function among others necessary to human freedom: 'Whereas the specialist's insulated point of view places the arts and other kinds of work in sharp opposition, it is in fact crucial that the

ABOVE: Joseph Beuys being interviewed by William Furlong at the Victoria and Albert Museum, London, 1983
BELOW: Joseph Beuys, 'Plight', 1985, mixed media installation at the Anthony d'Offay Gallery, London

THE WORK

structural, formal and thematic problems of the various work processes should be constantly compared with one another' (Beuys, *MANIFESTO*). Within this over-arching aesthetic ordering of life every human being, from 'his own position of freedom that he experiences at first-hand [will learn] to determine the positions in the TOTAL ART-WORK OF THE FUTURE SOCIAL ORDER'. Social sculpture in the present dispensation can only be an exemplary endeavour, a *model* of the possible, an enactment of hope and of commitment. Artists as diverse in their practice as Weiner, Beuys, Cage, Hamilton, Merz, Willats, Hiller, McLean, Andre, Breakwell and many others intuitively recognised the nature of the Audio Arts project and responded with generous contributions. That it was a work in itself encouraged them to enter their own work and conversation into its terms.

For many years the implications of all this for other aspects of his creative practice were perhaps more apparent to others than to Furlong himself, immersed as he was in the routine and piecemeal problems of producing the magazine, his ear and eye so close to the work in hand, hurrying to venues to record, followed by countless solitary hours in the editing room. He was, as well, constantly short of money for tapes and equipment, pushed for time and other resources. As late as 1982, when Audio Arts published the three-cassette compilation of artists' soundworks *Live to Air*, no free-standing work by Audio Arts itself was included, although by this time Michael Archer, his collaborator on the Audio Arts sound and performance works of the 1980s, was already deeply involved in editing the magazine.

During the 1970s Furlong worked in collaboration with Bruce McLean on a number of live works, notably *Academic Board* in London in 1976 and *In Terms of, An Institutional Farce Sculpture*, which was performed at Documenta 6 in Kassel. Both of these were satirical reflections on activities in the art school as examples of behavioural procedures characteristic of all bureaucratic institutions. In 1978 he had met Archer at a presentation of Audio Arts put on at the invitation of Nick Serota at the Whitechapel Art Gallery, to run concurrently with the Robert Ryman exhibition there. It was Kate Blacker, herself a sculptor, who as a selector for the wide-ranging survey exhibition 'The Sculpture Show', held at the Hayward Gallery in London in 1983, first publicly identified Audio Arts as belonging within a definition of sculpture as such. The artists in her selection, she wrote, 'share one main similarity, [having] a strong cultural awareness rural, urban, historical, political, local, mythological or sub-cultural, as opposed to an academic concern for established formal aesthetics or practice.'

In an interview with Stuart Morgan for the catalogue, she spoke of Audio Arts in particular: 'Audio Arts is important as a transmitter of another consciousness, of sensing art in space or sensing space as a container ... Audio Arts offers a way of

engaging in dialogue through sound, and that dialogue on the same 'level' as that of contemporary events. Art is no longer a secretive, studio-oriented activity with its own values … [Audio Arts is] playing on more than just visual perception. Sound takes up space!' The emphasis here is absolutely correct, for it locates Audio Arts accurately at the edge of, but within, the ambit of the visual culture, whilst recognising the paradox of that critical placement. Furlong emerged as an artist out of that culture; his assumptions, and the language he uses to articulate them, are those of a visual artist, more specifically those of a sculptor, which is to say that he is concerned with objects in spaces, and with the relation between objects, space and human meanings. Once more, a brilliant formulation by Weiner, an apothegmic work, has a particular relevance:

> ART IS AND MUST BE AN EMPIRICAL REALITY
> CONCERNED WITH THE RELATIONSHIPS OF
> HUMAN BEINGS TO OBJECTS AND OBJECTS
> TO OBJECTS IN RELATION TO HUMAN
> BEINGS.

The rich body of soundworks made by Audio Arts is described elsewhere in this volume by Michael Archer, who is well placed as both artist and critic to deal with that aspect of the production, and who has been Furlong's closest collaborator in the 1980s. Each of them has followed the example set by *Objects and Spaces* made for the Hayward show in 1983. They are made always in relation to specific places, and to the lived reality, social and linguistic, of those places. *Objects and Spaces* was perhaps the most generalised of these works, as befitted its inclusion in a survey of sculpture at a given time in a national and neutral exhibition space. There is a sense in which the Hayward is not 'a place' at all; it has none of the resonances, political and social, of the Orchard Gallery in Derry, for example, or of Wren's magnificent Protestant auditorium, St James's, Piccadilly, or of the working-class terraced house in Beck Road in London's East End that is the home of Interim Art, or of Wimbledon Football Club's Plough Lane ground. *Objects and Spaces* brought together, on a transparent disc set in the catalogue as a round window upon a map of the world, voices and sounds from all over the world, with the voices of inmates of Brixton Prison, whose world had been contracted to a small cell, a table and a bed: spaces, objects, human beings – these are the materials of sculptural action, their relative positions the articulation of its meanings.

The Audio Arts soundworks are essentially *montages,* consistent in concept and form with Eisenstein's classic definitions:

> Piece A, derived from the elements of the theme
> being developed, and piece B, derived from the
> same source, in juxtaposition to give birth to the
> image in which the matter is most clearly
> embodied. Or: Representation A and representa-
> tion B must be so selected from all possible
> features within the theme that is being devel-
> oped, must be so sought for, that their juxtaposi-
> tion – the juxtaposition of those very elements
> and not of alternative ones – shall evoke in the
> perception and feelings of the spectator (auditor)
> the most complete image of the theme itself.[4]

As in film it is the continuity of the imagery in time that gives the work its essential unity, so in these works of Audio Arts it is the continuity of the sounds that unites disparate materials drawn from within a given situation and produces the work's effect within the imagination of the auditor. Eisenstein's remarks on the active role of the spectator have a particular force in relation to the effect of the Audio Arts *soundworks*:

> And now we can say that it is precisely the
> montage principle, as distinguished from that of
> representation, which obliges spectators (audi-
> tors) themselves to create and the montage
> principle, by this means, achieves that great
> power of inner creative excitement in the
> spectator (auditor) which distinguishes an
> emotionally exciting work from one that stops
> without going further than giving information or
> recording events.[5]

Audio Arts soundworks have precisely this quality. They have nothing of literary narrative or discursive continuity about them: they work through aural texture and sensation; they enter the consciousness through the sense of hearing as a picture must enter through sight. Rhythm and interval, repetition and pattern, contrast and semblance: these are the abstract elements by which these works 'work'. And they must be comprehended themselves within the greater *work-in-progress*: the multi-faceted unfinished interrogative sculpture that is Audio Arts.

Notes and Preferences

1 The epitaph from Beuys comes from his statement 'I am searching for a field character' in the catalogue of the 1974 'active' exhibition of seven German artists at the ICA, London, 'Art into Society/Society into Art'. Other quotations from Beuys in this essay derive from this source, apart from that cited as from his *MANIFESTO on the Foundation of a 'Free International School for Creativity and Interdisciplinary Research'*, also published in the ICA catalogue. It was Beuys's lecture/discussion over several days at this event that provided the material for Volume 2 Number 1 of *Audio Arts*.

2 Roland Barthes, *Camera Lucida,* first published as *La Chambre Claire*, Editions du Seuil in 1980. I have quoted the 1982 English edition (Jonathon Cape, London) Part 2 Section 34.

3 The quotations from Lawrence Weiner are taken from *Portraits Section 2* by Weiner and Kathy Acker, in *Artforum* XX, 9 May 1982.

4 Sergei Eisenstein, *The Film Sense* (translated by Jay Leyda), Faber and Faber, London, 1943, chapter 1.

5 Ibid, chapter 2.

ARTISTS TALKING

Artists who engage with the structure and primary function of the interview

Art & Language

Noam Chomsky

Marcel Duchamp

Mary Kelly and Susan Hiller

Mario Merz

Nancy Spero

Philip Glass

Les Levine

Brice Marden

Richard Hamilton and Roy Lichtenstein

Gerhard Richter

Ilya Kabakov

Jeff Koons

Rachel Whiteread

Richard Serra

Ellsworth Kelly

Christine Borland and Craig Richardson

Eugenio Dittborn

Anya Gallaccio

Gary Hill

Joseph Kosuth

Art & Language

In the first issue of Audio Arts *members of Art & Language are heard in discussion. The listener can 'eavesdrop' as the group explore themes, theories and preoccupations. But in the following extract, Michael Baldwin starts the proceedings by exploring the parameters and assumptions underlying meaning and function in the linguistic discourse.*

What is it that we are going to regard as normal? Let's assume we want to 'catch' a lot of discourse. What are we going to regard as discourse to be caught, and what are we going to regard as discourse to be rejected or eliminated? One can only really do that on the basis of saying that inside the system there are going to be kinds of feeling or kinds of pragmatic parameters developed or envisaged, so it's like people finding themselves saying, 'I'm not listening to this rubbish,' and presumably finding the relations between these is again of some small significance. But Philip, for example, has been dealing with an idea where he's been taking a piece of discourse which already works out a number of points of reference associated with it, then trying to work out what could be sorted out from there as a point of reference of some discourse, whether it be thinking or dreaming or whatever one does. There are ways in which one exercises one's discourse – there are certain one-sided conversations, for example, that take place. One of the characteristics of our social sphere is, I would say, the one-sided conversation – and I don't mean one-sided in any axiological sense: I mean one-sided in the sense where you often find you have a kind of infant/adult situation, which shifts and changes quite rapidly. It's infant/adult in the sense that would raise a standpoint as to bi-linguistics to the extent that people tend to give up speaking coherently. It tends to be a bit like someone putting specific constraints or tolerances onto another person, and then there arrives someone who puts those into productive or non-productive or tolerant or permissive. The hearer is a recipient of this, and that is often reversed when a hearer becomes a speaker. Now, there's that sort of factual statement that is particularly characteristic of the way our discourse goes and not necessarily characteristic of the way that all apparently normal discourse goes – and certainly not of the way academic discourse goes on. There's that, I think, which is to do with context, and I am certainly not sure about what context is. There's this business of context in general, where all ends up with a situation such that to deal with context people would argue that one got on a regress. But I would argue against most of the people who would say, 'Ah well, don't worry about it, because you end up with regress'. I would have said a) there's linguistic content which isn't involved in regress, and b) however, is it not the case that the regress that one gets involved in, when considering context, is a function of the epistemology which will allow you talk in terms of a model, if you like, of all human knowledge; so the concept is that all human knowledge is accessible to you – in other words, it's an epistemologically relative concept, the concept of an epistemological regress, if you see what I mean. To what degree is it possible to introduce, if you like, the concept of interpretation which, if you like, is capable of noticing a revision on the idea of regress associated

with completed contexts of interpretation? That, I think, is a bona fide activity in the context of something that is as absurd as an art world or something like that, simply because it is a world in which one takes seriously the question of what do we now do, given the high instrumentality, fictiveness, operationality, so on and so forth, and no scientific series etcetera, etcetera.

It takes into account, if you like, the idea of one's study being intensive as distinct from extensive – intensive meaning looking into almost as many parts or looking for as many positively generalisable statements as possible about one's discourse as one can, which involves considering all one's discourse, but of course most of all what one considers is arbitrary fragments of one's discourse to that end. Now, whether it is arbitrary fragments or whether in fact there is one way in which there is an ordering in the way these things are selected, for example, is critical. One of the things that is interesting is, well, here we are with nothing to do, hardly anyone to talk to … what then is our position? Do you know what I mean? That as a sociological fact is something which makes one's situation very interesting, it seems to me. Here we are, sitting on our own with no visible means of support, no visible activity of a kind which we would generally regard as purposive, no production of discourse which one would generally regard as purposive discourse, yet that might lead to function, think, work etcetera, and what do I do?

Are you making assumptions about that? What you are doing in this context? The context of conversation can be in some way transposed or mapped onto the other context.

Noam Chomsky

Given this concern for language, artists referred to and often appropriated from theoretical work in related disciplines – philosophy and linguistics being primary points of reference. In the first issue Cyril Barrett, Reader in Philosophy at the University of Warwick, talks about the relationships between philosophy and art, and in the following extract Dr Christopher Evans and Noam Chomsky discuss models for the description of language.

CE: Professor Chomsky, many people assume that there are three models for the description of language, a finite state grammar, what you call a phrase structure grammar and your rather dramatic development, the transformational grammar. These are the kinds of things which lots of people find difficult to get clear in their minds. Could you say something about the three types of grammar, how they work, as it were, where they interact and so on.

NC: Finite state grammar is the kind of system that would result from the most sophisticated psychological models of

perception and production that one can imagine on the basis of the concepts of habit or habit structure or stimulus and response. The idea is that the system, let's say the mind, has a finite set of configurations, which is certainly true; that it accepts linguistic material one symbol at a time, which again is true, and as it accepts a particular linguistic symbol, a sentence is produced. Let's say the first symbol and the second symbol and so on are accepted by this system, and each time that the system is activated by the new symbol which appears it moves into a new state and finally if it ends up in some designated terminal state – then it has accepted the sequence as a sentence and has understood it or perceived it. There's no doubt that one ought to be able to describe any perceptual model in these terms for a finite device. The question, however, was whether the actual knowledge of language that the mind possesses is entirely representable in terms of such a device, and while there was a belief that that was true in the 1950s, it can be demonstrated that that is not true, and there is certainly no paradox or problem in that. So I think finite state models have virtually lost their interest as models for grammar. In fact, I know of no one who studies them.

CE: You are basically a linguist, philosopher and mathematician as well, and I suppose one needs to be those three things, really – or at least a mathematician and philosopher – to be a good linguist, perhaps. And yet you have had some very productive work with psychologists, in particular George Miller. How did you first come to work with a psychologist at a time when linguists and psychologists were considered to be absolutely poles apart?

NC: Well, I think George Miller and I found that our thoughts were moving along parallel tracks in the mid 1950s. As I recall, we must have begun talking seriously together and then working together by about 1956 or so. Miller had done very productive work on cognitive psychology, developing information theoretic models, and had begun to see their basic inadequacy, I believe, and we were jointly interested in the question of the relationships among the various kinds of models that we were discussing earlier and the reasons for and the basis for the inadequacy of finite state models, the most abstract models that one could dream of achieving within the framework of even cognitive psychology, let alone behavioural psychology as then understood. We then went on to investigate jointly both the mathematical properties of some of these more complicated systems and also the possible implications for psycholinguistics – a field of which he is very much the grand master – the implications from the hypothesis that these more abstract and complex models play a fundamental and central role in knowledge of language and hence in performance.

FROM ABOVE: Noam Chomsky, 1970; Mario Merz installing his exhibition at the Whitechapel Art Gallery, London, 1980; Philip Glass being interviewed by William Furlong, 1982

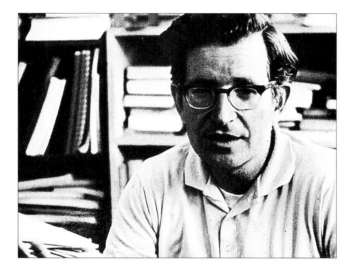

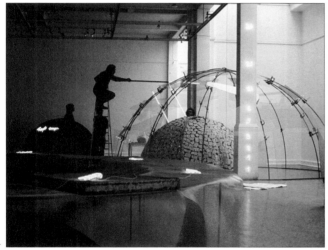

CE: Several things that you were saying must have seemed absolutely anathema to the psychologists of the 1940s and the 1950s. First, I think, the notion of there being a universal grammar, which is one of your important hypotheses, a grammar that is constant for every shape of human being, and secondly, the idea that the basis of this grammar must be somehow inherited and passed over. In many ways these ideas don't seem so shocking now as they did then, but I think it's worth trying to find out exactly what you are saying about the carry over of first of all the universal grammar. Do you still feel that such a grammar is constant and present in all human beings?

NC: Well, I think there can be no doubt among rational people that there is a very rich and complicated innate structure that permits us to acquire these highly articulated, very specific, extremely rich systems of knowledge, such as knowledge of language, on the basis of the highly degenerate information that is presented to us as language learners or learners of anything else for that matter. The only question is, what is the nature of this innate system? Here, I think, one can very roughly distinguish two major tendencies, two major beliefs which have a long tradition of controversy and conflict.

One approach – I'll call it empiricist, because I think it does express the leading idea of traditional empiricism – is that what is innate to the mind is a system of processes and procedures and analytic mechanisms, a kind of data-processing procedure by which the data of sense is given a preliminary analysis in terms of innate structures of perception and is then further organised. So, for example, when Hume says that that part of our knowledge which comes to us from the original hand of nature is simply the animal instinct of induction and that everything else is simply a matter of forming associations, he is describing what we might think of as a primitive data-processing procedure, speaking of innate knowledge – incidentally I think quite properly. That is a clear expression of one general approach toward the problem of acquisition of knowledge. We have data of sense, we have a preliminary processing system which analyses it into properties and so on, and then we have certain procedures like the procedure of forming associations, or of carrying out induction, or of developing habit structures of some sort, or carrying out constituent analysis. That's what I meant by saying that Harris's approach was the most sophisticated empiricist approach that existed, and our knowledge is simply the result of the application of these innate data-processing procedures to the presented data of sense. That's one approach. Another approach, which seems to me to express the leading ideas of traditional rationalism – and I'll here call it a rationalist approach – is to say that the structure of our system of knowledge is what is predetermined. It's the form of the knowledge that's predeter-

mined. We have a schematicism which determines the kinds of knowledge and the arrangement of principles and concepts that can be acquired on the basis of experience. This approach pays little attention to, and sees little interest in, such procedures as may exist to move from the data to the knowledge. If we think of the problem of learning as having three elements, namely input, operation and output, the system has a certain input of experience and carries out a certain operation and it has some sort of output as a result. That's learning in a most general sense. The empiricist approach takes the position that it's the procedure, it's the operation that is innate and is of fundamental importance, and the output is anything that that procedure determines when it is applied to the data. So if you think of learning as a function mapping input into output, it's the function that's of interest to the empiricists. The rationalists, on the other hand, are saying the function isn't of much interest and the output is very sharply constrained. It must be of a certain type, so a rationalist theory of perception would say that we perceive the data of sense in terms of schematicisms which are determined by, let's say, geometrical notions of a regular triangle, innately, and we see actual triangles as distorted variants of regular triangles, because the mind simply deals with those regular geometric figures. An empiricist might approach the same material by saying that we somehow form the notion of regular geometric figures by association or induction or whatever. Here is a clear case for the rationalist approach which was developed in the seventeenth century; in fact, it is almost certainly correct if developed in a modern form.

Applying these perhaps overly sharp differentiations to the case of language, there is an approach which is very well represented by the best work and the most sophisticated work in structural linguistics, which sought to express and develop precisely procedures of analysis which would yield grammatical structures, knowledge of language, if you like, by application to a corpus of data. That's one approach. The rationalist approach, on the other hand, says the kinds of language that are accessible to the mind are a very narrowly restricted class, and the task that the child has is to discover which of the humanly accessible languages is the one to which he is being exposed. On empiricist grounds, what the child would be asking is this: he would say, 'Well, I have this data of sense, now what kind of associations can I form and what kind of habits can I construct?' And so on and so forth – not consciously, of course. On the rationalist approach the child is more or less asking, 'I have this data of sense, which of the possible languages is this a specimen of? Is it a specimen of Japanese? No, because it doesn't fit the principles of Japanese. Is it a specimen of English?' And if that hypothesis is continued, he then uses the knowledge of English.

As these remarks indicate, I believe that the rationalist approach is correct, that the process of learning language is a process which we can explain as follows: the mind innately has a universal grammar, a very narrow restriction that permits certain systems and excludes other systems which would be equally useful for communication, but just don't happen to fit the structure of mind, and the task of learning is to discover which of the possible systems is the one to which the child is being exposed. It is the task of taking this universal schematicism, this framework, and putting a little meat on the bones, that is, finding out how it is articulated specifically in this particular case.

… It shouldn't be a surprise to, let's say, a physiological psychologist that our concepts of visual space are based on highly articulated, very specific schematicisms that are determined by the structure of the brain, by the structure of the visual cortex. I think it would be a rare physiological psychologist these days who would believe that our interpretation of visual space is developed by long procedures of association and conditioning. In fact, what he would expect to find and what we do find is very specific structures that are put into operation on the occasion of experience, but that have the character that they do because that's the way our brain is. If we were a different organism we would do it differently, and I don't see any reason to suppose that the case of language, or for that matter any other cognitive system, is any different.

Marcel Duchamp

Humour, irony, timing, wit and emphasis are all constituents of language, extending and adding layers of communication and meaning to the literal meaning of words themselves. This is evident in a 1959 interview with Marcel Duchamp, recorded in London and New York. The interviewers were Richard Hamilton, Charles Mitchell and George Heard Hamilton.

MD: The first one was in 1913, it was a bicycle wheel.

GHH: Just an ordinary wheel?

MD: An ordinary wheel, a bicycle wheel on a stand, I would turn it as I passed by. The movement of it was like a fire in a fireplace, it had that attraction of something moving in the room while you think about something else. Then the second one was a bottle dryer, you know, they have them in cellars, in the French cellars to put the bottles on. Then the third one was a snow shovel which I did here in New York when I first came in 1915. That was just a plain snow shovel bought in a hardware shop and it's now, or a replica of it is, in Yale. Another one was called *Why Not Sneeze?* Of course the title is not a descriptive title because that ready-made was made of a small birdcage in which instead of a bird there were cubes which looked like sugar cubes.

GHH: The cubes were of white marble.

MD: That was the pun, the visual pun – that when you picked it up you understood it was marble and not sugar. I also added a thermometer in it. Another one was the phial. I was in Paris in 1919 and I was thinking of bringing back a present for Arensburg in California, so I went to a drug store and said, 'Will you give me a phial that you will empty of whatever serum that is in it and seal it again, and what will be in it will be Paris air, air of Paris'. Of course it had to be, so the druggist did it and I brought my present to Arensburg, to California, and it was called *Phial with 50cc of Air of Paris.*

GHH: Was that the last of the actual ready-mades to be manufactured?

MD: Yes, but in my notes in *The Green Box* I mentioned some that could be made. One I call 'a reciprocal ready-made'. You take a painting by Rembrandt and instead of looking at it you use it plainly as an ironing board. You iron your clothes on it, so it becomes a ready-made reciprocal.

GHH: It's rather hard on the Rembrandt.

MD: It is, but we had to be iconoclastic then.

GHH: Mr Duchamp, there are, then, two kinds of ready-mades. Those which already existed, so to speak, before you came upon them, and those which you have assisted. Do you put any priority on one kind rather than the other?

MD: No, no. It was to add a little diversity to the idea. It was not a very active part of my life – except that when you make one or two ready-mades a year you have plenty of time for something else.

GHH: Do you think anybody else could make one?

MD: Yes, everybody can, but no, I don't attach any value – I mean commercial value or even artistic value – to it. Hardly anybody would do it for the sake of doing it.

GHH: Is there any way in which we can think of a ready-made as a work of art?

MD: That is a very difficult point, because art first has to be defined. All right, can we try to define art? We have tried, everybody has tried and in every century there is a new definition of art, meaning that there is no essential or one essential that is good for all centuries. So if we accept the idea of trying not to define art, which is a very legitimate conception, then the ready-made comes in as a sort of irony because it says, here is a thing that I call art. I didn't even make it myself. As we know, art, etymologically speaking, means to make, hand make, and there it is ready-made, so it was a form of denying the possibility of defining art, because you don't define electricity – you see the results of electricity but you don't define it.

GHH: But with the ready-mades it seems to me that they carry out of the world of everyday life, out of the hardware shop, as in the case of the snow shovel, something of your own sense of irony and wit, and therefore can't we believe that they have some sort of …

MD: Message?

GHH: Not message, no, but value which is artistic. Even though you haven't made them yet, your intention in getting them derives from everything else in the world. Does not that give them, possibly, some kind of intellectual value?

MD: It has a conceptual value, if you want to say conceptual – I don't know what it means exactly, but it takes away all the technical jargon of painting. Painting should be made with colours, painting should be made with pencil, with brushes, and when you take something that is not made by those technical instruments then you don't know where you are. You don't know whether you should take it as a work of art, and that's where the irony comes in.

GHH: The irony of course is very much part of the Dada spirit, isn't it?

MD: Yes, that was a very important form of introducing humour in a very serious world at the time, during the First World War.

GHH: You said once to me some years ago that the Dada spirit had been operating, so to speak, in New York with you, for instance, and Man Ray, before Dada was named as a movement.

MD: Oh yes, yes, it was in the air, as many of these things are, and we certainly had the same spirit as in Zurich when Tzara and Arp and Huelsenbeck started under the name of Dada. They found the name. Of course the name was a good flag around which all these ideas …

GHH: A slogan?

MD: Yes, a slogan, and that helped the movement a lot, and of course the Dada spirit has always existed. It exists today, someone like Rabelais certainly is a Dada in essence, so is Jarry (a great man), and we could find any number of them in the past centuries.

GHH: Would you consider Dada more than just a criticism of art? Is it also a criticism of society?

MD: It is much more. It's been the non-conformist spirit which has existed in every century, every period, since man is man.

GHH: Another work is the 'Large Glass', *The Bride Stripped Bare by her Bachelors, Even*, in the English translation, which is now in the Philadelphia Museum.

MD: It was started in 1912/13/14. I worked on it before the war and even though I tried in that big Glass to find a completely personal and new expression, the final product was to be a wedding of mental and visual reactions. In other words, the ideas in the Glass are more important than the actual visual realisation.

GHH: But this sounds almost contradictory, because a work of art is primarily a visual experience.

MD: Yes, but this welding of two different sources of inspiration gave me a satisfactory answer in my research for something that had not been previously attempted. Being the young man who wants to do something by himself and not copy the others, not use too much of the traditions. My research was in that direction, to find some way of expressing myself without being a painter, without being a writer, without taking one of these labels and yet producing something that would be an inner product of myself. The two things, mixing up the ideas and their visual representation attracted me as a technique, if it has to be a technique after all. This hybrid form explains why I didn't have anyone to agree with me more or less, or to follow my ways of looking at it.

GHH: You had to invent everything for the first time.

MD: Yes, because as you know, the revolution of Courbet was mainly a visual revolution, what you call a retinal revolution. He insisted without even mentioning it that painting is to be looked at and only looked at, and the reactions should be visual or retinal, plain physical reaction in front of a painting. This has been going on since Courbet and still is in vogue, if I might say, today. If you speak to a painter today, he will never think of an anecdote, it's all the line, the form, the play of the colours together, and the more abstract the better.

GHH: And all that has nothing to do with the Glass.

MD: I thought it was a reaction against the retinal conception of painting, and I think it still is, because of the introduction of the conceptual, not entirely literary, because this is literary painting – it's been done before, of course, but much deeper literary. It's using words, but everything that uses words is not necessarily literary, as you know.

The interview continues in London

RH: One thing that Duchamp says in the general notes again is this: 'Always or nearly always give a reason for the choice between two or more solutions by ironical causality.' Ironical causality is one of the techniques by which he makes decisions. But it is always a very prim, conceptual decision.

CM: Yes, but this can be a joke at the same time.

MD: Yes, this can be a joke all right, but it's based on the fact that I have my doubts about real causality. There's no real reason for using causality. Why not use it ironically by inventing a world in which things come out differently from the usual one? You can imagine a new causality in which you invent your own reasons for this or that, don't you think so?

RH: But do you see a distinction between your own activity, which is a world invented by you, and the activity of a Surrealist proper – people like Dali, who tried to work without any conscious effort? One might suppose that your juxtaposition of something which you call a chocolate machine combined in the same picture with something that you call a 'symmetry of uniforms and liveries' is a Surrealist activity, but these ideas of yours are always closely related into a system. They are not arbitrary juxtapositions – you always seek justification for your act. The Surrealists stressed the fact that these juxtapositions were unjustified.

MD: Yes, I do, it's not entirely fantasy. The subconscious really never, never interested me very much as a basis for an art expression of any kind. It's true that I really was very much of a Cartesian – if you could use the word *défroqué*, which means unfrocked – Cartesian, because I was very pleased by the so-called pleasure of using Cartesianism as a form of thinking logic and very close mathematical thinking, but yet I was also very pleased by the idea of getting away from it. It happened also in several places: Roussel, a writer who wrote these completely

fantastic descriptions of the same order, where everything can be done, especially when you describe it in words, anything can be invented; and in *Locus Solus*, in *Impressions d'Afrique*, that's where really I found the source of my new activity in 1911 or 1912.

RH: In spite of the fact that one thinks of you as sitting right on top of Cubism, you felt a need after just one or two years of experience of Cubism to find a new path for yourself, and I take it that this is the way in which you found it, by an exploration of intellectual and conceptual terms juxtaposed to the physical configurations that you made.

MD: Yes, very soon I felt impatience, so to speak, with Cubism – at least impatience in the way that I couldn't see any future for me in it. In fact I touched Cubism rather a little. The *Nude Descending a Staircase* is a style like Cubism, naturally, but the addition of movement in it, which seems to be Futuristic, is Futuristic only because the Futurists had spoken of movement, were speaking of movement at the time. That doesn't make it a new idea of theirs: movement was in the air. There was something more important than the Futurists for me in that case, which was the publication of photos of fencing or horses galloping and so forth –

RH: By Muybridge.

MD: Yes, that gave me the real idea for the nude. It was only later – months later – that I saw the Futurist Balla with his dog and twenty legs. And even there it was only Balla and I who had the idea of multiplying the legs, but surely it was entirely different. He really used planes more than lines. In other words, even today you can compare them and see that there is no direct influence from painter to painter. Especially as I never knew them. I never knew Boccione – I met him at the end of January in 1912, and I never had any real relationship with them at all. So movement took me out of Cubism, if I may say. Up to then I wasn't sure. I did the *King and Queen* after that, and it was the end of Cubism for me. Already there were some other alleys – how to get out of Cubism – and I found it in the *Chocolate Grinder*, which was completely static then, although it might move if you let it move, but it was completely a reversal, forgetting about movement, forgetting about Cubism and finding some new way for my expression. The source for it, as I say, was Roussel, who gave me the idea of inventing new beings, whether made of metal or of flesh. The bride is a sort of mechanical bride, if you want to say – it's not the bride itself, it's a concept of a bride that I had to put on the canvas one way or another, but it was more important than that – I actually thought of it in terms of words before I actually

drew it. What the Glass does represent is not a copy of the bride in her best clothes or otherwise, yet they are called the bride, and the other part of the Glass is called the bachelors. In other words, you can see the bachelors in not abstract form but at least not detailed form or not natural form. In the same way the bride is an invention of a bride of my own – a new human being, half robot and half four dimensional. The idea of the fourth dimension also is very important in that period. Anything that has three-dimensional form is the projection in our world from a four-dimensional world, and my bride, for example, would be a three-dimensional projection of a four-dimensional bride. All right, then since it's on the glass it's flat, so my bride is a two-dimensional representation of a three-dimensional bride who also would be a four-dimensional projection on a three-dimensional world of the bride.

RH: The 'Large Glass' has many layers of meaning, both conceptual and philosophical. It also uses many layers of symbols, primitive or sophisticated, but irony is always present.

MD: Yes, it is ironical. It really probably took birth in my mind from the fairs, you know country fairs in France at least, where they have a wedding scene, and you have big balls that you throw at the heads of the bride and the bridegroom and the guests. They have disappeared now, but they used to be at every country fair, a little stand, and the great joy of the children was to make the bride fall out when hit in the right place, and she was in white and the bridegroom was in black … you see, the country fair has been a milieu for the painters since Seurat. That's an influence that I can admit, in that case, where I was probably tempted to use it and I did.

RH: All through the Glass you use fairly clear-cut symbology of a very direct kind – man and woman are identified, and the operations, the functions of the machinery are all explainable in sexual terms, in terms of sexual relationships, which is the basic preoccupation of the Glass.

MD: Yes, eroticism is a very dear subject to my life, and I certainly applied that liking or that love to my Glass, and in fact I thought the only excuse for doing anything is to give it the life of eroticism, which is completely close to life in general, and more so than philosophy or anything like that. It is an animal thing that has so many facets that it is pleasing to use it as a tube of paint, so to speak, to inject in your production. It's there, it's in the form of fantasy. 'Stripped bare' had even a naughty connotation with Christ. You know, Christ was stripped bare … it introduces eroticism and religion – I am ashamed of what I am saying.

RH: There has often been an element of the sacrilegious in Duchamp. The gesture of painting a moustache and beard on the *Mona Lisa* is all the more blasphemous for not being executed by a Philistine. How do you feel about the works of art of the past, their deification in museums?

MD: I have a very definite theory – call it theory, so that I can be wrong – that a work of art exists only when the spectator has looked at it. Until then it is only something that has been done, that might disappear and nobody would know about it, but the spectator consecrates it by saying this is good, we will keep it, and the spectator in that case becomes posterity, and posterity keeps museums full of paintings today. My impression is that these museums – call it the Prado, call it the National Gallery, call it the Louvre – are only receptacles of things that have survived, probably mediocrity. Because they happen to have survived is no reason to make them so important and big and beautiful, and there is no justification for that label of beautiful. They have survived. Why have they survived? It is not because they are beautiful. It is because they have survived by the law of chance. We probably have lost many, many other artists of those same periods who are as beautiful or even more beautiful …

RH: And how do you feel about the consecration of your own works in museums?

MD: The same way. I am not concerned because I do not consider myself any different from the others, and I think that my real feeling is that a work of art is only a work of art for a very short period. There is a life in a work of art which is very short, even shorter than a man's lifetime. I call it twenty years. After twenty years an Impressionist painting has ceased to be an Impressionist painting, because the material, the colour, the paint has darkened so much that it is no more what the man did when he painted it. All right, that is one way of looking at it. So I applied this rule to all artworks, and they after twenty years are finished. Their life is over. They survive all right, because they are part of art history, and art history is not art. I don't believe in preserving, I think as I said that a work of art dies. It's a thing of contemporary life. In other words, in your life you might see things, because it's contemporary with your life, it's being made at the same time as you are alive, and it has all the requisites of a work of art, which is to make, and your contemporaries are making works of art. They are works of art at the time you live, but once you are dead, they die too.

RH: I learned that you interested in the writings of Roussel. You are probably interested in the writings of Rabelais. You can accept the perpetuation of ideas through a text, but you are less inclined to accept it through a painting.

MD: The reason is that ideas can survive more without distortion. Death is longer for ideas, because the language stays on for at least a few centuries, in the case of Rabelais. But I am sure we don't understand a word of Aristophanes or of Homer, even. Our interpretation of Homer is very, very twentieth century. Do you see what I mean? The distortion that every fifty years the new generation gives to old works of art and the new ones too, is not justifiable. In other words, fifty years ago we liked this, a hundred years ago we liked that, showing the doubtful judgement of humanity on works of art, and that's why I like it to be only twenty years or to have a short life.

RH: It is sometimes said of you that when you received notice that your 'Large Glass' – a work on which you had spent an enormous amount of time, energy and thought over twelve years – was smashed, that you responded in a very indifferent way to this, that you didn't care. How did you feel?

MD: I didn't care. When I learned it I was lunching with a friend of mine who knew it, and she couldn't, she *couldn't* announce it to me. It was very funny. So in fact when she was so much moved by the assignment she had to announce it to me, my reaction was really a cold reaction to help her, instead of despair. It was exactly like that, it was not despair at all. I accept any *malheur* as it comes. I mean, I'm not going to fight it too much. I don't fight back.

RH: I wanted to know how you react to the title that has been given to this series, 'Art, Anti-Art'. What is the concept of Anti-Art for you?

MD: I am against the word 'anti', because it is like atheist as compared to believer. An atheist is just as much a religious man as a believer is. And an anti-artist is just as much of an artist as the other artist. An-artist would be much better, if I could change it, instead of anti-artist, A-N-artist, meaning no artist at all. That would be my conception. I don't mind being an an-artist.

RH: The one strain which has run throughout your life as an artist, or a-artist, is the idea of duality. There have always been on the one hand works that are very meticulous and painstaking, which are evolved through the most elaborate systematisation both technically and intellectually, and on the other hand works that appear to have been thrown off so casually, and works which you have actually produced no physical effort yourself on. Can you say something about this balance between the ready-mades and the Glass, and the other works, which are

very painterly in their execution.

MD: Yes, well, the ready-made was of course a deliberate activity by which I forgot all about my meticulosity. It was again a form of freeing myself from any form of programme. Suppose I started the Glass, and then I would go on making the Glass with a very meticulous technique and so on, and then probably one day I woke up and said, why should I be so meticulous? Contradicting myself again, you see. And I did, by thinking of the ready-made. I suppose that was the psychology of it. I don't know how it came about, but I imagine it so now. Do you think it might explain it?

RH: Yes. There seems to be a great fear in yourself of pomposity, and this introduction of a technique which is so casual does seem to free you from any engagement with yourself, almost.

MD: Correct. Yes, it's very important for me not to be engaged with any group. I want to be free, I want to be free from myself, almost.

RH: Yes, I think that is your unique contribution, a desire to dissociate your ideas even from yourself. But the ready-mades, which seem so casual, still retain an aura of precision. The limiting of their number, the choosing of an occasion when you will make a ready-made, a destination for the ready-mades –

MD: Yes, I introduced again very elaborate decisions about details even for the ready-mades. The fact that it was not made with my hands did not stop me from finding other ways of applying my meticulous technique to them, you see. In spite of myself I am a meticulous man.

Mary Kelly and Susan Hiller

In 1977 Audio Arts recorded this conversation between Mary Kelly and Susan Hiller, two women artists deeply involved in the problems of developing their work within a 'male-dominated society and art world'.

WF: When we discussed the idea of making a tape originally, it was felt important that two artists concerned with evolving a meaningful women's practice, initiated the discussion. Growing out of the recent public conference organised in London by the Women's Free Alliance were a number of issues – perhaps we shall take some of them up later – but can we begin by discussing the differences between, on the one hand, evolving a meaningful practice generally and on the other, the problems of evolving a meaningful women's practice. Presumably the two things would

have something in common and overlap, but there would be a residual area within which you as women would find yourselves situated.

MK: Possibly I'd always find it necessary to elaborate some general historical kind of conjuncture within which we as women were working, and I think what I said in the seminar, 'I feel it is quite important that some notion of the social totality which includes a number of instances that I have defined as economic, political and ideological', actually helped to provide an understanding of the limits and possibilities of an art practice, because I place it very much within ideological instance of that social totality. I'd say that an art practice didn't just reproduce the ideology of that moment, but in fact it reworked it, and if you are going to define the practice it was through a kind of reworking of that ideology – in my case a feminist ideology – in such a way that you produce a new meaning that has actually a long-term political effect. I feel that kind of statement actually covers the oeuvre from a kind of crude insertion into the political instance. I mean, you can actually never claim a direct effect at that level. I think that a lot of the problems of people on the Left have come from that type of reduction of an art practice to a political practice. In fact it means that nothing exciting about art comes to the fore, but if you do engage with it at the level of the ideological instance, then I think you have got another set of problems which are how you actually understand the subject in terms of ideology. Again, I would say it is not a constituted subject but a subject being constituted by that moment. That allows you to say how the female subject is being constituted at that moment and how in a sense the women's art practice has a possibility of even revitalising the practice at a given historical point.

SH: Mary and I have been talking about these things on and off for some time, and I like the way we have punched right into the exact point of our disagreement by her statement, because, although I am completely emotionally in sympathy, in a sense, with her position, mine is so divergent from it in a way. I started from the idea of the subjective, what I called the necessity for truth telling in art, which strangely enough has led me to similar conclusions, although I wouldn't place the causes specifically on the level of politics and ideology but rather on the overall level of culture and language which is to me more of an overview and also bypasses a lot of male thought on the subject – which is another point of divergence that we have. I feel there's a struggle to unite in my practice as a woman and an artist; there is a struggle to unite the subjective with the language of public discourse or the art meta-language, or wherever we want to situate that particular problem, because culturally women are very much disadvantaged. They are alienated from the mainstream lan-

guage or distanced from it to some extent, and consequently at the moment you either have women artists who are speaking the ordinary, dominant languages of art and speaking it rather politely, or you have a kind of confrontational approach which thinks of crashing through the dominant structure and coming up with something else. I don't feel it that way, I don't perceive it that way, and it seems to me that everyone is both a victim and a kind of beneficiary of the culture. As women we are not in a position to speak our own language. After all, in our society we do all theoretically share a language. It's not a culture that has a man's language and a women's language, but because of our experience there are certain disjunctions, certain discontinuities, and I think very valuable new perceptions. Now, I have always called these conceptions 'paraconceptual', because they are not encoded linguistically and they are not encoded in art practice, and if there are particular kinds of things which tend to be in a sense future oriented or even slightly science fiction which interest me and I think it is by this kind of paradoxical statement, an awareness of the disjunction and the playing off with one's own self – the eye of the artist, the subjective eye and the objective eye are not unified for women artists.

Mario Merz

During the 1980s Audio Arts collaborated with the Whitechapel Art Gallery and produced a series of audio–visual presentations relating to current exhibitions. These included Joseph Cornell, Max Beckmann, David Smith, Bruce McLean and Mario Merz. In order both to produce a tape/slide programme to accompany the Merz exhibition and to record his commentary for an issue, Audio Arts spent a week with the artist in the gallery during the setting up and installation of his exhibition. A discussion was then held with Merz, Nick Serota, then Director of the Whitechapel, Mark Francis, Exhibitions Organiser, and William Furlong. The following statements from the recordings refer to some of the works in the exhibition.

Luoghi Senza Strada

MM: The bitumen covers come from oil, usually used for construction, making streets or the like. It is a fantastic material to use since it is such a concentration of both the liquid and non-liquid power of the world. After a process of millions of years, earth becomes oil, so that bitumen is a reality showing the power which the earth itself has. This is what makes it possible for me to use it.

The Double Igloo

It is not my job to explain my work exactly. When I explain, I put myself in the position of making a new work, and the work is always in the doing of it. For instance, with *The Double Igloo*, the reality of this piece is that it is necessary to do it on site. If you look at the work you have a sensation about it, not because it is sculpture, but because, for example, each piece of glass is in flight around the structure. It is fixed for the moment of the show, but it is in flight between the earth and the sky. This is true for all that is built by man, a castle, a monument, a Greek column. Each thing has one direction, like each piece of glass. Together, they become one place.

The Painting

The painting was made on 14 January in the gallery.

The painting comes from and works against the old classical idea of fully representing man, his body, hands, head, feet and all. Here I take a part – the foot and some of the leg – and repeat it ten times. This piece of leg is like a gramophone record which is stuck so that you get a fragment, repeating itself time and again. It is related to the spiral and is made to destroy the idea of the classical representation where the full structure has to be shown. This kind of work is also related to time since each foot is made one time. When you do it ten times, you have an idea of time itself. Someone seeing it without knowing my explanation would, I think, have the same sensation about it.

Q: What do you want people to go away thinking from your exhibition?

MM: I don't know because I don't have any idea what people themselves should think. They might take away a feeling against the architecture that they see around them in the streets. Also an idea that the time used to construct a work is the time of the work. But I don't mean that they would think this directly, since art is undirected, it is an invention by man to express something indirectly. Art is not meant to explain, but to show what it is impossible to explain.

Nancy Spero

As with Merz, many of the recordings with artists were made during the installation of their exhibitions. These interviews benefit from this initial focus, which can then be broadened out to include underlying concerns. Here Nancy Spero talks to Skye Holland about her works at the Institute of Contemporary Arts, London in 1987.

SH: Your work may have caught the mood of women artists who find themselves in a state of flux in Britain at the moment. The feminist movement took us all a bit by storm through the

seventies, and there are peculiar modes of work that came out of that, and one's feelings are that if one makes work that is about feminist issues, or political issues even, when one is a woman artist there are certain constraints which surround the way in which we work. For example, there is a strong movement of photographic imagery with text. How do you feel your work fits into the kind of feminist ideology? Do you feel that you are addressing the problems of representation of women in your work?

NS: I can understand your constraint because it is very powerful here. Many of the artists do approach their work from the theoretical vantage point. So I can understand your frustration in using text and photographs and also I can understand your frustration at the implication, if not downright rules, of what one can represent – the rules of representation, misrepresentation, let's say the correct political way of approaching feminism and using symmetry. I feel that I do attack this problem in another way, and that perhaps my work straddles what might be called figuration and conceptual art as well. It's kind of like a combination of both. Here it is hand printing on paper, yet to me it looks like painting. I trained as a painter and I have painted for a good deal of my career. On the other hand, it isn't painting in the traditional mode. What I am doing is trying to make a symbol, in a sense, of women through the ages and not to represent or be didactic about what women should be. I am also trying not to make a narcissistic art, and I think that perhaps the printing might help this in that it depersonalises. You know what I am saying. The replication of the images you see gives movement, gesture, and it doesn't then have the viewer standing static, in a didactic way with a picture frame, and saying this is a finished product and this is my view. That is the intention, that one sees out of the corner of one's eye that the work continues.

SH: I get the very strong feeling myself when I stand in the middle of that room of being surrounded by a kind of cultural embodiment of who I might be, my past, things that might be subconscious. They might be feelings of a mythological past which are very strong presences in all women.

NS: The sources are diverse, and let's say some are easily recognisable others not so. I take a lot of the images from non-Western cultures. I have images from the prehistoric to the present all the way, and I combined and re-combined. I have images from prehistoric caves in Africa and from the French caves, I have prehistoric Australian Aboriginal and probably from the Spanish all the way up to media photos of women athletes in the Olympics. In between there is a Hittite goddess, a crazy kind of image, she has got a very long, cone-shaped hat and

then it balloons out on top. She is nude to just below the waist and she is offering her breast and at the side she has two strange, monstrous-looking children. They look male but they also don't look quite human, and the whole thing is quite ambiguous. That is from Turkey. A woman tried to translate for me to find out who this goddess was and as far as she could see it was Hera. So I combined a piece that is not in the exhibition with a couple of contemporary fashion figures and with the figure of a nude woman obviously from Africa. She is kneeling at the base of this Hittite fertility figure, and the way I have put her there it is like an ambiguous gesture of whether she is giving an offering, praying, you know – just what is she doing there? But obviously she is relating in some very ambiguous way to it. I have the feeling that many women feel that that work atomised her or fractured her into little parts. Maybe all contemporary people do – urban people, men as well as women – but I think that for women, particularly those that have children and a career and all these various things to take care of, you know there are all kinds of disparate activities.

Philip Glass

As well as recording artists' speech it soon became evident that Audio Arts was the ideal medium of the related areas of performance and experimental music. The work of musicians, including Philip Glass, Steve Reich and Glenn Branca in New York and Michael Nyman, Cornelius Cardew and Gavin Bryars in London, was more openly received by the art world than by the musical establishment. This often resulted in performances in art galleries rather than concert halls. Recent English Experimental Music, *published in collaboration with* Studio International *in 1976 included works by nine young British composers (see Catalogue, p 138). The tape included 'The Otherwise Very Beautiful Blue Danube Waltz' by Michael Nyman performed on five out-of-tune pianos, each out of sync with the others, in the foyer of the National Theatre in June 1976. In this interview Philip Glass speaks about collaborations in the late 1960s with other well known New York figures, and his 'music theatre' pieces, which include* Einstein on the Beach, The Photographer *(a work about Eadweard Muybridge) and* Satyagraha, *a reading of Gandhi's life.*

WF: As a musician you have for a long time performed and worked within visual arts areas – lofts in New York, for instance, in the 1970s. Perhaps this is because of connections that have been defined between your work and the art of that period. Did you feel that you worked in those contexts primarily because visual arts audiences seemed to feel an empathy with the music you were concerned with?

PG: I think the thing to remember if we go back to that period, say the early seventies and the late sixties, is that what we're talking about is a community of people that were living and working very much together. So that Yvonne Rainer, Sol LeWitt and Richard Foreman and myself and Michael Snow, the film maker – we were actively sharing the stages of our work with each other. When you talk about the audiences, we were the audiences. The audiences were the other performers and the other visual artists in this downtown New York scene. I would say there were shared interests; I don't think that we were writing for each other so much as expressing in our own ways these different ways of looking at these things. This was very true of theatre, the Maboo Mines began about the same time – all the people who are in their mid careers now, in their forties – and I met Bob Wilson during that time also. It was very much a community and it was something that was very important at that time, because there really was hardly anyone else. The audience was kind of acquired over the years. Now there's quite a large audience, but at that time we played in lofts and galleries because that's where we lived and worked. I wasn't in a concert hall for years. First of all, there wasn't any producer for the work at that time. I didn't even work in a proscenium situation for years for the same reason.

WF: I'm wondering about the performance element of the work. Since then a lot of those spaces have become well known for performance art, and presumably there is an element of that in your performances. They're not exactly works that hundreds of other people are going to suddenly perform. I don't know whether they do now?

PG: Since I have been doing the operas *Einstein on the Beach*, *Satyagraha* and the *Akhnaten* it is less true now, now there is a possibility for other companies to do work. The Stockholm Opera, the Netherlands Opera the Houston Opera are companies that I am working with and have worked with. Those are things that all happened let's say, after 1978 or 1979, so in the first ten years the performances were simply confined to my own performance situation. Nor was I interested in finding situations beyond that. Partly it was for economic reasons – at that point I still hoped to make a living through playing. I discovered then that you never really make a living through playing, but I have been able to evolve a livelihood through writing. But the playing was a way for me to make sure that the work would get heard. I felt that if I didn't do it, it wouldn't get done, and that was true for many years. Now that people want to do it, I'm not so inclined to do it except for these large theatre pieces. I call them theatre but really they are music theatre pieces.

WF: A lot has been written and discussed about the cyclical and serial notion of your music, but I was very interested in the idea of content, how you felt this entered your music and how you actually intended content to function within what was a fairly structural repetitive feeling.

PG: I think that there was always a certain high emotional content to even the early structural pieces like *Music in Slow Motion*, it is something you really can't miss. It is not really a cerebral piece. It is a piece that you get a big emotional whack from as you're listening to it. In that early context the structuralism is so much in the foreground, but I don't think we're ever unaware of the emotional content of the work. It is interesting, though, as I work more in theatre – remember that I began with the Maboo Mines in 1965, when they were still living in Paris, but when I got involved with these large theatre pieces, first with Bob Wilson and then later on with the ones I did for the Netherlands Opera or the Holland Festival. Theatre music really has a very different kind of demand from the abstract music I write for the ensemble. For example, with *Satyagraha*, the setting of Gandhi's life, you're talking about a three-act opera, and the question is, where are your high moments? What happens before the intermission? Where is the finale or is there one? In fact, with *Satyagraha* I chose to do the last act as a long epilogue, about an hour long, to the first and second act. Each has a build of its own. Each one builds to a finale of its own, and in the third act there comes a long kind of quiet coda with a little build in the middle. So that's a whole way of thinking in terms of theatre time, which you never think about. I wrote a piece like *Dance* for Lucinda Childs and Sol LeWitt. We were not thinking about a narrative time line at all. It's hard – I understand now why so few symphony composers wrote operas and so few opera composers wrote symphonies. Once you get into that way of working you have to wrench yourself out of it, almost. It becomes a way of thinking. It has its own direction, its own development. You start developing your talents in that way, you kind of want to go on with it. So my inclination is to work more in theatre now. I've become more and more a theatre composer, and my relationship with the ensemble and the other more abstract pieces is partly because I've worked with them for so long that the music really, I feel, is just now getting played really well the way we can play it.

Les Levine

If something can be used to sell you Coca-Cola, then that exact same system can be used to sell you an art idea.

Les Levine begins by describing the concerns of his exhibition

'Ads' at the Marian Goodman Gallery, New York. 'This exhibition used the art gallery as a marketing platform for photographic projects designed to be billboards and media campaigns' (Shelly Rice, Art Forum, *March 1980). Advertising for Levine represents a useful model of communication within contemporary society – useful in the sense that messages and their meanings can be conveyed through media such as TV and billboards without the inhibitory factor of something 'being art' and therefore requiring 'intellectual consideration'.*

A predominant theme throughout the tape is Levine's concern that art should have a content that is discernible.

I have said time and time again that abstraction is the enemy of art – the main purpose of art is to make things more clear not less clear, and running away from issues into abstraction, avoiding content because you think it's better to be more mystical, is not going to make art survive.

Rather than excluding areas of social and political concern from his work, Levine comments:

An artist's main function from my point of view is to include everything that was previously outside of art.

In Documenta 6, Levine exhibited a sequence of images depicting world leaders (at that time) Nixon and Brezhnev in a variety of activities including eating, waving, gesturing and speechmaking.

In the twentieth century the whole name of the game in politics is what kind of clear, explicit images you can make for the people who are going to vote for you.

Levine goes on to discuss the renewed interest in painting amongst younger artists and the polarisation between some painters and media-based artists:

I am not against painting, I am against the idea that something has to be painting to be art.

Finally, to questions about the context for presenting art Levine concludes,

That old argument of – is it the art world or the real world? – it doesn't interest me because finally in time everything is the real world.

Brice Marden

The relationship between artists and Audio Arts has often been collaborative. It has been seen as another dimension to practice and as an extension to the possibilities of realisation and presentation. This has also applied to a number of galleries and art spaces, one significant example being the Anthony d'Offay Gallery in London, where a number of important recordings were made, including the last interview in English made with Joseph Beuys, reproduced elsewhere in this book. Other important interviews included those with Francesco Clemente, Bruce McLean, Gerhard Richter, Ellsworth Kelly, and, in 1988, Brice Marden, from which the following is an extract.

WF: I must say, looking at these paintings, the first thing that strikes me is expressed very succinctly in a recent *New York Times* review of an exhibition of paintings that you held there quite recently at the Mary Boone Gallery. Michael Brenson, who wrote the article, claims that in the past, touch and process were concealed, but that now touch and process are suddenly visible in this series of works, and there is almost a sense of a handwriting beginning to emerge in them. How do you feel about that?

BM: Well, touch and process were also in the other paintings. I always felt it was quite evident if you looked for it. It wasn't sort of self-evident but it was very definitely there. It may be that these paintings reveal more of an underlying emotional state that existed in the other paintings but which just wasn't coming out. It was coming out in my drawings, and that is why I pushed the painting to this extent to get into my paintings what I was getting into my drawings, which seemed to be obscured in my older paintings. It wasn't obscured but it wasn't in the forefront. It wasn't in the forefront of the thinking or of the practice but it was there, it was part of it. So I just tried to open it up. They look different, but in the long run they won't look different from the paintings I was doing.

WF: Was it in any sense a desire to resolve that dichotomy between the drawings, which reveal a very calligraphic kind of sense, and the panel paintings of the past, which tended to be very flat and didn't really reveal much of the process of making as far as you the artist was concerned?

BM: Well, I think the older paintings had more nature; my involvement with nature came through in the work. I think in the older paintings there were feelings about nature that were really expressed quite deeply. Observations were expressive on one level, and this gives me an opportunity to express them on more levels. Right now I am involved in a lot of drawing and drawing out of ideas and the colour ideas haven't really been applied that

much. That is something I want to work on to. The drawing has been coming much more directly from nature. It is not a matter of drawing from nature and then making an abstraction. It's like trying to get closer to the basic reaction you have in seeing it. It's not an empathetic response to nature but it is somewhat akin to it. You see something in nature, you draw it and then you want to maintain that kind of energy you are seeing and putting down, and when you have put that down you want to get that same energy into the work in the studio. So I don't think of it as an abstraction, say taking a picture of nature then changing it and changing it. I just think I am working with the same kind of energies all the way through a project. It is more searching to be able to depict this energy. It is like an inner strength or a life force. It seems to me that the greatest thing you could do would be to make life, and it is a constant attempt to get close to that in painting. There has been an involvement in oriental calligraphy and a certain involvement in oriental thought about which I have no expertise though I struggled through some articles about it. But there is a thing in calligraphy. They try to get a certain spirit through – an inner spirit, a sort of Zen thing, and that is an influence.

Also my painting has always really been, I have thought, directly related to the New York school of painting or the Abstract Expressionists. I have always felt that no matter how it was classified with Minimalism and this and that, that it really reflected more of those kinds of ideas – the possibilities for catharsis, you know, an emotional and expressionist attitude. I think this is sort of coming back – it's not that these paintings are Abstract Expressionist paintings, they are not, they don't deal with what I can remember. I got involved with Minimalism when I was in school. Teachers were referring to cliches of Franz Kline, de Kooning, Pollock that I was making in the paintings, and I consciously tried to eliminate them, but when I eliminated them I ended up with this Minimalist surface.

Richard Hamilton and Roy Lichtenstein

Although we communicate more through speech than through any other medium, even given the sophistication of modern technology, it is perhaps strange how little importance is attached to the retention of the spoken word. Being able to return to and witness individuals' ideas as they converse must provide a valuable instrument in understanding motivations. A discussion conducted between two people serves to focus agendas, to test and explore underlying assumptions and perceptions. Here Richard Hamilton and Roy Lichtenstein engage in such a discussion with Marco Livingstone at the Museum of Modern Art, Oxford in May 1988. The artists discuss specifically the development of their work and its references within the context of Pop art, both in Britain and in the USA.

ML: Richard, when you formulated your definition of Pop art in 1957 in the famous letter to the Smithsons, what was it you actually had in mind?

RH: That was a definition of what we were calling Pop art, which was art produced by the mass media. You had to distinguish it from folk-lore. There was art being produced by people painting canal barge buckets and there was art being produced by very sophisticated advertising people who knew exactly what they were doing and directing it at an enormous audience. It was this area of interest that we were concerned with and distinguished the advertising man's idea of art from the folk artist's, and instead of calling it popular art we called it Pop art. It had nothing to do with fine art at that time because there was no such thing as 'Pop art' as a category of fine art.

ML: You were quoted quite early on as saying you wanted to make a painting that was so despicable no one would want to hang it.

RL: Well, this is one of those after-the-fact statements that sound okay at the moment, but I think that most people saw it that way. I think that if I had seen one of my own paintings, Pop paintings, ten years earlier I might have felt that way. Because I was involved in the kind of aesthetic that really comes from Expressionism, I suppose, and Pop art countered all of my training. Everything I did in school was involved in a direct sort of Expressionist response to nature in some way and then it became more abstract and had elements of Cubism and so forth. So everything from the beginning was countered by what I did. When I made the change, I didn't think that basically it was different but I thought it felt a lot different, would look a lot different, and was still brought into the realm of art. Not just because it was brought into a gallery or museum, or because I made it larger or something like that, but because I felt I was organising it in a traditional way, even if it didn't show.

RH: I think you came up with a key idea when you said that you were responding to nature, or the early work you were doing was a response to nature. It always seemed to me when I began this experience of painting pictures which were based on this letter that the difference was that I was no longer concerned with nature. When I got to America I found that there were other artists who had made the same decision. My life as an artist having been built on the idea that painters responded to nature, it was interesting to find that that wasn't what I was doing. I was responding to pictures in magazines and comics or cinema or

whatever – and there was a good reason for this. Art had moved to a point where abstraction was the only thing possible. Rauschenberg ends up with his blank canvas after Malevich had done the same thing – the most outrageous thing that Malevich could do was have a white on white, and then Rauschenberg thought, well, forget the white on white we will just have white. There wasn't much to do after that, and so there was a way back. Were things going to be reactionary so you looked back at nature? That wouldn't have been a very interesting way to develop, and so artists in America and some here also thought that the way to return to nature was to return at second hand. You looked at the way nature had been reinterpreted into another form and it was that new form that became interesting. I think this is the thing that unifies people who have been labelled as Pop artists: it is no longer about nature, it is about the conversion of nature.

RL: And of course I don't think it was about nature anyway, because when I said I was responding to nature I was responding to Manet, Cézanne or Van Gogh. Obviously I didn't invent the idea of responding to nature in that way, it had been invented through a succession of artists through history, and I would be drawing like a child if it weren't for that. So that the idea that you are responding to nature is just something in your head. You are actually responding to the history of art, the things you were taught, and what you think is a direct response to nature in my case is a direct response to Manet or maybe Picasso.

ML: In the States Pop art often is seen to be presented as an extremely American style, perhaps the most American style of painting in the century.

RL: Well, people kept saying that. I feel that it is a style based on commercial illustration and I suppose we went further earlier in those days than other people did. I mean we were polluted by it. The architecture and advertising, we just got it started, it was after the war and America was fairly wealthy and Europe wasn't, and I suppose we just got a big start on the sale of refrigerators and all that. It changed the landscape a lot, I think, in the fifties. You were aware that the real architecture was not Le Corbusier but McDonald's hamburger stands, and in spite of the idealistic that was the reality of what the environment really was. Of course there were older things in America, but anything that was new had this aspect, and anything that didn't was older and came from Europe. Los Angeles and places outside of New York had much less relationship to any architectural tradition than anyone could recognise, and it is still that way, so there was a feeling that whatever was new in the environment went through this filter of commercial art and had a certain kind of appearance and feeling

ABOVE: Roy Lichtenstein, final study for Artist's Studio, Look Mickey, *1973, pencil, coloured pencils, cut-and-pasted paper and* Magna, *41x55cm, from an exhibition of work by Roy Lichtenstein and Richard Hamilton, Museum of Modern Art, Oxford, 1988 BELOW: Brice Marden,* Untitled 3, *1986-87, oil on linen, 182.9x147.3 cm*

that we try to get. I don't know that all of this occurred to me and therefore I did the art. The philosophy didn't really precede the art, although there must have been a certain subconscious way you wouldn't do it, but a lot of it is thought up after the art. But there must have been some reason why a comic strip or whatever or simply a printed thing on a cardboard box seemed like an appropriate thing to do to me whereas it wouldn't have earlier.

RH: The thing that I found interesting about what was going on in America is that it was about ideas. Paintings had become about ideas instead of about gesture. Everyone was talking, all the art critics and all the theorising about art was that it was to do with gesture. Jackson Pollock was dripping paint on, there were these Tachistes in France, it was all supposed to be mindless. You just put paint on and something happened. Clement Greenberg was advocating the idea that artists didn't think, they painted from their stomachs: something went on in the diaphragm when you made a work of art. It had nothing to do with grey matter but what Duchamp had always said was that it was grey matter. That is why he felt outside. Then there were people like Roy coming along making a brush stroke. I think there is a good example in the brush stroke – to say that a brush stroke can be converted into other kinds of marks and mean brush stroke but have nothing to do with brush stroke physically, is a very interesting philosophical idea.

ML: There is an apparent anonymity in the depersonalisation which characterises almost all of your work since the early sixties. Was that largely a reaction against that Abstract Expressionist idea of the artist's personality being somehow in the substance of the paint and the gesture?

RL: Yes, I think that is true, and I think Richard said it very well about the mind as opposed to the touch, and there is apparently no touch in our work. There is not much art of the past – Poussin, Ingres – you could think of a lot of periods where touch wasn't the important part of the work. Art can be done in a different way which depersonalises it, but it is also fairly evident who did it anyway. It is a depersonalised style because it just seems printed and it is supposed to appear to be done by a machine. It is printed and it is fake and it is a copy and it is done from a two-dimensional subject rather than a three-dimensional subject and it does all the things that art isn't supposed to do and therefore isn't art.

RH: The interesting thing is that one turns very often to art, as you have with Picasso and the brush mark itself and the comic strip – it is all a form of art. The reason I found it so fascinating was that we were not going to nature any longer because perhaps eighty per cent of our visual attention as twentieth-century

beings or mid-twentieth-century beings was that we looked at two-dimensional things. We looked at magazines, looked at cinema screens, video screens, and this is part of our world, but we were also looking at art books so we were looking at reproductions of paintings. They were as much a subject, could be as much a subject as a film star or an ice cream cone. It seems to me to be very crucial, this idea of subject matter. The thing that I found fascinating about the American approach to it was that there was a kind of need for vulgarity, and I wanted to oppose that. I felt that there was something wrong about this, that because you were presenting your stuff in a vulgar way, that is to say because you were using a crude language deliberately, that you might feel the need in the beginning to express crude subject matter – hamburgers and boilers or old twine, it had to be fairly anonymous or unthinking. I felt it necessary to oppose that idea and that the Guggenheim Museum was just as much a subject as the doughnut diner in Hollywood. You don't have to make a split and say this is a legitimate subject matter for a Pop artist and that is not. All the world is Pop.

ML: I get the impression in your work that although you were interested in representing objects from very early in the sixties, it was almost like the archetype of an object. When you started referring to the work of other artists it became very specific. Why did that change occur?

RL: I don't know why, really. You can refer to a kind of a work or a specific work. I did landscapes and still-lifes as a kind of genre, but I also did specific Picassos; but the Mondrians are not specific Mondrians. The Cézanne was from a book which illustrated a Cézanne and wasn't from Cézanne at all, that was a diagram, and one that seemed to be in complete opposition to what Cézanne's feeling was, so to make a painting of that would be the same as making a painting of a cartoon.

The thing is that I knew people would take a large painting of a cartoon as exactly the same as the cartoon. It just looked like the same thing bigger. I realised how people would react to that after Abstract Expressionism, but I knew what I was doing with it. I had a feeling that I was really changing it a lot in its composition and so forth and was trying to reorganise it.

RH: There was something very exciting about my experience of the first work I encountered of yours. It seemed there was a new compositional event occurring in your work. It seemed to be your invention and it was like looking at Degas for the first time and realising that the picture was composed in a peculiar way because he must have had access to a camera or photographs, and there was something quite novel happening. What was novel about your compositional device was that it was a single

frame extracted from a sequence which was about action. What you did was to take it out of context and isolated a single frame. That's what makes it extraordinary.

RL: It makes it more absurd, really. It is part of a story and I'm taking the part out that implies something happened before and after, and you don't know what it is and all of that. I picked them to be disturbing in that way, or humorous in that way, or evocative in some way.

ML: Roy, your paintings always look as though they have been done without any hesitation or any struggle. This is totally the opposite again of the previous generation, which wanted to dwell on the struggle, on the difficulty of making a work. Yet this exhibition of your drawings is perhaps more revealing of the processes than an exhibition of paintings would be in terms of actually showing how an image is arrived at or what changes are made to it. How do you feel about actually making these works public in the same way as the paintings? I know they have been exhibited and reproduced before.

RL: They probably look softer and not as hard as the paintings, or not as complete and maybe more expressionist in certain ways; some of the drawings, because changes occur in the drawings and the composition is worked out usually in the drawings more the way it would be in classical art than the way it would be in expressionist art. It isn't just that interaction, it is fairly well worked out before it gets to the painting. Then it is continued on the painting, but I have a fair idea of what it will be and I do a lot with collage and try purposely not to show the tracks of my work in the finished painting. This again is in opposition to Abstract Expressionism, which really went out of its way to show this interaction and so did many people before that. I felt it was a cliche to show that and to harp on that aspect of it.

ML: Your exhibition, Richard, is a very specific selection of your work. In the fifties you organised a number of very influential exhibitions which in a way seemed to relate to these installations and to the idea of controlling the whole environment and the way in which the work is seen.

RH: I do like to hang. That is something that always has interested me even from the early fifties. I did a show when I had just emerged from the Slade called 'Growth and Form', which was my first experience of making a space. I think that activity is a rather important one for other people. Beuys, for example, is an incredible user of his own individual constructs. They only begin to live and sing when he disposes them in a room, and it is what he does with the space that is operatic and Wagnerian.

Things really begin to happen, and Beuys's reputation is bound to suffer because nobody will be able to do it any more. You will never be able to see a Beuys as it should be seen, because the Beuys was the whole space. So my interest in this show has something to do with that. There is a new kind of form which is possible if you think about artworks in this way.

Gerhard Richter

In this rare interview recorded at the Anthony d'Offay Gallery, London in 1988, Gerhard Richter discusses his series of works 'The London Paintings' with Michael Archer, William Furlong, Jill Lloyd and Peter Townsend.

The relation between his use of highly literal and descriptive titles for the abstract paintings is examined, as well as the two strands that comprise his recent work, namely, highly figurative representational paintings of the landscape on the one hand, and on the other, the abstract series.

WF: Gerhard, can we talk about the 'London Paintings' that you are exhibiting here at the Anthony d'Offay Gallery? The first thing that intrigues me is the very literal titles they have, such as *Salt Tower*, *Brick Tower* and *St James*. The paintings themselves one could describe as being completely non-figurative, and I don't know whether you are happy with term 'abstract', but I was wondering if you could start by talking about how the paintings came about and what is in fact their relationship to the titles.

GR: These are just names, and a name doesn't mean so much.

JL: But the religious titles are very provocative. If you have a religious title for a painting it makes people think that they are about religious experience.

GR: The meaning comes from the chapels, from Westminster Abbey, and not from the person. No, they don't know it when they see the titles and read the titles.

JL: Are the paintings meant to have some religious dimension or not?

GR: I have nothing against this meaning.

WF: Are you happy, then, to accept the terms 'abstract' and 'figurative' as describing the two primary focuses of your work?

GR: Abstract and figurative are very simple terms and may be wrong. Abstract has another meaning, but we use these terms to say non-figurative and figurative, I don't mind.

WF: It is just that I get the sense that the paintings really aren't abstract; they are non-representational and seem to be about something very specific in terms of their surface and the way the paint is applied and the images that are created.

JL: Perhaps you could tell us something about the relationship between the two different types of painting. Do you see them as opposites or as related?

GR: They are both realistic in a way. The art shows the artificial reality and the other also.

JL: You don't see the paintings about nature as being natural, then?

GR: About nature, more natural, yes, yes.

WF: Yet there seems to be something that is very specifically non-natural, if you like, about them. When one looks at them one is in a sense looking through a filter at nature, and I get a very strange sense of time from them, but they seem to be very removed as well. They seem artificial.

GR: Yes, that is true.

JL: The paintings seem to be very different from the abstract paintings that you have been making over the last few years.

GR: The new abstract paintings are quite different. The paintings before had more structure, more composition. I am not able any more to give composition.

JL: Are these the beginning of something new or are they the end of a particular abstract phase?

GR: Yes, I have the feeling that I have to start with new things but I don't know what. Maybe I continue. I really don't know. I am in a state now without any idea.

JL: But you seem to like painting in that state – you like to paint without any idea. When we talked before, it seemed that you didn't want to bring any preconceived ideas to what you were doing.

GR: Yes, but then I had the idea to have no ideas. This is a bit different – now I really have no ideas, no vision for a new painting.

JL: But when you said you had the idea to have no ideas, it is a very conscious thing. You have to avoid having ideas. At the moment you are not avoiding it, it is just that you don't really know what is coming.

GR: Yes, yes.

MA: Do you find it worrying that you don't have any vision at the moment?

GR: Yes, yes. It is not so nice, but I know these interruptions from the past, longer or shorter.

WF: Can I just develop a point about the paintings? It is interesting how you have actually made them, because there doesn't appear to be a signature, if you like, or the artist's actual activity which leaves a trace behind that reveals the identity of the artist. That certainly doesn't seem to be present in the photographic paintings but neither in the abstract paintings, which I find interesting. I was wondering if this was a very conscious thing on your part, not to actually create any identity for yourself in the marks, in the way the paintings had been produced.

GR: Do you think they are anonymous?

WF: They are not anonymous but they certainly don't reveal the hand, if you like, of the artist.

GR: My handwriting is visible in the painting, even when there is no brush stroke in the painting.

JL: I suppose you associate the brush stroke with subjectivity, like the Expressionists, and you seem to try to avoid that type of expression of your own self or feelings.

GR: I never liked the Expressionists. Neither the old German nor the modern.

MA: You said that there is little structure in the abstract paintings. Certainly in the ones you were doing up to ten years ago you started off with a very small, quite heavily worked painting and then enlarged a photographic section of that to make the painting. Is there any way in which you do structure the paintings that are here?

GR: No, these are absolutely different from that time. You mean the blow up? No, there is nothing. When I mentioned that there is less structure in these paintings, I thought of the paintings only three years before or five years before. They had a composition and they were built differently.

WF: Is it something that you feel strongly about now – the idea of making paintings that are associated with a particular site – a particular building which has associations such as the churches and the towers and so on? Is that link important to you, that there is a reference at least in the title to a particular place?

GR: In this case, yes, for the 'London Paintings'. [*Translated by JL.*] It has to do with other things I was interested in at the particular time I was doing them – the Kafka that I was reading, or the fact that I am coming to London to do the series. It was on my mind and the titles became coloured by that.

JL: Is this to give an extra dimension to the painting as well, so that we don't see them just as formalist abstractions?

GR: Yes, yes, there is a hope or wish to give them another dimension. I have a similar experience when I paint from a photo and I destroy the image more and more, but still the title is there, so with the tourist paintings you can hardly see the tourists and the drama of this terrible thing, a man eaten by a lion, but you have the title and it is interesting.

PT: There is a passage in your catalogue which is a translation of one of your letters where you refer to nature as being without intelligence, without sympathy, but also being inhuman. Do you mean inhuman or do you mean ahuman, because inhuman is a very human term?

GR: This human we don't have in German, this difference. So I think I mean ahuman.

PT: As in amoral?

GR: Yes.

MA: I read that and found that quite interesting. Does that mean you don't see us as really being connected with nature in any way as physical beings?

GR: We are connected with nature. This is a very polemic sentence.

PT: It is. It means that the only interpreter of nature is ourselves as human beings, and in a way your abstract paintings seem to throw landscape back onto the viewer to look inside him- or herself for a response to the landscape which has nothing to do with the landscape. Is that so?

GR: Yes, yes.

MA: How important is it in this show to have the two types of imagery together, the abstract and the figurative?

GR: I think it is more understandable. They are realistic when you show both, but it is also possible to show only one type.

JL: Would you ever show the photo landscapes by themselves now?

GR: Not at the moment, no. I am more interested in the abstract paintings.

JL: So the landscapes are really there to throw an extra dimension on the abstract painting, rather like the titles give an extra dimension.

GR: Yes, yes. It has to do with this hope that I mentioned that they have more meaning, more importance for us. I feel always a lack of importance. I am just a painter.

JL: And you mean that we have to create this importance?

GR: Yes, I could do more. Paintings are limited in their effect.

JL: In their effect on the audience or in the potential they have to express something?

GR: We have a lot of problems in the world and the paintings cannot do very much.

WF: There were just one or two things about the photographic paintings. I saw that very large installation of the portraits in the Museum Ludwig last year, which I think is a very impressive piece, and I was just wondering about your particular thoughts about the photographic level of representation. Your painting in a way consciously emulates the photographic process, or is very close to it. What is the distinction, do you think? What makes your portraits substantially different from the photographic equivalent?

GR: I have two versions. Painted portraits from photographs and then photographs from the paintings. Sometimes I like the photographic version more – it is more modern, more of our time.

WF: But what are you thinking when you are actually making those very tight, very accurate paintings that are so close to the photograph?

GR: It is the only method I can use. The best except for colour.

ABOVE: Gerhard Richter, Sanctuary, *1988, oil on canvas, 200x320
cm (courtesy Anthony d'Offay Gallery, London)
BELOW: Gerhard Richter,* Beech Tree, *1987, oil on canvas, 82x112
cm, (courtesy Anthony d'Offay Gallery, London)*

They are not coloured, and a lot of photographs I had at that time were not in colour.

JL: Are you trying to make them look as realistic as possible?

GR: As realistic as possible, and sometimes I was able to do them better than the photographs – more clear. They were very small, some of them. It made it a bit better.

JL: But often there is a slight blur to everything that looks deliberate, as if you don't want it to be a perfect illusion.

GR: They become more realistic with this effect.

MA: When you say you want them to be as realistic as possible, do you mean you want them to look as much like photographs as possible or as much like reality as possible?

GR: I don't know a picture that was better than a good photograph.

WF: But they are conscious paintings of the surface of the photographic print. As an alternative you might for instance paint the actual portrait of the person.

GR: This is a facility we didn't learn. We are not able to paint. Very few painters, like Lucian Freud, can do this but all the others are not able. They didn't learn it. We have no school teaching this.

PT: But actually those paintings of yours based upon photographs – when I look at them my response is an emotional response not to the landscape you have painted but to the way I would look at a landscape like that.

GR: Yes, I think I understand. It comes from the photographic apparatus, yes?

PT: It is almost as if you have transferred a mood to me as I look at your work. You make me respond to that landscape in the way you know I will respond to a landscape locked inside me.

GR: It is good.

JL: I find the landscapes very disorientating in a way, because they seem very romantic and beautiful but they also seem very emotionless. I mean there is a sort of aimlessness about the landscapes. They are too far away or they are too close or something isn't quite right. Do you want us to see the landscapes as romantic things or do you like us to feel a little bit disorientated?

GR: Both is right. I think we have these two feelings at least when we see a landscape. We feel nostalgic and nostalgia means this double feeling.

MA: To go back to Bill's mention of the series of portraits, they are all of famous people. Is that a very personal list, as it were – are they all your favourites?

GR: No. Some of them I don't know and some of my favourites I didn't paint. They are not in this series.

MA: There is a painting of Kiefer's, *Hermanns-Schlacht*, which seems to me to be very closely related to that. It seems as if he has looked at that series of yours. Again it is monochrome – grey, black and white –and it has a whole series of portraits of his personal heroes.

GR: You said that these were his personal heroes, and that was the case not with me. He showed a direction and an ideology, but not me, I tried to make the opposite of a direction. I want to destroy.

WF: Mike mentioned Kiefer, and I was wondering whether you felt that there were any links or relationships between your work and the work of any other current German painters. I was wondering also whether you had any views retrospectively about Beuys, because you lived in Düsseldorf at the same time as Beuys. Did you feel you shared any common ground with those artists.

GR: I liked Beuys very much and sometimes I loved him, but also I tried to avoid him and not to be too close to him.

JL: In your diary notes when Beuys died you said that you thought there was a new task for you, or for German painters, now that Beuys was dead, and somehow you had to carry on what he was doing in your own way.

GR: Now we are doing it. We have at this moment to think again, but at the moment I don't have a new experience.

Ilya Kabakov

Ilya Kabakov talks about his installation 'The Untalented Artist and Other Characters' at the Institute of Contemporary Arts, London in 1989.

WF: Ilya, we are here in your installation at the ICA 'The Untalented Artist And Other Characters'. It consists of a series of

room spaces that have been cordoned off and divided. A lot of other elements are included, like the debris from a building site. In the catalogue you talk very vividly of the Soviet apartment and you clearly have a very strong relationship with the experience of having lived within apartments in Moscow.

IK: I don't want to depict the reality of a communal apartment and the details of living in one. It's not actually intended to represent the real thing. I really want to talk about other things in my work. It is more generally a question about closing a person in and about a person having to live in a space of four walls, and how he actually has contact with other people in this situation. In one respect it is a perfect situation for constant exchange and contact, being always surrounded with other people. The individual has to find some way of maintaining his personal self separate from this huge sea of people around him. The communal apartment is more a depiction of how a person mixes and how he protects himself from those around him.

WF: So in a way the apartment is merely being used metaphorically as a way of exploring the human condition. The installations here seem to be inhabited by, on the one hand the comic characters, and on the other hand very tragic characters. There is, however, a sense of the private here – of withdrawing into a private space.

IK: Another important metaphor in the situation of a communal apartment is that nobody chooses their neighbours. They are just thrown together and they have to live with them as they find them. The communal apartment divides into two parts, really – the corridor and the separate rooms where people live privately or separately in their own area, and the communal kitchen, which is a kind of battle ground where there is constant exchange and contact. Sadly there isn't a communal kitchen in this particular installation as it doesn't have a part in it.

WF: Let's just walk through to another part of the installation. This interior is entitled *The Man who Flew into Space from his Apartment* and it is rather like a cell with a seating contraption that looks as if it could launch somebody, and indeed there is a hole in the ceiling of this cell that someone could have actually been projected through, and the floor is covered with rubble from the hole in the ceiling. There are also various objects in the room that seem to evoke the presence of a human being.

IK: Every room is always like a prison, in a way, to a person. If you live in a room, to get to the outside world seems to be the ultimate desire. If you want to, you can just go out of the room into the corridor to the kitchen to meet other people. But this

outside world of the communal apartment is not adequate for him, and he wants to get right out of it. So the cosmos of space that he wants to get out into is for him like some kind of other world, some heaven, some wonderful place or some paradise.

WF: In that respect it opens up those issues to do with the artist's relationship to the state, which clearly one has to deal with when looking at the work, certainly within this British context.

IK: I don't think that is right, really. I am not arguing, but it is more about an attempt at trying to get into the other world by your own means, and although this character has tried to get into the other world by this crazy invention, it has a kind of pathos because it is obviously not adequate. It seems to us that it is silly and comic and idiotic, but on the other hand when he flew away nobody found him on the earth afterwards. So it may have been a successful experiment. We had no proof to the contrary. So it is an open question.

WF: This next one is again an enclosure with the title *The Short Man*. I also saw the Riverside installation where you had a maze of facets of books that are narratives. One thing that interests me is the way what clearly are autobiographical experiments are expressed through a third party.

IK: This room has three characters. There is the 'short man', who put the thing together and who composed it; there are my drawings, and there is also another character, who thought up the installation as a whole. So there are three characters working all at once, and it is not clear who is the main character, whether it is one of the characters that have been invented, or whether it is the further character who emerged and created the whole.

WF: We are standing now in the main section of the gallery, which, rather like at Riverside, you haven't been content to leave as the almost shrine-like space that it normally is. You have actually painted the gallery here rather like an institutional building with a colour half way up the wall, and there are paintings leaning against the wall. Through the centre, as I was saying earlier, is the paraphernalia of decorating and building within a house, and there is a sense of the incomplete, as though something has been started that hasn't been finished. Can you talk a little bit about that sense of the unfinished?

IK: This uncertainty about whether something is in the process of being built or in the process of being taken apart and thrown away is very elemental in the way the communal apartment functions. There is a sense of movement all the time and

never knowing in which direction you are going. When I actually put this installation together I never really knew whether it was going to be built any further than it is or whether it was going to be taken down. At what point that feeling begins is also unclear, because when you are building something there is always rubbish and when you are taking something away there is always rubbish, and the rubbish is very much a symbol of this uncertainty of movement. The rubbish is a symbol not only of the ruin of destruction and entropy, but it also has a particular potential because all these people's lives are really basically a clutter of things that they have drawn out of the rubbish to make their lives. So rubbish has a capacity to go either way. It is sort of neutral but a symbol of both things, of construction and destruction. There is always the chance that nothing but a lot of rubbish comes out of it!

WF: We are now in the space between the galleries here upstairs at the ICA. *The Composer who Combined Music with Things and Images* reminds me of one of the stories in the book of a concert in an apartment or in the corridor of an apartment and the ensuing complaints that were documented. You spoke of the desire to bring something within this very confined space that had some sort of cultural resonance. Perhaps you could elaborate on this piece.

IK: It is about this character who is very upset because people are just interested in washing up their saucepans and running around and not actually thinking of culture or having any cultural part of their lives. He wanted to force or encourage them to think about something more highbrow, and so he got them all together to sing as a choir and put together this combination of pictures and texts. It was very difficult to stop people rushing about and get them together, so he stopped them by actually putting up stands in the corridor. It was a way to compel them to join in. Terrible rows occurred and fights took place, and it is a fable about how people drive one another to their deaths.

WF: What I find very interesting about the work is that although it is clearly derived from a very specific experience that is removed from a Western audience or a Western society, it still seems to me to speak in a sort of universal language in relation to the human condition through the use of metaphor and symbol. I think it deals with issues such as private spaces as opposed to overwhelming social and political pressures of whatever order. There is a sense of the private, personal survival being investigated here.

IK: There were problems with the installation. It was very difficult to get people to understand what a communal apart-

ment was, and why, if it was so awful, people actually lived in it. But there is definitely some consideration of these more general issues there. It is a very successful metaphor of human life and existence, and this can't really be conveyed in something abstract, it has to be portrayed in something that the artist knows extremely well as a reality. If you have a really pure metaphor then it loses its bearing on anything real, whereas if you use something that is straight from reality then it will seem too autobiographical and not referring to other things. I hope this installation has somehow fallen between the two.

WF: How would you locate yourself within Soviet art? Would you see yourself as belonging to some tradition or some line of development?

IK: Avant-garde art suddenly came to an end, and then there was socialist realism, which came to its own end as well, and then at the end of the fifties unofficial art emerged, and I see myself as part of the unofficial culture. Some people see that as having already come to an end now. These three different movements have been directly connected one to the other.

WF: It's interesting, the idea of unofficial, because if there ceases to be an official, then what is the unofficial?

IK: It has always existed and it always will. It just has a different name. It used to be called socialist realism and now they call it something else.

WF: Are there any Western artists that have been particularly important to you in the area of using one's real experience and developing it into installation? One thinks of Beuys. Have Western artists had any sort of an influence?

IK: It is really hard to say whether they have had an influence, because we are so isolated and we have only had acquaintance with Western arts through little cuttings in magazines and bits and pieces. Only when we came to the West were we able to see these works and have real contact with them. But I feel there may be certain parallels in art because things emerge and things are so universal that they come out of their own accord in art or in an artist and they develop by themselves. It is possible that a similar situation would provoke similar artwork.

Jeff Koons

In the following short extract Jeff Koons is in conversation with Adrian Searle, and was recorded by Audio Arts as part of the 'Talking Art' series of discussions held at the Institute of Contem-

porary Arts, London in 1989. Koons, the contentious leader of New York 'commodity sculpture', talks about his advocacy of 'banality as saviour', his appreciation of Cicciolina and the values embodied in his work.

AS: Jeff Koons, you have a reputation which is not unmixed. Bad boy or saviour, self-publicist, vulgarian wit, satirist, critic of excesses of consumerism or perhaps even victim of it. The work you make is perhaps either great art or, as someone said, 'meta nick-nack'. I know that you've said that you believe absolutely in advertising and media. This sounds very much to me like the response of someone who grew up in a darkened room watching television and perhaps from an early age was inculcated in a belief of the great American dream. Is this true? And if so, how on earth did you come to be an artist?

JK: First of all, it's my pleasure to be here this evening, and one of the reasons I think that there are so many views about me at times that are negative, is because I am honest and I reveal the inner system of things and I just present things really the way they are. Other people work within these systems but they just don't reveal it and they are not honest about this. As far as my own history, I exploit myself and I exploit myself to what my limitations are. I was born in America, I'm an American artist even though I spend half my time in Europe over the last three years, and I'm deeply interested in European culture – more than American culture. I'm interested in advertising. I'm interested in the entertainment industry and media itself and I respond to it. Instead of reading twenty books a year I may read three, but I go through over twelve magazines a week and of course many newspapers a day. That's what I respond to. I tend to like things that are immediate.

AS: But this doesn't answer the question of how you came to be an artist and a very particular kind of artist. In some ways you might be seen as the apotheosis of Harold Rosenberg's 'tradition of the new', where it would seem that culture really is a voracious, hungry beast looking for novelty all the time, and somehow you have achieved a kind of status or kind of reputation which is based on novelty, and people are, like yourself, looking through magazines every month and finding either your advertisements or images of your work, and there's a great pleasure in that. I think you manipulate that quite strongly, you're very aware of the operations by which you get to be a famous artist.

JK: Referring to Rosenberg, the body of work that I did, 'The New' was about newness and it was about displaying an object in a state of being eternally new. It has nothing to do with being the newest model but just that the object could be placed in a position to be immortal, and that's my involvement with the new. I do like a sense of spectacle and I like the idea of Gestalt. As far as looking at magazines, I do not look just to find articles on myself but I like to look at magazines for the photographic quality. I think some of the best photographers in the world are working for commercial magazines, and these images are seductive, they are manipulative and they are just absolutely beautiful, and I always want to stay in communication with these images and that's where you can find them. I myself feel that work is revolutionary. I feel that my work is political. A lot of people think that political art is just art that addresses directly whether trees are being cut down in Brazil or women's rights in the arts or abortion or whatever, but I think that my work embraces all that area. I know that I participate within the culture because I do believe extremely in communication and trying to communicate with the public, but I do not feel in any manner that I ever will or do compromise myself. I feel that I am totally in control of my ideas and what I wish to do, so I do not feel as though I am working within this whole official culture but feel that I'm using the system to my benefit. The film industry and the advertising industry are communicating much better and much more powerfully and louder and clearer and manipulating and seducing and educating an audience every day, more than artists could even dream of at this moment, as far as our actual participation at this time. We have the computer industry, which stores more information than a painting ever can and can trigger information faster. So what's really left for the artist is to assume the responsibility to communicate again, to assume that you yourself, the artist, is a victim of their society and you have to let yourself be victimised so that you can experience your culture and have information to be able to communicate, and then you have to assume the responsibility to go out and victimise others. You have to be able to seduce and to manipulate, and these are positive things, and since we have not been doing it other industries have been, and if artists really do not wake up and become great communicators in the future, I don't even think there will be a term called art and people will just say, 'Well, I think that I heard that there was this profession and they called it artist …'

Rachel Whiteread

1993 Turner Prize-winner Rachel Whiteread talks here to Michael Archer prior to going as one of five British Artists included in Documenta 9. A subsequent recording was also made with the artist in front of her works at Documenta.

MA: Rachel, you have been selected as one of the five British artists for Documenta. Are you now working on the piece that

you are going to put in Documenta?

RW: Yes, it is actually in front of us at the moment. It is a piece which is cast in plaster and it is the space underneath the floorboards. It is actually probably the most formal thing I have ever made. I think it is quite difficult to make out what it is. I am showing that in one space in Documenta and I am also showing the two mortuary slabs that I made in another room.

MA: This piece that is in the studio here with us is in plaster which is about a foot thick. It covers most of the floor area of the studio and it is in strips, long strips about fifteen inches wide, the divides between them, I presume, being the support beams.

RW: The gaps are where the joists were, and there is an imprint – a kind of rough wood – on the inside, and then on top there is this very kind of sensitive colouring that has come off the underside of the floorboards.

MA: Which space did you use to make this cast?

RW: It is fictitious. I didn't want to use any particular room. I wanted to work with the space in Documenta rather than making something that maybe had a fireplace in it or whatever. I wanted it to be more formal than that. It is basically rectangular, but there are two pieces chopped out of it that I wanted to use as kind of viewing spaces so you could actually get further into the piece and look over it as a whole.

MA: Is this the first cast that you have done which is, as you say, fictitious? All the other ones I can think of have actually been of specific objects.

RW: Yes. Basically I looked for the floorboards and the joists. I was quite particular about what I wanted, but it was quite liberating once I had all those in the studio. I was just able to make a plan of a fictitious space, but I did do a lot of drawings and spent a long time trying to work out what the space was going to be like. I could have had an area with bay windows in it and all sorts of other things which would have made it far more literal.

MA: And that may have been just a repeat of the piece *Ghost*, which was the cast of an entire room.

RW: Yes. I think this piece actually came from when I first showed *Ghost* at Chisenhale. We put the piece up and painted the floor afterwards, and when I took the piece down there was this kind of map on the floor of where the piece was. It was like when you find a carpet in a skip and you roll it out and there is

a perfect map of the room. I was using that kind of idea and I suppose I wanted it to be quite kind of sinister as well in a way. I didn't want it to be too sinister – like mass murderers burying bodies under floorboards. I am going to Berlin at the end of June for a year, and the plan is to start making some work in wax when I am there. I think I will probably make another floor using wax – a very yellowy wax like ear-wax rather than the white kind of paraffin wax.

MA: You have used plaster for some time. The work you made before that was in a variety of different materials such as clothing, hot-water bottles, Sellotape and all sorts of things, and more recently you have also made work in other materials as well. How did you begin to shift out of using plaster?

RW: Well, I have actually used plaster for years. When I was at college I used it but not in the kind of scrim-and-chicken-wire way. I always cast little things: maybe from my body and things like that. Then I wanted to use plaster as a kind of monument material, but after making *Ghost* and then a series of bath pieces and a few other things, I really wanted to do something that was flexible. I was getting so fed up of the pieces being so fragile etcetera and I just wanted to make something that I could literally throw out of the window and it would bounce. It was just something as simple as that. I wanted something liberating. Once I started researching into using this material it had an enormous amount of possibilities. I have made probably eight pieces with rubber and I think I will continue using it. It is not that I want to stick with one material but I actually want to build up a vocabulary of materials.

MA: Is there always, as there seems to be, a very strong interest in the actual relationship of the body to the objects that you use? I am thinking of the fact that you would use tables, baths, things like that, things which are not necessarily out of the ordinary. In fact almost the opposite. They are just everyday, and they are not things that you would necessarily think of in those terms when you are using them, but when they are presented in the way that you do them, as kind of positive images of the space they occupy, that relationship to the body comes out very strongly.

RW: Yes, that is absolutely right. I have always used things that are basically found objects, things that we have made for simple, everyday usage. For instance, beds: I have made quite a few beds. They are completely kind of international things, beds, they are everywhere. In every corner of the world you will find a bed of some sort or other. And the way they are just abandoned in the street and you find mattresses up against the wall or rotting in an alleyway or something. I like that, that basically any one

ABOVE: Jeff Koons, Jeff and Ilona (Made in Heaven), *Aperto, Venice Biennale, 1990*
BELOW: Richard Hamilton, The Citizen, *1981/83, oil on canvas, 200x200 cm, from an exhibition of work by Roy Lichtenstein and Richard Hamilton, Museum of Modern Art, Oxford, 1988*

from any kind of culture or language can understand them, I think, or have some way into them. And also with tables. I remember the first table piece that I made. I basically wanted to give the space underneath the table some sort of authority that it had never had before. People always ignore that bit under the table or just dump things under there. Your legs go under there and you kind of stick things underneath tables. But actually casting it in plaster in some way kind of monumentalised it, and I felt quite happy that I had done that. I had actually found a space that was ignored to some extent.

MA: You are using the word monument. What exactly do you mean by that? Are you referring to a kind of traditional idea of sculpture as a memorial – the war memorial on the corner of the village and that sort of thing?

RW: When I was at the Slade I don't think I really made anything that sat in the middle of a room and you could walk around. I may have made things like that but they were very small. I remember the first kind of cast furniture piece that I made, *Closet,* which was the space inside a wardrobe. When I broke it apart and put it up in the studio I just felt this enormous sense of relief that I had actually been able to make something that was bigger than I was and you could walk around it. It might sound very fundamental but I had been struggling for about six years to do that, and that was quite a kind of revelation in some ways.

MA: That first cast piece, *Closet,* you actually covered with black felt.

RW: Yes, when I decided I wanted to make that piece it was simply that I wanted to try and make a blackness, a space, that space inside a wardrobe that maybe you sat in when you were a kid, something that we are all very familiar with.

MA: Since then you have just used the degree to which plaster can pick up the surface quality of the objects that you are casting.

RW: Yes, in some of the later pieces I use different kinds of oils and things for separators, which I knew would make the plaster slightly more yellow or do different things to the surface, and the different materials I use to make the moulds, to box the things in, became quite important. With the bath pieces I used shuttering ply for the outside. This is a kind of rough plywood which is used when you are digging holes in the road and you use something to shutter them off. I like the idea of having this space that you kind of dig into and that I was going to do the opposite with it. So I am always kind of careful and consider those sorts of details. They are not accidental.

Richard Serra

The extent to which Richard Serra's works establish an exacting tension within the space where they are installed is surprising given the economy of his materials and the reductive nature of the formal elements he employs. Serra's drawings in the Serpentine Gallery, London comprised rectangles of canvas covered with several layers of paint stick, a waxy, oil-based crayon.

WF: You have a show here of drawings that are installed on the walls, but could we start by talking about the work that you are perhaps primarily known for, that is your publicly sited sculpture. I was wondering what sorts of comparative issues there were between making a work for a public place and making a work to be installed within the museum context.

RS: Usually within the museum context you are bounded by the architecture and either the tyranny of the white cube or the constraints of the flat floor or the physiognomy of the building. You also have to take into consideration that within the museum structure the viewer is usually more thoughtful in that they are going to a context where works of art are to be perceived. Contrary to that, if I were working in a public space and place, you enter into a whole host of relationships that are not precluded but are different from those of museums or institutional structures in that the interface with everyday life is the mix of the casual observer or the audience, so to speak. So it is not just people who keep their finger in the cultural pie. The other thing that happens is that the context that you are presented with in urban sites, rather than landscape sites, usually has an interface or an intervention with a host of things that you can't foresee. Exits and entrances, subways, train stations, traffic flow, the character of the pavement, the context of the surrounding buildings, the ideological overtone of the situation you are placed in. Often what happens, particularly in outside situations, is that there is a presumption amongst corporations that want to support outside work for instance, that they will exhibit their liberalism by consuming works of art and using them as garnish or decor or badges, and invariably that eclipses any meaningfulness those works could have. The best example of that would be to drive up Sixth Avenue in New York and you can see where works that were built for one studio situation have been site adjusted to become nothing more than decor for AT&T or whatever.

On the other hand, museum situations offer the possibilities of experimentation and they offer the possibilities of using spaces and places to extend the boundaries and definitions of your work. I don't make distinctions between the audiences, because if you do that I think then what you are going to do is cater to the populus, and often what I've found is that if you start

undercutting yourself and starting to second-think what the audience might be, then you are probably playing a populus scheme where you are going to diminish your work for the so-called art of the people. My notion about that is that I would just as soon project a work that is not only significant in my mind's eye but interesting to an intelligent person, even more advanced in thinking than myself or more advanced than the audience that exists. I think the fact that when artists sell their invention to the status quo and diminish their creative drive to make accommodations they fall into the position of being bought off, either by corporate manipulators or government ideologies, and that art then becomes a part of the service community. Now, applied art and decoration have always been part of the service community, but it is not the extension of what the language of sculpture and painting has become, and I think anybody who is interested in extending those languages probably has to look very carefully at commissions that are presented if they are presented with constraints and dictates. For most art in public spaces and places, although there is a presumption of a kind of freedom that is usually a sham. Usually you are asked to accommodate or serve, or glorify, or enhance, and the notion of sculpture as sculpture or the notion of altering the perception of the context isn't taken into consideration. What the presumption is by most power brokers is that somehow they want to increase the value of their property and their philosophical outlook in terms of their liberal agenda, and it usually runs contrary to the development of a particular artist's work. There is a whole group of people now who purport to be architectural artists, and that has come about because, particularly in America, there is one per cent of finances given in new buildings for the acquisition of art, and architects, being fearful of most sculptors and painters, would just as soon take that upon themselves and use the money for their own purposes. So in place of sculpture we have Philip Johnson doing a golden boy for AT&T out of gold leaf and about eighteen feet high, which is nothing more than an appropriated pastiche on neoclassical Greek art and it just serves as a symbol for the capitalist building there and has nothing to do with sculpture. You will also have someone like Michael Graves in Portlandia doing a cornucopia for economic revival in terms of the sculpture, or you will have Frank Gehry trying to serve the needs of a smile by propagating his fish on buildings from Tokyo to Barcelona. I think all of those things not only demean sculpture and reduce sculpture to some sort of playful eclectic mediocrity or self-serving mediocrity on one hand, and on the other hand what it does is it prevents serious sculpture from taking part in the general dialogue in the outside world.

What I have tried to do is maintain my invention and build where I can in relation to spaces and places, and often what happens is an analysis is done of the site and the context, and the works are only built in the sites and contexts in which there is a comparative relationship – either formal or experiential – between the site and the piece, and often at times the pieces expose the nature of the sites or are critical of the natures of those sites. But I think when artists take on the potential of building in outdoor places they have to confront the history of sculpture and the history of decoration and consumption and analyse the situation that they have been cast in and decide whether or not they can make their most intelligent potential work in those spaces and places without having their hands tied.

WF: Do you have a sense of what an ideal space would be for one of your publicly sited works?

RS: I don't think there are ideal sites. I think every site has its ideological frame and overtone. There are leftover sites – traffic islands or whatever – but still they are subject to a lesser degree of a certain kind of ideological cover. I don't think there is a site that is ideal. There are sites that certainly are less than ideal. They would be military installations or governmental buildings or God knows what. I think if the pieces are just to serve those institutions they are going to be eclipsed by the context and the content in no way is going to be able to override the context. I think the artist has a possibility of walking away from those sites.

I don't think there is an ideal site. I think every site presents a problematic and I think it is up to the artist to try to deal as intelligently as he can within the nature of his own work and the body of his own extension of work into that field to see if he can make a significant and thoughtful statement. I am really interested in the potential of sculpture as sculpture. I am not interested in the potential as some self-serving material for populus consumption, nor am I interested in stroking the varieties of, and caprice of, trends that happen to use art for something other than its uselessness.

WF: What would be the criteria that you would bring to one of your works in relation to whether it succeeded or failed within a particular situation? We know of works such as *Fulcrum* here in Broadgate, and I saw a work in Documenta 8 where you had completely cordoned off a street with an H-shaped structure which set up certain sorts of confrontational relationships with spectators and with individuals that might encounter it. Are all those things important, and how do you want them to operate in the work?

RS: I don't think that site-specific works are a belief. I think that anyone going to them can reconstruct the reason for their inclusion on whether the work fails or succeeds in what it attempts to do in relation to its context, and if they find that it

enters into a critical dialogue in relation to that context, and it alters the nature and shape and space and place of how we know that context, and they have to rethink what that context means, and if it is then brought back into one of a sculptural concern not an urban concern per se, then I think that one has to come to the conclusion that one either accepts the definition being altered into one of sculptural convention or not. I think there isn't any way of saying that this is just some arbitrary belief system. All of those works can be ascertained by any viewer in terms of what they do in relation to the site to see if they are successful or not. That is not up to me to decide. I think that is up to the viewer to decide, but it is very clear that those pieces haven't just been dumped there in relation to the context, that they are built for the context in a meaningful way as a dialogue with that context. I think what I object to in some instances is that you have either politicians or people with political agendas not willing to enter into a dialogue with work in public spaces but rather to censor those works and to use works of art as a scapegoat for their own political agenda, and it is a very easy scapegoat because most people are very uninformed about the nature of sculpture, nor do they have any patience or concern for the language of sculpture. In some sense there is very little audience for sculpture. What I find disheartening is that writers have the pen, they have political constituency, film makers have a political constituency, but for the most part painters and sculptors have been divided by a commercial gallery situation which has kept them like horses in a stable competing against each other, and there is no political solidarity amongst them. Not only were my pieces destroyed to dismantle the Governmental General Services Administration Organisation that came in under the Kennedy administration, but then further the NEA scapegoated Robert Mapplethorpe to use him as a signpost to enforce their censorship. It has actually gotten to the point where it is divisive in terms of the larger body politic in America, and they have started with artists and they have moved right on to women and gays, and if you listen to it carefully the language reiterates the early language of the Third Reich.

WF: Can we move now to some other issues. Obviously issues in your work such as weight, balance, equilibrium, disequilibrium, scale and the sense of the weight of materials are important, but I wondered how you actually arrived at orchestrating those elements, those values.

RS: Well, it depends on the context in which you are building. I think one of the things that was interesting to me in working in the Tate – and I've been going back and forth there since I was asked to build a piece here – is that you realise that there is a preponderance of stone in that building, it is heavy and massive,

and what I have always thought in seeing work placed in those three rooms is that they were invariably reduced to objects; that the architecture in its pompous grandiosity consumed everything in there so sculptures, no matter how autonomous to their own internal dialogue, always seem to be somehow left over in a volume of space in which they were not taken into consideration. That is not to say I haven't seen some good works there, because I have. Some sculptors in the past have actually been able to deal with the volume of space and collect it into their form making. Offhand I can think Giacometti, who did it with a sliver of plaster – you probably don't need a lot of weight to do it; Degas drinks in the whole space with a kick of a foot. In my situation I have learned to focus on certain aspects of work. You just start dividing them up: you take something like balance and offhand you start naming sculptors and say, okay, Donatello, where's the balance? Giacometti, where's the balance? Calder, where's the balance? And you run it like that. Caro, where's the balance? Brancusi, where's the balance? And then you divide it again: Brancusi, where's the drawing? Where's the surface? Where's the concentration of mass? It would be the same as looking at a painter in relation to colour, line, shape, composition. How you isolate those elements and choose to focus on one aspect or the other informs your content and allows other people to be engaged or not within your degree of penetration into those aspects, and most of those aspects are part and parcel of building. You can't get away from the fact that you are using material. You can't get away from the fact that it has to be configured in some way. There are obviously conventional ways of dealing with it and non-conventional ways of dealing with it. If you want to put the focus on mass and weight it could be that you are doing that to avoid the piece being a leftover Easter egg in a big field. It could be that you want to make the whole space and place a volume and deal with the work, this field in its entirety.

WF: We will talk about this installation in a minute, but I just have one or two more questions. The material you use, the Corten steel, rusts, as everybody knows, but it changes, it has a life, in a sense it has a relationship to the elements, to nature.

RS: I think the notion that Cor-ten steel rusts is some sort of denotation of toxicity. It is probably the most interesting material in that it oxidises, rusts, so to speak, and then stops after seven, eight years, depending on how much saline is in the air or how much other toxins are in the air. When it stops it holds its skin and no longer rusts, and so after a period of eight years the pieces turn a dark amber, brownish black, and hold a continuous surface in perpetuity. That is the nature of the material itself. Now I have found it the working material most qualified to emphasise the nature of what I am trying to do. One of the problems that I see

FROM ABOVE: Rachel Whiteread, Ghost, 1990, plaster on steel frame, 3.05x3.2 m, Saatchi Collection, London (courtesy Karsten Schubert Gallery, London); Richard Serra being interviewed by William Furlong at the Serpentine Gallery, London, 1993; Richard Serra, Street Level, 1987, Cor-ten steel, five sheets at 480x1025x5 cm and 480x2050x102.5 cm, Documenta 6, Kassel

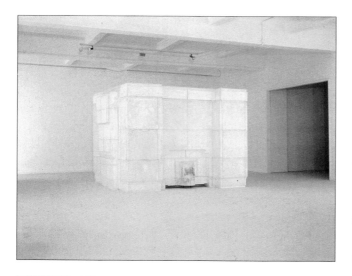

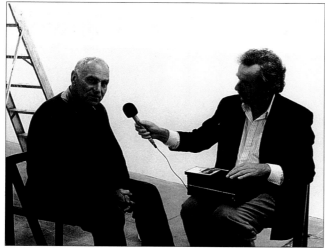

in most sculpture from the beginning of the century, from Gonzalez to Picasso to David Smith to Calder, is that steel was used as a picture-making element, it was cut, folded and pasted together and then painted, and no one really emphasised the fact that we had gone through an industrial revolution and there were other ways of thinking about steel, namely point load mass, statics, weight, gravity. Those principles had been applied by the engineers and the architects of the century but not by the sculptors. I have used the Industrial Revolution as an index to my own invention, which is very, very different from using steel as the hand maiden to painting where you cut and paste in glue or weld and configure in a way to make shapes or figurations.

WF: Preserving that reference to the integrity of an industrial material presumably is a vital factor for you.

RS: It is not the integrity, it is just realistic. It is the most intelligent way to use the material, because the material was formed for a particular function, and to deny that function, to make it look as if it were three-dimensional painting, or to paint it to cover what it isn't doing, to give it another emphasis, isn't really about the integrity of the material, because it sounds like some sort of qualification. It is just the most intelligent, realistic way to extend the potential of the material.

WF: Is that a reference to industry and to industrial processes – the use of steel and so on? It refers, as you were saying, to the Industrial Revolution where steel was an important ingredient.

RS: I think that you can look at different sculptors or different painters and understand that often their inventions are extended by employing the processes that were handed down through various craft concentrations, Don Judd, carpentry; Roy Lichtenstein, layout design; Cellini in the fifteenth century, goldsmith; Julio Gonzalez, forge and cut. There are ways that works are extended not simply through the notion of design or conceptualisation but through parallel structures or processes that then inform the making of art. I am not interested in the Industrial Revolution per se, although I have a tremendous admiration for people like Maillart and Roebling, and Mies van der Rohe and a lot of architects – Corbusier, and I think Rogers in this country is interesting and Foster in this country is interesting. I find them interesting because they have been able to use engineering as a potential capacity for extending their architecture. I see nothing wrong with that, in fact I think it would be slighting yourself not to use everything that is available in terms of the potential of what is to be done. That is not just to say that I am interested in the content of the Industrial Revolution. I am

trying to use the most intelligent extensions of how I see materials can be used, and if you have to apply engineering principles you have to become knowledgeable in terms of material. I see nothing wrong with that. It is like saying to Matisse, 'Why are you getting into colour? Isn't that kind of old fashioned, didn't that come out of the fifteenth century?' Well, maybe, maybe not.

WF: Here in the Serpentine Gallery you have installed a series of drawings on the walls. I wonder if you could talk a little bit about them, how you actually arrived at their location and the medium you have used?

RS: One of the things that become clear not only in plan but in any kind of analysis of the Serpentine is that it is a very regular space with a hierarchy of rooms. It is a central room which is squared with circular dome. It has a very rigorous formality to it. If you align the works to the overriding formal context, I think there is probably a possibility of augmenting that context but there is also a real possibility of entering into an affirmative relationship with that context, where the square in the circle are going to be reasserted for what they are and the architecture remain dominant.

What I did in the centre room was I tried to put the focus on the room as you enter and exit. There are two ways of coming in through two open doorways, and I tried to put the focus on the walls to make you turn to the right and to the left and to make you deal with the room in terms of right-angle perception. Take a step in one direction and a step in the other direction and try to hold the volume of the space between the two elements that I have placed in diagonally opposite corners. Having said that, the piece is only successful if you find when you walk in through the room that the work is meaningful in its own right, rather than that the architecture is dominant.

The way we know works of art is different from the way we know other things in that there is a particularisation of time, there is a sensation of time, and that sensation of time is probably one of the focuses that art has that other things don't have. Nature doesn't have it in the same way, furniture doesn't have it, some architecture has it; it means there is a thoughtfulness and a concentration and a sensation of time that is not literal time; that you are asked to participate in a dialogue where the works are a catalyst for experience that allows you to refer to things that you lack or things that augment your experience, or pushes you in directions that have nothing to do with what you have just seen but open up other avenues of thought whether they be poetic, joyful or contrary to that. I think artworks in themselves are only interesting as they engender other ways of thinking about the world. If in these drawing situations you arrive at this space and

place, you come to conclusions about how you move in a space and place, how you understand spaces and places. Particularly there is a piece in the back called *Serpentine Corner*, and since I have been coming here I have always found that that space is a little bit like walking through an airport where there is no possibility of locating anywhere, it is always in flux, always moving. I have tried to give that space a considerable amount of weight and location by anchoring a corner concentration in terms of its breadth and its height, and I think actually of the pieces that piece is probably easier to understand because the focus is so clear. The other pieces might be a little more difficult to comprehend in that they take time and there is a certain thought and analysis that has gone into them. Having said all of that, people will come with different amounts of information in terms of what it means to make a drawing in a museum and how these are viewed in the tradition of drawings and whether they are asking one to conclude that drawings can be many things. They don't have to be depictions or illustrations, they can be open to other kinds of articulations that have to do with how we know spaces and places. I'm not interested in painting per se because I am not interested in the content solely deriving from the definition of the boundary of the stretcher bar. I am really interested in the context being the informing aspect of the content and I have tried to make drawings that will bring you back into a dialogue between the context and the content.

Ellsworth Kelly

Three of the four works by Ellsworth Kelly shown in Documenta 9, Kassel during the summer of 1992 were subsequently seen in October at the Anthony d'Offay Gallery in London. In this interview, recorded in that exhibition, the artist discusses the critical relationship between the placing of his works and the space of the gallery, his concerns for 'form' and 'ground' and his early reasons for moving away from the use of regular geometric shapes for his panel paintings.

WF: If we could go back to something you wrote about the ground, which I think has occupied you to a very large extent. You said, if I can quote, 'I have wanted to free shape from its ground and then to work the shape so that it has a definite relationship to the space around it, so that it has a clarity and a measure within itself of its parts, angles, curves, edge, amount of mass and so that with colour and tonality the shape finds its own space and always demands its freedom and separateness.' I wonder if you could elaborate on that statement.

EK: When I left America in 1948 after studying at the Boston Museum School where I was painting nudes, influenced by the

German Expressionists (mostly because the teacher there came from Berlin) I came to Paris. I decided almost immediately that easel painting did not interest me any more and that I would have to find something else that could satisfy and I started doing paintings in panels, and some of the earlier relief paintings that I did were derived from architectural motifs and things that I would see in the street or in buildings, shadows etcetera. I wanted to take marks out of my paintings and gesture. I felt that mostly it was that painting to me at that time – 1948/49 – Paris was the School of Paris, meaning the painters like Léger, Picasso, Braque. They were great artists, but to me, arriving in Paris, I realised that I was not European and there was no tradition for me to continue in this way. Also their painting to me seemed too personal. I mean all painting suddenly became too man orientated – that the painter decided to do a painting and composed a painting. I stopped doing the figurative painting and I started doing some Picasso-like nude figures and some religious paintings that were related to Romanesque art. I travelled in France and Romanesque sites and went to the museums and was interested in early art, and somehow or other that led me into doing the panel works – one, two, three or four panels together were solidly coloured, had no marks, and the panel itself became the content. It wasn't a decision that I made to do this, it has only been later that I realised that what I wanted to do was in the painting, which I feel since the Renaissance has been form and ground sharing the same space. Sculpture, of course, has always been the form, and the space around the sculpture is the ground. So I think that doing these panel pictures they became the form, and the wall itself became the ground. In that way the painting or the work sort of came out into the viewers' world or out into the room, and that's perhaps intuitively what I wanted to do.

I was very interested in collage. You have a piece of paper which is the ground and you apply pieces of whatever on to it. The collages of Braque and Picasso and Schwitters had always very much interested me, and I think that rather than thinking of them as paintings, I felt that it was something in between painting and sculpture. Of the quotation that you used I now like the last part of it where I say something about the painting finding its own space. Of course it kind of demands its own space. I say, well, this red panel has to be just here and not two inches over to the right or to the left. In that last sentence I come almost as close as I have ever come to being a political artist. It says the shape finds its own space and always demands its freedom and separateness. I thought afterwards that is just what we all want. We all want to have our own space, and I think in that way the paintings are perhaps difficult to understand for people that have not been involved in the tradition of what has been happening to paintings for the past eighty or ninety years.

WF: I think there is a sense in which your works are uncompromising. They are not referential in the way that a lot of art is. They seem to stay put within the space and they activate that space and they set up very specific relationships to one as a viewer. One of the obvious relationships is that of scale. But you have talked about the desire to occupy an individual space and to have freedom within that space. That is another set of interesting relationships.

EK: It is you that moves in the room and they are similar to how we relate to sculpture. Sculpture that is of figures has content, but abstract sculpture like David Smith or Richard Serra for instance, where the forms are existing by themselves in space the content is form, colour and how we relate to the forms. For me painting is more and more satisfying if it is slightly larger than me so that it dominates me visually. I feel like I don't completely see it, except of course if I am more than ten or fifteen feet away from it and it becomes smaller. But even so, as I move from the left to the right in front of a painting it changes completely. To me, I want some of the mystery to be there that the person cannot completely capture in one look. My ideas are always based on some visual idea which perhaps is like that second of just seeing something even when we are not even thinking our eyes are open, and we see millions of images all day long. If you ever think about, when you are driving a car for several hours, all the images that are passing in front of your eyes, the images are building up, and I think with these works especially that they are fragments of things that we have seen somewhere.

WF: You mentioned painting in the Renaissance and how from then on the evidence of the signature, the trace of the artist's hand, so to speak, was present and this is something in a sense that you wanted to move away from. There is another interesting issue, I think, in relation to conventions that evolved from the Renaissance, which is the rectangular picture. The panels that you create often challenge that idea of the regular geometric shape, and I find as a result they set up very positive tensions within an architectural space which is more often than not based on rectangular forms, and your works seem to activate that space. The space becomes part and parcel of the sense of the work.

EK: Well, the early panel pictures, which I did beginning, say, in 1949 through the time that I lived in Paris, began with rectangles and squares in the panels. Just before that I was doing fragmented shapes that developed from cutting up drawings and rearranging them in the way that Arp had done. I had met Arp, and this interested me very much. So the fragmentation has been very important to me, because it is like chance entering into how

we see things. As we move our heads, everything that is in our space becomes fragmented. Though the earlier pictures were all rectangles and squares, when I returned to America I returned again to the 'form' and 'ground' paintings. I suppose I had felt that I was in a new city – New York City – and there was a different kind of work going on. It was the close of a period – the Paris period – and I had in a way to begin again. So I did very large, curved forms. I was experimenting with colour and form and the way that these forms would be cut at the edge of the rectangular canvas. I continued to do panel pictures from time to time, and then it was as if these kind of biomorphic paintings, big black shapes, were trying to squeeze the ground out of the picture – there was very little white around the edges. So I decided at one point to cut out the form in metal, and that happened in about 1959, I started doing some painted aluminium pieces. In 1952 in Paris I did what was really my first monochrome – the panel pictures were each monochromes but they were always done with a series of panels. I did a triptych in red, yellow and blue in 1965 and many groups of spectrum colours in rectangles, but I feel that to do a monochrome I would have to do something with the shape. In Paris when you used to go buy the stretchers it was either a marine, a landscape or a portrait, and they all had their different proportions. I felt like the rectangle or the square has always been a window and the content in the paintings was always something that was visible through an aperture. When you look through a door or a window and you start moving, of course what is inside the window changes very abruptly, and you can make your own abstract pictures that way. My first realisation of that came when I was quite young, when I was about twelve years old or I might even have been younger. One evening when a group of us boys were out on Halloween and it was very dark, I saw through a lit window a red shape, a blue shape and a black shape and I said, what is that, because they were fragments. I crept up to the window and when I looked in I couldn't find it, it had disappeared. Then I backed up again and said, there it is. So then I very slowly came back and realised it was a red couch, a blue curtain and a black piece of furniture, and it was like abstracting shapes. Just to remark that a very early age to me proves that for artists you just continue the seeds in you, continue working and trying to solve all these problems that interest you.

WF: Can you talk about the artists that you met in Paris and the work you saw that was important to you and perhaps had an influence on your subsequent development?

EK: Well, when I was studying in Boston, Max Beckmann was invited to the school because the teacher had come from Berlin. He was very fond of Edvard Munch and Kirchner and also Beckmann and all the students in the Boston school became kind of German Expressionists. Boston Expressionism was influenced very much by the German Expressionists, so that when I came to Paris of course the two painters that moved me most were Picasso and Beckmann. Matisse came much later, of course, and I know that when I came to Paris on the GI Bill Bourse, I went to see if I wanted to enrol in Léger's class. I liked his painting very much but I decided that I didn't want a master, exactly. I wanted to go to Beaux-Arts where I could come and go as I pleased. I had painted the nude enough and I didn't want someone else's brand of abstraction to influence me. I remember seeing an exhibition of Kandinsky for the first time and I was lucky to visit some artists. I visited Arp several times; I visited Brancusi's studio and I feel that Brancusi and Arp and his wife Sophie Taeuber-Arp and also the late Monet seem to me very impersonal – not anonymous, exactly, but less personal than say Picasso and Braque and especially the abstract Tachiste painters. Paris didn't interest me that much and I really didn't know what was going on in New York. When I did return it took me a while to realise how important the Abstract Expressonists were, but at the very beginning I felt that here again was a lot of gesture and a lot of personality that was against the way I wanted to make pictures. I think, though, Brancusi of course always had a subject for his works. The way he made them and the way he ended up with the form being the permanent thing about his art influenced me very much. Also I visited Vantongerloo, who I became very friendly with, and I remember he used to lecture us a lot and read to us, and I remember thinking to myself, I am so glad I don't have to have a theory to make my pictures valid. So people refer to my work as hard edge and geometric, but I feel that they are to me more fragments of the real world in some way. I don't sit down and try to design a picture within the frame, but I need some kind of vision or visual for validity, and my eyes are constantly working against what I am looking at without thinking about what I am looking at but just moving my head and shaping things.

WF: You have said your work isn't in any way a reaction to American Abstract Expressionism, but I wondered if you thought in any sense that your work was part of an American tradition and how you would place it or locate it?

EK: To me I like very much De Kooning, Kline, Rothko, Newman, but again they were a generation ahead of me and they matured rather late, I suppose. They weren't like some of the young painters today, who in their early twenties already have a career and are doing very, very interesting work at a very young age. Of course I remember saying that Calder interested me, and he became a friend in Paris and I would see him when he was in Connecticut during the late fifties. But painting as such didn't interest me that much. Of the American artists, Audubon, Calder,

and the American Indians – the pre-Indians like the mound builders – are the ones that have influenced me more than painting as such – and of course Picasso. Picasso was something all of us had to get over, but I found it was really a reaction to easel painting. I wanted to sort of not do easel painting. The early paintings I wanted not to sign, I wanted them to be anonymous, I wanted them to exist just as anonymous icons.

Christine Borland and Craig Richardson

Small Objects that Save Lives *is the title of a work by Christine Borland shown at the Chisenhale Gallery, London in March 1993, which comprised eleven tables, clinically laid out with objects submitted by individuals invited to respond to the title of the exhibition. Craig Richardson presented his work* Unfolding, *consisting of combinations of words painted in black onto a powerful yellow background covering the extensive wall facing the entrance to the gallery. Here the artists, in conversation with Jonathan Watkins, the exhibition organiser, discuss their joint exhibition.*

JW: This exhibition of work of Craig Richardson and Christine Borland was conceived of some time ago. It is an exhibition of discreet works by you two, but you two working very much together. Could you explain to some extent how you approached this exhibition?

CR: I suppose we were each aware of what the other would be doing for this exhibition from exhibitions we had done previous to this one, one of which was a joint exhibition held two years ago. We are aware of each other's work and keep each other aware.

CB: Both of us up until recently lived very close to each other in Glasgow, and the exhibition that Craig was referring to, the most recent exhibition that we were in together, was called 'Guilt by Association' in the Museum of Modern Art in Ireland. It was with three other artists. The whole process of that exhibition was very much to do with discussing work and developing ideas. Both of us seem to work not only necessarily for one exhibition, and my opinion is it is part of an ongoing process, so it is not always easy to draw the line after each exhibition. The ideas keep on rolling although they become specific, depending on the location and the nature of the gallery space and the nature of the situation. So that process for Dublin, which culminated in the Autumn of 1992, was very much informed by the fact that we would be working towards this show here.

JW: In that exhibition 'Guilt by Association' Craig's and Christine's works were exhibited separately. In this case their works have been very much made to be seen together. It would be interesting for me to know how you see that change in the idea of looking, Craig, for example, at your work over Christine's, or Christine, your work is there in the reflected light of Craig's wall piece.

CR: It is also there in the attention to detail or the attention to vast spans of time or something. Maybe some of my work comes about through a lot of joint things you can look at in the work. I feel a lot of what we do is unspoken and I am just aware of what Christine is doing because she is following a certain avenue in her work and she is suggesting to me that she is going to do this certain work in Chisenhale, and that encourages me to push a certain aspect of what I want to do. I suppose you could say it is more of a process thing, and we just feel confident enough that it is going to work in the space.

CB: One of the most obvious changes when thinking about Chisenhale from Dublin was the nature of the space, the scale, and from the way we work it was obvious that we were going to take that into consideration and have it foremost in our minds. There was never going to be a problem with the works not working together, just because of the understanding that we have of what the other does, and the knowledge we have of how we are developing and how things are going along. As soon as I knew I was going to make this *Small Objects* piece after I had seen it work in Dublin my concerns for it working here were to really expand the piece, to see it on this larger scale, to see all the difference in implication that it would have in a space like this rather than a domestic space of Dublin. So these were the sort of issues I was talking over with Craig. He would tell me about works he was planning, some of which really changed, as did my initial ideas. So we kind of changed our ideas, spoke about it, just worked in tandem with each other. It was never going to be a huge problem because we would always be thinking of the other person and as soon as possible we would convey any changes in what we were going to do.

JW: There are two other pieces as well that we haven't yet mentioned. The *9mm Holes, Apples* of Christine's in the corner – six apples each with a hole in it – and Craig's work *Even Further*, which involves a set of shells painted blue and on these are objects that refer to some sort of torture or imposed restraint, and again are informed by the sort of concerns that we see in the wall piece and *Small Objects that Save Lives*. I think it would be interesting to talk about those concerns in the exhibition overall, beyond your approach to the space and the mechanics of working together. How has the eloquence of the work

changed through this collaboration?

CB: It can't really be disassociated from the qualities of the space and the way we work. Both of us had what you might term a major work, in terms of scale, that was the number one thing that we were talking about all the time. In Craig's case it was the wall piece and in my case it was *Small Objects*. Then in day-to-day working practice you are constantly developing other pieces, you have got other things on the go, and they might or might not become appropriate for the exhibition here in Chisenhale, but you just keep them ongoing.

CR: Unmistakably, though, within the show there is an agenda of violence, which I suppose we were skirting around, but on top of that we have overlaid this idea with various categorisations and our ways of presentation as a means to, I suppose, bring the viewer closer into these things rather than distancing them – which is an interesting idea as well, we could talk about it later, I suppose. Within the eloquence of the work there is an interesting idea of eloquence in terms of agenda, I suppose combined with intention. You know what is the intention behind us as artists and what is our viewpoint within the work, and I think that we try to avoid that. Not for any reasons of lack of confidence but more a case of it is a way of bringing people closer to certain things by having a certain amount of reserve, I suppose.

JW: Concerning the reserve that you mention, the apples for example aren't actually shot. We have talked about the way the work is arranged. These words, the connotations of which are awful, are so symmetrically placed on the rather nice yellow that serves as a background for them – and that, I think, is the reserve. There is reserve in that. The idea of a melodrama and a passionate gesture doesn't exist here.

CR: It would be a hindrance to get into understanding the work, I feel. It would be a way of writing off some of the aspects in the work that are somewhat difficult to talk about, because even in talking about it, it becomes melodramatic. So you often fall into talking about the process, which is in a sense a shame. But maybe that is the fault of language. The words are so loaded that when you talk about disaster, violence and murder, barbarity, saving people's lives, a whole range of things, it becomes immersed in a whole way of thinking that I suppose we are trying to look at but somehow trying to have a way of studying, though maybe reserve is not the right word, maybe it is a case of holding back and giving a space in between.

CB: It comes down again largely to the way we choose to present them and the fact that we are interested in a contradictory

sort of means of presentation and an idea in which the fundamentals of the idea can deal with an extremeness. But to me that wouldn't really be fully explored if that was repeated in the presentation. That just wouldn't work so well for me. I feel that that is not part of what I am interested in doing. The subject matter here in *Small Objects that Save Lives* and in the other works where I've used bullets and gunfire on different types of materials, different objects – if I was to present them in a melodramatic and unreserved way then that would just make the work become something I didn't want it to, because the actual process itself was about as kind of dramatic as you can get, so that would be far too overplayed.

CR: And we also have a paradox, since people are willing to spend time to enjoy a certain means of presentation as a means to try to understand certain agendas within the work, which is an enjoyable, fun thing to do.

JW: The ambiguity, the paradoxes, and even to an extent a sense of humour in the work counter balances what might be melodrama, but that is not to say that anything goes in terms of interpretation of the work. There are particular readings that would be more appropriate for one or the other, particularly, I would say, in looking at Craig's work. On the one hand, it is more to do with the imposition or the act of violence, whereas Christine's work tends to register some vulnerability. The apples have had this thing done to them and the objects are there to possibly save someone's life. So there seems to be this complimentary relationship within the works.

CB: For myself, that is an important part of my larger body of work, and in this instance the paradox exists between the loaded nature of the title – although there is a kind of hopefulness in making a piece like this, which is suggested by the title when you do actually see it. If you choose to focus in on 'Objects' individually, then it is obvious that the way people have reacted to that title in some ways is a bit sad, because we are trying in a way to protect ourselves by caring for and loving these very precious, intimate, personal objects. But when you think of the most literal reading of the title and you make reference to the bullet or the more literal ways of ending a life, then it is obvious that these things are not really going to protect you, so you have to look for a much more metaphorical response to things. So that sort of vulnerability and possible patheticness in the work is all part of it as well, and there is a hopefulness there that people needn't necessarily immediately be thinking of bullet-proof jackets and layers of armour. They can still have that ability to think of very personal things or things which have meanings other than the literal sort of protection thing.

Eugenio Dittborn

The themes of travel, distance and the journey are addressed not just in the physical distribution of the work but in the imagery of the paintings themselves.

In this interview, recorded during Dittborn's exhibition at the Institute of Contemporary Arts, London in 1993, the Chilean artist discusses the underlying concerns of 'The Airmail Paintings' and his use of imagery, which often depicts violent, ritualistic or unexpected death, appropriated from differing historical periods. Here the artist elaborates on his description of the resultant juxtapositions as a 'hybridisaton of a temporal kind'.

WF: Eugenio, could we start by discussing what you would describe as the underlying concerns of the works that you have presented here?

ED: Well, I think that probably the first one might be what I call 'Airmailness'. The airmail paintings are folded in a position and fixed to canvas which is absolutely completely and definitely rigid and stretched. The cloth is folded and then it feeds into envelopes and the envelopes are closed and the works travel, stamped previously, through the international airmail network. They are exhibited at their destinations and then they stop being letters or folded letters in transit and they become suddenly unfolded paintings and they are hung on the walls and exhibited with their envelopes beside them.

WF: The other aspect is the actual imagery that the sections contain. They are normally folded sections about eight feet by three feet with either photographically screened images or linear diagrams. Perhaps you could talk a little bit about your choice of imagery, because some of it is drawn from prehistory, or from historical sources.

ED: *Liquid Ashes* from the images point of view is made up of two different sets of figures or images. One set is of dead people that were preserved and found almost intact after two thousand years, in the case of Lindow man, for instance, and five hundred for the mummy. Then there is another set of figures that are fallen figures with somebody trying to protect them. That is the image found on the television of Benny 'Kid' Paret in agony at Madison Square Garden, and an image found in a magazine for children where somebody is lying on the road, and on the other hand there is a runner lying on the runway. Well, that is a description of the human figures of that work.

WF: You have retrieved images from history and prehistory of individuals who in the main met with violent deaths.

ED: Yes, here, for instance, is a concrete work in which an Inca boy sacrificed and preserved for five hundred years gets in touch with a Celtic man also sacrificed, and a sort of modern version of the sacrifice might be seen there in the agony of Benny 'Kid' Paret appearing on television – he died on television, let's say. On the other hand, this is a magazine for children that appeared in Chile about forty-five years ago and is an illustration of somebody who has an accident on a motor cycle going from one place to another.

WF: What determines your choice of imagery?

ED: I work in what the linguists call a paradigm. For instance, the figures are dead, violently sacrificed, and preserved by different means. By the desert, the bog, the Andes snow. We have that connection. And there is another paradigm there, of a fallen sportsman – fallen and abandoned, as everybody there is ignoring the figure.

WF: They are all people who are in a sense victims in society, are they not?

ED: Excluded, I would say. Excluded then marginalised.

WF: So you have in a sense retrieved these individuals from the anonymity of history.

ED: Yes, probably by connecting them. Because when you say that, I say, yes, but that is not all. It is not that they are there it is that they are there together. You see, you have this abyss. What is in between? That is the treasure, what is in between these spaces, these abysses? At the beginning you were talking about these different times and these different layers and these different histories. The work should have to repeat a sort of pre-established connection. I mean there isn't any, there is nothing, it is darkness there. The work produces the connections and produces a meaning because it connects the unconnected.

WF: The works are often a collage of imagery derived from different periods, and you use the phrase 'hybridisation in my work is of a temporal kind'. I wonder if you could elaborate on that.

ED: Yes, well, I tried to build or to construct a sort of pluri-dimensional time in which I create intersections and connections of figures that were alive in certain periods of history and were found afterwards. So in a way it is a sort of collection of remains and each of them contains a different time. So the intersection then is a sort of plural intersection of different times. That I think

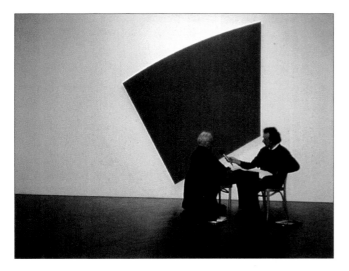

FROM ABOVE: Ellsworth Kelly being interviewed by William Furlong in the Anthony d'Offay Gallery, London, 1993; Christine Borland, Small Objects that Save Lives *and Craig Richardson,* Unfolding, *installation at the Chisenhale Gallery, London, 1993; Anya Gallaccio,* Red on Green*, 1992, ten thousand red roses and leaves, installation at the Institute of Contemporary Arts, London (courtesy Karsten Schubert Gallery, London)*

is very Latin American and it is a very important aspect of Latin American culture, the sort of premodern, modern and postmodern layers that you can find walking in the street. In ten minutes you can touch with absolutely different histories and times, and all of them are still sort of alive. What I do is like putting a piece of dry meat into water to make it softer and then to be able to expand it and then to look at it. In a way that is what I do. To work with several old pieces of different types of dry meats.

WF: It seems that in terms of both the themes of your work and the airmailness of the works, there is a very specific sense of the works being produced in Chile, a location away from the so-called centre, and in the catalogue there is this notion of works coming through the mail by virtue of the mail service from the so-called periphery to the centre.

ED: Yes, it is like bridges that this airmailness opens. It is to make a critique of the exiled against the one that never went out or away. So they are exiled for a while and they belong to Chile for another while. They don't stay or remain in any place for more than, let us say, three months. So these paintings might be called homeless. They are really homeless.

WF: So there is a real sense of the transitional, of the temporary, of the fragile that is a resonance attached to this work.

ED: Yes.

WF: You come from Chile and you have made your work there. I wonder if you could talk about the relationships between your work and your country and your context. How would you be specific about the links and relationships?

ED: You see my country has, as most of the Latin American countries, the capacity to forget everything. Then things become buried very, very soon and pass very soon, and other things remain there and you don't know how. My specific work is to unbury, to classify all these remains and to order them and make them legible and to connect them to create meaning. It is a sort of didactic work. Do you agree with that?

WF: I do. It is a form of iconographic archeology – cultural archeology – archeology to do with ideas and histories.

ED: Yes, yes, very much.

WF: Can we talk about the materials you use, because it is a non-woven material that is actually used in the linings of cheaper clothes. Why do you use this material?

ED: I have used this material because you have this mixture of a thick paper and a thin cloth. Most of the graphic tradition was made on paper and the painting tradition was made on canvas, so this escapes from the graphic tradition and the painting tradition and uses both at the same time in several senses. It is very light and you can fold it and you can iron it and you can put eyelets on it. It is very easy to hang. For this group of works probably the most important thing is that this non-woven fabric receives this liquid and is impregnated by the liquid so there is not a covering as in oil painting, this goes into the support. It is a lot to do with secretion from the human body; these secretions, as you know, are all related to passion – ejaculating, crying, saliva – and they are crossed by this liquid that looks non-dry.

WF: It gives a feeling of being an absorbent material like cotton wool or blotting paper that takes up a trace of what it has touched.

ED: Exactly. This might be another criticism of easel painting. The fact that the paint, the inscription is not on but into.

Anya Gallaccio

When it was shown at the Institute of Contemporary Arts, London, in the summer of 1992, Anya Gallaccio's Red on Green *was the latest in a series of installations she had made using cut flowers. Here the artists talks to Michael Archer and describes her involvement with her materials.*

MA: As you walk upstairs at the ICA towards the Nash Room, halfway up the final staircase you are met by this smell which is sweet but also quite thick. In the room itself, at the top of the staircase, there is laid out on the floor a carpet of roses to which nothing has been done.

AG: Well, they have actually had a lot of things done to them. There are ten thousand roses and I pulled all the heads off, so you have actually got a bed with all the stalks and thorns underneath and all the heads lying on the top. Because a lot of the roses were really blown and open because of the time of the year, when we touched them a lot of them just fell to pieces, which is why in some areas it looks just like petals. Then again, that reminds me of the thing you do with daisies – he loves me, he loves me not etcetera, and you pull all of the petals off. I kind of wanted it to be a painting – a bed and also a painting. Initially the surface was incredibly luxurious and velvety and you just wanted to roll in it. Well, that is what I hoped people would want to do, but now it looks quite dry. I saw the surface as the surface of a painting, maybe, but because the roses were virtually all the same colour

but were all different reds, to use each one as a mark, and as the light changed in here the colour changed a lot.

MA: Does it have a title?

AG: It is called *Red on Green*, which is from a Rothko painting. I use that because I wanted there to be some kind of emotional response to the thing. Also because I'd had some of the roses at home to do an experiment, and the red seemed to hover the way the colours in his paintings do – kind of glow. I wanted to use the whole of the roses and I wanted there to be a title which was very descriptive but also had something else – another connotation. I was thinking about what red symbolises and what green symbolises. Red symbolises passion, rage and is a hot colour, and green represents jealousy or naivety. I don't see this particularly as being about love, but it came initially from seeing an article about a garden of love. I kind of like the idea of having this red, this passion, if you want to look at it in that way, on top of naivety or jealousy. I didn't want the green to be evident at the beginning when the flowers were really full. I wanted it to be just red with a hint of green, but obviously as the flowers are drying out, more and more of the green is becoming exposed.

MA: That in a sense comes on to another thing that I want to ask about, which is the place that 'not knowing' has in the work that you do.

AG: I see the work much more as a collaboration between me and the materials. I have a kind of idea as to what they might do, but basically the materials always do what they want. I kind of feel disappointed by this piece – I don't know why. Actually it is interesting and it has done lots of things, but that element of chance to me is really important. I think that I am not imposing my power as the artist over my materials. Artists are supposed to be good at what they do and supposed to impose their will over their paint or their stones. I see it much more as a fluid thing, as a relationship in the way that you have a relationship with a person, and you might be able to anticipate the way they are going to respond to the situation but hopefully they will surprise you – or they should in a good relationship. Whatever kind of relationship that is, there is always this fluid thing, and that is what interests me. I am just starting something off and seeing if it does something and of course sometimes you are disappointed and sometimes you are not, you are surprised. I don't have a way that I want people to read the work. This is just ten thousand roses on the floor. That is all that it is but, maybe for some people, it will be something else. Maybe I don't know and maybe it doesn't matter if it isn't, but I don't want the work to be only read in an intuitive, female way.

Gary Hill

This interview with Gary Hill was recorded in London soon after the opening of his exhibition at the Museum of Modern Art, Oxford, where he installed Tall Ships, *which comprised projected images along the sides of a darkened corridor. This was also shown at Documenta 9 and subsequently at the Tate Gallery, Liverpool. While in Oxford he also presented a performance, 'The Madness of the Day', at the Human Anatomy Theatre, Oxford University.*

WF: Can we start by talking about your work *Tall Ships* that you're showing at the Museum of Modern Art in Oxford. Looking at the figures walking forwards, standing, being in a state between moving forwards and moving backwards gave me a vivid sense of an interrogation of my own presence. The work seemed to have a level of reality beyond the representational. Issues such as placement, displacement, distance yet intimacy, authority yet vulnerability came to mind, but those various states remain somewhat unresolved. I wonder if you could respond to that initial reading of the work?

GH: Well, it's such a clear reading … One of the basic things for me about the work – and this differentiates it from some of my other work – is that it's not really a work without the viewer, in a big sense, who I don't want to say completes the work, but rather launches the work. It takes the work and it's continually becoming, even as we speak. There's an accumulation of people's experiences … this is true for any experience but there's something particular about how the experience really comes back to the viewer in a very specific way. That it is not representation, that it is not images. It's not really about this, they are only there to trigger these questions in the viewer, which I didn't really think about so much when I made the piece. The multiplicity of viewers … there's something that happens there too that I didn't really predict, in a way. There's that turning on the single viewer, but since this is occurring among many viewers there's a relationship that develops among the viewers in the space. It's almost as if it could continue from this dark hall out into the space and go on. The boundary of the work is a funny thing, in a way.

WF: Was it originally conceived with as many projections as there are in the works we've seen in Oxford and Documenta? Was it ever a piece that involved just one projection?

GH: No, the original idea came from a particular possible space that was presented to me at Documenta – this long hallway. The first idea that I was playing around with was always figures down the hall, but they were going to be maybe two-thirds life size and come forward with a body language, perhaps idiomatic maybe, and speak, and then would stop when you weren't in front of them. They would not come forwards, they would already be there. So the trigger, the moment of attention, was not this movement towards you but rather speaking. So this all got, of course, turned around completely. There wasn't much time between the making and the first installation of the work, and I had only decided to put the child at the end once I had really begun setting up the piece. The reason for this was that I didn't want there to be this infinite feeling that down this hall forever there are figures, and having the child there allowed a de-limitation of the place but at the same time, because it is a child and because of the opening of her arms, there is still a sense of future … of possibility, and yet it still feels like some kind of space that things are taking place in.

Joseph Kosuth

This conversation with Joseph Kosuth took place during preparations for the exhibition 'Symptoms of Interference, Conditions of Possibility' at the Camden Arts Centre, London, 1994, a show that comprised works by Joseph Kosuth, Ad Reinhardt and Felix Gonzalez-Torres. Kosuth here descibes the nature of the collaboration between the three artists and their shared belief that it is insufficient for artists merely to produce objects: they should strive, rather, to provide a context within which their activities can be understood to have consideration of the nature of art.

MA: The most famous statement or dictum of Reinhardt's is this point about art being art as art and everything else is everything else. That is something that is absolutely of your own work too.

JK: In a very particular way. It has to be understood that before art can be understood as being useful in terms of our understanding of larger cultural mechanisms, we have to know what it is, and the point of the work in the mid sixties that was done using tautology was to see how an artwork works, to an extent to see how culture works, to isolate it and see how it functions. The word function came up a lot at that time. Tautology in art, of course, told us a lot more than the usual understanding of tautology when it's applied to the context within which one normally finds that is something to use as a model. For me it was quite an interesting thing. I never really saw it as being art for art in that way, but I felt that one had to begin with looking at what art was and separating it from a lot of other things. Particularly you have to understand that we were preceded by (and remember this is a very New York story) Abstract Expressionism and Pop art and there was a real need to clear

away a lot of other things to see in some sense the bones of the dilemma.

MA: The kinds of things you were doing came to fruition and were expressed in the late-sixties texts 'Art after Philosophy'. To what extent did you see your manoeuvres then as being related to other things that were happening in New York, other kinds of ideas that were being put forward which were also attempting to separate art that was being made in New York at the time from a European aesthetic tradition? Obvious ones would be the pronouncements of Donald Judd, or the kinds of things that Stella said about his black paintings rather than maybe necessarily the paintings themselves, again a rejection of an aesthetic tradition. To what extent did you feel yourself connected with that kind of thing?

JK: It was one of those things where you identified with it and wanted to improve upon it. You have to remember there was a kind of hegemony going on of Greenbergian movers and thinkers and the history that was of art, be it a local – one could say even a provincial – one, which I did see as useful. There were definitely for me useful aspects of Pop art, particularly Warhol, and a certain kind of detachment. They had got away from the erratic. Remember we were beginning to re-read Walter Benjamin at that point, and that was something that was interesting. I took objection to them re-tooling them and continuing to function as paintings. That was problematic, but certainly there was a real fear in which there was a kind of art that I saw as an attempt to marginalise what Greenberg called 'novelty art'. The Greenbergians were running museums, they were running the grant-giving panels, they were running university art departments – it was a serious situation, we thought. That's why I was accused of being cryptoformist. Well, as agit prop theory, part of its role was to locate itself on the turf of Greenbergian freedom, and use this kind of pseudo-scientific language to turn everything on its head, and I think it did that quite successfully. It dates it as a read, as useful as it was at that time, but it was very much part of that context. My immediate influences besides Reinhardt were surely a consideration of – not so much an attraction to – the exegesis of his work, but the implications of some of Duchamp's activities were thought a rich if dated minefield … a field in which one could do a lot of digging.

But the immediate influence was so-called Minimal artists, who had their own kinds of ways of influencing. Certainly for me immediately Judd, Judd's work and writing – one without the other would not have been so interesting. It was, again, what I learned from Reinhardt in that regard, that the two together were formidable. He said many things, such as, 'my work is neither painting nor sculpture'. Now these things of course have all been forgotten and the work became sculpture, essentially. This of course was the weakness of Minimal art, which I thought we had improved upon in terms of the work that my generation did after. We left a lot of things behind. I mean – I like to give examples – I think it is relevant to look within the so-called real work as art is represented – the fact that the Saatchi Collection skips over us, it goes from Minimal art to Neo-conceptual, but none of us are in that collection. And if you look around you see that a lot in America. I'm not lamenting it, it only shows in some ways how well we did our job. We were seen as not collectable for a very, very long time and still now in some circles.

It's been around for twenty-five years and people are beginning to realise it's part of the history, part of the story, and that it has to be manifest in that story somehow, so they're catching up.

The best way of talking about Conceptual art is, I think, the way Terry Atkinson discusses it, which has to do with the failure of it. In that sense its failure, of course, was part of its integrity and that is not to say that we do not continue working, but it defines in some way an understanding about the kind of contribution any artist can make, and it underscores the fact that being an artist is about a process, that there was no attempt to make a masterpiece that in one work would depict the world, that in fact one has the debris of a process that is left behind, and the totality of that process perhaps adds up to something that is meaningful. But I never expected any one work to answer all of my problematics as an artist, all the questions I have as a man in the world. All the different things I do succeed in an extremely limited way or fail in a very instructive way, and some of the works I like the most are perhaps spectacular failures. That should be the nature of the artistic process. That's what I call a play within the meaning system of art. It's quite another thing from making works in simply a signature style.

I've said this before, there's something problematic about all that work in the sixties: you know that somehow Judd has to make boxes, Carl Andre has got to put something on the floor, Flavin has to use fluorescent lights, Buren's got to do a strip and Lawrence Weiner has got to do a one-liner on the wall. It's a little bit like the shape of the Coca-Cola bottle, it's about product identification. It's about intellectual property identification as well. I always respected Nauman as far as his work is concerned, as he is not afraid of engaging that plan.

ABOVE: Joseph Kosuth, The Thing in itself is Found in its Truth through the Loss of its Immediacy *(detail), 1993-94, installation at Camden Arts Centre, London*
BELOW: William Furlong, Development, *collage and installation for* Process and Identity, *'Zone D', Leipzig, 1991 (see pp 125-126)*

ARTISTS WORKING

Artists who use the medium of speech as a primary strategy in the delivery or performance of their work

Andy Warhol
Laurie Anderson
Stuart Brisley
Buckminster Fuller
Tadeusz Kantor
John Cage
Joseph Beuys
Bruce McLean
Richard Long
Lawrence Weiner
James Joyce

Andy Warhol

*Andy Warhol visited London in July 1986, eight months before he died, for his exhibition of large self-portraits at the Anthony d'Offay Gallery. At the press interview the media turned out in full to ask questions, interview and photograph him. (**Q** denotes general questioners, **W/A** denotes Warhol's entourage.)*

WF: Can I ask you, were these paintings made specifically for this exhibition at the Anthony d'Offay Gallery?

AW: Yea, they were.

WF: Would you be making portraits, or was this at specific invitation?

AW: Yea, it was done that way. I'm just doing camouflage. So then I put a portrait on top of the camouflage.

WF: But they are screen-printed pieces of work, aren't they?

AW: And then hand touched up.

Q: How do you feel about your original remark about everybody being famous for fifteen minutes?

AW: We have a TV show called that.

Q: Called?

AW: Fifteen minutes.

Q: And you find it more prophetic as time goes by?

AW: Uhmm.

Q: The telecommunicants theme?

AW: Uhmm.

Q: Increase and all this kind of bumph.

AW: Uhmm.

Q: When you made that remark, was it with reference to the star syndrome, and Hollywood creating . . .

AW: No, no, no. Because televisions are on all the time. Everyone's on television all of the time. Whenever I'm on television they know me for the day and they forget about you unless you're on television all the time.

Q2: People often accuse you of laughing at all the people who spend large sums of money on your paintings – is there an element of irony, do you think, as you produce works that sell for sixty thousand dollars like the one below you ?

AW: I don't think they sell.

Q2: Some of them are sold and the exhibition hasn't even started. You are at least seventy or eighty thousand dollars richer this morning.

W/A: They're very well worth it because they're of the moment. Anything of the moment has interest for the moment and for whatever effect it has. People appreciate it whatever the value is.

Q2: You're not answering to the sense of irony.

AW: No, no, I don't . . .

Q: Is there, then, a social comment in any of your work?

AW: No, I just do whatever I do, you know, just get by.

Q: You're getting by quite comfortably?

AW: I guess so.

W/A: He's pretty comfortable.

Q: How much do you think of your success as an artist, probably the best known in the world at the moment, is as a result of your own personal image, yourself as a work of art?

AW: That's what everybody says, I work, I work all the time.

Q: And what about film and video, you don't seem to have done so much in that area recently.

AW: We're working on a TV show called 'Andy Warhol's 15 Minutes', which is thirty minutes long, so we actually do a lot of film cable stuff, and then we've got a new script called *Slaves of New York* by Tama Janowitz. We still do a lot.

Q: You're still a very busy man, then?

AW: Yea.

Q: Thank you very much.

AW: Thanks a lot.

WF: Is this series of paintings now complete, the ones that we see in the gallery?

AW: Yea, I plan to do some over.

Q: I played Mrs Pig in the Roundhouse in your play.

AW: You did, oh great.

Q: I did, I did and you came over and the producers said I didn't have an authentic American accent and you said I did, so great, thank you.

WF: How do you feel about making paintings in this moment in time, because you work in all sorts of media. What function do the paintings have?

AW: I do that every day.

WF: Paint?

AW: Yea.

WF: Do you use mechanical imagery, or do you make any drawings?

AW: No, I paint a lot, hand painting, I paint the background.

Q: And then do you change the paintings afterwards, paint over them completely?

AW: Sometimes.

WF: What major projects do you have planned for the future?

Q: Are there any new clubs in New York?

AW: Actually, the best club that's been opened is by Little Nell, she's opening the newest club in New York.

Q: Who?

AW: Little Nell

Q: The singer?

AW: Yea, yea, she's opening it in two weeks or something, it's supposed to have a whole set of new ideas.

Q: And where have you moved down to ?

AW: We've just moved into the centre of town.

Q: Is that The Factory? Has the whole thing moved? So where are you now, Fifty-something Street?

AW: No, Thirty-fourth Street and Madison.

Q: Do you still like Nick Rhodes?

AW: Oh yea, we just saw him the other day.

Q: His wife's opening a shop now, she's gone into the fashion business.

AW: Oh, she did, I didn't know that … I thought she was having a baby.

W/A: I guess she can do both.

WF: Are there any artists in Britain that you particularly admire or that interest you, any work coming from here?

AW: Well, David Hockney is the one I know most … Henry Moore is so great …

WF: What's your view of recent American Painters such as Schnabel? Do you find their work interesting?

AW: Oh yea, they are all friends of mine, I really like them a lot. Kenny Scharf painted my camera but he got stuck, Keith Haring is terrific and Jean-Michel Basquiat, although there are so many.

Q: Are you working on a movie right now?

AW: We're trying. It's called *Slaves of New York* by Tama Janowitz. She's a girl, she writes for the *New Yorker*.

Q: And she's done the screen play.

AW: Yea.

Q: Will you direct it yourself?

AW: Maybe.

Q: What's it about?

AW: Oh, just a girl living with other people.

Q: How long are you staying in London for?

AW: Oh, just a couple days.

Q: Are you still interested in writing books? Are you still interested in the idea of a novel? Are you going to write any more?

AW: I'm writing a book on how to go to a party … how to give a party.

Q: You're still really interested in parties?

AW: No.

Q: You're not?

WF: What's your impression of London so far?

AW: It's so exciting – it's just incredible.

Q: When was the last time you were here?

AW: I don't know, for one of the Wimbledon games . . . I can't remember . . . McEnroe or someone.

Q: Have you been to any clubs in London? Where would you like to go?

W/A: We're going to the Jungle Club and the Wag Club and the Cafe de Paris and every single one every night. What are the other clubs? Heaven, Taboo, they have it all lined up for us every night.

Q: Are you going to be here for the opening of Limelight?

W/A: I don't think so … because the opening is on the fifteenth, I think.

Q: It's going to be one of the best clubs here … have you seen the interior? It's really great.

W/A: Andy's my friend and he collects Barbie dolls and that's what he just tried to say. Andy just did a great painting of Barbie doll.

Q: Have you seen any TV commercials since you've been here?

AW: Oh yea, they're really good. The English movies are getting so good. I just saw *Mona Lisa* and I thought it was terrific. They're all big hits in New York now. I think English movies are going to be the best ever. *Room With a View* and everything, they're just great.

Q: Any particular directors and producers, or actors even?

AW: My favourite actress was the Tyson girl, she's so great … she's in *Mona Lisa*.

WF: How do you think this show looks in the gallery?

AW: It's beautiful. Yea, they really made it look nice.

WF: Have you made more works, have you left any out or is

LEFT: Andy Warhol at the Anthony d'Offay Gallery, London, 1986
RIGHT: Laurie Anderson, Riverside Studios, London, 1981

this exactly the number you made?

AW: Yea.

WF: What interested you in this project of making new portraits for this gallery in London? What's the incentive?

AW: I don't know.

Q: Why do you do self-portraits.

AW: Well, Anthony d'Offay asked me.

Q: Does the painting still stand up as a fact, which is what you said once about painting – 'all of it is a fact'?

AW: Yea.

WF: Have you been pleased or surprised about the response to you in London this time?

AW: Surprised.

WF: When you go back to New York what projects will you be working on?

W/A: He's working on a movie and I think he's doing a lot of things, actually. Shopping a lot.

WF: You went shopping this afternoon. Where did you go and what did you buy?

W/A: We went shopping in the clothing stores; he was looking in a number of fashion shops, Kenzo and Gucci

Q: I'd like to ask you a question, but I don't think you can answer me, but what is your definition of being famous? Is it being the centre of attention or is it being recognised by everyone?

AW: I don't think about it.

Laurie Anderson

This interview with Laurie Anderson was recorded at Riverside Studios when she was in London in 1981 to present sections from Parts One ('Transportation'), Two ('Politics') and Three ('Money') of her work United States. *Shortly afterwards her single 'O Superman', originally released by Bob George of One Ten Records in New York, reached number two in the British pop charts. The following extracts are taken from the interview made on that occasion.*

Social criticism is of course an element in my work, but the most important thing to me as an artist is not to be didactic but simply descriptive rather than prescriptive, I don't have any answers … Well, it's hard to think of a situation in which information is presented with total neutrality. First of all, when you're presented with what's called news in your country, it is not non-filtered, it is heavily filtered news, so that when I use my own filters to present information I don't consider them any more or less tilted than the kinds of information that are available.

Maybe this 'O Superman' song, for example, is a kind of love song for an idea of a country. One of the reasons that I use so many different kinds of media is to parallel the way one gets information. You read it in the newspapers, someone tells you on the phone, you listen to the radio, watch TV, go to the movies. It comes at you in so many different ways. I try to structure the work so you receive it in those ways as well.

One of the things about the music in the work is first of all there is no classical bass line at all. The ground of this music is generally to establish a very monotonous beat, it's a metronomic situation rather than a musical one … almost all of these things have a pulse that's very, very even and this then frees you to use real talking styles over that rather than being locked into a verse structure. So you can work outside of meter and use language the way it is used in an everyday sense, with all the stumblings and repetition and pauses and that kind of improvising with words.

Everyone has at least fifty voices, minimum. Their interview voice, their hailing a taxi voice or talking to their friends voice, their bureaucratic voice. Without getting theatrical I try to go through that range of everyday uses of the human voice, and that, combined with other kinds of official voices – the commentator, the moderator, the news reporter – make up the … chorus of this work.

This piece is made up of a whole series of highly structured codes … but I don't want people to necessarily see the codes sticking out. The most important thing to me is that the work is essential, it's conceived that way; and then later, if you want to, you can pick through the structure and see how it's all built.

The United States as a country is absolutely AM pop culture – period. And the audiences that go to different kinds of events in the United States are very distinct. People who go to rock and roll concerts wouldn't be caught dead at a down-town theatre or vice versa. To some extent that's loosening up. But my hope has been for American artists in particular to decide to possibly enter their own culture.

A lot of this work is … essentially digital … it's made up of movable parts.

Stuart Brisley

Audio Arts also recorded artists in Britain who were exploring social and cultural issues in their work. These included Stephen Willats, Conrad Atkinson and Stuart Brisley. The following extracts are taken from recordings made over four sessions in 1981 with Stuart Brisley. The artist speaks extensively about his major works as well as the issues surrounding 'live work'.

It wasn't a protest against bureaucracy as such, it was really much more a protest against the … conspicuous individualism which is another kind of conformity which is much more difficult to combat and totalitarian in its effect. I thought of the use of my own body … as being like a figure, a human figure but not necessarily being a specific person.

The camera can actually stand for audience … the presence of the camera is actually quite important. Sometimes it becomes more important than a person because it represents a certain sort of future.

The individual in relation to groups of people or groupings and also in relation to social division is what I am very conscious of … in all that I do … whether it be as an artist working in an institution like the Hayward or in the street or in education. It seems to be that in any kind of social circumstance one bumps into in Britain, one bumps into that social hierarchy and therefore it becomes the theme of my work.

All the time there's been a desire, an inarticulate desire, to find sources which are not the result of the imperialism coming from either America or more recently Germany, and sources that aren't located up on the 'high cultural area'.

It is difficult to do a work which isn't in some way reliant on the past. The problem of history was my recognition that in any new work one starts from a known position even though one has aspirations of doing a new work. It is inevitable that it is rooted in the past.

… I don't expect the future history of where we are at the moment to include activities that I personally feel committed to or understand … those more lively, more exploratory activities … they are the ones that aren't going to be celebrated.

At one stage I was thinking of my works as propositions – I did not see them as being failures or successes – always dealing essentially with the same central issue, which was the relationship between myself and others in the audience and the problem of class structures, inequality and so on.

When I started 'live work' it was very much to do with dispensing with 'middle men', to work directly with a group of people, dealing with notions of equality for myself as much as anybody else.

The only way that one can actually have any social function – maybe not even as an artist, but as someone operating within culture – is in fact to think in other cultural terms.

I would like to be in a position where I could actually move beyond, or get to a point where I wasn't actually making performances. It's just a recognition that performance has, as anything does, its limitations.

It is very curious to look at the kind of imperialist cultural actions that are going on and have gone on, like the American 'invasion' from 1956 onwards, the German 'invasion' from 1970 onwards. We are colonised to a large extent in the cultural field by those cultural activities which stem from countries with great political and economic power in the capitalist sense.

The very notion of art, it seems to me, has an aspect of alienation about it.

R Buckminster Fuller

A series of major events have been recorded by Audio Arts, events that by their nature are transitory, and would have otherwise been lost. Such an event was the visit to Britain in 1974 of R Buckminster Fuller and his two-hour lecture at Art Net in London. Here, in a short extract from that lecture, Fuller demonstrates his ability to generate inspired thinking as he speaks, whilst exploring the relationships between the human scale and the wider universe. This unscripted event could be regarded as a lecture/performance.

This is a very extraordinary moment going on humanity, and I have been travelling around the world, just completed the thirty-seventh trip around. I'm not a tourist, this is purely incidental to the way life goes. I am just beginning to feel our planet as really being a sphere. It's a very big sphere to you and me, but I'm beginning really to have some personal feeling of this as a home. People often ask me where I live, and I say, I don't mean to be facetious or rude, but I live in a little planet called earth, and that's what we really all do. But it's interesting now, I have got to the point where I really feel it as comprehensible, and I've had it statistically shown and made many maps of the world and made drawings of the world time and again, to actually begin to feel it pulsing together, and so I am really confident that humanity is now going through a state of transition on our planet, absolutely unprecedented.

Number one, we have very much more knowledge than we had long, long ago. Human beings having always been born naked, helpless, no experience, therefore absolutely ignorant, and humanity has had to find its way. Humans are really endowed in the first place with hunger so we are sure to take on fuel, and given thirst so we carry on the chemical processes and to breathe spontaneously. We are given a reproductive urge to reproduce ourselves and we finally get to wherever we're sup-

posed to get. We're certainly obviously here for something extremely important. The information that said that is so, that if we take the complexity of the chemistries of human beings, all the principles that they demonstrate as we know in physics and chemistry – there's nothing quite so complex as we know of in all the universe short of the universe itself. We seem to be almost miniature universes and yet then given hunger and reproductive urges, and being born ignorant man also was given vanity and a way to kid himself along, to excuse himself for making mistakes. That really indicates that nothing could be more important, we have to find out ourselves by trial and error. I find, for instance, I have personally lived through very great change that was not anticipated by anybody when I was young, and as each stage occurs, everybody acts as if they knew that all the time. Right now everybody knows that anybody could go to the moon, that's a very easy thing to do.

Humanity has, then, this strange way of immediately making themselves rather superior, retrospectively. The point is that I see these are characteristics and I am sure that these are put there in many ways to … they would not really carry on, they might become much too discouraged if they didn't have this self-deceit to some extent. So I found humanity so rationalising. It tends to think of itself as responsible for this whole universe and it looks on the stars and everything as decoration, and the whole show is right here, and what you and I decide the way the next election goes is the way the whole universe is going to go.

I go through the exercise myself very frequently in which I think about what we do know about the scale of things and general information, where we find out our little planet is eight thousand miles in diameter, the highest mountain is five miles above sea level, the deepest water five miles below that. Ten miles differential between the outermost points and the innermost points and ten miles in relation to eight thousand: one eight-hundredth. If you make a sphere, a six-foot sphere in polished steel it would probably be rougher than our actual earth, so when we have photographs being made of coming into the earth through the cloud cover, you can't make out if there's a blue of water and there's a brown of land, there's no slight suggestion of any altitude or any depth. You and I, human beings, average about – between birth and the total life, take all humans and average out the children – about five feet, there are about five thousand feet to a mile, so it takes a thousand of us laid end to end to make a mile, so it would take ten thousand of us to make the difference between the outermost points and the innermost points. So if that's invisible, you and I are about one-ten thousandth of invisible on the planet, and that planet is a very small planet, as a planet of the sun, and the sun itself is a rather inferior star.

If you look at Orion's Belt, which is very familiar to most people in the sky, the brightest star there is the Betelgeuse. The Betelgeuse's diameter is greater than the orbit of the earth around the sun. That's a good-size star. So we have this inferior star and it's one of a hundred billion stars in our galaxy, and human are beings endowed with the capability to discover principles and to develop refraction of light and to make lenses and so forth. We now have developed telescopes and taken photographs of billions of such galaxies. We now know of a billion galaxies of approximately a hundred billion stars each. Now, in that kind of observation, omnidirectional, out of all these stars 99.99 per cent are invisible to the naked eye, but we've been able to increase our information to have it there so that we might apply it. A billion times a hundred billion would be the number of stars we now know about; and try and make a billion times a hundred billion points around us a sphere for instance, you find it will be like having a steel shell and to have all the atoms in a steel shell around us would be something like that: the relative plenitude of those stars. I'm thinking about some such big, enormous shell or sphere and trying to find even a planet earth somewhere in there, it would be absolutely impossible and to try to find you and me – incredible.

I am quite confident that that show is not depending on whether the Conservatives or the Labour party comes in or whether it is Republicans or Democrats. I am sure that the universe is absolutely indifferent, in fact, this couldn't be more nonsense, we really are playing some games on our planet that have nothing to do with the really great big show. So I've been terribly excited through my life to try to find out about any of the clues of what the bigger show might be and how long we happen to be here.

Tadeusz Kantor

This extract from an interview with Tadeusz Kantor took place in London in 1981, when he was there to present his new production of Wielopole Wielopole *at the Riverside Studios. Its inclusion in* Audio Arts *demonstrates a crossover between the interrelated areas of music, theatre and the visual arts.*

WF: Can you talk about the process of 're-constituting' your childhood memories and their meanings into your current work, *Wielopole Wielopole.*

TK: You have asked me how reconstructions of events held in my memory are produced, and about the way memory operates, and about my youth and its counterpart in the performance. I would like to say that I do not wish to make a play or a book or anything resembling autobiography. It is not in any way autobiographical, because I find that would be illustration.

For me a work of art is a creation. Underlying creating there are laws of creation.

For me what is most important is to find, to discover, the process of reconstructing memory. It has nothing to do with events of my youth, my old age, my life, because, in my opinion, my life, my youth, my infancy concern no one.

In art what is more important is the means. I may be a megalomaniac, but I think that in this performance I have discovered the method by which memory is reconstituted, that is, the true, the absolutely true operation of memory.

I am not concerned with a story, with the continuity of events, those which go before and those which follow. There is no chronology here, neither of the events of my so-called life nor of the Gospel. Naturally after the Last Supper (*Ultima Cena*) you have the Ascension. Yes! I would place the birth of Christ after the Crucifixion, because that is how the memory works. The method of the memory is completely independent. When I dream, I imagine, because memory is imagination, I draw out of the repertoire, the storehouse of my memory, the photographic plates, plates which are in my brain.

My function in this performance is as the creator to make these photographic plates emerge by chance, since for me chance is very important in art, and has been since Surrealism.

I make one photographic plate emerge after another. Then I return and bring out the same plate. I do not discover the continuity of action but only repetition, piling up, the piling up of memory. For what is memory? The memory begins to operate when I return to the past. It is characteristic of everyone to return to his past, to his childhood. How does this return come about? One thinks, I was in this place in this year. And there is an imagery. There is the place, and there I am. And this image begins to pulsate. It appears and disappears. That is repetition. For me repetition of the same thing is the way in which the memory operates.

That is why I use this means of repetition in this performance. The same thing a second time, the same thing a third time, because I want to live in the past. It is for this reason that I say that I discover the true not the stylistic, the true method of recreating memory. It comes off. This is something important.

It has nothing to do with my childhood, with my family, with the army or with the church. It has to do with the way the human memory functions. That is most important.

That is my answer to the first question.

WF: You are very aware of how suspect the memory can be. You have written, 'The process of evoking memories is suspect and none too clean – it is simply a hiring agency.'

TK: The second question is whether the memory is suspect.

I say, in a certain sense it is suspect.

For me, it ties in with my idea of the vilest, most degraded reality. That is to say, for reality consists of those things which count, which are the opposite of illusion. But reality, my reality, my idea of reality, is quite different from the reality of, for example, the Dadaists. For me, reality comes into existence at the moment when reality begins to disintegrate. That is to say when it is about to be thrown into the dustbin. As I said in my manifesto, *Embellage*, reality is between the dustbin and eternity. Eternity is art; the dustbin is life. For me, for example, a car which can be used luxuriously, is nothing. It has the reality of life. But a car begins to become reality as material for art when a catastrophe overtakes it, that is, when it is wrecked, that is to say, when the car, the object, becomes a snare. That is, it has no use, no everyday use. Nevertheless it remains an object, but an object without a function in everyday life. It is then that the object begins to operate on the platform of art.

That is my credo. It is a 'poor object' (*objet pauvre*). Only an *objet pauvre* can manifest its objectivity in the philosophical sense. Fancy goods, such as a fridge or the car, are not objects. Objects of our civilisation, consumer items, are not objects, objects for art. It is for this reason that one can say that for all but the lowest objects all reality is suspect.

It is for that reason that my family is also what ought to be reality, as they say, at its lowest, because only in that state does my family became a work of art.

I did the same thing with my mother when I exhibited at ROSC in Dublin the pictures of my mother. My family said that it was a sacrilege because I did not exhibit them in frames as in a gallery, but I exhibited six sacks full of earth and each sack had a portrait of my mother from her youth to her death. And they were all on a coffin, a very dirty box. And that was a portrait of my mother.

I remember the reaction of the public who saw it in Cracow, because I was not in Dublin at the time.

But many old ladies were genuflecting as if in the presence of a grave. A work of art is a grave, a tomb. It's the same thing. There is an analogy between the portraits of my mother which I exhibited in Dublin and my family in this performance. The family is also very much degraded. Not because I have no regard for my family. That also is nobody's business.

WF: For many reasons, your work exists independently of any other current theatrical form, originating from an intensely personal experience.

TK: The third question: is the Cricot Theatre independent of other theatres? I am also of that opinion. This is not on account of my megalomania, but only because I am not a man of the

theatre. I am not a professional, therefore I cannot compare my work with the work in other kinds of theatre. I am not saying that the kind of theatre which I engage in is better than other kinds of theatre, I say only that it is completely different. This is because I am not a theatrical producer. I engage in the theatre as a hobby. It is for this reason, it is probably because I am not a professional, that I use the absolutely correct method. For example, with my actors I employ the notion of reality. It's my opinion that no theatre, neither the traditional or the conventional theatre, nor the avant-garde theatre of the present time, employs what is real. They play a role, represent. When you represent there cannot be reality. In representing there is always something or someone which existed before the play. That is to say, there is always a pre-existing reality – the drama, the play, the characters, the action. These all pre-exist.

Always, or at least normally, almost all theatre represents and reproduces something which exists outside the play. This is not reality. It is illusion; it is fiction.

I am for reality. That is to say, the actors do not play a role; they play themselves. Each actor plays himself. It is of no importance that he is my grandfather, father, mother, aunt or uncle. These are conventional roles. In my theatre the actor cannot play anything else but himself. It is the same with the objects.

For example, the death of my grandfather, my uncle, the priest, the brother of my grandmother, really happened. Many things really happened (existed) in my life. In the traditional theatre as in every theatre, the death of my uncle would be reproduced by an actor who imitated death psychologically. Here this is not so. Here you have the bed and the mechanism for turning it.

On the one hand there is the priest, the living actor; on the other the corpse, already dead. That is reality. I have discovered a situation which replaces the real situation. That is to say, the bed, the machine, an apparatus, and a man who merely revolves and nothing else. He does not die. He cannot die on the stage.

That's reality. That is the difference between my theatre and others.

WF: Yet you mistrust the concept of 'personal interpretation'. How do you therefore arrive at such a work (*Wielopole Wielopole*) that is both 'universal' and 'real' on the one hand and yet deeply personal on the other?

TK: I have no confidence in personal experience. For me, my experience is my work, my artistic work, that is my experience. I have no confidence in, for example, personal psychological states. It's nobody's business.

Painters, artists, many artists, often display their obsessions.

An obsession is a very facile motif for artistic creation. Naturally artists have obsessions, but you cannot explain a work by obsessions, eg in terms of mental disease, experience of life, being very unhappy or slightly mad or unlucky. That is of no interest to anyone.

For me, the example is Franz Kafka. He almost destroyed himself. His whole reason for living was literature.

I know many artists who explain their work with reference to a concentration camp. They suffered. I remember that also. It's very important. Probably I am very cynical but I am familiar with Polish art.

Polish art is explained in terms of martyrology. We have suffered much throughout the centuries. We always have martyrs in our art. The best painters and writers may produce masterpieces, but these masterpieces are incomprehensible to the English or the Germans, because of the communal martyrology. Martyrology does not interest anyone.

You must make a work of art which is universal. You must forget personal matters, personal display, exhibitionism. For me, a work of art exists. Everything is the work of art. My personality is of no interest to anybody. I am against explaining a work of art by one's interior soul. It is too facile, too easy.

I think that in this explanation we have an answer to the next question.

John Cage

In 1983 Audio Arts visited New York in order to participate in 'British Artists' Soundworks', an exhibition/presentation at Franklin Furnace. While in New York, a series of interviews and recordings were made. Here John Cage speaks about his appreciation of 'sounds', his approach to collaborations, the artists he admires and his views on contemporary painters such as Julian Schnabel.

WF: John, you composed a piece that was performed the other evening as part of the *Ear* benefit concert at St Bartholomew's Church.

JC: I called it *Ear for Ear*, thinking of the omission in the Bible of 'ear for ear'. They say 'tooth for tooth' and 'an eye for an eye', but they didn't say anything about an ear.

WF: Well, it's been said now …

JK: I didn't really mean to cut off an ear, I meant rather that this piece was based on the letters E–A–R and that it was composed and intended to be performed so that it could be heard rather than seen, except the – what would you call it –

the announcer or the instigator would say 'Ear', and those responding would be invisible. There's an instrument that is mysterious in the same way that it gives you illusions about space, the Japanese temple gong. Do you know that? When it's played as one plays the glass in a cafe (you know, by dampening your finger and then going around the edge) in the temple gong, if you take a heavy leather-covered wooden beater and rub it very slowly around the edge of the gong, even very large ones, the sound that's generated comes from one doesn't know exactly where.

WF: Just carrying on talking about sound, you've explored sound in a very broad sense, in many senses, in a total sense, from sound produced by man-made instruments to sound that naturally occurs in the environment. As with the Russian Futurists who used the sounds of industrial equipment and factory whistles and sirens and so on, do you believe that an interest in using natural sounds stems from the idea that perhaps our Western musical conventions in themselves can't adequately express and reflect ideas about the moment we live in, in the contemporary world?

JC: Well, one could have those ideas, but what I was doing primarily was ignoring the difference between noises and musical tones and trying to make a larger group which could be called sounds and that would include both of those. Just as the word 'humanity' includes the rich and the poor, so my notion of sounds is all of them, not just noises and not just musical tones but all of them. After hearing a group of sounds, we say the name of the composer, like Beethoven. I would rather remember the sounds. This stems from a Buddhist idea that all beings, whether sentient, like human beings, or non-sentient, like sounds or stones, our beings are the Buddha, so that we are living in a interpenetration of centres rather than moving towards one centre. Sometimes people get the idea, or get the experience, and it changes their way of living, and sometimes they don't. I remember a lady who years and years ago – it was in the thirties when I was just beginning in Seattle and I had a percussion orchestra and I was working just with noises – and she had been in the hospital and she came. She's a fairly well known person, Nancy Wilson Ross. She's an authority on oriental Buddhist thought and so forth. Anyway, she came to the concert of percussion music and she was supposed to go back to the hospital but she decided not to, she simply went home, and other people have told me that after hearing a concert in which noises are honoured as well as musical sounds, that they listen to the sounds around them with more attention than they had previously. This is also for me the effect of modern painting on my eyes, so when I go around the city I look, I look at the walls … and I look at the pavement and

so forth as though I'm in a museum or in a gallery. In other words, I don't turn my aesthetic faculties off when I'm outside a museum or gallery.

WF: You've mentioned visual arts, and of course you are very well known in a visual arts context and you've worked with a lot of artists like Rauschenberg and Johns and so on. Is there something, do you think, that is specifically to do with being a composer, an avant-garde composer in America during the period that you have worked . . .

JC: That it has to do also with the visual arts?

WF: Well, yes, that you've worked very much in conjunction with artists, perhaps, rather than with other musicians.

JC: I think it must be because, you see, musicians at the beginning would not accept my work as music. They told me quite frankly in the thirties that what I was doing was wrong. Whereas dancers accepted what I was doing. So I was accepted almost immediately into the world of theatre and the world of theatre includes the visual arts, includes poetry, includes singing. Theatre is what we're really living in. So that later when we had that group of David Tudor, Christian Wolf, Morton Feldman and Earl Brown and myself, I think that the thing that distinguished my work from the others, if I may say so, I don't know whether they would agree or not, but I think that what distinguished it was that it was more theatrical. My experience is theatrical. I like the other arts. I don't like to close my eyes when I'm listening to music.

WF: I was wondering if you felt there was an intrinsic difference between working as an independent individual composer or working in collaboration with others?

JC: You see, I found a way to collaborate with Merce Cunningham so that we really don't have to collaborate, we simply do our work separately after the most commonsense agreement, say twenty-five minutes, whether it's a humorous piece or whether it's going to be a serious piece. Then we simply work separately and we put it together in the theatre.

WF: Do you work with any visual artists at the moment, painters, sculptors?

JC: I have a very good and close friend William Anastasi, whose work I enjoy, and we play chess a great deal together, but we haven't collaborated on any actual work though we might. And his friend Bradshaw, I like her work. I remain devoted to

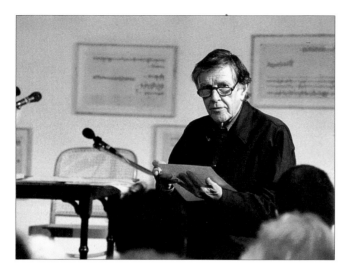

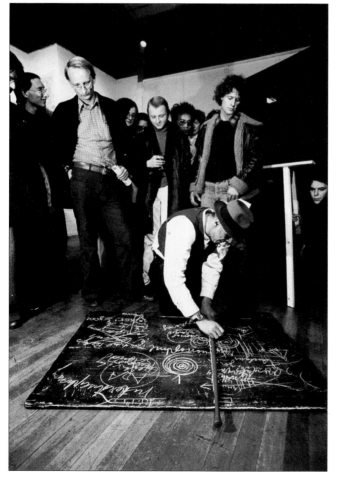

Jasper Johns and Robert Rauschenberg and I loved the work of Mark Tobey and Maurice Graves, though I rarely see Maurice. Did you know there's going to be a large retrospective of his work? I think it opens, in fact, tonight in Washington DC at the Phillips Gallery and it will come to the Whitney Museum here. I think it will be a blessing to see his work at the present time in the century. I mean a blessing in relation to, say, the exhibition of Schnabel and other such things, which suggest the negation of art. I don't like it, I don't accept it. I suppose Wittgenstein would say I should take a clicker out of my pocket and click it, in order to transform it into the beautiful, but I think that it's full of intention on the part of Schnabel, and I think the intentions are wrong intentions. I think it's intentional work and I do not like it, and I don't even think the intentions are good, and I don't even think the promotion of his work by the galleries is good either. I have no further confidence in Leo Castelli or Mary Boone. I work, as you know, using chance operations, and all of my work since the fifties can be said to be non-intentional. I have tried to get – as Thoreau tried a hundred years ago – to get myself out of the way of the sounds, and that's exactly what Tobey did with his white writing, and that is not apolitical it's anarchic.

It turns out, politically speaking, to be stronger than any statements such as Schnabel's. I would say, for instance, that the work of Thoreau, which is anarchic and which changed India, which changed Martin Luther King, which helped the Danes in their resistance to Hitler – I would say that these ideas are very strong socially even though they are non-intentional.

Joseph Beuys

I transform not the discipline or style . . . I try to metamorphose the whole understanding of art.

The following transcript is from the first series of recordings made with Joseph Beuys by Audio Arts. He was at the Institute of Contemporary Arts in London in 1974 to participate in the exhibition 'Art into Society, Society into Art' organised by Christos Joachimides and Norman Rosenthal. The exhibition presented aspects of German preoccupation with relationships between art, ideology and politics. Far from being a passive retrospective exhibition of artworks, the intention of the organisers and participants was that there should be an 'active' event with the artists present.

Against this background Joseph Beuys held lectures and discussions, mainly about his proposed Free International School for Creativity and Interdisciplinary Research. (The term School as well as University was used by Beuys at this time.) Audio Arts recorded many hours of tape on that occasion, and the following extracts focus on specific themes.

Description of existing world social and economic systems

JB: Now we have to speak once more about the new necessity that the things have to be done. And we see that the government cannot make these things and cannot give out this knowledge, and the specialists in faculties too are not able to do it. We must really collect people who are interested to reach these abilities. This must be the first step. We have to care that we find as soon as possible as large a quantity as possible of people who are propagating this idea, this new way to go, because there is no other way to go.

The established systems in the world are well known. There are only two principal ones – the Western private capitalistic system and the Eastern communistic system with a politburo with the principle of a one-party dictatorship. Both sides are special owners of the means of production. In the West there are private owners of the means of production. The politburo as a private owner is in principle the same thing, with the special difference that in the Eastern countries the lack is that there is no individual freedom. The difference in the Western private countries is that there is not enough possibility for brotherhood in economics, because it still exists abreast of freedom. I can speak about a revolutionary model now, but I could not do it in Russia. Here I can do it but, that is not as a result of politicians, it is a result of tradition. It stems from the bourgeois revolution – the French Revolution – with ideals of freedom, equality and brotherhood. There is a bit of heritage here. I need now the heritage possibilities not the results of the politicians. The politicians will take care that in the future there will be no more freedom. They will take this freedom from our heritage and they will destroy it too. Then there will come a very world-wide economical fascistic system without freedom, without equal laws and without socialism in economics.

Therefore it is necessary to start with this very intensively. This is the first step in organising these things, and then you can make proposals and you have to collect people who already have a knowledge in this new way – and there are already a lot of people with such, I am not alone. For instance, my Office for Direct Democracy already has followers and has already collected people who research in this field. Yes, we look to and collect from the past and models in the past where this idea appears already, and so it is a systematic research in this field. This must be the inner task and the inner aim of a Free International University for Creativity and Interdisciplinary Research.

This is the idea of this model, and I try to establish a university like this. Nevertheless, this Information Office for Direct Democracy is a small model for a free and independent school. It must have more effectiveness, and therefore I try now – and this is my next step – I try to establish in Düsseldorf, in Glasgow, in Dublin and in Belfast this type of a school.

Re-structuring of society by individual creativity and self-management

I speak about the fact that all theories and ideas have to be after the idea of art.

The idea of art is the principal means for other things in that the people do it by their own creativity; it is a very simple thing. I find it the rule that everybody is in a special way an artist in different fields. Surely not all people are painters – this is a reduced understanding of art; but in all fields every living being is an artist. Then he has only to create from his ability in the field of the society. First, it is a culture organisation, then the democratic sphere; two, then the result will be a change of behaviour in economics. All this whole field, all this sub-social field is material for the moulding power of everybody. This is the principle, and we have to find more effectiveness in this direction, because the existing political structure is struggling against this idea of freedom, equality and brotherhood. Therefore all the systems are from the devil, and you can really say the systems are anti-human. The actions of the political parties are anti-human.

WF: So do you feel, then, that on the one hand art and science can determine or define an aspect or a facet of society, and on the other hand you have got political systems or systems of constraint on human beings that also shape or provide a facet for human beings and their existence?

JB: Exactly. As a result of having history and as a result of this government structure with the so-called parliamentary democracies, as a result from the French Revolution, surely. There was one step in history with a bourgeois revolution and with different results. For instance, technological results, the results in science, the result in the so-called exact nature of science idea. But together with this exact nature of science idea the whole point of creativity came out of discussion. This was a ruling idea, therefore, and a repressive understanding of science, a materialistic understanding of science. Nevertheless it has a special function and there is a special demand for this science, but only a special demand. As a rule, the exact nature of science idea plays only in the whole idea and understanding of science – the role of a special vector in this. You can develop from this, for instance, technology and mechanical things – you can go to the moon with this thing but you cannot develop, for instance, a soul science, a spiritual science, an imagination science. Building up of the whole field of creativity with the power to build up by self-management of the whole body of society – that you cannot develop from this reduced understanding of science, and therefore I say, no, we can make a theory like this and like this. You

can make a lot of theories and a lot of structures, we have to do it. Therefore I think the only thing which could work would be a permanent forum in this matter, where all the scientists and artists are discussing together. If they discuss together they will find overlapping insights into the problem. The whole problem is a problem of insight.

Education as a strategy for bringing about change; participation – education – information

WF: So in this proposed total restructuring of society – given that it is agreed upon that this is a useful and important thing to take place, where does one go from here? Is it a question of education? Is it a question of protest?

JB: Firstly, it is a question of education, because a question of protest is too early and is a result of education. Only the people with the ability to protest, they protest only when they know the problem and they find reasons to protest. Therefore the protest is already an act of solidarity as a result of education and information – information, education, participation. These are three very important things in culture. But now the culture is exactly organised. There is no possibility for everybody to become educated. Only privileged persons can enter the schools. It is not the ability for the majority to participate in all cultural events and events in the society. And there is no information, because the information we know from the TV is manipulation; it's a lie from the beginning to the end, a lie or a distortion of the problems. Therefore the most important things are participation, education and information. It is not possible in this structure now. This was a problem when we tried to start this, all other things would be illusions. And there we tried to make directly organisations and institutions. For instance, my model of the direct democratic bureau is a model for free information, free education and free participation, because it is an independent structure in society – an independent school. You could say already it is a type of free school. Therefore you have to cut the dependency to the government, and surely this is only a knowledge. Surely it is difficult to do it but you can do it already better when you have the knowledge that it is necessary. If you understand the problem then it is necessary and it cannot function as another solution, then people in the future will do it. If this is a real clear knowledge and the result of a clear objective science then it will come one day. Therefore firstly you have to do the research as objectively as possible, then the real solutions will follow. Then you could say that the whole problem is a problem of thinking, and in this way is a problem of science.

WF: How would you define that, because what we term

science is largely responsible for some of the problems or difficulties that exist?

JB: Now we come once more back to this total understanding of science and the reduced understanding of science. Now the manipulating power of the systems works with the reduced understanding of science. They work with the materialistic, atomistic exact nature of science idea, and the system works against the interest of the majority of the people. This is very important – that they have already a theory and a tool with which they can work. Therefore the people need a tool too, they need a theory too – that is necessary to know. Then you have to throw light on this repressive understanding of science. The new interesting theory for humankind is the science of humankind. Now we are on the point. Not the science of material. Surely the science of material conditions in the laboratory is very important to develop technology, but you cannot develop from this reduced understanding of science a science about humanity, and I am speaking about this total aspect. Therefore it is anthropology, but not a restricted anthropology in a positivistic understanding. It is more than this. You could say it is a kind of *sophia* – like philosophia – it is a *sophia* of humankind. This is the whole aspect of science. Then you find the special functions of science, the necessity to have materialistic science, because it is surely necessary. Therefore I am not against this reduced understanding of science, but I say what is necessary is to enlarge this understanding of science. You see, science is very important because you have the only possibility to go into research with nature, for instance, with the resources of nature, with iron and with metal, with what physicists do and what chemists do and all these people do. This kind of research is very important, but it is not the only aspect of science.

Evolution from drawings to action art to environment art and social sculpture; ICA blackboard environment

WF: What about the artworks or drawings that you do. How do you see those fitting into this wider system?

JB: This whole project is my artwork, you know. This catalogue says exactly that the period of my drawings ended in principle in 1960. After 1960 the character of the drawings is going more in this direction, but there is not so much drawing, because I was interested more in action. Therefore the beginning of my activities is drawings. It is a time when I made sculptures, and I made objects, and from 1960 to 1970 I was fully involved in action art and environment art. For instance, this is an environment and becomes more and more an environment as a result of this doing. At the end of the exhibition the floor will change more

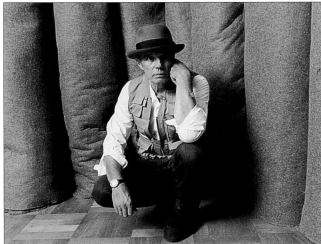

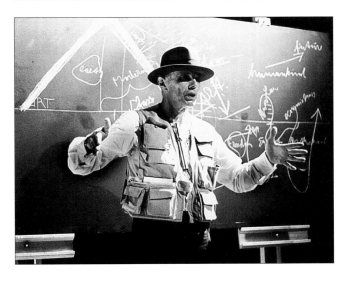

and more to a black floor, because every day I do more black spots as a result from this discussion. I do not make it artificially. It is exactly a result of the discussion with other people, with this kind of action. Therefore it is still action art, only now the content is changed.

WF: There is no need for these to be preserved after the time that you have used them?

JB: No, only if the ICA is interested, perhaps. But first this show goes to Edinburgh, and I cannot find time to go personally to Edinburgh and stay the whole time there, so we will give this stuff to Edinburgh.

Structure of school, practical problems; the three levels: the faculty level, open forum, the institutes; ecological problems, evolutionary science

JB: First you have to see that it is a work in progress, and because it hangs together with money resources and with supporting moneys, perhaps we can start in Düsseldorf with only two or three teachers, because I have not found that all people who are there are active to do it without payment and without money and only for so-called idealism. We have to find money for the teachers and for the equipment, and I will say only as an example how we tried to promote this idea. We already have a free space from the community of Düsseldorf. They gave us an empty hall one hundred metres by one hundred metres. There is nothing inside, therefore we have to care for heating, electric light and for chairs and for a minimum of equipment. For this we need already a lot of money for a very simple kind of administration, a secretariat and three teachers and equipment. These teachers are not established teachers like civil servants. They have only a contract for half a year or a year because we are trying to find interest in all sides of society and we can only make contracts with teachers or informators to work there. This is a dynamic system and will not have the civil servant structure to call for a professor or teacher for longer than one year. After one year the interest in the school and the whole entity is there, then we can make a new contract with the same person.

Now in the beginning there are three teachers. These are three initiators of this movement and cannot for instance realise the whole structure of the school. The whole structure of the school has more levels. For instance, the faculty level where students can come to study officially and they can make a special end with a special bill of study. Not state examined and all these things, but they can study a special faculty. That is the faculty structure. Then there is the common open structure where everybody can come at any age and teach, learn, have information and all these things in relationship to the faculties, a coop-

eration. The third level will be the institutions. An institute for ecological problems, and an institute for evolutionary science. The idea of evolution directed to the whole body of society for finding solutions for building up the social organism. These are therefore three levels. Two institutions inside a common open forum for everybody and the faculty structure. Because this idea is developed from the idea of art, a student could study painting there, for instance, or sculpture or architecture. This founding group comes together every month to speak about the development of the school. At the moment we are fully engaged with the problem of the money. We want to have some money from the government because this is the only serious formula not to reach a private school structure.

Q: In a way these teachers will become civil servants, because you have to make a contract with government.

JB: No, no, we have nothing to do with the government.

Q: If the government gives you money . . .

JB: Yes – no, it is a problem, exactly. We will be fully independent but nevertheless we will have money from the national income. That is a new idea, otherwise it would be like a normal new university or another kind of art school. They are all fully independent of the ideology of the government by means of civil servants and dependent teachers. We will have all independent teachers, the school will be self-managed and we will make contracts.

Q: But the situation today is that the government will just give you money for influence.

JB: No, that's not the matter, that's not the problem

WF: Otherwise you would have the money already.

JB: Then surely we cannot have the money from the government. It's possible that you are right that the government is only inclined to give the money where they have the possibility to speak with us, or to have a special power in this school, but if this were the fact then we would not have the money from the government. Then we would have to look for other resources for money.

Moving to a more effective position as an artist within society

WF: I am interested to know the way in which a sculptor – an artist – becomes involved in this restructuring scheme for society.

This is surely traditionally outside the limits, which I imagine has something to do with your attitudes at the moment towards art.

JB: That is another problem. The artist now existing is a special type developed from the past. He runs the traditional line of the so-called culture without the ability to reach the body of the society. Therefore he stands in an insulated field of action and cannot reach the point where everybody is involved with his life, with his questions. Therefore we would say this type of an artist and this behaviour of the culture is now fully divided from life, is fully divided from the interests of the majority. Therefore from the point of view of the majority of the people with their sores and with their problems, art looks like a special luxury – a luxury for rich people, for privileged people, for people with more advantage in class and all these things, and therefore this is a division from art and society. But because this is exactly the fact, artists do not begin to transform the phenomena in the special fields, the so-called art-historical line. You see, for instance, the possibility to change the style in sculpture, as from Minimal art to body art and from body art to conceptual art. Because this cannot work in this direction, we are speaking about reaching everybody's point where he has his problems in society, and where the whole body of the society is a problem we have to see it as a form problem.

I transform, therefore not the discipline, the style in art, like artists who are interested in changing from Minimal art to body art to conceptual art; I try to metamorphose. This is the normal running coming from the past exchanging styles and so-called innovations in all these special fields where artists are acting as sculptors, musicians, poets. Then we become so-called modern art. Surely this is a special possibility in changing things in the world, but as long as they are only possibilities to come to innovation in this insulated field, this insulated field cannot reach the whole body of society. This is a cultural behaviour or activity whose activities in the cultural institutes like museums, art schools, galleries and market problems are fully divided from the interests of the body of society. Therefore I try not to change this stylistic understanding in these special fields. I try to metamorphose the whole understanding of art. If this is the art coming from the past, until now I try not to transform the styling in the special fields, I try to widen and to metamorphose the whole understanding of art. In this moment appears another thing. I enlarge the understanding of art to the point where everybody is a creative being in the different fields of the body of society. Therefore I am no longer only speaking about artists like painters, sculptors, musicians. I am speaking of everybody living in the world as a potential creative ability to come and create, for instance, self-determination and so on.

Plight

Beuys now speaks on the occasion of his installation 'Plight' at the Anthony d'Offay Gallery, London, October 1985. This was to be his last major interview in English. He died in January 1986.

WF: Joseph, perhaps we could start by you talking about the sources of this piece of work, which has involved installing felt around the interior of the gallery and placing a grand piano, a blackboard and a thermometer.

JB: It all started as a joke, being related to the difficulties that the gallery was in when the very noisy deconstruction of the building behind Anthony's wall was taking place. The reconstruction of buildings close by will remain for the near future. Anthony, who was very despairing, asked me if it would not be better to go away from that place. I told him that I did not think that was necessary and I said, you have to stand it for a while. The place is good and the connections from this gallery to the other galleries are okay so there is no reason to move just because there is a noise for say two years, perhaps. So then I made a joke and said I can easily make a kind of muffling sculpture. I had the idea of a muffling sculpture with felt and also to make it as a big exposition – that was a joke. Then we forgot about it and didn't speak of it any more. Then only three weeks before I received a letter from Judy Adam, Anthony's assistant, and she mentioned earnestly that it would be interesting to make a third installation with this kind of meaning – insulation from outside influences such as danger, noise, or temperature or whatever. Then I decided to make this piece, so I developed this kind of installation. Before I was intending to make it parallel and synchronic with the exposition of German art in the Royal Academy. I thought it would appear as a stone sculpture here. But I found this much more interesting now, in relation to the pieces that are in the exposition of the Royal Academy, since what they are completely missing is one of my main works related to action, performances, environment, and also the materials which belong to those actions. There is fat missing, there is felt missing. So I thought it would be a very good thing to make the impression on the people who will surely appear from all over the world to see the show. The show includes my most beloved and most powerful material; that was felt. And then I felt people could get information from a wider understanding of art. While those pieces are wonderful, they show a little bit too little about theory and, let's say, the whole scope of the meaning of my wider understanding of art. That was the reason.

WF: There is a recurring theme that one sees in your work. There are ideas to do with survival and to do with the human body and so on. Although that piece is concerned with insulating a space from the outside, it seems to me that on walking in there one becomes very aware of one's own body or of one's bodily functions.

JB: Yes, that's right, and that was also the reason to use such materials. Since I was not interested to stay with the idea of visual art, I was interested to point at the necessity to determine the idea of art to us all, to all the senses existing in human beings and even to develop new senses. If they are not there now, they will appear in the future. If people are training and are really interested in art they could develop more senses. So this is now related to the senses of touching and surely also to seeing. This remains. I am not against vision, surely, because it's one of the most important senses. You have a kind of acoustic effect, because everything is muffled down. Then there is the effect of warmness. As soon as there are more than twenty people in the room the temperature will rise immediately. Then there is the sound as an element muffling away the noise and the sound. So this concert hall – I could also call it a concert hall – muffles down the sounds almost to zero. And to express this the grand piano is inside with a score on it. There are lines for notations on this blackboard but there are no notes. There is nothing on it, and instead of this there is a fever thermometer on it to stress that the warm quality is the most important quality for me and is a very important criterion for the quality of sculpture. One person will feel more this kind of accommodation of warmth and other people will find it sucks away the sound. Other people will feel, let's say, even becoming oppressed, because there is also a negative aspect in the original idea and isolation. The negative side is the padded cell, which is a kind of torture thing.

WF: Because one is deprived of a response by the environment?

JB: Yes, right, there is no response there is nothing, the outside cannot break through. That's more the oppressive element, I would say; then the positive thing is the warmness and the possibility to protect you from all sides. Nobody asked me what does it mean until now, this is the first time. I give only the answer that I found it very necessary during all my attempts to widen the understanding of sculpture, being related to human-kind's creative structures and senses and in thought, feeling and winning power. So it is necessary to describe the reasons why I work with this material, but it needs an exploration towards the special meaning of this special piece. It is visible immediately, so therefore I speak about the theory only until now. What could I say? Yes, surely I try to give already a lot of reasons how it came to such a result. The history started with this joke, with the special condition of Anthony's gallery and so on; then the reason why I

principally use the material is that I try to use a material that is transformable into psychological powers within the being who is not aware nowadays about his or her creativity potentials.

Because our time tends to work with a kind of ideology, they call those things sculpture and paintings visual art. But I think the vision plays only one role and there are twelve other senses at least implied in looking at an artwork. So I try to change the understanding of art, which leads to a wider understanding of art, and that's what I call anthropological art. So this is for me also a series in which anthropological art has to appear after modern art. I find the period of modern art ended in Germany with the beginning of Hitler's time. In England I am not so clear, but I am almost sure this is almost the same. I think everything which came after the war was a kind of reminder of possibilities from the modern impulse, which dates from the turn of the century. Now especially, people are speaking without any idea about the necessity and logic of art. They speak once again of modern art but they call it postmodern, and this for me is a falsification. This is not an organic transformation of the idea of art. It is only a kind of cancer, because they don't know how its next step should take place with the transformation of the power of art. They don't know that it should be related to everybody's creativity, and that the participation of everybody in the idea of art in any field and character of work should take place, and that every future discussion on the changing of the social order will fall if it does not start to base itself on the creative being, with the possibility to make self-determination, self-administration and self-govern-ment. So this transformed idea of art means a lot and maybe it appears to be bold, but I think this boldness is necessary to overcome bad positions in the social order.

WF: Why do you cite the Second World War as a point of significance and change?

JB: Yes, you could also take this time of the necessity to change the understanding of art from the modern art – the ideology of *moderna*. You could shift it ten years later or ten years earlier, but in Germany that was the time when this modern art disappeared and a kind of revival took place, and some very interesting painters appeared even after the Second World War. What I was missing with them was the theory of the thing. So in looking for the importance of modern art, which for me is very, very important, completely independent of whether it is German modernism or Dutch modernism or French or Italian modernism or Russian modernism – Mondrian, for instance, or Malevich. Tatlin had Futuristic ideas, Cubistic ideas, Surrealistic ideas. They are of the significance because they are the signalisation for future time where everything is done by a person. Because all those names like Surrealism, Cubism, they were developed from

single persons, and every person as an individual is able to create his own culture completely. Like in the older cultures. The Egyptian culture was under a kind of rule and it was a great and gigantic culture, but it was not developed by the free individual being. It was commanded by the Pharaoh, who was pretending to be a representative of all the future gods. So all future arts, therefore, were determined from the top as a collective art. It ended with the Baroque time, and after the Baroque time there slowly and with some difficulty started the tendency to give it to the free person as a cultural way to develop and determine his or her own idea of the world. So every artist now in German art – be it Expressionistic, or be it Surrealistic, or be it naturalistic, shows that he is able to create a world of his own. But with all this signalisation towards this potency existing in humankind they make the signalisation for this possibility but they didn't develop the theory.

It is especially interesting that Marcel Duchamp, who tried to destroy the whole kind of tradition, was hinting towards the common worker with his *pissoir* piece, because he said this is an artwork only if it's shown in a special other context. But he missed the point completely to find out the logic in saying that if this is a work of art which is done by some Mr Mutt or an anonymous worker in the factory, then the creator is really the worker. So he didn't enlarge all the work and all the labour to the new understanding of art as a necessity to study everything in humankind's labour from this point of view. That would have been of very big importance because it could then have two kinds of discussion with existing ideology on society, the capital-istic systems and the communistic systems. There is a germ in the right direction set down and practised by Marcel Duchamp, but then he stays away from any other reflections, so he didn't understand his own work completely. So to be very modest, I could say that my interest was to make another interpretation of Marcel Duchamp, and I try at least to feel its most important depth which was missing in this work. So with such statements the silence of Marcel Duchamp is overrated. You know after he stopped working and playing chess and such things and he didn't speak any more about art so much, was completely silent, he cultivated this kind of silence in a very old-fashioned form. He wanted to become a hero in silence or in saying nothing or resigning his whole idea of art. Art also is Marcel Duchamp. I will say that during this time when he was silent he could have reflected his work and come to a real other result about the meaning, impact and, let's say, effectiveness, because he was really interested in the transformation of art but he didn't trans-form it. He showed some pieces that shocked the middle classes, the bourgeoisie, the people of *piccolo borghese*. So from this point of view he belongs to some of the tendencies of the Dada stream. So I try principally to do this thing further on over

the threshold where modern art ends into an area where anthropological art has to start – in all fields of discussion, not only in the art world, be it in medicine, be it in miners' problems, be it in the information of state and constitution, be it in the money system.

WF: If we could finish by perhaps returning to 'Plight'. The meaning of 'plight' is also the lot of the individual, the actual position of the individual. One talks certainly in the English language of somebody's plight – what they are actually left with, what their position is, what their role is – and there is an implication that perhaps their position isn't all that satisfactory in the world if one describes somebody's plight, which presumably is part of the meaning of the space that you have made.

JB: I was interested to stress and to tackle all that runs through the meaning of the insulator idea. To show both sides of the installation, the positiveness of this and the negativeness. This English word plight is not only this special bad situation that you are speaking of, it means also the betrothal of the plight, it means that is love implied, there is a positiveness or trust. Also in English this word has two completely different meanings. One goes in this direction and one goes in that direction, so it was useful to take it as the title for this insulating environment.

WF: Could we just finish by talking about the exhibition that you are in at the Royal Academy. I'm interested to know how much you feel part of what one would call a German identity in terms of recent contemporary art, particularly recent painting. Do you think you share very much with those artists? Is there something one can pin down in your work?

JB: No, as soon as you are trying to restrict this question or to reduce this question on works of art which are only recently done in Germany, I feel completely dubious about the connection with this. But I am completely secure that I belong to German art. To give you a real and radical example, I would not be here as an artist if there had not been a personality like Wilhelm Lehmbruk, a sculptor who I admire very much. His existence led me to the decision to become a sculptor and to get interested in sculpture. I didn't even know what sculpture was when I saw it the first time during the Hitler time, when I was relatively young and shortly before I became a soldier. I saw a kind of catalogue which was not burned in the book-burning activities of the Nazis. I saw a catalogue of pieces of Wilhelm Lehmbruk and immediately I saw this is my ability – to try to show that there is a lot of possibility with the idea of sculpture, whereas I was otherwise only confronted with the social realism of the Nazi time, and you know this just didn't touch me even – didn't give me a feeling of

what it was a necessity for. But as soon as I saw some examples of Wilhelm Lehmbruk's work, I saw that with sculpture you can change the world. Such a kind of feeling I had then, and that was for me the important person. Surely I belong to this tradition.

WF: But can you actually identify anything particularly about your work in terms of its concerns, its underlying theories, its attitudes that one could say that that was very much derived from a German consciousness.

JB: Well, you know people tend to have no idea about the nature of what a German being is, what it means to be a German. The judgement is done only on very banal, foreground things which result from the bad history of the period from the beginning of this century with the First and Second World Wars. The people are immediately connected with the kind of description of the German nature which has principally nothing to do with German nature. It can appear within the German nature because this nature might have some potential to take on such things under special conditions. The nation idea is easier to realise with a country that is geographically isolated. The splendid isolation of England Albion, you see. But Germany on all sides is surrounded with different cultures, and it was the idea of the idealistic poets and philosophers such as Johann Wolfgang Goethe, for instance, and Novalis and those persons, and almost everyone you can think of was speaking about the necessity to see Germany as being in the middle position in the difficulties which will stay on and on in the world, and this bridging between extremities is not realised by German people. So the German spirit has principally to do with bridging and helping others and not helping themselves and bringing themselves to power or to a kind of state, even. The idea of a state is a complete misunderstanding of the German soul and the German ability. So the function of the German is it lies in the middle of Europe. He belongs to the middle European countries.

This in Germany is a specially hard position. This is now exactly the opposite to a bridge. There is the Berlin Wall, so this possibility to mediate between extremities which are always coming from the East and from the West is exactly the spiritual position of the German ability. In music, in philosophy, in poetry, in sculpture, in painting and also in their work. So also their social organisms should be constructed after this idea. This is deeply existing, I insist; and this is not only a formative activity – I insist that everybody will find in the German soul this longing for bridging the difficulties in the world to find solutions for any problem, be a helper, be a mediator and find the bridge position in the centre of Europe.

Bruce McLean

Audio Arts has collaborated on numerous occasions with Bruce McLean, who, as did Beuys, immediately saw Audio Arts as a primary and highly relevant context for his practice. Both artists frequently use spoken language in their work, so the opportunities provided by Audio Arts appeared obvious from the outset. Other collaborations with McLean are discussed elsewhere in this book, but the following monologue by the artist was recorded in the Audio Arts studio and presented in his performance at the Riverside Studios, London, in 1983.

In a monologue triggered by a visit to Documenta 7, McLean explores the themes of art-world politics, social posturing and posing observed in the artist's characteristic analytical, critical yet humorous manner.

'Yet Another Bad Turn-up'

BM: Here was I sitting with two Dutch friends, Whork Van Hogh, Whork der work der work der work … sitting there, you know, and they were saying, 'Good God, isn't that Joseph Beuys over there?' and I said, 'Yes, it is Joseph Beuys, but he's sitting on his own.' But what he was doing was he had a bit of a hand on the side of the face, leaning on the forefinger looking completative, completative, com, com, com completitive. Uhm … I can't speak English. Complititive, completive con … he was contemplating something. Bit of hat, you know, face looking thin, a hat coming down over the eyes, wife had gone to the lavatory again, kids have gone to buy a packet of cigarettes. I don't know whether they've gone to buy the cigarettes or she's gone to buy the cigarettes but they all disappeared. Joseph left on his own without the sign of any click, ck, ck, click ck ck, click ck ck, click ck ck, you know the old Pentax Olympus click, ck, ck – that thing – and the hat's coming down the head, leaning more into the cheek on the finger, sinking into the flesh looking very depressed. I didn't want to make a big move, like say, 'Oh, hello, Joe,' because he'd of thought I was some sort of toading groveller, which of course I am but I didn't want him to know that, so this is before we had the pincer movement from left to right – Saatchi – the Dibbling, née Saatchi Dibble, Dibble, Dibble, and the Fatty Joachimides bit. Don't know where Norman was, he may have been down the lawn a bit, I think, probably fiddling with the Burens. However, there was a lot of music going on, or or or or or or you know, heavy Vivaldi stuff, but the funny thing was that Joseph was sitting there and suddenly got into a posture crisis . Didn't know what to do with his legs, had his legs crossed with a big seal-skin boot … you know, Green Party … I think it was seal skin, bit of a zip up the front. And there he was sitting with his boots on, bit of a huge gabardine coat, you know, Aquascutum, I suspect, clothes from the House of Pierre Cardin, not, you know, the House of the Shaman, I think a slight … so

anyway, he's sitting there, this is absolutely unbelievable, couldn't, didn't know what to do. So he saw me looking at him and he couldn't get his pose right and he kept going left to right, right to left, up and down, crossed his legs, folded his arms, repositioned his fingers, didn't want to see if his wife was coming. He was looking for a reflective surface to see if she was coming back so she could talk… nobody wanted to sit next to him because they didn't want to be seen to be toading with Beuys who was sitting on his own, 'cause of the Beuys thing, you know. The head of the Luft – he was there and you know … looking a bit like… you know who, when suddenly there was I with two Dutch people click, click, click, click clicking away at Joseph Beuys. They started doing a bit of clicking to try to get him into his rhythm again. The minute they started clicking him he began to get animated and decided to do a bit of heavy posing, click, click, click, an arm came down, head went back, arms folded, bit of a pose, little bit of a nod, nobody paying any attention to him because at that moment – this is what I was trying to get at in an earlier bit of the tape – was what then happened was that Joachimides made an entrance from the bloody sausage stall … in the Strasse … the bratwurst cabin, what's it called? Bit of a bratwurst cabin, bit of a sausage in a bit of a mini-roll, a lot of mustard and all that sort of thing. He made a big entrance, couldn't see Norman and thought, 'Hello, something's adrift here.' He came in, everybody turns round – bit of a rightways move… 'Oh, hi, hi, hi!' Just as he was about to go, 'Oh, hi, hi,' … here comes Charlie Saatchi down the bloody Strasse with Doris Dibbling. Née, no Doris, Saatchi, née Dibbling, née Dibble, Dibble, Dibble, née Dibbling, Doris, she comes in a pair of matching Courtelle bloody flared trousers … a little bit tight around the … you know … that bit … sort of flaring a bit, now everyone thought, Good Lord, really are they slip-on shoes or laced-up ones. This isn't the style we expect from the man who is controlling the … you know, British Conservative Party, I mean really the people who seem to be voting for the Conservative Party perhaps aren't in fact the long, thin brogue, you know – Barry Barker kind of ex-Anthony d'Offay shoe type, it's not them at all it's a bunch of bloody … it's all this north country ay, ay, ay, ay, ay, ay, ay. You know, it's all this Dibble, Dibble thing, it's all a kind of football manager mentality, a little through lounge number, you know with a jangle, bow jangle nickle-nackles and the sun tan and the big medallion piece, I mean … so then they appeared and everyone went, 'Aahh, hi,' and went, 'Oh, no,' and then just as that happened, Mary Boone appeared from the right. Total fucking chaos. People were moving left, right in and out, shaking it all about. It was like a fucking hokey cokey. So anyway, everyone stood up, they thought, 'Ah, we'll stand up'. I didn't stand up I just remained seated looking at Joseph Beuys who no one was paying attention to, nobody said 'Hi, Joe,'

and Joe didn't say 'Hi, Mary,' didn't know who Mary was, you know, bit of a … Um … has been described as a bit of a … bit of a …yeah.

However, we won't go into that now, that was also a description used by someone else for someone else who's a friend of hers and it's all a bit Third World, it's all a bit hanging about with medallions, you know, the big lapels, bit of a funny shoe, gold thing on the shoe, a bit of sun tan and two-tone spectacles, this sort of thing – and the hair, a bit like thatched hair, heavily art directed – it all begins to make a bit of sense – and there's old Joseph with the gabardine coat. Aquascutum, four hundred pounds, bit of a hat falling further down his head, looking pretty stylish, I have to admit it, apart from all this dross, and all this Longo nonsense, and it's all up there, this Cindy Sh … you know, all that … who are they, these people, Brauntuch, Troy and, you know, Rip Torn, they're all there … I just jumped up and said, 'Oh, hi, Charlie,' and left.

It all happened in that cafe on the corner of Sausage Strasse, Documenta 7.

Richard Long

Sculptor Richard Long agreed to work with Audio Arts on a tape in 1985. This included a conversation with William Furlong, which was juxtaposed with the artist reading the following word pieces:

Side 1
'A Moved Line'/Dartmoor 1983
'Mountains to Mountains'/Ireland 1980
'A Straight Northward Walk Across Dartmoor' 1979
'The Isle of Wight as Six Walks'/1982
Side 2
'A Four Day Walk'/England 1980
'Mississippi River Driftwood'/Louisiana 1981
'Granite Line'/Dartmoor 1980
'A Five Day Walk'/England 1980

In this extract from the conversation Long starts by talking about the formal elements in his work.

WF: You talked about walking a line and a driftwood circle. You have tended to use very simple forms in your work from the sixties – straight lines, circles, spirals. You haven't ever felt the need to make the formal components of the works any more complex?

RL: No, I don't think you can get anything more strong or powerful than those things. I like the idea that a circle doesn't belong to me and that lines or circles are universal human images that belong to everyone. Also they belong equally to all times in history. So I am not interested in making an idiosyncratic personal mark. I like the idea that if somebody sees one of my works in the land they see it just as a mark of a man, not of Richard Long. I think the first time I actually used a circle I just used it almost without thinking about it. It just seemed a good thing to use. I see it also as a very modern idea, like I said before, it is outside of time, in a way. I think a lot of art is made now which belongs to the present, but it is like a stone. A stone is millions of years old and yet it is a stone here and now. So maybe the circle can be given all those meanings. A circle is a very perfect human idea.

WF: To some extent you are presumably working on the associations that people will bring to those images, because people won't actually be able to go to the Andes or wherever.

RL: No, it is not my intention that people from the art world will see my remote works. The whole idea, the thing I find interesting, is that art can make what is not necessarily seen, or if it is seen by people it is seen by people outside the art world. Like maybe a shepherd or someone. Maybe the person who sees it won't recognise it as art, but I quite accept the idea that a photograph brings the idea of that work into the art world in another way. Also I think it does enough to seed the imagination. It is not meant to stand for the work, it becomes something else, it becomes art in another way.

WF: Without labouring the point, would it be unacceptable to you to think in terms of one of those remote spots where you might make a work to be designated as the site of one of your pieces of art.

RL: Yes, that would be wrong. One of the points is that the place should be anonymous in the art world. Really the only thing that reaches the art world is the image of the work. I might just call it, say, 'A Line in Iceland'. So the title is very abstract; it is not important to know where it is. It is only important to have knowledge of it through what the photograph looks like. The work might not last very long; I'm not interested in making permanent works which would turn into a famous site or something. In fact a lot of landscape works you might only see by standing in the position where the photograph was taken from. If you stood to one side you might not see the line. In a way the photograph makes it visible. In the space of the landscape, the piece is almost invisible. It is only when you see it in the photograph that you have that focus of attention.

WF: One piece I have seen recently by you was a piece of

Avon mud at Coracle actually pressed into a series of concentric circles with your hand. Perhaps you could talk about this – drawing with mud in its relationship to Avon and so on. Is this a new series of groupings of work or are they an extension of the other pieces.

RL: The hand piece at Coracle is just a continuation of my other mud works. It is just that I have changed the procedure. I see those mud works as being as much about water, in a way, as about mud, because in fact there is always a small quantity of mud and then it is mixed with a lot of water. It is obviously more clear in the splash work that I did. This was just to chuck a bucket of muddy water at the wall, which left a beautiful print of silt down the wall. Water is one of the themes of my work. For example, I have walked between the sources of rivers, or I have used the length of a river to be the length of a walk, or I made a piece on Dartmoor where I drew a circle on the map and then I walked down all the river beds within that circle so that I was using river beds as a footpath. I like the idea that when you make a walk along the road you are tracing the way like a human record on the land, whereas if you walk down a river bed you are following a sort of natural path.

I suppose the River Avon was always a kind of potent influence in my childhood – this big tidal river in Bristol, which has the second biggest rise and fall in the world. I was always fascinated by the beautiful mud banks of the river and I suppose I have just ended up by making art out of it, finding a way to turn it into my work. Also talking about the hand prints, my work has always been about my own physical scale. In a way, my walk is about my own strides, my own footprints. It is about how far I can walk in a day. So the footprints and the handprints are all about the same person. It is always a human scale.

WF: One other way in which you have worked is through publication. You have actually been involved in a lot of publications, haven't you? What role do you see this having?

RL: Well, that is another way of putting the work out into the world. It just does that job. It makes the ideas available to the people very cheaply and easily. The work is not about possession. To say 'to know it is to possess it' is not quite right. It is like people can know a fact of life. That knowledge is common to everyone – no one actually possesses it on their own.

WF: What you are saying reminds me of Australian Aboriginal concepts, which don't actually include the concept of possession but a place and location and site.

RL: I would hope my works are close to that same spirit, yes.

It was never really my intention that my early landscape works could be owned or possessed. That is why I feel it is like the American land artists with their emphasis on possession and ownership of the land, and really not being artists unless you have so many thousands of dollars to actually make the art. I never had any theories at the time but I obviously must have been attracted to the idea that you could make art with almost no means at all in the parts of the world which were free for everyone to use.

WF: I suppose when it comes to the natural landscape it is mysterious in the sense that the land is what really gave people sustenance, and their relationship to the land in the past was obviously very positive. In one sense or another there must be some sort of undercurrent of that there. But as well there must be a feeling of civilised society – urban society – conspicuous by its absence, because now we have the means to actually put buildings and factories everywhere, so the fact that there aren't factories and buildings in a remote spot is based on some conscious decision by people living in an urban society.

RL: I think these places are only mysterious to the people who don't know about them. You know, I would say most of the art world and a lot of the art critics have urban perceptions and urban sensibilities, and so the things that I do, the places I go to, to them it is mysterious and romantic. But in these places there are often people living their normal everyday lives – you know, like in Nepal it is quite well populated. So I don't feel as though I am making an escape. The world is like that in those places, and I use the world as I find it. I think it just depends on where you are standing in the world, what opinion you have of it, what perception you have of it. In fact most of the world is like the landscapes that I make the work in. It is only a small percentage of the world that looks like central London or New York, it just happens that that's where all the art is. Art is basically an urban culture. So I feel that my work is more about reality than other art.

WF: When I said mysterious I didn't really mean romantic. What I was really referring to was that when you go around remote areas of Ireland you very often see the remains of ruined cottages of people who actually once lived on the land and no more do, and that makes one start wondering about the people and about how they worked on that land and how they lived.

RL: Yes, and I do too. The work doesn't precisely relate to those problems, if that is what they are. I suppose you could say that I have actually found a way to go back into the land and use it in a different way from those farmers, and maybe those farmers couldn't use it, but I can – but that is not really my prime motive.

I go there just because they are great places. I don't think work is really about any kind of social stuff like that. One thing I am aware of is that the surface of the world is actually made up of all these different layers of civilisations. People have used it in different cultures for different reasons all through the centuries. Whatever I do on the land is just like one more layer on these layers of marks, historical marks, and my marks will in turn be superseded by the marks of other people. So it is really just part of the human pattern on the surface of the world. In other words, I take my place on the same surface as all the other people. Some of the sculptures are impermanent but they illustrate permanent ideas. For example, I might make a spiral of seaweed on a beach in Cornwall. Now that pattern itself will be washed away by the next tide, but the record of it through the photograph just demonstrates that the cycle of patterns of seaweed left by the tide in a natural way has gone on for millions of years.

WF: Until quite recently you have been fairly reluctant to write about your work or talk about it. Do you feel now more confident or do you feel that you should be talking, or what?

RL: Doing something like this is a struggle. In the early years I had this idea that the work should speak for itself, but of course it doesn't actually work like that. I think if the work becomes well known to a certain extent, then people start writing about it anyway. It is a bit like Chinese whispers. If there are only a few articles written by misinformed people, if that is all there is about you then those articles take on an importance that they shouldn't have. So I did my first piece of writing in a way just to try and set the record straight. That was the reason for doing the statements. I think art is a very moral activity. It doesn't threaten people, it doesn't use people, it sort of humanises us, I hope. My work really is just about being a human being, living on the planet, using nature as its source. On another level it is also about making up other things by doing things that I enjoy. It is not really about a struggle, I actually enjoy thinking about ideas, I actually enjoy camping and being on my own and the whole business of lighting fires or choosing a camp site and sleeping on the ground. I always get my best sleep on some stony patch somewhere. I love the whole ritual and rhythm, the great simple rhythm of being on a walk. It is just like getting up with the sun and making breakfast and walking all day, being very tired in a very physical, simple way. Apart from anything else it is just a very good way to live life. Somehow I have found a way to make it into art.

WF: Presumably, that is really the source of your work, that physical involvement with nature.

RL: Yes, it is – yes – you said it.

ABOVE: Richard Long, A Circle in Alaska, *Bering Strait driftwood on the Arctic Circle (courtesy Anthony d'Offay Gallery, London)*
BELOW: Lawrence Weiner (centre) with Miranda Frawley and William Furlong, 1980

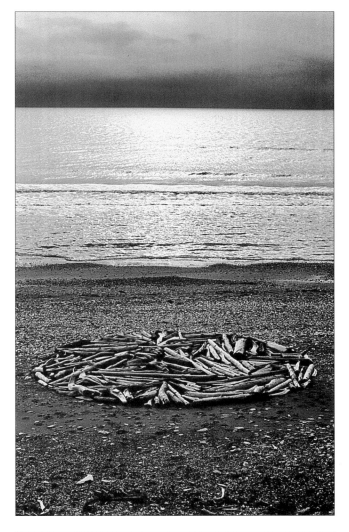

Lawrence Weiner

A conversation with William Furlong concerning twenty works by Lawrence Weiner. As the interview/work proceeded, the voice of Miranda Frawley could be heard reading the texts by the artist. These readings are keyed into the interview by letter and reproduced at the end.

[a]

WF: *An Object Tossed from one Country to Another.* What object and which countries?

LW: Any object, and most feasible for tossing would be two countries that butt on each other.

WF: Why should an object be tossed from one country to another?

LW: Not to fall into the habit of answering questions with questions **[c]** – why not? Movement is a sculptural procedure, movement is a sculptural fact. Sculpture deals with objects. The placement and movement of one object from one place to another is a legitimate sculptural fact.

WF: Is that statement an intention or a description?

LW: It is an empirical reality. An object tossed from one country to another.

WF: We are to believe that no other action is necessary other than the object of language as we have expressed it, or as I have expressed it and you have defined it in text.

LW: If it is possible, without confusing the issue by relying upon documentation and relying upon illustration, to convey the same information by physically tossing one object **[d]** from one country to another, I think that it would be the same. It is a form of language. Language is just most convenient at this point.

WF: Could the language describe the activity in any other way, and if it did, would the idea become different?

LW: Well, it conceivably could. But that is asking if a red painting is in fact different from a blue painting. Yes, of course, it would be a different work of art.

WF: *A Turbulence Induced Within a Body of Water.* Would it be important to experience this, or rather, how should one experience this?

LW: One does experience it by the use of **[b]** language. When one experiences this in a more physical sense one would translate it in one's head into language.

WF: How crucial is it that a different person will feed in or load in their own experience into the same work?

LW: Totally crucial in the choice of using language as a means of presenting art.

WF: So in fact any single work has many different realities, depending on the number of people who witness that work.

LW: We are not talking about witnessing, we are talking about an essential quality of art – whether art should look or be a certain way or whether art could look or be a certain way. If art is presentational rather than imposition, the use of language obviates various problems of the artist's reality and perceptions being better than your reality and perceptions. It is not that at all, it is the content of the work itself that we are **[a]** trying to get to.

WF: But the content of the work changes. It is different for anybody who confronts the work.

LW: It is the context not the content when we are speaking of turbulence. A turbulence is a turbulence. We are not speaking in terms of degree. Degree is as well a sculptural form, but in the particular work degree is not of the essence. The essence is the idea of the turbulence and the idea of a static quantity of water.

WF: And not the experience of the turbulence of the body of water.

LW: Experience and idea are exactly the same thing there, they have to be related to the relationship of human beings to objects.**[c]**

WF: A turbulence induced within a body of water seems instructive or descriptive. *To the Sea* seems to deal with language in another sense, as though it is a notion – a prescription – of something to happen rather than something that is happening or has happened.

LW: No, I am afraid you have tripped yourself up in that because *To the Sea* is not a prescription, it is an immediate happening. It is something that is immediately realisable. I don't see any prescriptive qualities in any of the work. The work does not give instructions or imply that there can be no participation with the work itself without complying to instructions. It is an

empirical fact. I think grammatically they all hold as empirical. **[d]** There are no instructions – there are no prescriptions involved.

LW: What we are working within is in fact only related to previous aesthetics instead of the realisation that now certain facts are **[b]** accepted within our own experience. This has a tendency to overburden our movements to the extent that by the time we have finished placating and placing within a context that they don't belong in to begin with, there is nothing left to fulfil our needs, the resources are expended. If you could just accept the fact that the representation of art by the use of language is in fact the existent, then we can deal specifically with the content. Whether an object tossed from country to another is in fact a useful, interesting concept within the society – that is the question. The question is not which object, how does this fit into a context of art. Of course it fits in the context of art, it was presented and came across in a context of art.

WF: The statement you have just referred to, however, seems much more specific and available to those kinds of questions, as opposed to the statement *Done Without*, which is more abstract.

LW: I don't see it as abstract. I see it as a total material relationship – done without. That is one of the major premises of any kind of art that would require assemblage instead of just removal. Removal itself – you can't build a stone sculpture without either adding to it or taking away from it. You can't build anything **[a]** without either adding to the material or taking away the material unless you move from place to place, and these are specific sculptural problems that one comes to deal with.

WF: Similarly with *Made Quietly*.

LW: There is quite a difference between making something noisily to place it within its context or making something quietly.

WF: To what extent are the works elements of an overall narrative?

LW: Narrative is a funny word. Everything that relates from the transference of any form of information **[c]** from one human being to another would be constituting narrative. I am interested in the relationship of human beings to objects and objects to objects in relation to human beings, and perhaps my work at this point for the last period of time has been concerned with a continued research into the implications of the relationship of human beings to objects within an art context. So if there is a

narrative or an anecdotal narrative, the anecdotal narrative would be that I am continuing my research into one artist's relationship to objects, taking for granted that if one human being does something it relates to the perceptions and needs of another human being, so the artist then becomes a surrogate for one section of the society researching into the relationship of human beings to objects. It is not an egotistical feeling to think that you are representing, because I don't present work in an impositional manner – I present it in a presentational manner of my observations within an aesthetic context, and if they are of use to the society, they may be used.**[d]**

The Readings

a) Art is not a metaphor upon relationships of human beings to objects and objects to objects in relation to human beings, but a representation of empirical, existing fact. It does not tell the potential and capabilities of an object or material, but presents a reality concerning that relationship.

b) There are very few material relationships of human beings to objects that have at various stages have not required various forms of human-being-to-human-being relationship. The utilisation of media presents these various relationships at the moment of the presentation of what in essence is a material relationship. The utilisation of media as both presentation and representation seems to require no justification other than the presentation itself.

c) The obvious change in the relationship of art to a culture is perhaps that the explanation, not needed justification, of the existence of art is being allied to the concept of production. This reading, while obviating some form of social unease, is not in fact the case. Art is, in relation to its society, a service industry.

d) The artist's reality is no different than any other reality. It is the content that gives the perceptions and observations of an artist within the presentation, art, a use factor within the society. The acceptance of the need for this distancing by society, in fact the need itself of a society for its art to function, has led to the misconception that art and artists are apart from society unless they do not function as artists.

e) In relation to probable use within a culture, ie Western:
 1 An artist may construct a work.
 2 A work may be fabricated.
 3 A work need not be built.
A reasonable assumption is that each being equal and consistent within the intent of an artist, the decision as to conditions rests with the needs of the receiver upon the occasion of receivership.

f) In general:
 1 My structure is your structure.
 2 Your structure is my structure.
 3 Their structure is our structure.
 4 Our structure is their structure.
 5 A structure is the structure.

g) Is a structure moved from there capable of relating content from here with some probability of comprehension of its use?

h) 1 Does the attempt leave one further than before?
 2 Can the title ever change within the same structure as before?
 3 Is just the act of assurance an acceptance of before?
 4 When can a change of location make it not as before?
 5 In a name, is it not as before?
 6 If owned, is it not as before?
 7 Where is the accounting?

ARCHIVE RECORDINGS

For an exhibition/presentation of Audio Arts at the Whitechapel Art Gallery, London in 1977, the then director, Nick Serota wrote, 'The initial aims of the magazine were to record discussion, conversation and dialogue between artists and people in related disciplines. Verbal interaction is often the means through which formulation, development and clarification of ideas and intention takes place, and sound recording, which allows us to return to this level of communication, can provide a valuable instrument in the understanding of individuals' activities and thinking.'

The emerging policy of Audio Arts extended to the inclusion of important archival recordings that were unavailable elsewhere. These included James Joyce, WB Yeats, Marcel Duchamp, Futurist Noise Machines and Wyndham Lewis, who, with characteristic Vorticist energy and pace read extracts from his poetry in a recording made at Harvard University in 1939.

A sense of time and period is also evoked in the recordings, and this is integral to their authenticity.

James Joyce

In this rare recording made in 1929 by CK Ogden of The Orthological Institute in Cambridge, James Joyce clearly uses language for its phonetic and 'musical' dimensions beyond literal meaning and narrative. Joyce now reads part of the Anna Livia Plurabelle extract from Finnegans Wake.

Well, you know or don't you kennet or haven't I told you every telling has a taling and that's the he and the she of it. Look, look, the dusk is growing! My branches lofty are taking root. And my cold cher's gone ashley. Fieluhr? Filou! What age is at? It saon is late. 'Tis endless now senne eye or erewone last saw Waterhouse's clogh. They took it asunder, I hurd thum sigh. When will they reassemble it? O, my back, my back, my bach! I'd want to go to Aches-les-Pains. Pingpong! There's the Belle for Sexaloitez! And Concepta de Send-us-pray! Pang! Wring out the clothes! Wring in the dew! Godavari, vert the showers! And grant thaya grace! Aman. Will we spread them here now? Ay, we will. Flip! Spread on your bank and I'll spread mine on mine. Flep! It's what I'm doing. Spread! It's churning chill. Der went is rising. I'll lay a few stones on the hostel sheets. A man and his bride embraced between them. Else I'd have sprinkled and folded them only. And I'll tie my butcher's apron here. It's suety yet. The strollers will pass it by. Six shifts, ten kerchiefs, nine to hold to the fire and this for the code, the convent napkins, twelve, one baby's shawl. Good mother Jossiph knows, she said. Whose head? Mutter snores? Deataceas! Wharnow are alle her childer, say? In kingdome gone or power to come or gloria be to them farther? Allalivial, allalluvial! Some here, more no more, more again lost alla stranger. I've heard tell that same brooch of the Shannons was married into a family in Spain. And all the Dunders de Dunnes in Markland's Vineland beyond Brendan's herring pool takes number nine in yangsee's hats. And one of Biddy's beads went bobbing till she rounded up lost histereve with a marigold and a cobbler's candle in a side strain of a main drain of a manzinahurries off Bachelor's Walk. But all that's left to the last of the Meaghers in the loup of the years prefixed and between is one kneebuckle and two hooks in the front. Do you tell me that now? I do in troth. Orara por Orbe and poor Las Animas! Ussa, Ulla, we're umbas all! Mezha, didn't you hear it a deluge of times, ufer and ufer, respund to spond? You deed, you deed! I need I need! It's that irrawaddyng I've stoke in my aars. It all but husheth the lethest zswound. Oronoko! What's your trouble? Is that the great Finnleader himself in his joakimono on his statue riding the high horse there forehengist? Father of Otters, it is himself! Yonne there! Isset that? On Fallareen Common? You're thinking of Astley's Amphitheayter where the bobby restrained you making sugarstruck pouts to the ghostwhite horse of the Peppers. Throw the cobwebs from your eyes, woman, and spread your washing proper! It's well I know your sort of slop. Flap! Ireland sober is Ireland stiff. Lord help you, Maria, full of grease, the load is with me! Your prayers. I sonht zo! Madammangut! Were you lifting your elbow, tell us, glazy cheeks, in Conway's Carrigacurra canteen? Was I what, hobbledyhips? Flop! Your rere gait's creakorheuman bitts your butts disagrees.

ABOVE: *James Joyce, Zurich, 1915*
BELOW: *Wyndham Lewis, 1920*

BEING THERE

The international exhibition as a source and catalyst for discussion, commentary, analysis and opinion

Attendance at international exhibitions, including the Venice Biennale and Documenta, have provided a consistent theme in Audio Arts activities. These periodic events provide a focus for artists, critics and curators, particularly during the opening days. By being there, 'on the spot', Audio Arts has been able to gain access to spontaneous opinion, analysis and commentary. Indeed, the discussion becomes part of the event. As well as the art, the event itself is examined as to its relevance and role as an appropriate model for the presentation of contemporary art.

VENICE BIENNALE 1984

Howard Hodgkin

Venetian ambience with the sounds of bells from churches along the Grand Canal, an orchestra in St Mark's Square and a naval cadet brass band performing next to the lagoon provide the opening atmosphere for this issue. The sounds provide a rich and evocative introduction to the location, conjuring up the Venetian experience, with all its theatre, drama and history. In the British Pavilion in the Giardini section of the Biennale, Howard Hodgkin talks about his memorable exhibition there, hung on pale green walls.

WF: Howard, we could start by talking about the exhibition as a whole, before we talk about specific paintings. Certainly the first thing that strikes one on walking in here is this incredible green that you have decided to paint the walls, so that the exhibition has a very particular feeling that perhaps one wouldn't come across if it were to be put on elsewhere. I wondered why you decided to put the paintings on green walls rather than white?

HH: Well, for various reasons. The first one, the most important, is that I think white for the colour of my pictures is entirely the wrong colour. It reflects far too much light, and in the distant past people used to hang pictures on colours like dark red or dark brown, which don't reflect much light. Therefore the light is entirely reflected by the pictures, so you can see them much better. But also it's the form of the actual pavilion itself, which without being great architecture is good architecture and has a very sympathetic series of differently proportioned rooms, which when they were painted all one colour, ie the ceiling and the door cases being the same colour as the actual walls, lost a great deal of their shape and form. It was very nice to bring that back by painting the walls a different colour to the ceiling. It reflects the light beautifully, and the walls have an identity of their own.

WF: Although the walls still do reflect the light and although they are still luminous, they seem to establish the plane of the walls as well, whereas white would probably make it difficult to identify where the surface of the wall was in this Venetian light.

HH: Absolutely right. I was about to say to you, it gives back the walls a surface, and in this Venetian light, which is extremely bright, if they were white of course one would also be entirely dazzled. But one last thing about the walls: what surprised me

was the great difficulty I had with the British Council about the colour. They thought – which is interesting, and I'm not saying this in any derogatory way – they thought that if they were not white, people would remember the colour of the walls rather than my pictures.

WF: Moving on, then, to the pictures, they're not hung in any particular chronological order, are they? Because you have actually decided here to only show paintings produced over a ten-year period, is that right?

HH: Yes, that is correct. They've been hung where I felt they looked best, and with all hangings of any number of pictures, one finds that some things hang themselves: there is the only place for this picture, and there's the only place for that, and that is what we began with. The real trouble comes when you have to fit in the others. But the biggest picture here, which is the biggest picture I have ever painted, needed as much space proportionately as a very small picture, and as they take up a great deal of room, I had to use up nearly half a room for one painting.

WF: In terms of the way that you make your paintings, I know you make them over a long period of time, and there's evidence of a constant process of revision, alteration, that you actually apply to the painting, but the starting point often seems to be a very literal experience that you've had, and then they proceed from that sort of basis. In this painting *Souvenirs*, can you talk about the history of it, how you arrived at it?

HH: Yes, I can. The title is quite precise, it is memories of one single apartment in New York, which belongs to a great friend of mine, and its views. It started, as it were, as a spread-out view of the apartment. I don't know what one calls this, but it's as if one could see into four rooms at once and see simultaneous things going on within them.

WF: Would it, for instance, have started off by being representational? How did you actually begin the painting – was it painted from memories when you came home?

HH: It was painted from memory, like all my pictures are. I never paint from the motif, and in this case it would have been impossible, because it contains multiple views. I found it very difficult to paint for various reasons, not least because its scale was so new to me that I was constantly frightened that I would make an enlargement of a small picture, and as I've only just finished it with great difficulty and anxiety, I don't really know what I feel about it, but the one thing I am sure about is that it is not a small picture made large. I think the scale of it is completely

convincing, and when I saw photographs of it, one couldn't tell what size picture it was, which of course is the acid test, I think.

Dr Willi Bongard

Dr Willi Bongard's authoritative yet controversial newsletter was distributed in Europe in the early 1980s. In it he ascribed 'points' to the top one hundred artists according to the venue and the prestige of an exhibition. Here he critically evaluates the importance of the Venice Biennale, whilst enjoying the experience of being there.

WF: I know of your activities through the newsletter you publish regularly about the state of the art market, which is seen as quite significant. What is your particular interest in Venice, and do you have a professional analysis to do with market prices and so on that it might be interesting to reveal at this point.

WB: My special interest has always been Venice, the city. I think it is worthwhile coming here, and everyone will tell you that Venice is a great work of art, and I love to see it at least every two years – despite the Biennale, almost.

The Biennale is the same distressing affair which it has been for as long as I can think back, at least the last eight, ten, twelve years, in the sense that when you come here to look for good new art you will always be disappointed. Except for one or two artists, the Biennale is a very frustrating affair, but I am used to it and so I am not surprised and I am not really mad any more. I realise it is an institution. People love it. Artists love to be invited, critics love to come here, collectors come here, museum people come here. First of all it is a meeting place for people, and that is what I like.

WF: In the international scheme of things in the rating of individual artists, is it significant? You would know a lot about that.

WB: Well, as far as the rating of artists is concerned, it is a terrible word anyway. I don't believe in rating artists any more, although I know that you think that Willi does this terrible list of the top hundred and so forth. The Biennale happens to be one of the seven hundred parameters in order to be able to tell who are the top hundred. But to be very open about that, you get fifty points if you are an artist invited to come here but you need 8,500 points to be the number one hundred. So that may give you an idea of how important the Biennale is in terms of recognition, reception, reputation and fame or whatever you call it. I don't think that any artist who is somehow sound of mind thinks that

the Biennale is important as far as his career is concerned. It is a lot of fun, hopefully, for the artist, it is nice to be invited, but it doesn't really tell you anything and it doesn't make you a greater artist and I don't think that artists can expect a lot from being shown or being represented or whatever you call it.

WF: Are there any particular artists that you have discovered on this visit or that you knew about before you came and you think are going to be seen as very important in late 1984/5. I know this is asking you to do the impossible and to make a prediction.

WB: What is very important I couldn't tell. The importance of an artist is not the thing that I think I am able to judge. I mean, importance – what is it? Is it in terms of prices, or are you the most discussed or talked-about artist? As far as the Biennale is concerned, again I don't think it really adds to an artist's fame or that it makes a difference. I haven't discovered an artist that I haven't known before. But I couldn't believe what I saw in the British Pavilion with the green walls. I thought, 'What did they do to the Hodgkins?' Until I learned that it was by request of the artist. I couldn't believe it. I almost dropped dead. But I understand that this is the artist's request and I think that he thinks that it adds to the pleasure of his pictures.

As far as the Austrian Pavilion is concerned, I know Attersee. I have followed his work, and in my view it is the best work I have seen in the fifteen or twenty years since I came across these paintings, because he seems to be less concerned with images and he is much more painterly. Maybe this is partly due to the new wild artists, although I had a little chat with him and he denied it. The paint paintings are probably the best ones in terms of painting, although they are not really paintings but are the best I have seen in the Biennale, and the Lothar Baumgarten piece is for me too educated. You have really to go to university and to be trained on the job in order to be able to understand it, and I think he demands too much. You come in there and what the hell is going on? At least it doesn't communicate for me – it is too complicated – it's too esoteric. That is why basically I don't like it, okay, but that doesn't mean a thing.

WF: So your overall feeling about the Biennale is …?

WB: The sun is shining, the city is glorious, wonderful, and the Biennale should go on, and I hope to be able to come here in two years' time. But from an art point of view, I think we could do without the Biennale. But the human aspect is wonderful in so far as I think it should be protected and I will fight for the next Biennale. I hope there will be another one, okay. I hope I don't sound cynical.

John Walters

Many of the interviews and conversations recorded at Documenta and the Venice Biennale were made as a result of meeting people by chance. This is not so difficult, as most people are usually at one of the exhibition venues or travelling between them. John Walters, then a BBC producer, provides a commentary in a vaporetto en route to the Giardini.

WF: Having seen the Aperto show again, we are on our way to see the Giardini part of the Venice Biennale, and I have John Walters with me. John, you are going to give us your feelings about the whole thing. This must be slightly *déjà vu* for you, having been here before.

JW: Yes, I did come here two years ago to a BBC Radio thing, and again as always the overriding impression is one of the muddle-o Italiano. When you think they have got two years to get this blighter together, you know, and they still can't get things unpacked. When I came two years ago to do a radio piece like you are doing now we had three days with the critics going around trying to get artists and things. Then I came back with my wife because I wanted to see the work in situ and I wanted to go down and see the Accademia and the churches and so on and I thought, fine I will come back for a week. I came back about six weeks later. At The Cellars at that time, where John Roberts' selection is, they had started to put up a sign saying 'Biennale'. When we all arrived they had about got the 'i' and 'e' and 'n' – and stand back and have a look. By the time we got there in August they have got around to second 'n', and you can imagine that by the time the whole thing closed they would have the 'Biennale', and another bloke comes along and it is like the Forth Bridge and he is taking down the 'B' … and that is the way it is – it is the great hang up with this whole thing, always.

Now I'm going back to the gardens with you because I want to see the official representatives – Howard Hodgkin I've seen. The British, I am glad to say, were there – and that is one thing we will say for British art. It is here. No nonsense from that lot, we are there manning the barricade. It is Rorke's Drift, in artistic terms. Howard Hodgkin is there and the work is there, and certainly compared with the work around it, is very dignified. There is no question of that. There is a solid body of work there. Instead of a white backdrop, as you've probably noticed already, it looks like an avocado sort of backdrop. You know, a kind of avocado dip – or in British terms, perhaps watercress-soup walls. But on the other hand, that has got a kind of bathroom-style restfulness which one needs at the Biennale, because it is a shambles. It is a delightful shambles, we like it, and everybody likes Venice, and it's the old problem that art is too good to be left to the Italians. They have had their burst of it and because of the

old names they think … it is rather like New Orleans putting on a jazz festival – the guys aren't there any more. They were there when it started but they have gone, and the name New Orleans means jazz and the name Venice means art, and so they think they can put it on. In many ways it ought to be put on here but taken out of the hands of the Italians, in my opinion, and I don't like the look of their work – I think it is called something like 'the cultured painters', which looks like absolute codswallop to me, speaking as an uninformed layman.

Hello, we're pulling away from San Zaccaria … now we are moving further along towards the gardens and just keeping the audience amused here, but them Cellars there that John Roberts is mainly responsible for, he has done a good job, I think, in his selection. He has got interesting people whose work I would like to see. Out of John's hands is the fact that one can't see it. There is Paul Richards' stuff there, just inside the middle one. He was rather depressed when I saw him last night; he was a bit – I don't know – a couple of drinks, a bit under the weather about his work. Of course you cheer him up and say, 'No, it looks fine,' but it doesn't look fine. You might as well exhibit in a coal cellar. The light, for anyone who has never been there before, is like being in a barn. There is strip lighting in the roof.

British artists Kerry Trengove and Rose Garrard, of course, are well selected with interesting work, and Helen Chadwick is down in the third one. But the trouble with Helen Chadwick is that she is sharing with the Americans – mainly the graffiti artists – and I went in yesterday and there was Keith Haring in there, working up a ladder, slap, slap, slap and on goes the day-glow colours. He has got a cassette player going, 'Hey baby ba booy'. People are attracted: What is this, is this disco art? And they turn up, and Helen Chadwick is next to him almost like somebody who is trying to get a string quartet together. A fairly delicate remembrance of all sorts of things there.

I think it is almost always terrible for the artist. The artists don't like the experience of coming here. They think their work isn't well represented, but strangely enough everybody enjoys it. Don't ask me why, but everybody enjoys it.

VENICE BIENNALE 1988

Tony Cragg

In 1988 Tony Cragg was Britain's representative at the Biennale and like Anish Kapoor, who exhibited in the 1990 Biennale, showed in Britain at the Lisson Gallery, London.

WF: The reception of your works here seems to be very positive. You have worked on this project for quite a long time now, and in fact we talked about it very briefly at Documenta. Are you now too close to this to say what you think? Are you pleased with the way it looks?

TC: The installation was more or less ready in its rough form about five weeks ago, and now with all the interest, which is very nice, I have quite a lot of distance on it and am satisfied. The way it developed was interesting for me. I came here in the autumn and looked at the space, which is a curious mixture of architecture – it is not a very serious architecture – and I thought about what I needed to make an exhibition here. I made my notes, went home and then realised that that was all rubbish. I actually just continued to make the work I wanted to make and had planned, without getting too involved in installation-type situations, which I think is more or less what I talked about in Documenta.

The thing is not to make installations and not to get involved in too many things. The space, I would like to say, is not very big. It is a very atypical situation for an exhibition because it is not a museum exhibition, but there is the kind of expectation involved, if not more, as there is with a museum. The installation, I must say, was very unnerving to do. More like going up on stage than making an exhibition. But the actual preparation of the work was very calm, and I made much too much work for the whole thing, but it was nice to have a choice at the end.

WF: One thing that strikes me is that most of the work here is very new – 1988 – and yet there is an amazing diversity in its imagery, if you like, and perhaps we can be specific as we are standing next to a piece which is untitled. It is iron, I believe, with a large shell-like form, and emerging just beneath that are what appear to be musical cases, again in metal. What was the source of this piece?

TC: It is actually not iron, it is steel. They are musical instrument cases cast up in steel. The shell is a form from a fossil that I have had since I was twelve years old. The work is a reflection, in a way, on the way in which a natural form like a shell grows. There are geometric growth laws involved, which has a sort of harmony in it and it has a reference for me to musical instruments. I didn't want to put musical instruments in, I preferred to take the case as it is a bit more inferred. Also, the first musical instruments were probably things like cow horns and shells, so there is that little bit of formal content, and that's roughly some of the thought behind it.

I don't have too many theories or ideas about what the work is about. You have to stand in front of it to know what it is, and I have some things that I consider when I am working.

Michael Archer: Do you always have particular things that generate the form of works?

TC: You mean like the fossil I described or something. Not always, I have very different sources, I don't cultivate it. I would suffer greatly without it but I don't cultivate this multiplicity of things. I am so chaotic in my thoughts and everything that I can actually never seem to have a system in my life for anything, so that is the way it is. Sometimes there is a very strong model, or sometimes it is just like starting off with a material without any indication where it might go to.

MA: As well as the variety of forms there is also an incredible variety of media. Is that something you like to keep going all the time?

TC: I don't think it is media – the medium is just the sculpture as far as I am concerned – but there are some materials: wood, bronze, steel, plaster. You are quite right, rather a lot. With regard to the installation of the work, the show isn't thematic, but at the same time there are thematic groups of things. I do like to keep a sense of relationship in the whole.

WF: Shall we move into the next room, where there is a bronze spiral of what appears to be cast children's toys – teddy bears, ducks and so on – and on the opposite side of the room there is a wooden piece. Can we talk about this. Is the source of these objects that surround you at home?

TC: No, not really, but I must admit that my children treated me like a child murderer when they saw what I was going to do. No, this is more to do with genetics: it is a reference to the DNA helix and that sort of collection of animal genetic material that is there in a very subverted, banalised, rather sad way. The work actually turned out better than I thought. These very soft, silly things suddenly revenge themselves and they become a little bit sinister. I am a little bit frightened of them sometimes. They have eyes – all the models have virtually the same little plastic glass eyes, and there is something happening in the work with the eyes. They seem to be dead but they stare back up the whole work. I can't say that was my decision, it came out of the plastic process of making the work.

WF: The piece is titled *Code Noah*; do the titles come after or before?

TC: Always afterwards. I don't think I am very good at making titles. It is a separate thing, and I am happy if a title gives a good way into the work. With the title *Code Noah* I am happy with that reference to a Biblical way in which a man, a human being, through whatever motivations, can be the custodian of all that kind of genetic material.

WF: The piece behind us is a wooden construction called *Loco*, and the elements seem to evoke function, in a sense.

TC: The four elements that form the base and make the surround of the work are actually from industrial wooden patterns for making steam trains. Somewhere between the wars they came from a disused factory in France, and I tried to make an assemblage out of these elements because they interested me. They were originally bright colours and a very hard surface, and my solution after several really awful works was to say, okay, now you have to learn how to make a wooden object, and I made this element which is actually a self-portrait, looking a little bit like Mussolini, and I put it into the work.

WF: Shall we move into this next room now? This is a piece in bronze and steel entitled *Inverted Sugar Crop*. How did this piece come about?

TC: This is a work I made about a year and a half ago. It is partly a memory of my grandfather's farm where in the winter they had sugar-beet to feed to the cows to tide them over to the spring. So there is a memory of that, thrown up in the corner like the last odds and sods – and also Halloween, of course. Then there is the idea that these things are like a sort of hybrid plant, or like battery chickens, which become industrial objects and have this kind of bloated ugliness about them, but then they on take a new dimension, which I like.

MA: They work very differently to the toys, where you have something soft which becomes very hard. These don't seem to take on that kind of feel, being cast in steel.

TC: Yes, it is probably because they cast them so fantastically. The plant parts and the stems seem to be so fantastically filigree it avoids that, I think. The animals become somewhat dead.

WF: Contradictory, in a sense, to be cast in bronze. Shall we move through to the next room. There are pieces here which seem to evoke other pieces you have made in that they evoke the idea of a vessel or a container.

TC: Yes, containers are always good things in the whole of archeology. I mean, I think most civilisations have been gauged or somehow measured by their pots and their glasses, but I don't think that is the reason for making the work. There are washing-up bottles made in steel, which for me have a very formal figurative relationship. I have welded onto the surface of them several objects which were originally in plastic. I had them made

in cast steel and then welded them on to give the objects a kind of outer life; it's as if they are like limpets, as if something is starting to attach itself or is accumulating. It could be on a very microscopic level – antibodies starting to attack foreign bodies in the body, that kind of thing.

WF: We will walk now into the final room, and there is a piece with five cylindrical turrets that reduce as they move towards the top. Again, they look like machine parts or engine parts.

TC: Yes, they are mainly from scrap from the scrapyards and they are disc-shaped objects stacked up on one another so they go up in a tower. They have a sort of architectural reference and are also like something invisible or microscopic, like some strange nerve cells in the back of the eyes or something.

WF: You have mentioned the microscopic dimension a few times and you have mentioned DNA. Is that an area that you think reveals something quite important to you, the idea of scrutinising something?

TC: The theme of the objects and the materials that we produce and how they are relative to nature interests me greatly – this massive world of unvisible, unperceivable information that is around us. We know about things like genes and chemistry and stars and pulsars and electricity, but nobody sees the damn stuff, so that which one can perceive is being left behind by a huge ball of invisible, non-perceptual information. I think it is a problem and there has to be some way of dealing with that – not to make it harmless, but there are millions of images there that are concerns.

MA: Chemistry has formed quite a rich vein for you over the years, and speaking as we were about vessels and the use of everyday things like washing-up bottles and also flasks from experiments. I notice there is a three-necked flask there, *Mother's Milk*, cast in steel, and these sand-blasted things here which one uses in chemistry experiments. These glass objects are made from sand but they have been reduced by the same material.

TC: Yes, for me one of the formal things about it is this glass, this breakable, shattering material. Those holes make it look very morbid, very soft, and everybody assumes it is done with acid but it is not, it is just the sand-blasting working at it. The containers for me are very important because these things are like a synonym for a stomach or an almost Hieronymus Bosch-type container.

VENICE BIENNALE 1990

Anish Kapoor

Anish Kapoor, Britain's representative at the 1990 Venice Biennale, talks about his works whilst walking around the British Pavilion.

WF: I am very fortunate to have some of your time, because I know it is very hectic. You have had a lot of people, television crews and so on, that want to talk to you, but here we are in the British Pavilion in front of *Void Field*, and I wonder if we could just set the agenda for the conversation we are going to have. Something that keeps recurring when I think about the pieces I see here and your work in general is a comment you made about your work which was, 'I don't wish to make sculpture about form, it doesn't really interest me. I wish to make sculpture about belief or about passion or about experience'. I think a much broader approach needs to be adopted in perceiving what you do.

AK: I think that is probably true. Over the last ten years or so there has been a tendency to see the work in terms of my background, and I feel that's a shame. That has really not allowed me to deposit what I feel might be possible. But it has also restricted other people's experience of the work, and I think that is a battle that has been fought and will continue to be fought.

WF: Some people have said that the notion of the spiritual that is used in discussing your work is a welcome addition to the vocabulary of art criticism of recent contemporary work.

AK: For a long time now it has been a taboo subject. It has been something that one has not been able to properly deal with, and yet it is a fundamental of the human condition and we must somehow deal with it. It is a treacherous path, I think, in between meaningless sixties talk and real things. As human beings we have consciousness, and therefore that must be dealt with on some level.

WF: And yet it appears to have been denied.

AK: I think artists have dealt with it. I am not so sure that those that write about art have been able to deal with it. It requires, I think, on some levels a great deal of intelligence and humility or whatever that is.

WF: Having read a lot about your works in preparing for this conversation, I have an instinctive feeling that something quite fundamental is being missed very often, and perhaps a Western

FROM ABOVE: Tony Cragg, Loco, *wood, 160x240x220 cm, British Pavilion, Venice Biennale, 1988; Julia Scher with her installation in the Aperto, Venice Biennale, 1993; Anish Kapoor,* Void Field, *installation in the British Pavilion, Venice Biennale, 1990*

literary tradition isn't a very adequate way of discussing what you do. At the end of the day the work is here, it has its presence, and the words have their presence, but the two didn't seem to me to correspond.

AK: I think we are talking about experience. I don't think it is enough to talk about the spiritual or such things and leave them as ideas. One has to somehow have this whole thing experiential and not just intellectual. I would follow, to a certain extent anyway, Beuys's kind of notion about the spiritual: that intuitive intelligence is the highest kind of intelligence, and in the end intuitive sense is all that one has to go on – as an artist of my kind, anyway.

WF: Standing here watching people coming through this gallery, looking, responding, I don't get the sense of an installation in the traditional way, I get a sense of a site.

AK: Yes. The idea of place has always been very important to the work. A place that is in a sense original. I mean by the word original to do with first, and I think that is to do with centring oneself – allowing a thing to occur specifically rather than in general. A lot of the works are about passage, about a kind of a passing through, and that necessitates a place.

WF: I am reminded about the early Aboriginal response to the first British settlers, where the notion of ownership didn't have a corresponding concept, it was much more to do with place and to do with site and relevance to a particular area.

AK: I think Barnett Newman also had a very sophisticated and concise way of understanding that art needed to occur in a place. He often used the Hebrew word *Makom* to refer to the present and the beyond in his painting. That is an area I am engaged in.

WF: In relation to the starting point, is there a linear thread that you actually trace in these series of works? With the powder pieces there is much more of a correspondence and relationship within the sequence, but something like *Void Field* seems quite independent of that sequential development.

AK: It is. Works feed off each other. They do grow out of each other. Here I think the work forms itself both in the room and in the emptiness of the room or in the conjunction between emptiness and fullness. That is not to do with specific physical relationships between the objects but really much more to do with some specific relationship between the body and the objects, which I think is slightly different. That I think is quite a change from the early work.

WF: The actual evidence of the artist is missing. There is no sense of the artist's hand here.

AK: We have just come through a whole period of expressionism, of artists depositing themselves in their works. I just don't believe in it. I don't believe that artists have anything to say. I think there must be a way and there is a way of arriving at a conjunction of things that have their own reality quite independent of the artist. Leaving hand out has always been a feature of my work in that covering things with pigment was a way of removing hand. Similarly here, as you say, there is very little hand. Of course that is also something that's part of a post-minimalist tradition, I guess.

WF: Can we move into the next room and just have a look at *Madonna*, the large blue piece. You have said on a number of occasions that the work is completed by the person looking at it. How do you elaborate on that statement, because it implies a pre-knowledge. What is the actual element being added to the work?

AK: I think again it has to do with not too much hand. It has to do with me not saying too much, not being over present. I think one thing that has happened very clearly is that from being about the outside of forms with inside implied in the early work, it has turned into a condition which is about interiority, and in some way I seem to have discovered that emptying out is filling up, and filling up only with what you, the viewer, can bring.

WF: We are standing in front of *Madonna*, which is large. The diameter of it is about nine or ten feet, and if one looks at it and stands where we are, about four feet away, it is very displacing; one loses one's orientation, which I presume is really a product of this deep blue that you have used. One is drawn into it and somehow lost. It is quite disturbing in a very interesting way.

AK: Well, I always had this ambition to make something totally frightening. This isn't, but it will happen to me when I can do it.

WF: Colour clearly is very important in your work.

AK: Yes, it is. In a way this whole show is about a conjunction of opposites. That has clearly always been a feature of what I do. Here the conjunction is between that which is physical and present and that which is not. It is not enough, I think, to speak about void as an entity. In some ways it needs to be physically present, it needs to be experienced, it needs to be there, as big a reality as it can be.

WF: Obviously we can't escape the fact that you have made this exhibition here in Venice, which has a very particular sort of light, a very particular sort of history, culture and so on. How did you respond to that aspect of making this exhibition?

AK: There are works in this show which do tangentially refer to some of that tradition. This work refers to the Madonna of Torcello. Her blue robe identifies her as some cosmic mother, some originator. I see void as a potential space, in some ways, rather than a non-space. It is certainly existential to some degree, but a condition of beginning rather than of end.

WF: Could we move to the next room. The other issue that you have often talked about is that of an interest in alchemy and chemistry in relation to art. You mention Beuys and you also mention Duchamp. In a sense it is the magical qualities that materials and forms and spaces can have that interest you and motivate you more than the form or physicality.

AK: Yes, it is, and here *It is Man* is simply a stone with this room cut out of it.

WF: This carved hole in the stone – when people are drawn into it, somehow one is drawn into oneself, because of this endless blackness that one is facing.

AK: I think these conditions are very hard if not impossible to put in words. I must let that be the experience of the work.

WF: Now this is a piece called *A Wing at the Heart of Things* and it is two large slabs of slate covered in a blue pigment. I would like to ask you about the relationship between the pieces here with *Void Field* and the others. Is there a conscious dialogue that you are interested in?

AK: Very much so. This work *Wing at the Heart of Things* is in a sense the opposite of *Void Field*. If *Void Field* is about mass and no mass – that is to say, sky or night contained in earth – then the act of painting these two stones blue somehow makes them weightless, somehow reverses that process. It comes to be earth contained in sky. I find that kind of dialogue of opposition very important. I think perhaps there is a similar play between *Void Field* and *Madonna* and between *Void Field* and *It is Man*. One of the tasks of this show has been to try and get the whole show to work as one work, so that the sequence of events that occurs through it concur and oppose one another.

WF: Another characteristic in the early pieces, the powder pieces, is to do with radiation, and in these pieces with holes

within them, to do with absorption.

There is a piece here called *The Healing of St Thomas*, and unlike any of the other works in the pavilion, this one is part of the fabric of the room. You have actually cut a slit in one of the walls, which has a red powder within it. Perhaps you could talk a little bit about the work.

AK: Of course it refers to a piece of classical Catholic iconography, the incredulity of St Thomas. I didn't feel I wanted to make a work about disbelief, but it seems that St Thomas is healed of his doubt by putting his hand into Christ's wound. It seemed sufficient to think of the room, the house, the building, as an image of the self, and the wound occurring there in some real way. The reason why I was drawn to that in the first place was that it seems to be an image about the femininity of Christ – that in some way on a very deep level this process of healing has to do with some kind of transformation into the feminine. In the context of this show I find it difficult to articulate that there is a very powerful relationship between wound and void. That is to say perhaps they both, through some kind of clearly sexual metaphor, refer to points of origin, and that seems in this context to be important.

WF: Moving to the next room – if we can actually get in there, because of the people – there is a piece called *Black Fire,* and it has large boulders of either coal or anthracite and then a vertical, concave canoe-like structure.

AK: It is evidently sexual and it is also perhaps the odd thing out in this show, but I felt it was important to have it here because it perhaps makes some kind of bridge between a wound and a void, as we were just saying. Perhaps it articulates in some different way the idea of site or place and the idea of physical and non-physical presence, or material and immaterial.

WF: You have chosen a material that is symbolic of heating and of providing support.

AK: That is clearly part of the imagery too.

WF: Finally, the actual context of Venice – it is a strange experience in many senses. How do you feel that the context has worked for you and the works here?

AK: It has been marvellous for me. This show seems to have had a good response, and that is good, but what I think is strange that one of the issues here is that I am Indian and yet I'm representing Britain, and that is something that I have had to deal with. But perhaps the whole notion of the five or six grand pavilions with the rest on the periphery is something that is out of date, it seems to be a kind of model from the thirties or whatever. We need to change that. I feel that somehow we live in a much more global culture – perhaps the beginnings of a real post-colonial culture – and it is necessary somewhere to have a wider possibility for artists other than in the Western context.

WF: The Venice Biennale tends to close down international art categories, and you are an example almost of the contradiction of the Venice Biennale in that you do bring together a whole range of cultural influences and interests and consciousness that becomes something else. You have talked about the notion of global culture that isn't local or parochial.

AK: Perhaps more than local and parochial, it isn't hierarchical. I think that is the real issue in the end and that is something to be resisted with a great deal of education above all else. We have got a long way to go there yet, I think.

WF: Do you get irritated by this constant identifying of this strand in your work?

AK: That makes me furious. I have a great resistance to trying to look at the work for its Indianness or through my Indianness. People have walked in here and said there is a peculiar smell to this show, did you use Indian spices. The extent to which this kind of fantasy goes is incredible, and I think it is to be resisted with great anger and energy.

VENICE BIENNALE 1993

An important agenda for the 1993 Venice Biennale was that of nationality and national representation. The traditional pattern of each pavilion being specifically identified by its national representation was challenged and became part of the character of the event. This shift acknowledged the mobility of artists and their choice of working location. Although based in New York, Joseph Kosuth showed in the Hungarian Pavilion, and similarly Hans Haacke and Korean Nam June Paik presented their work in the German Pavilion.

Many of the issues rising out of this agenda are discussed in this double issue of Audio Arts, but first Richard Hamilton talks about his works in the British Pavilion.

Richard Hamilton

WF: Richard, I have looked at the installation here, and it would be interesting to talk about the underlying rationale of

the works that you have selected.

RH: Well, the pavilion is very symmetrical with a large central room which you enter through a grand porch at the end of the Avenue of the Biennale lined with trees. It is the most gracious position in the whole thing, and you overlook the world. France is on the right, Germany on the left, adopting rather lower positions in attendance on this beautiful central position. Of course, this is all harking back to a hundred years ago, and so it is rather silly to think of it in these terms nowadays, but by just sheer chance this beautiful little space was offered to Britain at a time of its imperial power and it is a wonderful space. The symmetry of the building consists of this big room and two smaller but quite generous rooms at each side. Then they lead into two other rooms, and then there's a linking room along the back, which is the only room that isn't top lit and it is the most difficult to hang in. It is a very pleasant space but it is not really giving you the glories of these other rooms, which are very high and sunlight pours in. The light is so filtered and so diffuse that it lights everything evenly, and everything I have taken out of its packing case has been transformed into this very easily seen image, instead of the problems that I have always had in hanging my pictures, in that the surfaces are very uneven because I work on them for a long time.

WF: You have chosen works from quite a range of years in terms of your career.

RH: It seemed to me that there was the possibility of using each of the rooms to enclose a different idea. The central room is a political space with rather big, dramatic statements about Northern Ireland and Kuwait; then the room to the left is perhaps more sentimental with a mother and child. One of the things I have enjoyed about this particular installation in this pavilion is that the doors between the rooms are very large and generous, so when you are standing in the central space you have a beautiful wall to hang on, which you can see through the doors on either side. So I have enjoyed the felicities of hanging a new painting of a British soldier in Northern Ireland and a painting called *Mother and Child* so that the gun of the soldier is pointed at this child beaming out under the care of its mother. The war games on the other side – which is a picture of a television screen with the 'News Night' sandpit being used by Peter Snow – relates very nicely to the other room, which is about consumer goods, with the lux picture, the hi-fi and so on, and it all seems to flow very evenly from one to the other, but each room has a well defined theme.

WF: One of the high points for me, and quite a surprise, is

coming into the room where you have hung the *Lobby* paintings. Reflected in one of the glasses is an addition you have made to the wall of the pavilion, where you have actually painted up some flowers on a feature.

RH: Yes, the curious thing about this pavilion is that the whole structure was no doubt quite open before it existed as a gallery, so walls have been built between pillars. When I first encountered these rooms I looked at the strange excrescences and lumps that appeared all over the place, which have obviously been knocked about a bit and covered with many generations of paint, and they are not very attractive. I said, isn't it possible to get a cold chisel and knock them off and flatten off the wall, but they said, oh no no, I don't think we had better go that far. I thought that the lumps were so ugly, and it would be perhaps interesting to see what was underneath. It became clear that there was marble underneath this thick layer of paint, and I happened to have bought some paint stripper by error. I put paint stripper on the base of the column which intrudes into the room, and the marble began to reveal itself after going through layers of white paint. As I was working further I was told, ah, this is Howard Hodgkin's green, and so each layer of paint was reminding somebody of some previous Biennale. Finally I had to repair the plaster work around it and I began to make this rather pleasant little shape which began to look like a vase, but it didn't look quite deliberate enough, somehow. So I thought I would use it as a plant pot and I painted it – fairly crudely, I must say, using the available colours of green and cream from the *Treatment Room* – and just put in a few plants to make it a little more evident that this was intended rather than a hangover from something else.

WF: Did you make work specifically for this installation?

RH: Yes, when I was approached by Henry Meyric Hughes and Nick Serota during an invitation to lunch at the Tate, the subject was broached that I might be asked to do the Biennale the following year, and it was almost made a condition that I should produce a major new work. Since I am in the habit of producing a major new work about once every three years, it was a bit of a shock to have to take on the commitment to do something in six months. I was involved in the process of creating a new studio in Northend, which has a lot of sophisticated new equipment, so I thought that would probably help me out. But of course the first three months I simply spent learning the programmes in this new technology that I had acquired, so in some ways it set me back, but once I got things going it moved fairly smoothly, and I was able to realise an idea that I already had. I didn't have to dream up a new subject, because the subject was already in

my head before the request came.

WF: Which piece was it?

RH: It is a painting – if you can call it that – of a British soldier in Northern Ireland. I had made a painting called *The Citizen*, which is the Republican character, and as an opposite side of the coin I made a picture of an Orangeman, which I called *The Subject*, because of course Ulster people insist on allegiance to the Crown. It seemed that that was the end of it, but then I began to feel that there was a missing ingredient, that there is the British component which should be represented in some way. I had been to Northern Ireland a few times and the first time I visited there I was astonished to find these characters with camouflage, carrying these Armalite rifles and very often with paint on their faces. But in an urban environment this camouflage, which was designed for woodland, isn't really very effective, and they stick out like a sore thumb. Red-brick camouflage might be much more appropriate. But the thing I found most extraordinary about it was that they walked a hundred yards apart and back to back. I had in my mind that the figure would be walking backwards, and as I developed this theme I began to realise that it was rather tricky to represent this figure in such a way that it was clear that he wasn't stepping forwards and that he wasn't standing still but that he had this backward movement. It seemed to me that this was symbolic of the British position: you walk backwards.

WF: I think there has always been a political element implicit in your work in various ways, but in your recent works it has been much more overt. Is this something now that you feel you have to deal with, some very specific, identifiable political imagery?

RH: Well, I have never felt myself to be interested in political subjects, but as time has gone on, I have felt a slight depression about the social position and the political situation and I suppose it is expressed. But I don't think of it as being political, I think of it as being media orientated, and this is inevitably the outcome of looking at the media. It is not a political position, it's simply trying to observe the situation as it is without taking sides. I think it is difficult to avoid the implication that I am perhaps more sympathetic to the South than the North. I think the resolution of the Northern Ireland problem is inevitable and that is going to be a unified Ireland, and it is absurd that it has gone on so long as it has, and it is a historical anomaly that the position should be as it is. On the other hand, I don't feel myself to be mocking the Orangeman. I think that that is a dignity he has chosen to adopt and I am perfectly happy to represent him in that way. I should

think that there is even the possibility that the person represented in that painting would feel that this is the way he would like to be seen – as a symbol of the North's position.

WF: The dialogue that is created by the juxtaposition of those images sets up some interesting possibilities in relation to the way in which the issues are usually polarised, and the imagery doesn't occur together any more than the politicians occur together. There is always a sort of fracture, whereas your dealing with them somehow allows a sort of dialogue or a debate to be set up.

RH: Well, I would like that to be the case because I feel that art in a way is going to be the ultimate solution and that is going to be the kind of expression which moved me in the television shots of the Maze Prison. That it is almost an aesthetic experience that they are going through, the way they are putting their shit on the walls is almost like an act of writing or describing their situation pictorially, and there is a very curious difference between each of the cells. You get a personal style emerging: in one cell you get a Rothkoesque treatment and in another cell it would be more Pollock like, and it seemed to me that if you worked for three years expressing this protest on the walls then it is visual and it is not just about smell. I saw also pictures of Mairead Farrell, the girl who was killed in Gibraltar. She was on hunger strike in the women's prison in Armagh, and her markings are so feminine in comparison. They are little tiny spidery markings and enormously complex. So in a way I felt that this absurdity of people using their excrement in this way was a kind of artistic expression as well as just being a political statement in protest. I find the whole thing very moving at that level of being a kind of aesthetic. In the same way Orangemen have a kind of aesthetic in the way that they present themselves with symbols and colour. Not only is the imagery of Northern Ireland about symbology but also the imagery is very powerful.

WF: Just finally, Richard, here we are sitting on the balcony at the British Pavilion. The crowds are building up, and you have actually finished your installation. What do you make of it now? Are you pleased with it?

RH: It is like Gooch batting for England and making a century. I have never been to a Biennale either as a participant or a visitor and I have always scorned it as being a sort of art circus, but I have found this particular year is a very good one for me because it is the year when the oldies can get into the act. I always thought you have to be under thirty to participate, but Louise Bourgeois is even older than me and Nam June Paik and Haacke are not so far off my generation. I don't feel that they're the kids …

FROM ABOVE (left to right): Richard Hamilton with his work The state *in the British Pavilion, Venice Biennale, 1993; Richard Hamilton being interviewed by William Furlong on the veranda of the British Pavilion, Venice Biennale, 1993; Miroslaw Balka, '37.1', installation in the Polish Pavilion, Venice Biennale, 1993; Miroslaw Balka, at the Venice Biennale, 1993, with (left) Anda Rottenberg*

Michael Craig-Martin

Still on the veranda of the British Pavilion, Michael Craig-Martin discusses Hamilton's installation and comments on the structure of the Biennale.

WF: Michael, have you been able to form an overview of the 1993 Biennale?

MC-M: I think it is a strange Biennale in a lot of ways. In a way Biennales are always going to be the same in that there is always an awful lot of rubbish and a few interesting things, and you really have to search to find those things. But some of the pavilions are interesting, and there seems to me to be some strange sense of linkage between them in a way that is unusual. I think in the British Pavilion Richard Hamilton's work has never looked more wonderful, and I think it is a very successful use of the pavilion. The exhibition seems to be very coherent, and it is very striking, looking at the paintings of *The Citizen* and *The Subject* and now the soldier. There is that aspect of Richard's work which has political content. Then you go to the German Pavilion and there is the most extraordinary piece by Hans Haacke commemorating the meeting of Hitler and Mussolini, and that it is the German Pavilion in Venice where they met in 1934. Haacke has torn up the whole of the floor so that it is rubble, and people walk across the rubble of the room, and there is something incredibly moving about the experience. It is probably the most striking piece in the whole show.

WF: One thing which seems to have happened this year is that the normal structure of the Biennale has been fractured in the sense that national pavilions have accommodated artists from other countries, so you don't feel you are walking into mini-embassies, and there is a sense of internationalism about this one.

MC-M: That is absolutely true, and besides Hans Haacke in the German Pavilion, who one always thinks of as American, there is also Nam June Paik there, and there seems to be much more freedom about people acknowledging who are from certain extractions. So there is, I think, a change in idea about multi-culturalism, which is hardly surprising, but it is interesting the way that it has manifested itself here by your being surprised by who you see in different pavilions.

WF: I must say, over the last two or three Biennales, I had thought that the structure of the presentations was somehow out of sync with what was going on in the real world in terms of artists moving to other countries and working and practising, and so this seems to be a little more sympathetic.

MC-M: In a way, the whole structure of the Biennale is absolutely ludicrous, and we are standing in this last vestige of the empire. You can't help thinking at the British Pavilion in Venice that when Hong Kong goes this is the last outpost of the Empire sitting at the top of the only hill in Venice, right at its pinnacle – an Edwardian classical building. It says so much about the history of the Biennale itself. I think there is a real sense in which the Venice Biennale is an exhibition of architecture; it is an exhibition of the exhibition spaces and the artists just get slotted in. Sometimes it hardly seems it matters what the filler is, because real statements are made by the pavilions. As it becomes more and more untenable it looks more and more absurd, in a way, being able to identify the country so much by the pavilions. I think there is something else I find very strange about the Biennale. There is a way in which it should be an occasion for a country that was not rich, was not powerful, in other ways, to make a strong cultural impression. In reality what happens is that the richest and the most powerful countries dominate virtually every single time. Obviously that is a very complex subject why that should be, but it is apparent again this time.

Rudi Fuchs

Rudi Fuchs brings a critical perspective to the Biennale and challenges its curatorial character, as does Jan Hoet, Director of Documenta 9, who is also critical of Hans Haacke's installation, 'Germania'. Recorded on the steps of the German Pavilion, the sounds of people walking across the torn-up flagstones in Haacke's work can be heard in the background.

WF: Rudi Fuchs, what do you think of the 1993 Venice Biennale so far?

RF: What we have noticed now more than ever is that there is a kind of slow breakdown of what used to be called international culture. Years ago the national pavilions were like islands, and these islands were very noble, and there would also be small countries, but every country has become a small country now, and everybody has asserted his national identity, his national traditions, so at this point Iceland has become equal to Britain, and France equal to Bulgaria. For some reason everything is weird. Before that, years ago, we used to look for any common denominators between the English, the French, the German, the Dutch, etcetera to see if there was some common factor. Now more and more I feel that we try and look for the differences. Now this is either good or bad, I don't know yet. I have a feeling it is bad, because I think what we call modern art and modern culture is based on the international or a Utopia that has something universal, and that the universal is something we have to

reach by transcending our national things. Maintaining a nation-alist stand of a big country has almost no meaning any more. This is a very strange exhibition for that reason and so it is very interesting.

WF: So is the model of the Biennale something that you have confidence in?

RF: Oh yes, I think the Biennale should exist for ever. The next time will be the centenary, and I think it is very important that an exhibition like this, which kind of celebrates modern art, continues and continues, and that the Biennale will always be there to give confidence in art. This is one place where every two years art people can enjoy themselves. They can enjoy the sunshine – the English complain because it is too humid and not cold enough and so on and so on, and the artists complain about the food because it is too rich in olive oil, and that is all part of it, and we need this Biennale.

Jan Hoet joins the conversation –

JH: I think the Venice Biennale has been installed in order to get out of the dilemma of nationalism. Now we are busy re-installing it again. That is a great problem, that is the dilemma of today. There was nationalism without any ideology in the nine-teenth century, and ideology has found its surrogate in the democracy of the twentieth century, and democracy has not been used in the right way, I think, as an abstract language. It is only used as a tool to make everything which is banal more celebrated.

WF: It is interesting to bump into you here, and I can't help thinking about comparisons, since you were the Director of Documenta 9. Obviously there are very different constraints on each of the major exhibitions, but is there a way in which you can talk about the identities and distinctions and how they reflect contemporary art and contemporary culture. On the one hand, the Documenta, which is an individual curatorial activity, and on the other, Venice Biennale, which is a composite of curatorial interests.

JH: Documenta was based on the foundations of the indi-vidual creation of the artists. It was a dialogue between the curator and the artist, and that was the risk I took. I didn't make a Documenta which was an imperative looking through the eyes of one person, but of many people. It was the synthesis of the relationship between the maker of the exhibition and the maker of the art. It was very much a driven exhibition trying to confront the German love for perfection with the physical confrontation regarding the dilemma of it. Hans Haacke never would never

have done this work if he hadn't seen Documenta because it is very physical. The problem is that it is too obvious. It is based on nostalgia in history. He is confronting us with the dilemma in a direct way and not trying to propose how to get out of it. He crashed everything in history, and I think we have to get out. It is too long, you know. My God, when will the Second World War be finished, that is my question. In Documenta it was more warning the people of the danger that we cannot get out of the dilemma, whereas here we are confronted with the dilemma.

WF: Apart from Hans Haacke and the sounds we can hear in the background, can you be specific about any other part of the Venice Biennale?

JH: I like very much Kabakov, for example. I like Kounellis. I like Tapies – such a young artist. I like very much Kabakov because it is ambiguous. It is about structure, it is about chaos and it is about order and it is about establishment and it is about democracy, it is about ideology, all these issues. He brought them out together in one beautiful poetry, and that is unbeliev-able.

WF: Let me ask you a final question: had you been Director of this Venice Biennale, would it have been different?

JH: It is very difficult. The Venice Biennale has to deal with all the political issues because of the pavilions. They are all installed independently of your dialogue, and that is a great problem. The Biennale is there to celebrate the artists of the country or to celebrate the country, and that is a little bit problematic. Nevertheless, it is always interesting to see the Biennale, because you see so many things and you see so many artists. How they deal with the kind of command, because the command is a kind of frame and some artists can find this free place, give a sign for the future.

Hans Haacke

Now Hans Haacke speaks about his impressive work 'Germania' and responds to his critics.

WF: Standing at the German Pavilion, we can hear the sounds of people walking across the fractured paving stones inside, but could you describe the underlying concerns of this work?

HH: As I often do, I work with the context. For a number of years there has been the phrase 'site specificity' in the art world, and the context in this case is the Biennale in general and it is the German Pavilion, and what was exhibited in the German Pavil-

FROM ABOVE: Michael Craig-Martin on the veranda of the British Pavilion, Venice Biennale, 1993; Jan Hoet in St Mark's Square, Venice, 1993; Hans Haacke, 'Germania', installation in the German Pavilion, Venice Biennale, 1993

ion, and the people who came and also Hitler, the architecture of the pavilion, which was restyled in 1938, and then very much also the present. The date on the emblem above the door is 1990 – the date of the re-unification of Germany and also the currency adjustment – and inside I think I make reference to the past as well as to the present.

WF: In fact you have an image as you come in the door of Hitler actually visiting this pavilion to see an exhibition. Was that in a way a starting point for this work, because it is site specific and historically specific too.

HH: It was not really a starting point, but it underlines that this pavilion has a political history and that art exhibitions – including an exhibition like the Biennale – also play a political function – something we often overlook or try to forget. It locates the art world in the general social environment. Hitler, as you know, also had his ideas about art, but it would be wrong to focus exclusively on this image, it is one of the ingredients with which I am working.

WF: How do you want the work to be read in that sort of metaphorical sense, because clearly it is not only to do with Hitler and to do with history. As you were saying, it is to do with politics, which are just as prevalent today but in different ways, perhaps implicit rather than explicit.

HH: Well, it is of course a metaphoric work. I do not provide information that was not available before. Maybe people were not aware that Hitler visited the Biennale, that he was guided by an Italian general secretary in a fascist uniform.

WF: What about the floor, because that has been entirely ripped up and it is uneven, just like a building site. What were you attempting to say through doing that?

HH: As I said, in 1938 the pavilion was restyled by an architect from Munich following the example of the new house, the Deutsche Kunst, that Hitler had unveiled and opened a year earlier in Munich, so this is a monument of sorts of Nazi architecture here. And it was in 1938 that the parquet floor that was in the pavilion until then was replaced by marble slabs. It is these marble slabs that I ripped out and are strewn all over as if a storm went through the building. In terms of figures of speech, you can extrapolate metaphorically what it means that the ground is broken up.

WF: The work has made a very strong impression. A lot of people refer to it. However, there are those who are also very

angry about it, and I am thinking particularly about Jan Hoet, who I spoke to yesterday. Are you concerned about that sort of reaction?

HH: No, I am not concerned, but I am sometimes surprised, because of course I am trying to figure out what motivates Jan Hoet and a few others to burst out in anger, what is behind that. Since I haven't spoken to him, I haven't heard what he had to say directly, and as we have had no chance to discuss this I cannot respond to a reasoning that I am unfamiliar with.

WF: I think it is to do with the use of history and this reference to Hitler and the past which he believes should be disengaged with.

HH: Well, maybe he is fortunate enough to have been born in a country in which Hitler did not play the role that he did and therefore it is not a problem for him.

WF: Has the work met your expectations in its realisation? Presumably this was conceived in the abstract, so to speak, and now it is realised. Do you feel it is the powerful work you intended?

HH: Well, since most of the works that I make are site specific, I cannot test them before they go public, and so it is always a gamble. My impression at the moment, judging by the reactions of the majority of people, is that the gamble paid off. I have met a lot of people, particularly people of my generation, who were rather moved, much more moved than I ever expected, and particularly those people who either personally or their families went through hell, seem to be extremely moved to the point that I have seen some of them close to tears.

WF: It is certainly extremely physically challenging as well as conceptually challenging, the idea of walking through the space and not being secure on the ground because of the way in which the slabs are uneven and smashed up. It has a sense in which you have to orientate physically towards the work as well as mentally.

HH: I am glad that I can manage with practically no words. That of course is something that is a particular challenge and a particular problem in an international setting like the Biennale where I cannot presume everybody speaks English or German. It would have been extremely cumbersome had I had to resort to words in order to clarify things. I have done works in the past that were extremely wordy, and it was quite clear to me that this was absolutely out of the question in this setting.

WF: Just finally, did you conceive of this work before you visited the pavilion or did it arise, rather, out of a visit and subsequent research?

HH: I did not think of what I would do here until I saw the pavilion both on the outside and the inside twice, both in the winter and in the summer. But I was aware of the fact that the lighting conditions and the general atmosphere here would be drastically different in the summer, and I therefore came back and I sat in the pavilion for a while and it was probably the sense that I got from the physicality of the site that eventually led me to think about the building as such being the material of the work. I was also fortunate, I should say, to get hold of a dissertation that had not been published on the history of the German Pavilion and I familiarised myself with the history of the Biennale, and all these things gave me the background that eventually led to something that I hope is charged without using very many words.

Miroslaw Balka

The Polish artist Miroslaw Balka speaks about his works and his installation in the Polish Pavilion. The political context in Poland and Balka's selection are expanded by Anda Rottenberg, the curator of the Polish Pavilion, and Anna Kamachora, a critic from Bratislava.

WF: Miroslaw, could you first of all describe the works you have installed in this pavilion?

MB: It is not easy to explain in words, because it is a very big installation. It consists of three parts so it is a kind of triptych; the first part is the corridor, which is eight metres long and 160 centimetres wide; the walls are three metres high and they are covered with a thin coat of grey soap to a level of 190 centimetres, which is my height. The soap is the cheapest soap you can get. This belt of soap on two sides leads you into the space, which is divided into two parts, left and right. My intention was to come first into the left part, which is more active. The works are made from steel that has been touched by the weather a little bit so there are signs of rust; the other materials I use are an artificial carpet which is turned upside down, some small pieces of used soap, steel rope and two trash cans. So this is a very active part of this exhibition. Then when you see the right part it is more peaceful; it is very horizontal and consists of the terrazzo plate and heat and ash.

WF: You have described the works physically, but can you now elaborate on the idea of scale in the installation?

MB: The main size in this exhibition is the size of the floor, of the kitchen in my studio which I use as a model, and it is repeated in three moments, the first time represents a flood, the second is the form for something, and the third is just a body.

AK: I wrote in the catalogue that in a way your work is related to the average temperature of the human body. The title of your installation is '37.1'; how is this related to your work?

MB: The normal temperature is thirty-seven, so this extra point has the rather symbolic meaning of being like the first step into a fever or like the last step out of a fever. This was the meaning of the title. I think that here the temperature is much higher because of the temperature outside.

AK: Anda, could you tell me something about why you have chosen Miroslaw Balka for the Polish Pavilion. Is it because his work is representative of the current situation in Poland?

AR: In real art we can't speak about current situations. Situation describes the average, and I would rather stress the quality of art as the main consideration in choosing Miroslaw, with whom I have worked for over eight years. The intention is not to represent the country; the intention is to let the artist make a real piece of art to be seen by the whole world, and my conviction is very simple: Miroslaw Balka is simply a very good artist and that is why he is here.

WF: The issue was raised about the relationship between the political characteristics of Poland and your selection, and you seem to be saying that you weren't particularly concerned; but can you talk a little bit about Miroslaw's work in relation to the context, because there must be some links.

AR: Miroslaw's early works were of course in opposition to both the underground church movement and to the official movement. He raised up the very personal point of view in a way which in my view was more than just an artistic statement. It was an attitude towards politics. Politics cannot interfere in art. That is why I would say there is a very specific relationship between politics and the generation of artists who started in the eighties. There were a lot of very ironic manifestations in which Miroslaw participated, like the mirror in the circus, reflecting some official problems or habits in the field of art. What he is now doing also refers to those levels, but the language has changed. Of course his personal experience is deeper because it is longer. It is probably more serious than it was at the beginning, but the attitude doesn't change much.

Yoko Ono

The following interview with Yoko Ono was recorded via a telephone link with New York soon after she returned from installing her work 'Two Rooms, 1993, Particolare' in Venice.

WF: Yoko, could you start by describing your work in the Biennale?

YO: It is an environment piece, or shall we say an instalment. It was one room, rather cathedral like – high ceiling, a skylight and so forth – and I set it up in one room as two rooms. On a conceptual level, the two rooms represented East and West, Eastern culture and Western culture, which are two cultures that are within me. So there is a statue of Christ on the wall, and the whole room is painted as sky, even the floor. In the sky there is a Christ on the wall and also there is a Bible in front of it and three church pews. There is a holy water bowl in which there are pieces of sky that you can take when you come into this church-like atmosphere. A little closet-like space, it is kind of separated, and inside there is a body lying down, with a blanket over it covering the face and body with just the feet sticking out. On the wall there is a sign, a kind of graffiti, that says 'spiritual fanaticism breeds physical terrorism, pray for humanity'.

WF: What are the underlying themes of the work, were they themes that have interested you and occupied you for some time, or did you respond to one of the themes of the Biennale itself?

YO: Initially when they told me that I was going to be represented in the Asian section, I thought that was quite interesting, and suddenly my Asian roots came out. From where I see it, as an Asian, there is such an exchange of culture and the Western and the Eastern cultures are always flowing together in us. I think that is not a reality of a regular Western person because a Western person more or less tends to live inside a Western culture and the Eastern culture is kind of outside somewhere, out there in the Third World. But coming from the so-called Third World, the Third World is always aware of the Western culture which in one way or the other permeates our culture, and so there is always the memory of two cultures in us. I wanted to show the fusion of those two cultures and so there are six white chairs covered with a mantra. The chairs were very unusual. I went to a shop and found six chairs which were in very bad condition, all falling apart. I asked them how much they were and they gave me a ridiculous price, and I said, come on, this is falling apart, and they said, well, these are very special chairs. That sounded like the usual thing that you get in cheap shops, and then the lady there just sort of uncovered a seat which was already falling apart, so she didn't have to tear it. Inside the seat

there was a cloth and on that cloth there was a message that was scribbled like graffiti which said 'Down with Hitler, Nazism: they are responsible for death' and that kind of thing and a drawing of skull and bones and things like that. I was just totally amazed. It was something that the upholsterer had slipped in, otherwise it could not have gotten in there, and these chairs were from the days of the German Occupation in Paris. It was very easy to assume that those messages were written by the upholsterer and slipped in there. If at the time it had been discovered that he did that I would hate to think what would have happened to him, so it was a very courageous thing to do. It was very strange that I was looking to make a 'wish piece' and found the chairs which already had their own prayer. It was a very strange experience, and I felt that at the time when there is already again a rise of Nazism or new Nazism it was very important to bring this message out. So on one wall there is Christ and on the other side there is a message. I framed the two messages which were in the chairs, and they are on the wall opposite the Christ. Somehow it represents the pain of being a persecuted race, pain of being the other.

WF: The curators' agenda for this Biennale seems to reflect a lot of the issues that you have discussed. That is, of one culture addressing another, the movement of people across national frontiers and through various ideologies and beliefs. So in a way, this Biennale has been a very suitable context for you to explore things that preoccupy you.

YO: Well, when I was asked to present my piece in the Biennale I was not aware how appropriate it was. 'The Road to Asia' is the title that really gave me the inspiration. It gave me a feeling of going back to my roots.

WF: Can I just return to one element of the installation, the figure partially covered by the blanket, which gives a sense of a slain individual. Is that meant to be read specifically or is it a much more general reference?

YO: Well, I think an act of genocide happens everywhere and we are all victims of it. I think the history of the human race is the history of violence, and instead of blaming each other we should realise that we are all victims of it. So it was not to blame any particular sector of the world but to just present the reality that is going on, and it is going on in the same room where we pray to Jesus Christ, and the Bible, as you know, is bleeding. I think it is a very real work in a sense. Some people might think of it as a surreal work, but I think it is very real in our spiritual world.

WF: Issues to do with spirituality, belief, faith and ideology presumably are issues that motivate much of your work now.

YO: But it is very dangerous to say spiritual, because in a way I am saying spiritual fanaticism breeds physical terrorism. It was wrong of me to say spiritual world as I mean to say in our spiritual reality that we are existing together in this way. What we do about that is something else, but I just wanted to first show the reality.

WF: Do you have any general comments on the Biennale itself as a totality or a part of it?

YO: Well, I was surprised that it was a very different kind of Biennale from the past. Many women are represented, and very interesting avant-garde works were represented. I felt that the Venice Biennale was usually quite boring and usually represented people whose feet were in the coffin or something, people who are quite established, and this time it took some daring works.

WF: Yes, the whole underlying concept for this Biennale is completely radical. I think it has completely changed from the past in relation, for instance, to the concept of nationalism. The national pavilions often invited artists who worked in other countries, so the whole concept of nationality seems to have been dissolved and eroded, which in a way is a very positive movement.

YO: It is also the times, too. I think it is influenced by the times. It started the year the Berlin Wall fell, and there is no more cold war between the Soviet Union and America, and in fact the Soviet Union disappeared. People are much more aware of the political situation and aware of the fact that we are all in it together.

Aperto: Fragments

The previous interviews were recorded at the Biennale's main site, the Giardini. The following extracts were recorded by Liam Gillick at the Corderia, the location of the Aperto section.

The Voice of Jean-Luc Godard

Philippe Parreno: Can I speak to you in French?

LG: No, your English is really good anyway.

PP: Yes, but I want to speak in English in the voice of Jean-Luc Godard … [voice changes] It is just an open space with sometimes snow, and there are some pictures. Emotional pictures, like, say, Samuel Fuller. And you can use this image.

There is sometimes snow and sometimes not snow.

Pest Control
Carsten Holler: People never get upset with this child-catching piece. Even parents with children. Because somehow everyone secretly hates children, even if you have them, because they make a lot of noise – and they take all your time and they cost a lot of money. Somehow you hate them but you still want to produce them.

The Continental Style of Play
Simon Patterson: On one wall we've got the Last Supper arranged according to the flat back four formation, Jesus Christ in goal. And on the other we have the Last Supper arranged according to the sweeper formation, which is the continental style of play.

LG: Showing this work in Italy gives it an edge.

SP: I was talking to an Italian gallery owner who understood the work, but first he asked me if I was a religious artist.

Behaviour
Carter Kustera: I was arrested in Virginia Beach a few years back and had to produce a driver's licence and the cop said, 'Oh, you're Canadian. I thought all Canadians were nice'.

Che Guevara *v* Emily Dickenson
Meg Cranston: I've done a lot of work which is about listing and information. I did a piece where I made a giant balloon which contained the amount of air that it would take to read the complete works of Jane Austen. So it was a way of trying to show something that is invisible. The experience of reading rather than having the books. You could stand by the works and be dwarfed by the experience.

A Table Covered with Instructions
Hirsch Perlman: It's a manual on how to conduct interrogations. I've been working on it for a year. It's written with the attitude that anybody at all might want to, or have need to, conduct an interrogation, and that anybody at all may be a potential source of information.

Contemporary Critical Viewpoints
LG: What do you think about the Aperto?

Giorgio Verzotti: Oh, I think that the Aperto is very nice and I have seen a lot of very interesting works in the style of 'Do the Right Thing', and I think that most of the artists are doing the right thing now.

Hospital Corner
Christine Borland: It's about 150 blankets. I didn't count them all, but they're piled on top of each other to almost bed height. They're all folded very neatly, so the top cover is the one which dictates the size of the whole piece. The top cover is the key to the work in the sense that it is a well loved, well patched, well worn top cover. A patchwork quilt that has been in my possession since Belfast five years ago. And I used to hunt that kind of thing down. So it is genuinely well loved by me.

Re-Negotiation
Francesco Bonami: Maurizio Catelan is Italian, but I decided to include him after his short visit to New York. We talked extensively and he took a space here that he sold to an advertising agency, which is using it in a very professional way. Yesterday the people from the agency came here to see if the lighting was correct. It is a straightforward piece. He sold the space and they gave him money.

Forced Art
Sean Landers: The text is a piece of one thousand pages titled *One Thousand Pages or I'll Blow Your Mother's Brains Out*, because it's forced writing.

Rirkrit Tiravanija's Noodles
LG: What we've got is the tin or aluminium canoe, and in the canoe are these gas burners, and on the top of each burner is a large pot of water which is being heated by the burners. Around the piece are a number of tables and chairs, also a couple of other artists have installed their video work close by so you can sit around the tables and watch some of the videos and eat some noodles from the large stack of noodles that were here but have now all been eaten.

Interviewer and Interviewee Divided
LG: I expected it to be much more disgusting, but people seem to be interested in it as just a thing. They don't recoil and go 'ugh' or anything.

Damien Hirst: I think everyone's interested in seeing inside things. It's just unavoidable and you can't help it. It's removed enough so you don't get your hands dirty or anything. And it's held together.

LG: How did you cut the cow in half?

DH: With a chainsaw.

On the Buses

Henry Bond: I came here two weeks ago to make the film. A short film shot on the water buses. Venice has often been used as a signifier for a world turned upside-down. With the received ideas I had about Venice as well, very mundane and simple situations in Venice become much less readily recognisable. I was using 'camcorder intimacy' to take mundane and simple situations and use that in the context of my received ideas about Venice.

Solaris

Angela Bulloch: It's about the way the lip-synching doesn't work in an entirely correct way. So you would have something which is very English in terms of the spoken language, but looks like a bad translation. In fact it ends up looking more like a Brazilian soap opera.

Security by Julia

Julia Scher: I've used architectural elements that are culled from many different venues of surveillance. And this is an archetypal broken penis flagpole with a supporting but ineffectual scaffolding behind it. Everything that I could get made of aluminium is made of aluminium and it's kind of chunked, bolted together, in ways that are not normal in surveillance practices.

It is not 'Criticable'

Nicholas Bourriaud: First, I work merely with theory. I'm trying to explore new ways of thinking about art. It is the most interesting thing for me. Secondly, curating a show is something quite exceptional for me. I like to do it every year or couple of years. I don't think we have things to say every year.

DOCUMENTA 6, 1977

Documenta, held in Kassel, Germany every four years, whilst having a very different character from the Venice Biennale still acts as a focus for the international art world during the opening days. It therefore offers substantial opportunities to speak to artists, critics and curators about the work and the event. Audio Arts has attended three Documentas: 6, 8 and 9.

Wolf Vostell

Wolf Vostell starts by speaking from his darkened installation, where television monitors could only be reached by wading through water with a torch.

WV: I'm the first artist in the world since 1958 to use television sets in pictures ... I feel that now if you find 250 television sets in this building it's really a dictionary. Documenta is really a dictionary of art inventions.

WF: What about the image you use on the television screen of a classical building and a jet fighter?

WV: You know, my idea was to put the jet fighter on this building. We had the financial problem resolved, the technical problem was all right, but the Documenta Society came up with a pretext that it would be too dangerous, it is difficult to tie up, it would fall down. So we found it was a kind of censorship not to allow me to put the star fighter on the roof. This room was always conceived as what an aeroplane does. An aeroplane does not sit quietly on the roof, when it is in action it produces all this. This is not an illustration, a direct illustration, it is an indirect illustration, it's a sociology around you, and I just don't want to put the horrible image in a comfortable context. I want you at least to be confronted with this negative information on our world.

WF: The images with television screens are only accessible by wading through water. What is the point of having the water in the way you have?

WV: I want to produce an equivalent to the cars in the information you see, and I want you to feel uncomfortable when you see the negative information on the disaster. That means all the world today is sitting with whisky glasses and beer glasses in front of the television set and seeing disasters and war and natural catastrophes. But in art I have a chance to make another comment on this imagery. Tomorrow I shall have honey bees in a case here, living honey bees. They will be flying around, so I shall put the camera on the honey bees. So I'm comparing the bee with the aeroplane, the life of the bee with the life of humanity, and putting the question why the nature objects are mostly positive and why all the objects and ephemera made by mankind are practical and positive but at the same time produce all the destruction.

Braco Dimitrijevic

At the same exhibition Braco Dimitrijevic talks about his sequence of photographic works which challenge the processes through which historical importance is ascribed to places, people and objects.

BD: This piece is obviously set up for this show, but the idea is old because I have done similar pieces. This would be a masterpiece, and this would be a reason for books to be written,

and this could be a million pounds or whatever.

WF: In fact, just looking at the photographs which are displayed on a semi-circular wall overlooking a staircase, the locations you have chosen would normally have absolutely no significance beyond their functional role, but you have seen them as a possible location to have significance – like the corner of a kitchen, or a telephone kiosk, or a bit of a corridor.

BD: Obviously in this piece the photography as photography is not important for me. Most of these photographs would be completely meaningless without this logic frame. Nowadays, more or less at the end of the twentieth century, some say that everything would be beautiful, but I am not so sure if everything would be meaningful as well. So I was trying just to get any kind of photograph which has a certain kind of meaning and signification, and in this work I was just simply attributing the meaning. So actually those were personal interpretations, because the kitchen corner could have different meanings for two different people, and the same is true with a gallery space, or the street space, or facade – or any location, in fact. I think that it could help make some kind of personal history. I don't believe in this general history, I think everyone should create his own history. Recently I thought, 'how can I believe when I cannot even read my own handwriting one day later?' So, in a way, how could I believe in something which was written by somebody else five hundred years ago? So this particular piece in the show is pointing out this different logic, different history.

DOCUMENTA 8, 1987

Bill Woodrow

WF: We're back at the Orangerie now, it's a wet afternoon. Bill, we've just been in to look at your installation and it's extremely hot in there so we've come back out. What generally do you think about Documenta 8 and your place within it?

BW: I'm still trying to figure out exactly what my place is in it. I'm a little clearer about the concept of the whole show now than I was when I first came, but I am still not clear exactly what it is by any means.

WF: How do you feel about the juxtaposition with design pieces, or designed interiors?

BW: That's one of the things I'm still coming to terms with. It's not something that initially bothers me, because on one level I don't mind what is next to my own work, which is basically what

the question is about. I don't mind unless it's something that really intrudes physically upon it. In the case of the design things, I think it's an interesting idea. I don't know whether it has come off … I'm still formulating that one…

WF: When you were invited to participate in this Documenta, were you aware of this theme – that they had developed an argument about the idea of a social role and placement of art and design?

BW: No, not really. I was invited and asked to make a large work for the Documenta, a large room-sized installation. I was asked if it would be like another work that I had made, in the concept of it taking up the whole space and the kinds of things it used. I thought it was a bit strange to be asked to do something like another work. I decided I wasn't going to do that, but that I'd still be in the show, so I said, 'sure, I'll do it'. But I did come back and look at the space in February and decided that I would make one large work that would fit into quite a big space. I had no idea what it would be or anything at that point, and I didn't know what the work would really be until I started making it, a month and a half ago. Going back to the previous question of the whole concept of the show, I didn't have any notion of that when making the work. I made the sculpture in the same way I make anything else. I made it purely for myself, just within the restrictions of knowing or hoping that I would get the space that I knew about.

WF: Perhaps we could finish by talking about the work which I believe is called *The Lure of Civilisation*. I suppose the starting point is what one sees in there, which is three harps that seem to be semi-constructed in a bronzed sheet material and semi-deconstructed, also with a number of items such as a crocodile and flowers and a microphone stand and inverted bowl shapes on the ground with a piece cut out of them. It actually fragments the space quite considerably, doesn't it? The space becomes quite tricky to walk through – it interferes with the passage of people.

BW: The whole sculpture is made from approximately thirteen copper hot-water cylinders. This sheet material of the cylinder, the base and the tops make the bowls, which are like oil lamps on the ground. The three harps are in a 'state of decay', the whole sculpture has this air of decay … the microphone isn't connected up, the harps aren't playing music, they have a few strings, the crocodile is dead, just limply arched over the middle harp, and the bundle of wheat in a way lies between the two, because it's something that we could use as a produce, in the sense that it's cut, and again it's dead, but it has some optimism

about it, because it can be made into something else. And generally the whole atmosphere, when I was making the work, turned into a monumental or shrine-like concept.

WF: Yes, I got the archeological, tomb-like sense.

BW: Yes, with all these little lamps that are lighting up … in a way I can't be more eloquent than that, because I didn't have a set idea of what the work was about before I actually started out on the thing. The initial idea was to make a harp, and that turned into three harps because I liked the first one very much and I wanted this repetitive motif; and then there's the decaying aspect which came in, and the whole work developed from that.

Michael Archer: There are some themes in it in terms of the imagery and the ideas that seem to be fairly consistent with the kinds of things you've treated over the years. The idea of the microphone on the stand as a metaphor for mass communication has been there throughout the eighties, and also the idea of music as being some kind of medium employed in that form of communication. But also there is what seems to me something that connects this with some of the other recent work of yours I've seen, which is a much more overt statement of ecological concerns and social concerns. Would you think that's a fair statement?

BW: Yeah, that's quite a fair statement. Just in terms of the images that are used, I think they're like the microphone for communication and power, and the animal for natural systems, and then the wheat as food, and the harps are quite interesting for me because although they are a contemporary instrument, they have a very strong image of history for me. Obviously I know where images of harps come from, right back to Greek mythology, but they're not specific, they just have this very strong image of time in them, which I like very much, and the lamps seem to fit with that in a way.

DOCUMENTA 9, 1992

Richard Deacon

WF: Richard, we are now in a park just outside the central galleries of Documenta 9, standing by your piece. There are children playing on it and there are people sitting on the aluminium boundary that runs around the wooden work, and the first question that comes to mind is, do you mind, or are you happy about the public involvement with your work?

RD: I have mixed emotions. I anticipated a certain amount of

ABOVE: Free International University discussion, Documenta 6, Kassel, 1977, (left) Joseph Beuys, (centre seated) Angelo Bozzolla, (centre of panel) Caroline Tisdall
BELOW: Joseph Beuys discussing his work Honey Pump, *Documenta 6, Kassel, 1977*

user use or viewer use of the work, and when you make something of this height you have got to accept that people will sit on it, particularly in such a popular area as a park. I had anticipated that, but I don't particularly like watching it, because it makes me uncomfortable. I always worry that I am going to see someone do some damage. In principle I quite like the fact that people enjoy the work, and in a park obviously you can't legislate as to how people should behave in front of a work and you rely on a certain amount of good faith that goes on between you and the public as to whether the thing survives or not.

WF: Did you choose the particular location in this park?

RD: Yes, very much so. I chose a site that was viewable from above, and as you come down the steps it is a very visible position, although it wasn't obvious as such until I put the work here and it was a clearly visible place from almost all over the park. I chose a relationship between the trees, and when I first came here without the pavilions the trees were very particular, very individual and very precise in their relationship of one to the other, and I wanted to try and make a work that was as individual and as precise in its relationship to the other things around.

WF: In the mock-up or visualisation in the catalogue you make three-dimensional models of the trees. You then made a drawing and a maquette. Can you talk a little bit more about how the piece relates to the two trees, as they seem to have been important features in how you formulated the work.

RD: It was to do with the characteristic of individuality in the trees and the very interesting formal relationship they had and wanting to work in between them as against somewhere else, and this is the lowest point of the park as well. The model was a means of trying to work out some of the scale of things, and I actually think I probably intended to make a higher work when I first started. I realised afterwards that I didn't want to make a work in the park that was taller than a person. It is intended not to dominate, and this partly accounts for the kind of use it gets. It is set at such a low level that it is very easy to climb on or to sit on.

WF: That is in fact the next kind of comment. There are people sitting on – and I don't know whether you would describe it like this – an elliptical aluminium wall that is thick enough to sit on and the height that is appropriate to sit on within which is – and again, whether you would describe it like this – a pod-shaped fabricated object. How did the two elements arise. Is it easy to talk about that? There is a metallic collar around something that gives a sense of the organic – something that is growing –

something that suggests a pod that actually could become part of a living organism at some point.

RD: Well, that is certainly one evident reading of the work. The title of the work is *Bikini*, and the obvious answer to the question as to why it is called that is because it has two parts and it also has a ring around it like an atoll and the interior has a kind of full sexuality to it. The word bikini entered the language for two reasons almost simultaneously. The first explosion on the Bikini atoll was four days before the two-piece swimsuit was introduced in 1946, and the designer used the word bikini in reference to the Bikini atoll. So there is a whole set of interesting relationships between the organic and the inorganic and the destructive and the procreative and the trivial and the deadly serious which are a kind of sub-text to the work. In some ways you could almost describe the foundations of post-1945 Western Democracy as being based on that duality of motif – a certain kind of freedom of lifestyle coupled with an awesome threat. That kind of darkness isn't particularly present in the work, although the connotations of seed within the central section and even some of the connotations of shape do have that kind of side to it.

WF: Do you have anything to say about the context of Documenta? You are actually away from what I could describe in quotes as the 'politics of placement' within the very specific spaces. You are out here in the park.

RD: I chose to be out in the park because I didn't want to get involved in the politics of space in the interior, and I was also invited to consider making a work for outside, which very few artists were. At the last Documenta a large number of artists made work for outside spaces, so I gained a lot from the fact that there aren't many, and the work actually does have its surroundings and the relationship to place remains fairly clear. So I think that from my point of view those art political questions don't actually apply. I have the site that I wanted in a clean situation, and if the work succeeds or fails it is my business rather than being able to say it was messed up by having to make compromises at the last minute.

I have never done a Documenta before, and the quality of carnival that it has is slightly surprising to me. It is more exuberant than I would have thought. In general terms, I think that there are two things that go on in these situations. One is that there is a certain amount of politics, as you mentioned, and the other is that in fact the people who probably get the most out of Documenta are the people who don't go to many shows, because it provides an opportunity for them to see a large collection of work at one time and engage with it in a way almost no other situation

provides. Even in a big show that is in one location, people don't party around in quite the same way and live with the art, which you have to do if you want to see Documenta. You have to give up quite a considerable amount of time and you have to put some leg work into it; you do see work in a variety of different situations, and the sequence in which you see work is going to colour what you think, whereas for someone who has seen a lot of exhibitions, a lot of the time they may think, well, he didn't do so well, she didn't do so well, she did very well, and those were badly shown. Those concerns tend to be foregrounded. Probably an art audience is not the best audience for Documenta. A corollary for that would be to ask the question whether for an art audience, given that you know the work, whether you can construct a discourse around it and form some idea of what the Documenta, which cuts through the strata of art world activity at one point, means. That seems to be much more difficult to come up with.

WF: So arising out of that, do you think there is a particular or specific agenda that this Documenta will be remembered by?

RD: It is to soon to say that or to give a summary of that. There does seem to be a more deliberate attempt to let work impose upon other works, and to view that as a positive confrontation rather than a negative confrontation, and to encourage that, so that those little blue hands with their plastic bottles – which are a kind of crass example of that – are permitted to proliferate throughout the Fridericianum Neue Documenta and the Halle. But there are other occasions where you can see that there is a deliberate kind of confrontation: one of the most sex-explicit works is juxtaposed next to some of the most worked, abstract paintings, and those kinds of confrontations must in some senses be deliberate rather than just accidental.

FROM ABOVE: Richard Deacon, Bikini, *Documenta 9, Kassel, 1992; Lawrence Weiner being interviewed by William Furlong on the steps of the German Pavilion, Venice Biennale, 1993; Klaus Rinke with his installation, 'Fridericianum', Documenta 6, Kassel, 1977*

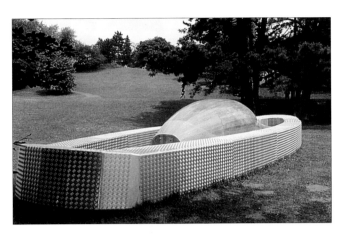

TAKING ISSUE

Recordings that arise out of particular issues and debates

Several editions of Audio Arts *have provided a context for the discussion of particular issues and preoccupations within contemporary art. These have included 'Ideology & Consciousness' with Conrad Atkinson, Mary Kelly and Susan Hiller, 'Feminist Issues in Contemporary Art' with Margaret Harrison and Lucy Lippard, and 'Artists in Residence' with Helen Chadwick, Maggi Hambling and Ian McKeever. 'Issues & Debates', a double issue of* Audio Arts *produced in collaboration with* Artscribe *magazine, was devoted to examining the current tendencies of contemporary art in Europe. Recordings were made during July and August 1991 with artists, curators, dealers and critics in Nice, Cologne, Berlin, Leipzig, Dublin and London by William Furlong and Michael Archer. Contributors were asked whether or not they felt there has been a shift in emphasis between the art of the eighties and that of the nineties, and if so, to try to define the character of that change. Is it the result of an inevitable exhaustion of interest and a consequent turn in the fashion cycle, or is it in some way due to recent social, political and economic change in Europe? What are the important issues for art in the nineties? A particular focus, reflected in the following extracts, was the impact on art practice of German unification.*

Sophia Ungers, Dealer, Cologne

MA: Cologne obviously stands out as the most important centre in an international sense. Is the decision to move the government to Berlin going to have an impact on the cultural elements here?

SU: Well, it's going to have an impact on economic elements, which could have an influence on cultural elements. It's one of the biggest mistakes we've done since the war. But the problem with Berlin in the past is that it has been a very young and very old city, but you didn't really have businesses here or the collecting potential, so that artists couldn't expand and neither could the galleries. So maybe in the long run it could become a cultural point, but because we are also closer to the rest of Western Europe we are not going to lose our importance, no.

MA: Have you noticed much of a shift in the kind of things that are interesting artists over the last few years?

SU: What I think is special about German artists at this point is that there are many different directions, it's not like everybody has to be doing one thing. When I go to New York I feel as though everybody has to be doing something which is now politically correct. This wasn't a term last time I went to New York and now this time it's everything. Here I think there are very different things happening. People are involved in different situations. There are the artists like Christian Nagel's artists who are more involved with what are they involved with – with making an image of themselves as group; also with the self-referential work; with work that is maybe in a way political. Then there are the more individual artists, some are painting some are sculpting. I don't think you can say, 'German art is doing this at this point', I really don't. I guess at the beginning of the eighties you could say it was painting, but since then it's been very diverse.

MA: Is the current political situation in Germany something that features a lot in artists' work?

SU: Not yet, I don't see it happening at the moment. Surprisingly enough. I mean, when the Wall came down, nothing was really changed in the work that I know about. I find it quite an interesting thing that they're not paying any attention, in a way. I think it shows that if there is political or social meaning in the work, it's more an essential meaning.

MA: Has there been a feeling on the part of the dealers that they need to explore what's going on artistically in the East?

SU: I would say the dealers that I'm working with, or I compare myself with, or I would like to be in contact with, are really not yet that concerned with what is happening there.

Also one must remember that those artists who wanted to come and have contact with the West, did come. Richter, Hérold, Penck, Baselitz – they all came from East Germany, so it wasn't like everything in East Germany was hidden.

MA: Do you think that this is a general feeling as much as an

individual one on your part?

SU: In a way I think it's general in my generation, yes I do. I think we have pretty much separated ourselves from East Germany, and now it's part again. There's no emotional pathos like maybe with the older generation, who can now have their homeland back. It's like, oh well, an addition – and I think that's quite a healthy attitude and I don't mind having that attitude.

Isabelle Graw, Editor of Texte zur Kunst, Cologne

We realise a terrible lack. As an example, let's take Berlin. It was of course already clear for five or six years that Berlin would be the new capital, and it's a logical claim history would make in order to fill a certain psychological gap, I guess. So there was a *mise en scène*, of endless democratic or pseudo-democratic discussions in order to give the impression that this was really a decision which was democratically thought through. But on the level of the press, you would never have a reflection going in that direction. The same with the so-called upheaval in East Germany, where it was always represented as if the German population has altogether revolted against the regime, which is nonsense because you can easily find out that in 1988 Schlck Goldkowki and Honecker were already sitting around a table discussing an eventual confederation and were very aware of the fact that economically it couldn't continue. So all these myths of a popular upheaval or of democratic decisions are never revealed as such.

The same with East German art production: you have basically two very stupid lines: the kind of Immendorff approach – they compromised themselves, they worked for the regime, and I wash my hands in clear water; or the kind of reactionary art critic of the Feuilleton line such as Beaucamp, who would praise the handcraft, praise certain painterly values which can without shame be found there and which are now imported in order to reinforce and make possible this kind of artistic practice. In between that there is nothing in order to understand what the re-unification could mean for East German art.

MA: What is the impact on artists here, such as Immendorff?

IG: Among the artists I know, there's an incredible attempt to ignore the near and to be interested in far-away otherness.

Marius Babias, Art Critic, Berlin

That something has changed is clear. We can see that by the fact that the market failed. The dilemma of the eighties was that artists such as Jeff Koons, for example, represented a cynical tendency of our capitalist world to make things very big, very nice, but not necessary. It is like a big bourgeois illusion, that art is something that has to delight you. Art has to investigate a social context in art itself, political themes are something else. He produced only pieces which nobody needs, that don't give you any critical value. But I think our generation is not interested in these points, not interested firstly in earning money: we are interested in themes, social themes for example. Now in Berlin since the Wall came down, the social realities are personal, biographical, and you can't escape this problem. So I think people who work with art react in their work with this political change. It's not only the fact that Germany was re-united but also the war in the Gulf, for example. And they try to reflect the role of art: what function has art? Is the function to put questions, or is the function to sell ideas about beauty? My interest and the interest of some young artists which are for example in the Metropolis show, like Maria Eichhorn or Fritz Heisterkamp, young Berlin artists, their interests are very social. Of course they produce some pieces, but these pieces don't expose traditional ideas of art or beauty. Those people are art of course, they have aesthetic qualities, as the traditional art, but they try to put questions about certain themes. These younger artists in whom I am interested put questions about the role of art, but also put questions about the role of us who look to art.

Thomas Wulffen, Critic, Berlin

WF: Do you think that the changes that we can expect in the art of the nineties will be triggered by the process of change, of cycle, the relentless requirement from the art world for new work, or do you think it will be much more to do with a reaction, for instance, to the political changes in Europe to do with the world economic situation?

TW: I think we have to expect a mixture of both forms of changing. I think the reaction to the economic changes already exists, but it takes longer to react to historical changes which have taken place in Europe. We can't know the ideological background to the works of Eastern artists and they can't know our ideological background, and I expect that this situation will last twenty or even thirty years before we reach the stage where we can talk on the same level. Capitalism has won, in a way. But nevertheless, there are some parts of the East which we should in a way incorporate in our system, and I think the loss of Utopia is not good for art in itself, and I hope some Western artists will react to this.

WF: If you're talking about an art in the nineties that is more

conceptually based and less to do with object making, is there an inherent challenge to the axis that has developed between New York and Cologne, which is very largely based on dealership and the selling of work?

TW: I think there will be a moving from the axis New York–Cologne to the axis New York–Berlin–Moscow. The challenge to the whole system, I don't think that it will work. In that sense I am pessimistic. One can only hope that the artist finds his own place in that system, but he will not really change that system. I think even the idea of changing that system is romantic, and the interesting point is that you work with that system without being swallowed by it.

Bruno Brunnet, Dealer, Berlin

I think artists can't close their eyes to the things that are happening around them in the street. Here, for example, we will have in our near neighbourhood about two million jobless people in Germany. Then there is the problem with the living situation, with the studio situation, with AIDS, with people who are kinds of refugees who come from Eastern Europe and from southern Europe to Germany because they think it some kind of economic paradise. I think all these things will reflect in the art which we will have in the nineties. The social development is one part; on the other hand, a lot of artists are looking for new contexts in their work, and this is a normal development process which has nothing to do with the other thing. I think there might be some artists who still have to work on canvas and they are asking themselves, 'What am I doing? What am I doing this for? Where am I doing this and why?' And this leads them to new questions. Here in Berlin, we have to find a platform where we can talk; we also have to let the wall in our heads fall down.

Dr Klaus Werner, Director, Gallery of Contemporary Art, Leipzig

Most of the artists are now looking for fertile soil where you can put your seed into. Everything has been destroyed, all the institutions I loved or hated, such as the Staatlicher Kunsthandel of the DDR. You know that many of the artists lived by them, though it was run by the government, and now they will have to find not only a new market but also a new system of distribution and sale.

There were of course many reasons for our own history, and it would not only be wrong to turn away from what has been, it also would mean neglecting isolation. It should be taken seriously. Many artists had seriously to reflect their situation; however, they have been surrounded by many, many hurdles and

FROM ABOVE: Christos Joachimides, Berlin, 1991; Bruno Brunnet, dealer, Galeria Fahnemann, Berlin; Rudolph Remmert (right) speaking to Judy Lybke, dealer, Eigen + Art, Leipzig, 1991

due to education and history they were not able to break through the walls – in the double meaning of walls. At the moment most of the people find their identity more easily in a new car or washing machine and other consumption articles than in art. The young ones are learning very quickly and obviously have less difficulty in changing their minds and themes.

Judy Lybke, Eigen + Art, Leipzig

WF: What are the things art can gain and what are the things art can lose from re-unification?

JL: What do you mean by re-unification, do you mean the occupation? I can't see this country united, we are occupied. To me it is like digging out your grandparents from the graveyard and with them the old ideas. The re-united Germany to me does not mean unification of the old ideas. We have developed independently and if we were to come together, it would mean, to my artists and myself, a step back. As a matter of fact, a new trend was visible in 1985, and in my opinion all that has happened already. For the next few years, my forecast will be you can't expect many of the Eastern artists to get through on the market, because the positions on the art market are already reserved. The functions and those people ruling the market are not occupied by Eastern, but by the other people. There are many, many artists here, uncountable, but only a few galleries. Most of the artists here would like to co-operate with Western galleries. The number of galleries was not enlarged, but the number of artists who would like to make their living from making art has doubled. That is one aspect. The other aspect is the art is of high quality, but before you can find someone who is engaged in our art, it will take time. Now nobody would like to be known as handicapped because they are from the East.

Rudolph Remmert, Reclam Publisher, Leipzig

WF: How have the circumstances changed for artists since reunification, and what were the circumstances like prior to the event?

RR: Before I could travel freely and before the fall of the Wall, my main partner in the art business was the so-called Staatlicher Kunsthandel, art trade run by the government. This art trade represented the only those artists who were members of what they called the Artists' Association. This does not mean that all artists represented social realism, but it was the only possibility for the majority of artists here to sell and to get a certain value in foreign money. The commission rate for the Staatlicher Kunsthandel was very high, but Western currency was very strong, too, so that it was more than a compensation. But the real scene happened somewhere else. As we are in Leipzig, one of the places was of course Eigen + Art. Others worked in a splendid isolation in their homes. Sometimes they had teachers, professors at the very few places like Dresden and here that allowed them a certain freedom, though knowing they were unable to enter the international market. There was much more going on than people imagine: they also had their little secluded groups, 'cliques' in the French, where they knew they could trust each other. They had these home galleries – not professionally, private galleries were, as you know, not allowed. Some of them moved into the open countryside, especially into the north, into the Mark Brandenburg or Mecklenburg or Pommern, lonely rural areas, and very soon these places became very important meeting places where they could discuss, compare, have arguments without risking their careers at school or university.

Christos Joachimides, Curator, Berlin

I think there is a decisive, swift kind of change in the middle of the eighties, when a new generation appears publicly, on both sides of the Atlantic. It is concerned and is involved in the visual arts of today in a totally different way from the generation we have followed at the beginning of the eighties. So the real gap, the drift, takes place, according to my interpretation, at the middle of the decade and goes on up to today. We see that this young generation, revolting against the painterly establishment, tries to find some points of references in Pop art, in Conceptual art, in Minimal art. But if we grab a little deeper, then we realise that there is a profound new attitude, and I see the main centres of this revolt principally in New York and in Cologne. Then it goes on later to France, Belgium and very recently in a startling and surprising and interesting way, in England. There is a new generation in London today, in the far east of the city, which is very much in a position of importance in the discussions of the nineties. I think the main preoccupation of the artists today is the media society, a second-hand reality which is transmitted and communicated. Now Eastern Europe is accessible, we discover more and more a very sad and difficult situation. Being there and looking carefully, we see of course the devastations of the old system that are most visible in the cultural field. Especially in our field of the visual arts there is a lot of skill and craftsmanship, but very few really authentic positions and authentic personalities. Very few indeed. Especially in the most politically suppressed countries, like Czechoslovakia and Eastern Germany.

WF: Is there a danger that their practices, their activities, will become completely overwhelmed, completely diluted, com-

pletely challenged, perhaps at the expense of something which we from the West may still not have recognised, but nevertheless was part of a significant period of history within which things did evolve both officially and unofficially?

CJ: This discussion, especially in this country, was very strong and very vivid in the last few years, and on that I have a very clear and very hard position. All the young critics and artists I spoke with were absolutely against a kind of East European Kindergarten. They want to be judged like the artists in Brussels, in London, in Cologne or in Milan. Given how difficult the situation is, it was for me one of the greatest and most brave statements I have heard. They are absolutely aware they can survive as serious artists, or as a serious art scene, only if they cope with the standards of aesthetic discourse we have in the West: there is no other way.

John Hutchinson, Director, Douglas Hyde Gallery, Dublin

WF: How have the critical issues changed in the last ten years in Irish art?

JH: In a very broad and yet very specific way, identify is at the heart. Now, the way in which identity has been approached historically, been explored in Ireland, seems to me to be very closely linked to narrative, to story telling. It's interesting that when you look at the ways in which landscape has been reproduced in Irish as opposed to Anglo–Irish tradition, you find that landscape has very strong historical associations. Landscapes are places where things happened, not so much geographical, physical environments; it doesn't have the picturesque associations which landscape would have in Britain, say. To most Irish, landscapes are a place where things happen, where people are killed, where people were born, and again because of Ireland's history – it is a cliche but it's nonetheless true – Ireland is a more literary than a visual nation. This may be because the prerequisites of visual sophistication haven't been present in Irish society for a long time, although they have in an Anglo–Irish or an ascendancy aspect. So things have been passed on in an oral sense, either through the written word or through story telling, or through music, and I think narrative is very much bound up with that sense of history. Those two things, identity and narrative, seem to me to be the central aspects of a lot of Irish art, and they come to the fore in the two artists I would consider to be arguably the most significant in Ireland of the last decade, James Coleman and Paddy Graham. The one being a painter yet dealing with questions of identity, story telling, myths in various ways, but looking at them in a more emotional, less

self-aware, less critical way and manner than James Coleman. But both of them – and a lot of artists similarly but these two figures crucially – are dealing with questions of identity and narrative in different ways.

Patrick Graham, Artist, Ireland

My concerns are essentially those of a kind of rural person who paints. I have a deep suspicion of intellect used in the sense of conning rather than aspected towards wisdom, a deep suspicion of the kind of frantic sensationalism in art. I have a very great respect for process, things evolving, and also a great respect for craft. I've gone back to the great awesome kind of notions of art embedded in Piero della Francesca. Religion is a rural concern, it's not really a city concern. Intellect destroys the kind of dark romantic magic of religion which is still with me. The really dark romance I have about life comes in a sense from that rural background, and these have always been my concerns. I've seen lots of people trying to deal with them in very intellectual ways and I have never really understood what they were trying to do. They have turned them into isms. It's this also kind of linear thing that has happened to art, this linear kind of aesthetic. I think people want more and more for things to happen.

A really deep impatience, perhaps that is one of the great things about coming from the country, having this patience, having this notion of process. The great concerns are sexuality, religion, less so politics, less so those kinds of interests, but sexuality and religion and kind of magic and kind of lostness … Those essential things are put together in some kind of great emotional and historical context, and all the conditioning and all the intellectual conflict that comes from that inherited bag of historical sludge, if you like, and trying all the time to make paintings, trying to survive it … The same process goes on in painting as a bloody form of making a straight furrow in a field. Loss is another part of it, alienation. With me, aesthetics have lost all value, especially the power of critics, the power of writers to demand from artists that they answer an intellectual or a cerebral kind of hunger for sensation, or for something new to talk about.

Declan McGonagle, Director, Irish Museum of Modern Art, Dublin

I think the principles that were in place in the eighties were about product, commodity market, form over content, the focusing on the medium being used as some sort of automatic placing of artists in the pecking order, and so forth. Whereas already in the nineties a major shift has taken place. One thing that that practice did in the eighties and particularly in the eighties was, to put it

simply, in a place like New York you couldn't avoid people on the streets. If we take that as a metaphor, I think artists and art institutions cannot pretend any more to be innocent. We cannot avoid noticing the people who are on the streets. The New York model is just that reference point, in a way, in terms of the aggressive art market, but outside there are people on the streets: AIDS victims etcetera, so those particular bubbles began to burst. It's just not possible to claim ignorance of those realities. That is not to say that artists describe those realities, but they deal with issues that arise out of them, and there is a growing acknowledgement in one area of practice of the social environment within which artists work and within which art is made and which indeed creates art. On the other hand – and this is very interesting – you have two polar activities, you have the sort of mega hit shows, the mega hit museums, operating on a sort on international, corporate level to some extent, and then you have the other direction, the other strand of activity, which is again concerned with ideas, meaning, place, identity – and this is true of artists' practice as well as the practice of an institution. So those seem to me to be the forces at work.

Karsten Schubert, Dealer, London

I think art in the early nineties has become less cynical again, and less preoccupied with its own marketability or status in the world. I think the artists are much more interested in their work. As a result of that, criticism has gained a new lease of life, because the work is really discussed for its own sake, which didn't happen in the eighties.

They basically accept that postmodernism – or whatever ran under that label in the eighties – retrospectively doesn't look that great and doesn't look like a theory that actually holds, and they realise that they have to continue working on that old project called modernism again. I think that's what all the artists working in Britain right now are doing. When you listen to what people like Ian Davenport or Gary Hume or Michael Landy have to say about their work, that is not postmodern theory any longer: that is really serious modernist work that they are trying to do, but in a postmodern climate, which is really what gives it a very interesting twist.

In a way, I think the British artists are at a great advantage here because we sort of missed out what happened in New York in the eighties, it never arrived here. Maybe the English are just too intellectually lazy to take on all that complicated stuff, and at the beginning of the nineties there was suddenly a generation of artists working here who didn't have to carry all that eighties luggage. They started afresh, and as result of that everybody from Europe and America suddenly started looking at what is going on in London … It's not work that is concerned with references any longer, that whole thing ran its course in the eighties and it got really boring – I mean, the stuff became so self-referential it was a joke. What you see here is work which is very much concerned with, for want of a better word, basics, or ground rules, or the lowest common denominator, or what is the least I can do to create a work of art – and that didn't happen in the eighties.

Jon Thompson, Critic, London

What seems to me to be happening in England now amongst young artists is a kind of irreverence, it's almost a kind of class irreverence. Maybe it's sort of like punk ten years on or something. You can tell with young artists now that what really gets their goat is the predominantly middle-class model of the British art world – that goes for the dealers, that goes for the critics, it goes for the so-called quality newspapers' treatment of art, the institutionalisation of art.

WF: What do you think, then, are the issues for art in the nineties?

JT: Well, this may sound rather old fashioned, but I think the issues are moral and ethical issues. We have gone on for a long time now saying that art doesn't necessarily have a moral or ethical purpose, and I think that was okay before the Berlin Wall came down, because in a way the moral and ethical purpose was taken up by us looking at somewhere else that has been the opposite to what we wanted as a society. But I don't think that works any more. I think we now have to decide internally within our own society what art should be doing, what it should be giving to us, and that is a moral and ethical question and a political one – not that you can separate any of these three things. I suspect that that will be the issue which really comes to the fore in the nineties. I think you are going to get a new generation of artists who test a lot of the values that have been extant from what has been the rather tired period of the mid eighties.

Stuart Morgan, Critic, Brighton

Gradually as the eighties moved along we had a small groundswell from the middle of Europe, from curators and intellectuals who felt that they had never had their just deserts in America, and that because their values were quite different from American values, and the art that they supported was perfectly different, something should be done about this. Maybe they and maybe the artists – I think probably the critics and the curators – invented an idea of a conceptual painting. The idea was that conceptual art had gone so far that it had to collide with its exact opposite, and

what could possibly happen? Would there be an implosion? Would there be a black hole? What would come out of the other side? So we had a kind of painting that commented on painting of the past and resulted in something that was or was not painting. Well, it's fine if you are clever to say that something is or is not painting, but to most people it looked like painting. Now, it seemed to New Yorkers that this was new, and they tried to buy it up like they have bought up other European movements in the past, and it has to be said that they failed …

Maureen Paley, Dealer, London

One of the most interesting things is that some of the artists we are looking at now and are taking up within the gallery system have actually been very much working on their own initiative immediately upon leaving college, and some of these very large exhibitions that they organised have made great impact. I don't think that artists should be completely confined to gallery space – I don't think they were in the sixties or the seventies and I don't think they should be now. I think that some of the structures in the eighties were unfortunate in certain ways, and I think that a lot of those artists are often looking for other outlets in publishing or in edition making or in other areas that are extremely important to make sure that the whole situation is healthy and thriving, so I think it's a very intriguing time.

Iwona Blazwick, Curator, London

For me, a lot of the art practice over the last decade has been almost iconoclastic in that it has actually been unpacking various presumptions, various traditions, most broadly around modernism. But it has also been a time when various different sorts of groups – gender groups or whatever – have been trying to find their own language in making definitions. It's almost like deconstructing a situation and reconstructing it. Throughout that period I think a lot was discussed, and art seemed very much about language and about allegory and about distance and about appropriation and irony and simulation and so forth, very much tying in with theory.

The other impulse was in a sense to look back at that whole phenomenon of work to do with a rejection of internationalism, about artists exploring their own cultural histories etcetera. Nonetheless, both seem to me not to be about the here and now in a situationist sense of something which is very immediate and real. I must say, I felt that for myself that tendency toward allegory meant that in the end you started feeling as though art became a series of strategies, and without wishing to go back to some notion of avant-garde transcendence or whatever, what I find in myself and what I see in a lot of younger artists at the moment is a concern to reconnect with that sense of the irreducible experience of the art object, if you like, or the space or the relationship with the spectator, which isn't necessarily a cerebral one.

Michael Archer and William Furlong in the Audio Arts studio, 1991

COLLABORATIONS

Collaborations, presentations and events

In addition to publication of the magazine and the production of artworks, Audio Arts has both initiated and been central to a wide range of collaborations with artists.

Academic Board, *Battersea Arts Centre, London, 1976. This collaborative work with Bruce McLean arose out of the experience of working together in an art school in the 1970s. A developing tendency in such institutions was for senior practitioners to be replaced by spurious quasi-managers who pursued personal ambition. This scripted work explored manipulation and control according to hierarchy expressed by relative positions around a vertical table. The agenda for the meeting comprised opaque and trivial matters, such as the redecoration of the caretaker's flat, which involved the projection of 20 shades of mid grey from the Munsel scale, from which the board was invited to make a selection.*

Announcement sheet for '4 Seminars' organised by William Furlong, Robert Self and Richard Cork at the PMJ Self Gallery in 1975. The public event, with its live interaction, was regarded as integral to the debates taking place within contemporary art in the mid 1970s. All four seminars, which are unpublished, were recorded by Audio Arts.

Academic Board, *agenda item 1, projection slide of 'complex' decision-making model*

Die Grosse Bockwurst, *recording session, Whitechapel Art Gallery, London, 1977, with Kevin Atherton, Mark Boyle, Susan Boyd-Bowman, Ian Breakwell, Maria Broodthaers, David Brown, Marvin Brown, Marc Chaimowicz, Michael Craig-Martin, Rita Donagh, William Furlong, Gilbert & George, Peter Green, Nigel Greenwood, Richard Hamilton, Margaret Henry, Joan Hills, Mary Kelly, Ron Kitaj, Robert Medley, Bruce McLean, Jane Morant, Sandy Nairne, Ruth Piercy, Barbara Reise, Martin Rewcastle, Norman Rosenthal, Dieter Roth, Nick Serota, Duncan Smith, Jonathan Williams*

Bruce McLean, In Terms of, Documenta 6, Kassel, 1977 *(from right to left): Bruce McLean, Duncan Smith, William Furlong. Aspects of* Academic Board *were developed in this work, which was structured around a grey corridor where the suited performers observed and checked each other's arrival and departure times through the doors on each side of the structure. The work was also presented outside the Serpentine Gallery, London, in 1977.*

Riverside TAPE/SLIDE Sequences, *1980, mailing card for the event. As with* Nine Works for TAPE/SLIDE Sequence, *the Riverside series extended the concept of original artworks being presented to an audience as time-based events.*

Nine Works for TAPE/SLIDE Sequence, *list of artists from the card accompanying tape/slide edition package*

Nine Works for TAPE/SLIDE Sequence, *Kevin Atherton's sequence*

Audio Arts, when it began in 1973 offered tapes on literature (W. B. Yeats and Edna O'Brian) as well as contemporary music and the visual arts. Very soon it settled down to present, in cassette form, interviews with artists and works that the artists themselves had made. The time was right of course for artists to make works which could be dispersed easily and which was sufficiently different from the conventions of painting or sculpture. Audio Arts exploited both this appreciation of the nature of audio tape and sound as a material to work with. It had a minimal quality used by artists such as Weiner or Troostwyk; the nature of language itself, investigated by these artists, was enhanced by the temporal nature of recorded voices. If Weiner could say something in a given time and add another voice in counterpart then his audience were closer to a given work than experiencing it in the gallery. The artists were also able to edit and manipulate sounds and statements in a way similar to building up or making a work in any other medium. This facility is great deal cheaper than film) was something that Bill Furlong offered alongside audio magazines of the visual arts elsewhere in the world such as Fast Forward (Australia), Mag (Vienna) and the New Wilderness Foundation (New York).

Audio Arts also became a magazine of record; it could be used to provide recordings (often edited highlights) of conferences, discussions or performances. It embraced the issues as they appeared (feminism, ideology and consciousness) but managed to present them from the artist's standpoint and to remain sufficiently free of the establishment. Look for example at its reporting of the ICA debate *The State of British Art*.

Alongside this reportage Audio Arts has produced long interviews with important British and foreign artists. These also have been outside the mainstream and have almost always created art which was anti-Establishment. Furlong has developed the enviable knack of saying little yet providing a sympathetic listener to the artist talking about his work. On several occasions (Stuart Brisley, Braco Dimitrijevic) he has found the material collected over, say, sixteen hours could only be usefully reduced to three or four and produced a double issue. This flexibility and sensitivity to the material is another Audio Arts hallmark; it is preferable to squeezing the work into a specified format. Alongside the work with British artists, he has interviewed visitors when they have had important exhibitions here and on occasions made special works with them.

Bruce McLean has for a long time been a collaborator with Bill Furlong; they have worked on each other's patch and this special relationship has resulted in the best of the tapes; recordings of performances and the soundtrack of the 'Masterwork'.

Furlong has, like any good editor, exploited his idiosyncracies; he has pursued his interest in contemporary music, an area overlooked by most historians of the visual arts, and his contacts with the folk traditions of his native Northern Ireland.

Above all he has maintained and fostered very close links with the artists he set out to serve; these people rather than the librarians, archivists or curators are the primary users of Audio Arts, because they feel a sympathy with the way in which things are done, and the way the work is handled.

It is extraordinary that this by now substantial pile of cassettes should have been produced in the editor's spare time in a bedroom in Clapham using the simplest equipment. Their influence has been substantial, not only in encouraging artists to think seriously about sound but also in allowing artists to direct for themselves the critical approach to their work. I hope that Furlong is given the support he deserves; he has it from artists of all generations as the list for the new tape 'Live to Air' proves.

Richard Francis

Live to Air, *front panel of brochure produced by the Tate Gallery, London*

Live to Air, *installation at the Tate Gallery, London, 1982*

Image from a tape/slide catalogue for 'Sorry, A Minimal Musical in Parts' by Bruce McLean with Silvia C Ziranek. The catalogue comprised two slides and a C10 cassette.

Audience at the 'Audie' Awards Ceremony, 1985, a grand gala benefit night for Audio Arts organised by Bruce McLean and Mel Gooding at Riverside Studios, London in October 1985. Participants included Patrick Heron, Paul Richards, Richard Cork, Anthony d'Offay, Richard Hamilton, William Feaver, Kerry Trengove, Barry Barker, Barry Flanagan, Waldemar Januszczak, Richard Deacon, Nick Serota, Mary Kelly, Susan Hiller, Kathy Acker, Milena Kalin-owska and Silvia C Ziranek. Many others supported the event, particularly Joseph Beuys, Antony Gormley, Sarah Kent, Charlie Hooker, Knife Edge Press and Barry Flanagan, who contributed the artworks. The event took the form of a Hollywood 'Oscar' ceremony, with leading individuals from the world of visual arts being nominated and receiving an 'Audie' award designed by Antony Gormley.

BRITISH
SOUNDWORKS

APRIL 14–MAY 14

This event is supported by the National Endowment for the Arts and the British Council

STUART BRISLEY
LEVELS & DEGREES
the artist will be at Franklin Furnace continuously as part of and to make this work from 14th to 19th April. An installation will remain until May 14th. The work concerns consciousness at three levels and includes speech, sound, constructed and collected elements.

GERALD NEWMAN
TIMES
soundworks by Newman will be presented at 2 and 5pm daily from April 14th to May 1st. Works comprise complex, interrelated audial 'components' collected from many sources including radio broadcasts and news bulletins of a social, economic and political significance.

CHARLIE HOOKER
UNDERCURRENTS
performance May 5th at 8.30. The sound structure for "Undercurrents" includes choreographed movement through space by performers producing percussive sounds combining with sustained chords played over instruments such as the violin, viola and cello

SILVIA C ZIRANEK
A DELIBERATE CASE OF PARTICULARS
(THE INTEMPERATE HEART)
(*I ATE ART*)
performance May 12th at 8.30. (May 10th at 10pm, Pyramid Club). Ziranek uses wit, irony, association and contradiction as a 'strategy' to examine social attitudes, conventions and preconceptions. The form of her work is that of the carefully chosen and juxtaposed word,the monologue and dialogue performed with associated props of a 'domestic' or culinary nature. (Pyramid Club 101 AVE A. NYC. tel. 420 1590)

AUDIO ARTS
MAGAZINE ON CASSETTE
between April 14th and May 14th over 50 hours of artists' sound works, interviews, conversations and documentation of performance works will be available for listening. Cassettes available include, "Live to Air" sound works by 44 artists published last year and the new issue including Richard Hamilton, Jean Tinguely sculptures and Philip Glass

Franklin Furnace archive, exhibition & performance 112 Franklin Street, New York, N.Y. 10013 (212) 925-4671

'British Soundworks', Franklin Furnace, New York, 1982, mailer produced for the event

Real Time, *Institute of Contemporary Arts, London, 1985, Bow Gamelan in performance. This pilot live arts programme for television presented at the Institute of Contemporary Arts, London, included Stuart Brisley, Mona Hatoum, Kevin Atherton, Richard Strange, John Walters, Susan Hiller and Waldemar Januszczak.*

Dieter Roth, Harmonica Curse, *Polaroid photographs from the cassette edition made with Dieter Roth, comprising a photograph and cassette for each day of the year from 14 February 1981 to 13 February 1982. Each day Dieter Roth played a small accordion for half an hour and then took a colour photograph of each location. This varies from his studio in Iceland to his studio in Stuttgart. This work in image and sound represents a poignant and powerful self-portrait of the artist over the year.*

(From left to right) Hansjörg Mayer, Dieter Roth and William Furlong during the production of Lorelei

Dieter Roth, Lorelei, The Long-distance Piano Sonata, *1981, Dieter with Bjorn Roth. A multiple made with the artist and co-published with edition hansjörg mayer, comprising 37 hours of piano music, a prepared radio-cassette player in a wooden case with a hand-drawn lid.*

Front cover of Technique Anglaise, *edited by Andrew Renton and Liam Gillick. An Audio Arts recording of Lynne Cooke, William Furlong, Liam Gillick, Maureen Paley, Andrew Renton and Karsten Schubert discussing current trends in British art formed the text of the book, which was published by Thames and Hudson in 1989.*

Inside pages of Technique Anglaise

PUBLIC AND PRIVATE

Michael Archer

Although by some criteria it is a simple task to distinguish its own artworks from the rest of its multifarious production, in other ways it seems invidious to try to differentiate between the various aspects of Audio Arts activities. There is a set of concerns that underlies them all, particularly the creative use of the 'space' made available by recording technology. To put this another way, the opportunity to exhibit, when it arose in 1983, seemed a natural development from the curatorial and editorial work that Audio Arts had done up to that time. It was clear, in any case, that Kate Blacker who, as one of the selectors of the 1983 Hayward Annual, extended the invitation, did so because she considered Audio Arts already to be an art practice.

The Hayward Annual in 1983 was devoted to sculpture, and it seemed appropriate that the work should explore the relationships between the conventional, physical space of sculpture, and the audial environments habitually inhabited by Audio Arts itself. It is worth describing this work, *Objects and Spaces*, in some detail, since the principles upon which it is conceived, the *modus operandi* and the broad thematic interests it explores are relevant to the Audio Arts output as a whole.

The tape for *Objects and Spaces* comprises two distinct but interdependent parts. Blank tapes were sent to people around the world with the request that they record, in a space they commonly use, a brief description of that space and of one object within it. When gathered in, these recordings were edited together into a kind of global journey. The transition from one location to another is effected either verbally – the current speaker saying, 'And now over to an object and a space in ... ', or formally, through the juxtaposition of related objects or audial or visual stimuli in the two places. Meanwhile, for the second part, material was being collected in Brixton, the area around the Audio Arts studio in South London. Machines in an amusement arcade, an African drumming workshop, church bells, a police surveillance helicopter – all of these sounds allow access to different imaginative territories: computer-generated virtual space, one's sense of cultural identity, the realm of religious belief, the privacy of others. Each is mapped onto, or is made explicit as, part of the cultural reality within which Audio Arts is embedded. Over this accompanying tapestry of sound, inmates of the local prison discuss the thoughtscapes they visit from the physical confines of their cells.

This is, then, the material used in the piece, the stuff that has been manipulated to produce the final work. Two things need to be said about it. Firstly, the continuity between the magazine and the artworks must again be stressed. The founding intention of Audio Arts to provide the kind of access to its material that the printed page is unable to give, lies at the centre of this and all subsequent works. An interview with an artist about his or her work is all the richer for having been conducted in the gallery in which that work is being exhibited. The ambience of the space and the immediate presence of the works make an important contribution to the way the tape sounds and hence to the kind of information and emotion it is able to communicate. Similarly, sound gathering for artworks is in all instances site-specific. That is, it is one stage in a project formulated in response to an invitation, since each work, and the issues it attempts to address, is specific to the location of its realisation.

The second thing that needs to be said is that 'manipulation' is the right word to use here. Both the 'objects' and the 'spaces' of the work, since they exist for the audience only as sounds, are in many respects as impalpable and abstract as the ideas behind it, and yet their treatment is implacably physical. Although there has been a slight nod towards increasing sophistication over the years, Audio Arts has consistently used the simplest possible equipment in realising its ideas. This can partly be put down to the perennial story – lack of available funds – but it is as much to do with a desire not to indulge in technological possibility for its own sake. Amidst what is perhaps the ultimate exercise in postmodern schizophrenia – sitting in a studio in London while walking through a Viennese gallery at 11 am, looking out over Sydney Harbour at 11.15, being screened at an army checkpoint in Belfast at 11.30 – the best way of accommodating these disparate experiences while still retaining a toe-hold on something resembling reality is to bring them together physically. Using a machine to extract from these tapes and then to recombine the excerpts by pressing a button would be too distancing. By contrast, chopping out sections with a razor blade and splicing them together with tape enforces an intimacy with the material which roots its otherwise ethereal presence. This same kind of anchoring is an aspect of the work itself. A clear flexi-disc was produced with, on one side, the string of objects and spaces,

and on the other, the collage of local sounds and voices. Thus it is Audio Arts and its social context that provides the focus for the other material.

Once the flexi-disc was produced, the question remained, as it still does with all time-based work, as to how the gallery audience was to be presented with it. Ultimately, the object one saw in the gallery was the inevitable cassette deck atop a plinth with headphones attached for private listening. But what one heard was not simply a cassette of the material that appeared on the disc, but a recording of the flexi-disc being played on the radio. In other words, what one was provided with was evidence that the work, and the particularities of each element within it, had already been delivered into the private spaces of countless other recipients. Just as contemporary science finds it necessary to analyse space, not in the conventional terms of three dimensions, but by the means of at least eleven, *Objects and Spaces* teases apart the knotted interweaving of physical properties, ideas, beliefs, wishes and intentions that constitutes the reality of any given location.

Dissemination has always been a parameter in the productive outlook of Audio Arts. Quite apart from the audio-cassette, the ultra-convenient, demotic format whose appearance stimulated the magazine's founding, Audio Arts has variously used, or at least paid attention to, a number of other means of communication: radio, record, telephone, personal ads, tannoy, performance. Radio, first used in *Objects and Spaces* as a means of re-broadcasting material received from around the globe, moved centre stage as the *provider* of material in the *Radio Garden*, originally commissioned by Declan McGonagle for the 1990 Tyne International 'A New Necessity', and subsequently purchased by him for the Irish Museum of Modern Art. The garden of the title is an area of ground on which are erected a number of radio aerials. These are arranged in a configuration of points plotted along two axes drawn on a world map, both passing through Gateshead. With Gateshead as the centre, and with radii determined by the plotted points, a number of concentric arcs were drawn on the map which, between them, crossed most of the world's landmass. Using a short-wave receiver, brief recordings were made of transmissions from all points along each arc and were then played back through small speakers at the base of the appropriate aerial. New recordings were made at frequent intervals throughout the period of the exhibition, so that potentially one could, by means of this continually updated information, learn of sudden and unforeseen occurrences in one part of the world and keep abreast of the development of events, their coming to fruition and passing into history, in another. Sudden storms create havoc, stories bloom and die: *Radio Garden*, like so many horticultural creations before it, offers as the seasons advance, a microcosm of the world.

'A New Necessity' was staged in conjunction with the 1990 Garden Festival in Gateshead. For an earlier festival – Stoke, in 1986 – Audio Arts made *Six Works for Telephone*. Monthly recording sessions of conversations with visitors to the festival allowed a sequence of pictures to be built up, showing its changing scene and mood. They could be heard by simply dialling the telephone number advertised in all the kiosks around the site. One could, of course, listen to it from anywhere else in the country too, and it was important that the number was prefixed by the code for Stoke rather than the anonymous and unplaceable '0898' usually reserved for commercially available recorded information services. This extraxt is from the first telephone work, heard in May:

– It's all concreted at the back. It's concreted at the front.
– Small, it's got a lot of grass. It's got loads of flowers, we've got four lawns, four big lawns.

The Stoke festival, like others of its kind, took place on land reclaimed from a derelict industrial site, and as the months went by the question that cropped up more and more was what would happen to the land once the festival was over. The noise from the small steel-rolling mill nearby provided a background to doubts about the wisdom of short-term prettification in the absence of long-term structural aims.

The point to be made here is neither that Audio Arts set out to make a political statement about the inadequacy of the government's urban regeneration policy, nor that, having set the project up, it was decided that the piece could be transformed into such a statement. It is, rather, that the structure of the work is sufficiently open to allow issues of importance within the locality to come to the surface and, once there, to breathe.

Material-gathering has most often been simple vox pop: stopping people in the street and asking them to answer a few questions. They are never complicated, not aimed at eliciting particular information, and not designed to pre-select through being answerable only by certain types. They are most often, indeed, almost banal: 'What's your favourite food/TV programme?', 'Do you like it here?', 'How do you like to relax?' and so on. Further more, even if someone makes a directly critical or supportive statement in response to a question, it will as likely as not prove impossible to use in the subsequent treatment of the material which takes place in the studio. It is crucial in all Audio Arts works that meaning arises out of this process of treatment, through the focusing upon and repetition of sounds, the juxtaposition of one word or ambience with another, the exploration of the speech tone and dialect peculiar to a place, the setting up of relationships between the meanings of words and their sounds, or the sounds of the environment in which they are uttered. The kind of dynamic equilibrium between the various elements

which must to develop for this to occur is almost inevitably upset if words demand that their meaning alone be addressed. In expending the effort to 'say something', they wrench themselves from their surroundings, denying themselves a space within which to resonate.

Resonance was the key to the installation and accompanying record made for Interim Art in 1987 in that the exhibition space itself literally became a sounding box for the often direct and volatile conversation recorded in the vicinity. The gallery is in a house in Beck Road in east London. The houses in one half of the street are rented to artists, and their sense of community is strengthened by a railway bridge which separates them from Beck Road's other inhabitants. Just round the corner there had until recently been a thriving street market. This no longer existed, and many of the shops and houses lining the street were either derelict or had been rehabilitated by the council in ways displeasing to the local residents. The social tensions in the market street and the contrasts between it and the nearby artists' enclave were marked, and the work was an attempt to find a figure for that sense of unease, awareness and expectation.

Two piano wires were stretched taut across the gallery space. Starting from different points, one low down, one on the ceiling, they converged and were fastened close to one another on the skirting board at one end of the room. Trained on this point were microphones plugged into a Revox which, although switched on and loaded with a full reel of tape, was not recording. The record, *The Difference/Head Low*, which was not played as part of the show, used recordings from one of these wires, another running the length of the hallway and a third stretched across the road under the railway bridge outside as a backing for the highly charged comments of the locals.

Maps have been used frequently. As representations of a place they are rich and satisfying in their use of coded and symbolic forms, and they are essential as a way into an unfamiliar location. The standard British 1km:1.5cm Ordnance Survey provided the basis of the first major Audio Arts installation at Londonderry's Orchard Gallery in 1983. Sections of the two relevant sheets – Derry, where the show took place, and Brixton – were shot on slide and projected onto the walls of the gallery. This 'ground' was then animated by overprojecting handwritten snippets culled from taping sessions in the two places: names, favourite food, local pubs and so on. The imagery filled the gallery: on one wall were the blocks of map being enlivened by these names and attributes of recorded locals, opposite were long, thin strips of map 'spliced' together at an oblique angle like the joins in an edited tape; there were other configurations on the third and fourth walls, and yet, at the end of each day when the power was switched off, the show disappeared completely.

In conjunction with the installation and in place of the conventional catalogue, an LP was produced which covered a range of treatments of the previously taped material. As with the works already discussed, there was no intention to use the Orchard project as a means to exploit the political 'charge' of either Derry or Brixton. The tracks on the record concern such things as work, relaxation, the vagaries of the weather during the period of taping, and television, since it is through the way in which these commonplaces were discussed that the differences and similarities between the two geographic areas became clear.

Such was the case, too, when Audio Arts worked in Newcastle-upon-Tyne: 'What are the differences between this place and elsewhere?' – 'Well, accent for a start.' The distinctive sound of the Geordie unlocks all of the unspoken feelings about the cultural differences, real and illusory, economic, climatic, social and psychological between the north and south of England.

Looping, repetition, multi-tracking, abutting sounds, fragmenting and reconstituting them: these techniques have a legacy as long as tape recording itself, and they have consistently remained the building blocks of Audio Arts soundworks. With Accent for a Start, recorded in Newcastle-upon-Tyne in the winter of 1986/87, a sampling keyboard, by then a common piece of equipment, was used for the first time; another development was the incorporation of much longer sections of the street recordings, often entire stories, into a number of tracks. These changes meant it was possible to play the familiar, often cliched effects of digital fragmentation off against the breaks, hesitations, reiterations and digressions of ordinary speech.

Although conceived primarily as an LP, *Accent for a Start* was presented on its completion in a series of performances. In each city in which it was staged, performing arts students – either musicians or dancers – were given tapes of the twelve tracks to use as the basis for their own improvisations. Involving students in this way would bring in another set of relationships between Newcastle, the original site of the work, and the character of their own environments. Audio Arts devised visuals and only met with the students shortly before the performance in order to discuss the integration of all the elements. Thus, while starting from the same material, the performance was made new each time through the injection of extemporised sound and movement.

Collaboration with students is important. Audio Arts engages with, and finds meaning in, the very ordinariness of those it encounters. Bill Furlong has had a full-time post in an art school throughout, so it seems inevitable that this, his own quotidian reality, should find a place in the Audio Arts output. The roots of this influence can probably be traced back to *Academic Board*, the multi-media performance devised with Bruce McLean after they had both experienced the regime at a certain south London art school in the seventies. But the first time students took part in an Audio Arts event was the performance of the tape work *Arris*

at St James's Church, Piccadilly, in 1986.

St James's is in the area of London's smarter West End shops, and the materials gathered – quite often from tourists since the work was prepared during the summer – brought out issues to do with the exchange of goods and people. The tape manipulations derived from this were published as a boxed cassette but were augmented for the performance by a number of other pieces. Two of these should be mentioned.

Firstly, *Sound, Time and Space*, an improvisatory work for organ. St James's Church was designed by Sir Christopher Wren as a consciously Protestant space. Its openness, good sight lines and general acoustic qualities all help the congregation to see and hear the preacher clearly. Wren himself wrote of attempting to establish these architectural attributes in contradistinction to the mood and ambience of Catholic churches. For *Sound, Time and Space* organ music was recorded in Audio Arts' local Catholic church; the tape was cut up and sections of blank tape were inserted to produce a sequence of short bursts of music, each followed by a silence. In St James's the tape was played back, and the performer, David Cunningham, attempted to reproduce during each silence what he had heard in the preceding block of sound. Sound, Time and Space returns to a theme implicit in the Orchard Gallery LP, its antiphonal form recalling 'Clapham, Creggan', that disc's opening track.

Secondly, *Telephone Piece*, a recitation for four voices taking as its text the myriad call-girl numbers that plaster all the phone booths in the area around St James's. The collision of the public and private realms in the offering of sexual services makes explicit the character of all the communication media used by Audio Arts. The potential to reach people is enormous, yet ultimately reception is an individual act. *Telephone Piece* shifted gear and was transformed for the performance *Placement and Recognition* at the Museum of Modern Art, Oxford in 1989. On that occasion the text was personal ads culled from a London listings magazine and a paper bought on one of Bill Furlong's frequent trips to Ireland. There is a marked contrast between the intense, sometimes desperate search for a good time and the requirement by elderly bachelor farmers for wives once their mothers have passed away. Perhaps the one exception to this public/private dialectic was the work for tannoy devised as part of the group show 'State of the Nation' at Coventry's Herbert Art Gallery in 1988. Even here, though, the communal nature of the audial experience was subverted by the decision not to build a tape from speech fragments, but instead to use the distress calls of various birds, signals of the invasion of territory.

Placement and Recognition, in fact, was a thoroughly student-orientated work. Not only were students involved in making the performance, the set from which remained as part of the subsequent installation, but they were also key elements in the

two sources of recorded material in 'Vinny', the related soundwork. Vinny Jones was at that time the star player at Wimbledon, the football club with which Furlong's own students were engaged on a project. Out of this and his work in Oxford, the record became a dialogue between the footballer and the President of the Oxford Union on the character traits necessary for success and advancement in one's chosen career. What strikes one, of course, is the sense of single-minded application and determination common to both. The visuals for *Placement and Recognition* comprised large photographs of Jones juxtaposed with colourful torn-paper collages: exuberance as a foil to ruthless professionalism.

Visual material is generated as part of every project. Sometimes, as with *Accent for a Start*, for example, it is subsidiary to the soundwork; in the case of the Orchard Gallery installation of *Placement and Recognition* it is a primary feature of the work as a whole. There is, however, a third strand of visual production, the series of scores stimulated by each new working location. These scores are more visual equivalents to, rather than plans for, the soundworks, since nothing could be realised from them in the conventional sense. Speech and its ambience figure as maps and bits of local newspaper, and the subsequent graphic treatment highlights and obscures, drawing relationships between the various fragments and pulling them into a whole in a way similar to the manipulative processes employed with tape.

Process and Identity, the work conceived for 'Zone D', the large international group show in Leipzig at the end of 1991, is purely visual. A pair of shallow display cases was placed on each of a set of trestle tables arranged in three rows of four: twelve tables, twenty-four vitrines in all. Each case contained a large photograph of a scene in Leipzig together with other, smaller images and various substances. These additions performed a range of functions, obscuring or revealing, emphasising, contrasting with or offering commentary upon different aspects of the larger image. Made early on in the process of German unification, *Process and Identity* offered clues for an investigation into how the economic, political and legal imperatives reshaping the cultural landscape conflict or mesh with more immediate and personal inclinations and desires. Echoing the market stalls in the square above the underground exhibition space, the work presented itself as a self-contained museum, albeit one which, because of its makeshift and moveable character, is highly adaptable, infinitely transformable. Consistent with all Audio Arts work, *Process and Identity* was a combination of material from Leipzig, the site of its realisation and consumption, and south London, the place of its gestation and preparation.

Aspects of both *Process and Identity* and the earlier *Radio Garden* were evident in the 1993 work *Time Garden*, the Audio Arts contribution to 'Ha Ha, Contemporary British Art in an

Eighteenth-century Landscape', held at Killerton Park, Devon. Twelve tables were again used, each one labelled as being associated with the countries that fall within a certain time zone. At one end of the lipped table top a clock set to the requisite difference from GMT was boxed in and covered with a protective sheet of Perspex. The remainder of the table provided a shallow tray which was filled with an appropriate growing mixture and planted with grass seeds from one of the countries. The gardens at Killerton are themselves a monument to similar practices: the planting of seed from around the world was made possible by colonialist expansion. Unlike the carefully nurtured garden stock, however, the seeds in *Time Garden* received nothing but the most rudimentary attention and were, on the whole, left to their own devices during the five months of the exhibition. Inevitably the results were mixed, some seeds managing to germinate and grow, others coming to little or nothing. In addition it was clear by the end that many of the trays had been contaminated by indigenous seed blown in from the surrounding parkland. Likewise, the clocks were unable to remain within their allotted time/space frame. Even though they all kept going, their lack of precision meant a gradual slide out of sync into a far less systematic relationship with one another. As *Objects and Spaces* and *Radio Garden* did before it, *Time Garden* remaps the globe, bringing disparate ecologies into contact and registering the degree to which social and economic, as well as environmental factors affect fertility and abundance, barrenness and lack.

These last two works, *Process and Identity* and *Time Garden*, did not involve the use of sound. Nor did *Articles and Instruments*, the cloth-bound boxed multiple published by Remmert and Richter Verlag, Berlin in 1992, although its themes of surveillance, control, information gathering, secrecy and deception, stimulated by a visit to the newly opened former Stasi headquarters in Leipzig, quite clearly encompass the technology. There should be no puzzlement about this. Audio Arts, in spite of its name, has never operated on the assumption that sound, in and of itself, carries any privileges in respect of artistic relevance. It has never been 'the' medium to use for its own sake. In all instances it has been the location and the possibilities offered by it that have shaped the choice of strategy and materials. Alongside these projects of the past two years, soundworks have also been made, most notably *Crossings: Girls in White Stilettos and all that*. This was commissioned by BBC Radio 3 as one of four works by different composers that would in some way use London's Broadgate Centre and the adjacent Liverpool Street Station. Using snatches of conversation layered with the sounds of people's passage through the plazas, concourses and open spaces of the area, and of the public entertainments laid on for passers-by, a picture is built of the architectural environment and its inhabitants. The critique of the ideological underpinnings to this eighties financial and commercial development must be looked for in the play between the materials of Crossings. For the wish, as ever, was not to visit a place and pronounce upon it, but to forge an imaginative and complementary connection with its particularities.

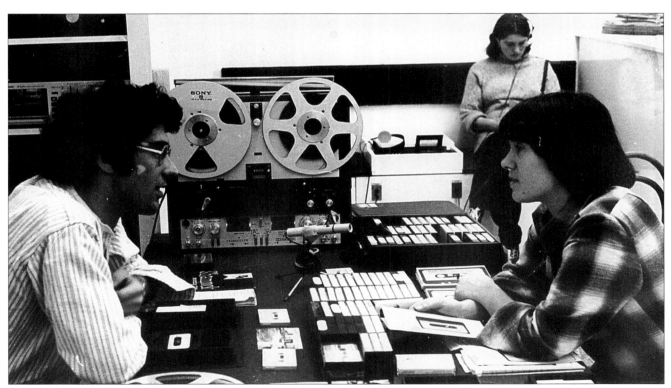

Audio Arts installation at Whitechapel Art Gallery, 1976, with Michael Archer and Sally Williams

ARTWORKS

Original works by Audio Arts

The underlying concerns of the artworks have included location, place, authenticity and identity, realised through a variety of media including soundworks/records, installation, performance, drawing and radio broadcasts.

Objects and Spaces, *flexi-disc for the catalogue*

Installation for Objects and Spaces

Objects and Spaces, Hayward Gallery, 1983. Three primary elements, a flexi-disc in the exhibition catalogue, a gallery installation including three cassette playback machines, and a radio broadcast, explore the significance of the objects that people own and use and the spaces in which they live. Inmates of Brixton prison on one side of the flexi-disc are juxtaposed with recordings that define specific spaces – a police helicopter (a space under surveillance), church bells (a spiritual space) and a 'space invader' machine (an electronic space). On the other side a linked sequence of individuals around the world discuss the objects and spaces around them. The work was also realised through the radio broadcast in that the recording was then superimposed into private spaces.

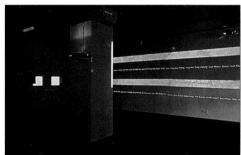

Installation for the Orchard Gallery, Derry, 1984

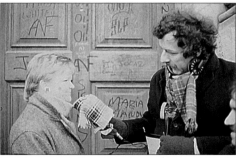

William Furlong gathering material on the streets of Derry

Sound score no 7 for the Orchard Gallery LP, 1984

Announcement card for the installation and LP

Projections from the installation

Audio Arts/Orchard Gallery, Derry, installation and LP, 1984. Imagery was based on sections of maps, of both the Derry and the Clapham/Brixton areas. The text referred to signatures of individuals who had contributed to the LP record, which was built up from interviews recorded on the streets in Derry. Location, space, time, accent and voice provided the material. Tracks: 'Clapham, Creggan', 'Song from Two Gaps and a Pause', 'Love Song', 'Just Getting Through It', 'Ums and Ahs', 'TV (Part 1)', 'Bilko/History', 'Five Words, Two Places', 'Side Issues', 'Saturday O Saturday', 'Wind Damage', 'What Else Did You Want to Know?' and 'Monday to Friday'.

Michael Archer (left) and William Furlong in St James's Church for Arris

Public performance of Arris, *ICA Public Works, St James's Church, Piccadilly, London, 1986*

Poster for Arris

Sound score, audial images and imprints 1 for Arris *Sound score, audial images and imprints 2 for* Arris

Performance rehearsal for Arris

William Furlong gathering material for Arris

Arris, Institute of Contemporary Arts Public Works, St James's Church, Piccadilly, 1986. The performance/presentation included five performers, play-back from tape and the church organ. The event was structured around 13 soundworks and a sequence of projections: 'Sale and Exchange': '5 for 20/6 for 50', 'Sweet but also Gingery', 'Bear Pit', 'What Are You Doing Taping?', 'Telephone Piece'; 'Locality and Transience': 'History Painting', 'People, Face, History, Colour', 'What do You See/What do You Hear?', 'California, Southern Part', 'Scale', 'Ums and Ahs', 'Sound, Time and Space'. Grey Watson wrote of *Arris*: 'The spatial properties of sound, usually relatively ignored, are for Audio Arts at least as interesting as its temporal ones. In fact, the two are interwoven. A sound is not instantaneous but exists for a period of time: how it modifies over that time, how it decays, will depend on the acoustic qualities of the space, and it is therefore possible to 'map' a space using sound, producing an audial imprint or image of it. Audio Arts is also interested in the idea that if a space has not altered physically over a given number of years, a sound made there now would be the same as it would have been that number of years ago, thus establishing a direct link between the present and the past.'

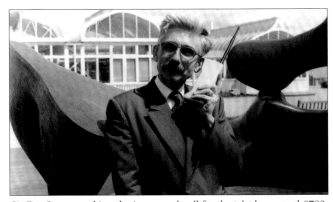

Sir Roy Strong making the inaugural call for the telephone work 0782 272121, *the National Garden Festival, Stoke-on-Trent, 1986*

Michael Archer (left) gathering material for the telephone artwork for the National Garden Festival

*0782 272121 – Six Works for the Telephone,*1986. Six three-minute pieces produced as part of the sculpture programme for the 1986 National Garden Festival at Stoke-on-Trent could be heard between May and October on the above telephone number. Monthly recordings were made with visitors to the festival, and again a concern for place and location is explored through the spoken word. Colloquialism, accent, local humour, intonation and emphasis evoke and explore cultural identity, social attitudes and local preoccupation; the particular industrial history of the area was taken into account. Towards October inescapable questions about the future of the site and those who worked there were asked.

Computer-generated sound score

William Furlong gathering material in the Broadway Market

Drawing/collage for sound score

Drawing/collage for sound score

Audio Arts/Interim Art, London, 1988. A gallery installation and a 45 rpm record. Material was recorded within the 'domestic' spaces at Interim Art, the adjoining railway arch, and a street market nearby. Stretched piano wire converted the spaces at Interim Art into acoustic chambers or 'instruments'. Out on the street in Broadway Market, passers-by were stopped at random over a period of weeks and asked their thoughts about living in that particular area of East London. The piano-wire recordings made in the house and arch provide the pulse and rhythmic structuring for the orchestrated patterns of speech. Also exhibited were a series of computer-aided drawings related to the project. Tracks: 'The Difference', 'Head Low'.

Accent for a Start, *LP record*

Projection images for Accent for a Start

Projection images for Accent for a Start

From the performance Accent for a Start, *Newcastle-upon-Tyne, 1988, with projections of food for 'Song for Edwina'*

Jo Pryde in the performance Accent for a Start

Computer-generated visualisation for Accent for a Start

Accent for a Start: Commissioned by Projects UK in Newcastle, this consisted of a performance related to a series of soundworks derived from live recordings. The themes and audial texture gave rise to the structure and content of each piece.

The performances were structured around 12 three-minute tracks from an LP record incorporating dance, live music, projected imagery and recordings previously made out on the streets in Newcastle-upon-Tyne. Performances took place in Newcastle, Manchester, Bradford and London, and were structured around the following tracks on the LP: 'Accent for a Start', 'Canny', 'In Relation to What?', 'Uniform', 'Warm', 'Song for Edwina', 'It's About Time', 'Canny Place', 'Everything You Could Possibly Want', 'Friday/Saturday Night', 'Buckets of Sand' and 'Mint'.

'Vinny', from Placement and Recognition, *Museum of Modern Art, Oxford, 1989*

Mapworks performance by the students of the Foundation Course, Oxford Polytechnic as part of Placement and Recognition

Map collages for Placement and Recognition

Placement and Recognition, *Oxford Polytechnic football team carrying out training routines to the soundwork 'Vinny', 1989*

Studio shot in art school with students. Working in art schools has provided both source material and opportunities to test ideas for artworks with students. Elements of this installation in the foundation department at Wimbledon School of Art were used in Placement and Recognition *(with Brian Westbury).*

Map collage for Placement and Recognition

Placement and Recognition, 1989: Audio Arts at the Museum of Modern Art, Oxford. A live work, a related installation and a sequence of wall panels presented at MOMA were part of an ongoing series concerned with ideas, behaviours and imagery through which social, cultural and economic attitudes are defined and sustained. The image of a packed Oxford Union debate provides a symbol of the authority associated with the university. By way of contrast, another image is that of the Wimbledon Football Club player Vinny Jones, who has received attention for his approach to the game. Words used, such as assertive, uncompromising, aggressive, ruthless, confrontational, powerful, provide a key to behaviour valued elsewhere within contemporary society. An Audio Arts single 'Vinny' includes a speaker from the Oxford Union, recordings from Wimbledon Football Ground and various musical treatments. The live work also featured 24 students from Oxford Polytechnic and club members and coach from the polytechnic's first football team. Elements: '24 World Maps', 'Vinny/Collage Sequence', 'Large World Map', 'Torn Maps', 'Four Surveillance Cameras'; as part of the live work lonely heart ads from various magazines were juxtaposed and read out by Duncan Smith in an anxious, staccato radio announcer's voice. Their wording reveals social, cultural and economic priorities as well as overt and covert sexual expectations.

Radio Garden, *installation for 'Tyne International', 1990*

William Furlong locating the masts for the installation Radio Garden

Sound score drawing No 2 for Radio Garden

Radio Garden: Audio Arts at the First Tyne International, Gateshead, 1990. The most recent in a sequence of works entitled 'Placement and Recognition', *Radio Garden* explores local, national and international consciousness and identity in relation to borders. Within a site 26 metres in diameter, 12 'radio towers' some 50 feet high are erected at specific points plotted across two axes on the world map which intersect at Gateshead. Four towers are located on the first axis, drawn at 55 degrees latitude, falling on Moscow, Gateshead, Derry and North America. Eight towers are sited along the second axis, plotted across a projection of the world map at 120 degrees on the compass. This axis falls across Europe, the Middle and Far East, Asia, South East Asia and Oceania. At each of the eight points plotted on the axis an arc is drawn and intersects a further series of countries. At the base of each tower, radio broadcasts are heard originating from countries located on the specific arc.

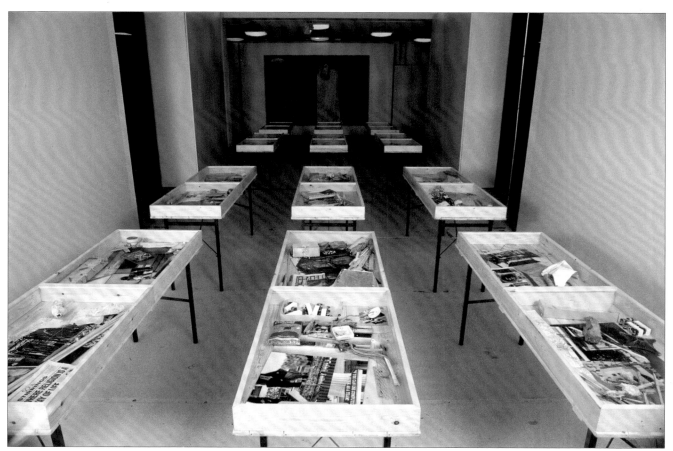

Process and Identity, *installation, 'Zone D', Leipzig, 1991*

Imagery from Leipzig included in the 'Zone D' installation

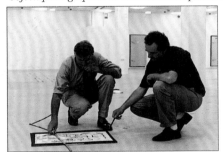

Objects photographed in the Stasi Headquarters, reference material

Collage 2 based on Stasi themes including Leipzig main railway station, 1990

Dr Klaus Werner with William Furlong in the underground messe *hall, Leipzig*

Surveillance photography from the newly opened Stasi Headquarters, reference material

Development collage and installation

Process and Identity, 'Zone D', Leipzig,1991. Conceived for the exhibition 'Zone D' in the underground *messe* hall beneath the market in the centre of Leipzig, *Process and Identity* evokes meanings through the juxtaposition of photographic imagery and objects 'displayed' within 24 glazed cabinets on 12 tables, suggesting the idea of a temporary, portable museum whose objects and images are drawn from everyday life. Other themes include the ownership of property, the freedom of movement, the mechanisms of power and authority, the inner-city environment, cultural history, consumerism and so on; it also explores a dialogue between London and Leipzig, acknowledging the perceptions and values that the artist brings to the place where a work is realised.

Articles and Instruments

Articles & Instruments, (1992). A multiple by Audio Arts published by Remmert & Richter Verlag, Berlin, comprises a cloth-bound wooden case containing various objects. The work arose out of a visit to the Stasi Headquarters in Leipzig soon after it was opened to the public in 1990. The themes of the work include surveillance, the gathering of evidence, the disguise of the human face, the falsification and control of information. The cloth-bound case refers to the long tradition of Leipzig as a book-producing centre.

Stasi Jars: Love is Colder than Death, *a series of four drawings, 1992*

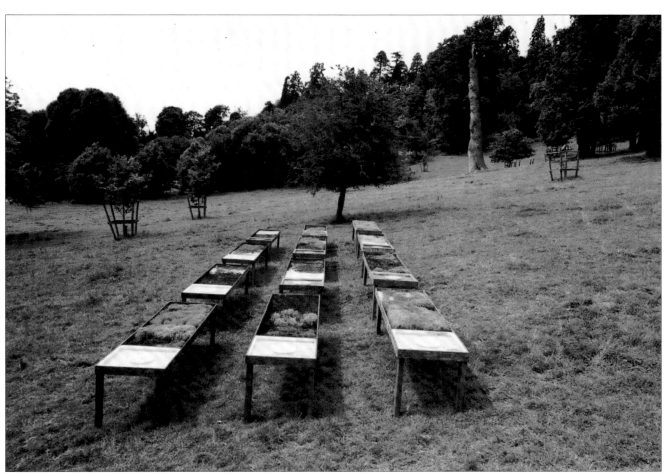

Time Garden

Time Garden, 'HA HA, Contemporary British Art in an Eighteenth-century Landscape, Killerton Park', Devon,1993. A site-specific work for outdoor installation extends the concerns of the *Radio Garden* of 1988. It comprises 12 trays, each eight feet by two feet, planted with grass seeds from each of 12 time zones. The composition of the growing medium in each one also relates to that found in its zone. At the end of each tray is a clock set to a one-hour time difference, thus creating a chronological atlas. The trays were installed as low tables on the wind-swept approach to Killerton House during the months June to October. In some trays the grasses thrive, while in others seed must fight for survival. 'Timeless', 'time-warp', 'time-scale', 'time-frame' and 'time running out', come to mind at Killerton, as do the inescapable relationships between the fertile environment of the park and surrounding areas, and other locations around the world, where human survival depends on fragile socio-economic balances.

SOUND IN RECENT ART

William Furlong

Sound has never become a distinct or discrete area of art practice such as other manifestations and activities were to become in the 1960s and 1970s. Although it has been used consistently by artists throughout this century, there has never been an identifiable group working exclusively in sound, so one is not confronted with an area of art practice labelled 'sound art' in the same way as one might be with categories such as Pop art, Minimal art, land art, body art, video art and so on. Another factor is the diversity of functions and roles that sound has occupied within various artists' work.

This failure of sound to construct a distinct category for itself has in fact proved an advantage, given that categories in the end become restrictive and the work circumscribed and marginalised. Therefore, in spite of the frequency with which sound has been utilised within artists' work, it remains remarkably clear of prior associations, historical precedent or weight of tradition. Sound has in fact provided an additional ingredient and strategy for the artist with the potential of addressing and informing senses other than the visual.

As a result, an increasing volume of work has emerged, particularly since the mid 1970s when, for the first time, artists could completely engage in the medium of sound through access to recording technology. This meant that the artist was in complete control.

Much of the work that evolved owed very little to conventional music with melodic structures. It was more concerned with collage, montage, overdubbing, reconstitution, juxtaposition with digital, chance or repetitive structures. The recording process offered a new context for artists, enabling them to generate artworks within a technological acoustic space, reproduced each time the recording is re-played. The work itself is therefore realised on such an occasion, rather than a reproduction or documentation of it. Furthermore, the consequent lack of dependence on a particular space or object released the artist from the associated constraints and restrictions. The mechanisms for externalising and disseminating the work were appropriately expanded through the record, audio cassette and broadcasting. The attraction for the artist of working with recorded sound no doubt resided in its characteristic of maintaining an integrity with regard to the relationship between the moment of recording and the subsequent hearing. The psychophysical and acoustic nature of the recording itself is structurally re-entered in real time by a listener on subsequent occasions. The distancing process and 'filters' associated with other media are absent, and the artist can therefore utilise this sense of the original experience when the work is presented.

As well as its own unique characteristics, recorded sound shares many of the characteristics of more traditional media such as painting and sculpture. Collage, juxtaposition, reduction and addition, contrast, abstraction, realism and so on are all techniques at the artist's disposal. It also has the potential to generate visual imagery in the mind of the listener. As well as defining its own space, recorded sound is also capable of defining and interacting with physical space in a sculptural sense.

Prior to the 1970s, artists' works in sound appearing in recorded form were primarily recordings of live events. This distanced the artist from the creative possibilities of the recording process itself, and the medium therefore became purely a means of retaining an acoustic event, or used as a strategy for its non-object-based nature. Artists such as Le Parc, Tinguely and Takis regarded sound as an integral consideration in their work. The sculptural object produced sound but the two could not be satisfactorily separated. The sounds produced were also dependent upon and arose out of the material nature and kinetic functioning of the work.

Given the diversity and elusive nature of what has taken place since the mid 1970s, it is not surprising that very little literature exists that draws together work carried out in this area. I also start at this point as a result of a personal involvement through the establishment of *Audio Arts* magazine on cassette in 1973. I will therefore use this period as the primary focus of this essay.

The editorial of the November/December 1976 issue of the British art magazine *Studio International* on the theme of 'Art and Experimental Music' stated that 'although several contributions in this issue deal with aspects of music from the viewpoint of art, the main emphasis rests on experimental music in its own right'. Important though that issue of *Studio International* proved to be, it is interesting to speculate that there did not appear to be a sufficient body of new work in sound stemming from artists themselves which might have altered the focus of the issue. It did

in fact reflect the attention given by the art world to musicians such as (in the USA) John Cage, Steve Reich, Philip Glass, (and in Britain) Cornelius Cardew, Gavin Bryars and Michael Nyman – an interest often not reciprocated by the music establishment.

I should, however, say that the overlap that has occurred across the boundaries of electronic music, concrete poetry and soundworks by artists is seen as healthy and mutually valuable, although at the same time it can defeat a straightforward linear analysis and easy categorisation. Furthermore, such an interdependency has prevented artists' work in sound being seen as a separate area of art practice.

Parallel to that issue of *Studio International*, Bob George in New York was producing his *Two Record Anthology of Artists' Aural Work and Music: Airwaves*. This project arose directly from George's involvement with many of the artists on the compilation. These included: Vito Acconci, Laurie Anderson, Jacki Apple, Connie Beckley, Terry Fox, Jana Haimsohn, Julia Heyward, Richard Nonas and Dennis Oppenheim. This double album represented a recognition that a small yet significant number of artists were utilising the medium of sound and regarding it with the same seriousness and creative attention as any other medium.

In his piece for one of the records, 'Labyrinth Scored for the Purrs of 11 Different Cats', Terry Fox created several layers of natural sound orchestrated into a dense, almost mechanical set of rhythmic vibrations. Laurie Anderson manipulated phrases played backwards and forwards at various speeds in her piece 'Two Songs for Tape Bow Violin', through the contact made between a strip of recorded tape attached to her violin bow and a playback head positioned where the bridge would normally be on a violin. Amongst the fourteen individuals on the two records there is no stylistic unity but rather a wide range of content and formal innovation alongside explorations into the translation of sound through recording and technology.

I do not, however, wish to suggest that the engagement was merely on a formal level – far from it. Artists were in fact making use of a medium that could convey and relate to the experience of living within and responding to the urban environment, invaded as it is by information conveyed through electronically based media. Here was a generation of artists who for the first time had gained access to a new medium and therefore would naturally wish to explore its vocabulary.

'New Music for Electronic and Recorded Media', an LP record produced in 1977, was the first anthology of women's electronic music and work in sound. It included works by Johanna M Beyer, Annea Lockwood, Pauline Oliveros, Laurie Spiegel, Megan Roberts, Ruth Anderson and Laurie Anderson. Like *Airwaves* it brought together a new generation of composers and artists who were exploring content and audial concepts through experimen-

tation and the manipulation of the recording process. Charles Amirkhanian, editor of the compilation, stated in the sleeve notes: 'Today we have composers willing to mix media and sonic materials in thoroughly inventive ways to achieve ends which are new sounding and often more engaging than that of "academic" avant-garde.'

A year earlier, in 1976, Audio Arts published the cassette *Recent English Experimental Music* as a supplement to the 'Art and Experimental Music' issue of *Studio International*. This included works by Howard Skempton, Christopher Hobbs, Gavin Bryars, John White, Michael Parsons, James Lampard and Michael Nyman. Unlike the Amirkhanian record, works on the cassette were based more on live performance (often in art galleries) using acoustic instruments. The pieces on the tape reveal both a re-evaluation of existing musical conventions with regard to structure and composition as well as a tendency to experiment with an extraordinary range of acoustic possibilities, instruments and sounds. Although not stemming directly from the visual arts, I include a reference to this record and cassette as a new generation of composers and artists alike were re-assessing established conventions with regard to sound and producing new work that extended beyond conventional boundaries.

Both in America and Europe, Conceptual art had created the space for work to develop outside of the material boundaries of object making, thus allowing artists to incorporate temporal and time-based elements into their work. Furthermore, issues concerning context were also being examined by artists, leading to a wide range of non-gallery strategies, employed to externalise their practices.

In Britain, Gerald Newman was an artist alone in his engagement with recorded sound. As early as 1970 he presented a soundwork at the Lisson Gallery in London. In his works a concern for 'recorded space' is translated into a concern for the physical space where the work will be realised. This is normally a darkened room or area of the gallery arranged in such a way as to minimise interruption from those not listening to the work. The elements of his works have consistently come from radio broadcasts woven together across the four tracks of his tape recorder to produce a dense layering of sound. The starting point has often been a news bulletin of major social or political consequence; yet the resultant work tends to transcend the immediate or local and address a more fundamental and substantial level of expression.

During the mid 1970s European artists did not enjoy the same access to recording technology as their American counterparts. Yet this situation was rapidly changing through the introduction of mixed-media areas into art schools. Tape recorders and synthesisers were being purchased alongside video and film equipment for students anxious to work in media more to do

with the present than the past.

As a result, sound quickly became an integral part of performance, mixed media and installation works. Artists including Bohmler, Roth, Nauman, Kounellis, McLean, Oppenheim, Morris and Anastasi incorporated sound as an integral part of their work. In Britain, Charlie Hooker's performances also demonstrated a structural involvement with sound: rehearsed performers move along a marked-out floor area which also serves as a 'score'. They produce percussive sounds with sticks and footsteps according to a pre-determined mathematical and rhythmic structure. Stringed instruments are often heard as part of the performance. In 1973 Nice Style, the World's First Pose Band, held a 'press conference' at the Hanover Grand, Hanover Square in London. Part of the event involved the banging of fridge–freezer lids, being opened and shut in an orchestrated, posed tableau. Following this, questions were asked and answers given to a reducing press contingent and were (loosely) translated into several languages.

In the spring of 1973 Audio Arts was established and was present at the Hanover Grand to record Nice Style. The recordings were then edited with the group's co-founders, Bruce McLean and Paul Richards, and included two songs written by the group, 'Hoover Moover' and 'Mixer Trixter'; the final tape was then included in the second issue of Audio Arts along with a soundwork by Michael Craig-Martin, interviews with Noam Chomsky and Anne Wyndham Lewis and readings by Wyndham Lewis. The original aim in establishing Audio Arts was to create a publishing context within which information, ideas and thinking in relation to contemporary art would be expressed and disseminated in a primary form. However, it quickly extended to become a context or 'space' also for artworks, performances and other time-based activities. This format of combining elements such as soundwork, performance, interview, conversation, reminiscence and archive recording remains an underlying concept of Audio Arts. Other activities include producing individual cassettes (supplements) for a particular project, initiating tape/slide sequences, producing editions and functioning as an art practice in its own right.

In 1976, as an extension to the purely audial activities, Audio Arts invited nine artists to make a new piece of work for up to ten minutes of sound tape and five slides. The resultant artworks were then presented in various galleries and other spaces around the world. Venues included a cinema in Belgium, the Orchard Gallery, Derry, The Kitchen, New York and the Whitechapel Art Gallery in London. Another series of tape/slide works were shown at the Riverside Studios in London in 1978.

A continuous thread running through Audio Arts activities since its inception has been a concern for speech. Sound recording created an opportunity to retrieve and to analyse important facets of our culture contained within spoken language which were hitherto lost. In spite of new technologies we still communicate with others more through speech than through any other medium: events elsewhere are described through speech; it is within spoken language that ideology is embodied and expressed; evaluation, interpretation and assessment in the media takes place through speech; and for individuals it is through speech that ideas are evolved and clarified, concepts developed and attitudes formed.

The first issue of Audio Arts included a thirty-minute extract of Art & Language proceedings, in which discussion between four members of the group is used generatively to evolve and clarify ideas and arguments. Through interactive speech, that process of development can be witnessed in the recording. As well as many other contemporary artists using speech, the third issue contained a 1929 recording of James Joyce reading from Finnegans Wake, demonstrating how the psycholinguistic layers that surround spoken language can be manipulated to form expressive dimensions beyond literal meaning.

It is hardly surprising, then, that artists have used speech in their works as a potent way of focusing thoughts, conveying meanings and mapping ideas. Susan Hiller used a recording of her own voice as part of the 1981 work Monument in order to explore the ideology of memory, the history of time and the fixing of representation. Stuart Brisley used recorded speech to examine concepts of power, authority, manipulation and control. The speech in his works tends to be that of the disembodied voice of authority, the voice of instruction, the voice that tells us what to do, the voice that reassures us that everything will be all right if we follow the instructions. Much of Laurie Anderson's work centres around the use of language in spoken form. She combines an interest in audial language with technology in order to create powerful yet poetic insights into aspects of American culture:

> Everyone has at least fifty voices, minimum. Their
> interview voice, their hailing a taxi voice or talking
> to their friend voice, their bureaucratic voice ... I
> go through that range of everyday uses of the
> human voice ... the commentator, the moderator,
> the news reporter.

Bruce McLean uses speech to draw attention to social and art world politics, pretension, absurdity and consumerism as expressed within language. The verbal elements of his performances often use metaphor and humour as ingredients. The listener has to unravel the meanings, consider the implications, hear and respond to the un-said:

> People clicking away ... finger on the ... hat pulled
> well down ... legs crossed ... seal-skin boots ... zip
> up the front ... clothes from the house ... opposite

the bratwurst cabin, Sausage Strasse … Doris and Charlie enter from the left … a little tight around the … Mary from the right … heavy Vivaldi in the background … click, click, click …

The introduction of the Philips compact cassette in the mid 1960s undoubtedly contributed to the development of artists' work in sound. By the early 1970s, widespread ownership of cassette players, primarily used for pre-recorded music, had created a potential network for works originating other than from the predominant organisations of production and distribution. The use of this network was facilitated by the relatively low cost of cassette duplication and the fact that, with cassettes, no large financial outlay is necessary, unlike the production of records and books.

Apart from *Audio Arts*, other cassette magazines that carried artists' work in the late 1970s and early 1980s were: *Mag Magazine,* produced by Grita Insam in Vienna; *Voicespondence*, edited by Clive Robertson, Calgary, Canada; *VEC Audio Exchange*, produced by Rod Summers, Maastricht, Holland; *Fast Forward*, edited by Bruce Milne and Andrew Main, Melbourne, Australia; *Audio-graphics, New Wilderness Foundation*, produced by Charlie Morrow, New York. Others who have regularly put out cassettes include: Paul Thomas and Alan Vizents, *Media Space*, Perth, Western Australia; Ruedi Schull, *Apropos*, Switzerland; Peter Meyer, Stockholm, Sweden; Tony McAulay, *Turbulence*, Fanshaw College, Ontario, Canada.

A network of exchange and information was created by these magazines and cassettes, allowing new work in sound to be heard anywhere in the world, basically for the cost of the cassette and the postage stamp. As well as cassettes, I think it is appropriate to mention a limited selection of artists' records produced since the mid 1970s. David Cunningham, founder of the Flying Lizards, who, like Laurie Anderson, operates between art and rock worlds, produced his record *Grey Scale* in 1977 and *Functional Action Parts 2 & 3* by Tony Sinden in 1980. *Grey Scale* incorporated 'process' in a human sense through the structural incorporation of mistakes within the performance. This included a variety of instruments such as piano, organ and a range of domestic objects. Sinden's record was also concerned with 'process' and included the repetitive strumming of swing and drift guitars. Unlike *Grey Scale*, flaws and mistakes were not acted upon but left to become elements in the audial event.

Enzo Minarelli issued *Vooxing Poetry* in 1982. This was an important anthology of linguistic experiment and recorded sound including contributions from Bernard Heidsieck, Richard Kostelanetz, Rod Summers and Klaus Groh. Minarelli went on to produce a series of 'polipoetry' EPs called *sV*, extending into Europe many of the concerns of the work contained in the *10 + 2: 12 American Text Sound Pieces* LP produced by Charles

FROM ABOVE: Dan Graham, PERFORMANCE–AUDIENCE–MIRROR, performance at the Riverside Studios, London, 1979; Recording session for 'Artists in Residence' discussion,(left to right) Ian McKeever, Maggi Hambling, Helen Chadwick and Lesley Greene; Letter from Anne Wyndham Lewis to William Furlong, 1974

Amirkhanian for Arch Records in 1974.

In 1981, working within the rock music genre, Clive Robertson released his *Popular Songs* LP, and like *Corrected Slogans* by Art & Language issued in 1976, used the LP record as a socially acceptable vehicle of communication to challenge the prevailing attitudes and values upheld through capitalist ideology.

Nicola Frangione produced Mail Music Project in 1983, an LP containing a continuous programme of contributions from forty-seven artists including Vittore Baroni, Paulo Brusky, Leif Brush and Sue Fishbein. In 1985 Frangione produced the collective work Italic Environments which used recordings of the natural environment as a 'setting' for additional music and recorded elements. In 1983 Glenn Branca issued Number 5 in the series, Just Another Asshole. This LP contained individual contributions lasting under one minute from seventy-six artists and musicians. This record, like Mail Music Project, was in a sense a 'mixed exhibition' or an index of audial fragments without an identifiable theme or source other than those of diversity, innovation and energy. Branca's record included Dan Graham, Judy Rifka, Brian Doherty, Dara Birnbaum and Barbara Kruger. Revolutions Per Minute (The Art Record), produced in 1982 by Jeff Gordon, was a double album featuring text and soundworks by twenty-one individuals including Terry Fox, Margaret Harrison, Les Levine, Chris Burden, William Burroughs, Conrad Atkinson and Joseph Beuys. Fox's contribution is an excerpt from Internal Sound, an eighteen-hour (three-day) performance in the former church of Santa Lucia, Bologna, Italy. In this piece Fox plucks a three-hundred-foot length of piano wire stretched between the large wooden door and crypt covering, which become the resonators for the sound which oscillates throughout the church space in waves.

Jack Goldstein issued a series of records in the mid 1970s that were individually concerned with facts that make up ideas about American culture as manifest in myths of the present and past. On the theme of transportation, a heavy locomotive symbolically steaming across the open plane is reproduced on one side of the record, with aeroplanes passing overhead on the other. The repetitive chants and calls of cowboys rounding up cattle can be heard on another record, along with the related sounds of human and animal exertion. Similar soundtracks accompanied many a John Wayne-style Hollywood cowboy while he demonstrated the attributes and values of the ideal American male.

In 1981 Laurie Anderson's eight-and-a-half minute single 'O Superman' reached number two in the British charts. As a result she was able to utilise the structure of distribution and dissemination associated with rock music, therefore extending her work into a vast audience. Using a complex of electronics including the vocoder, conventional instruments and her voice, 'O Superman' expressed an acute yet poetic sense of the individual's isolation within a world increasingly dominated by technological inevitability. This was one of a number of 'songs' from Anderson's performance work United States I – IV. Another 'song' from that work, 'Let X+X', was released as a flexi-disc in the February 1982 issue of *Art Forum* and also included in her Warner Brothers LP Big Science released in 1982.

The success of Anderson's single was largely due to the extensive airplay it received. On the whole, however, British broadcasters have been reluctant to give exposure to artists' work in sound. The only exception to this is the BBC Radio One producer John Walters, who did so consistently before his programme 'Walters Weekly' was 'rested' in 1982.

In the same year as 'O Superman', Audio Arts initiated a project titled Live to Air, an international compilation of artists' soundworks, produced to coincide with a presentation at the Tate Gallery during August and September. The underlying concept was to bring together a body of work that had no form other than playback from tape. The intention was also to recognise a significant and growing area of art practice that, until then, had not been focused in one place for presentation or assessment. Forty-five artists were invited to make a work for the context of Audio Arts with an approximate duration of five minutes. The resultant works were then organised or 'curated' into four sections and contained within a three-cassette publication. The sections were as follows: 'Rock Idioms' incorporated works that used rock idioms and their associated structures and included Julia Heyward, Rod Summers, Bruce McLean, Dan Graham, Yura Adams and David Garland. 'Images & Narrative' concerned works and construct narrative through the juxtaposition and collaging of sounds and images, including Tina Keane, Jacki Apple, Adrian Hall, Richard Layzell, Ian Breakwell, Hannah O'Shea, Rose Garrard and Silvia C Ziranek. 'Technological & Audial Space' incorporated works that are concerned with, and refer to, the audial space created by recording technology, including Lawrence Weiner/Peter Gordon, Connie Beckley, Charlie Hooker, Maurizio Nannucci, David Cunningham, Dieter Roth and David Troostwyk. 'Urban Reference' focused on works that examined the relationship between the individual and the urban environment, and included Helen Chadwick, John Carson, Vito Acconci, Stuart Brisley, Les Levine, F Uwe Laysiepen/Marina Abramovic, Roberta Graham, Stephen Willats and Kerry Trengove.

It is clear that much of this work extends the artist's concerns beyond the conventional mechanism of the art world. It erodes the boundaries between traditionally defined categories, it uses something that surrounds us all and that we cannot shut out, it addresses a sensory level beyond the visual. Yet in the end we are left as always, with artists' intentions, the creative process, the ability to use the language to say something.

Things are being said – listen!

Some people never forget
(The use of sound in art of the early nineties)
Liam Gillick

… Sam Taylor-Wood dancing to the sound of machine-gun fire, a film loop in a darkened basement. At first the sound is unidentifiable but the rhythm is clear. Kirsten Oppenheim luring you into an enclosed space: the treatment of seduction to an all-over treacle that makes it hard to define. Lothar Hempel collaborating with the youth of Denmark, or organising concerts in Venice. Henry Bond's videos of Techno, sound checks and drummers, using a video camera and quick-cutting the results to a soundtrack of contemporary activity. Christine Borland's tapes of the breath-gaps of a saxophonist. Played in Portugal, the result fills the largest space with the shortest moments all cut together to form a record of what happens in between. Angela Bulloch's sound chairs and mats that trigger helium laughter or the Trans-Europe Express; walking into the gallery or sitting on its chairs is enough to make the work function. Peter Fend's depositions to the United Nations, using recorded documentation in an ongoing project re-assessing the geo-political structure of our environment. Douglas Gordon's telephone calls to unwitting strangers, leading to unease and disquiet. Christian Marclay's focus upon the vinyl disc. Re-mixing, zipping together record sleeves. An attempt to focus on the possibilities of an elderly technology. The Kelley Family using the imagery of the recent past and sending out a flyer that considers the potential of rock legend: a Californian cross-over that incorporates the work of Raymond Pettibon for Sonic Youth and others. Bethan Huws' invitation to the Bistritsa Babi. Brought to Britain and taken up to the North-umbrian coast, they sang to the waves and anyone who came. Martin Kippenberger's album of lounge music, not produced alone and not sung by him. Philippe Parreno's gallery guide and conferences in the voice of Jean-Luc Godard – the ultimate impersonation. Noritoshi Hirakawa with sounds of sex from behind closed doors. Georgina Starr whistling and crying. A video plays the face of the artist as you hear the sobs. Mat Collishaw and the ambient sound of death and dog barks. The installation is photographic and the sound backs everything up. Giorgio Sadotti leaving everything a rock group could ever need in a gallery space. As the visitors gain in confidence the sound is secretly recorded. Anya Gallaccio placing twenty-one whistling kettles linked to a compressor in an old pumping station. A painful sound that betrays a disturbing set of emotions. Richard Prince making a gold disc for Parkett. An edition in a frame for everyone to have at home. Fischli and Weiss making a rubber record that won't stand playing. It's more real than most records. Carsten Holler lecturing on sexuality and the possibilities of smell. The scientist joins the artists and shares knowledge in such ways that it is impossible to ignore the transfer of information …

ABOVE: Antonio Russolo, and the painter Ugo Piatti in the studio in Milan with the Intonarumori, 1914
BELOW: Tape recorder photographed in the Stasi Headquarters, Leipzig, 1991

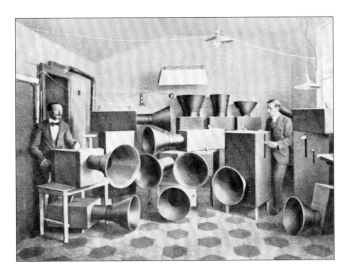

WORK IN PROGRESS

Mel Gooding

Well, you know or don't you kennet or haven't I
told you every telling has a taling and that's the
he and she of it (Anna Livia Plurabelle).
[1973 Volume 1 Number 3 Side 1: James Joyce reads from
Finnegans Wake, recorded 1929]

Resonances: Notes on the Work in Progress, 1994

1 A key: *soundings* in the continuous space of the world.

2 A clue: a capacious celebration – an international work,
a southwest London work)

3 The sound of a wall falling is heard on both sides: sound-
space is circumambient and continuous: it is nowhere
and everywhere. Audio Arts maps this space, using
techniques that are appropriate to it.

4 Art, like all forms of communication, depends on feed-
back; being a complex form of communication, it depends
on complex forms of feedback. The feedback is part of
the art event. The Auditor completes the exchange.
(Audio Arts makes art out of *listening*.) Using the tech-
nologies from which the concept derives, Audio Arts has
utilised feedback as means and metaphor. ('A work is
also made of the admiration we bring to it' [Duchamp];
'The characteristics of objects of art are believed to be
about, to be partly derived from, or determined by, other
characteristics of cultural and psychological systems'
[Bateson].)

5 There is space inside: inner space is continuous with
outer space. Inner space may be entered with particular
efficiency through the ear. Audio Arts exploits this fact.

6 When artists speak about art they become transmitters of
feedback. The feedback is part of the art event, the critical
being entered into the creative. Audio Arts exemplifies
this exchange.

7 Beuys is not the only artist to have understood that Audio
Arts is a social sculpture.

8 Critical oppositions: listening/surveillance
dialogue/prescription
boundaries/borders
distinctions/differences
identity/Identity
intelligence/Intelligence

9 '*A language* is therefore, so to speak, language minus
speech: it is at the same time a social institution and a
system of values ... In contrast to the language which is
both institution and system, *speech* is essentially an
individual act of selection and actualisation . . .' (Barthes)

10 Audio Arts: voices (multifarious actualisations; instances
of the thing itself; poignancies).

Audio Arts 1973-94: Listen! *Here Comes Everybody!* begin
again.

CHRONOLOGY

William Furlong/Audio Arts

Born 1944 Woking, Surrey

Selected Exhibitions and Presentations

1967	'New Contemporaries', Tate Gallery, London
1968	Royal College, Slade and Academy Schools Exhibition, London
1969	Northern Ireland Open 100
	John Moores', Liverpool Exhibition
1970	Edinburgh Festival
1972	Greenwich Theatre Gallery
1973	Founded *Audio Arts* magazine, on cassette
1976	Whitechapel Art Gallery, London
1976	*Academic Board* with Bruce McLean
1977	The Bucherwald, Brussels, Belgium
1978	Modern Art Gallery, Vienna
	Arts Council Gallery, Northern Ireland
	Project Arts Centre, Dublin
	'Art for Society', Whitechapel Art Gallery, London
	Artist consultant to DHSS on APG Project
	'Reminiscence Aids for the Elderly including those with Mental Infirmity'
1979	Battersea Arts Centre, London
	Ulster Museum, Belfast
	Douglas Hyde Gallery, Trinity College, Dublin
	Chapter Arts Centre, Cardiff
	'On Loan', Coracle Press, London
1980	'British Soundworks', Franklin Furnace, New York
	The Kitchen, New York
	Riverside Studios, London
1981	George Patton & Ewing Gallery, Melbourne
	Experimental Arts Foundation, Adelaide
1982	Riverside Studios, London
	John Hansard Gallery, Southampton
	'Live to Air', Tate Gallery, London
	Sydney Biennale
	'Audio by Artists', Walter Phillips Gallery, Banff, Canada
	'Audio', Moderna Museet, Stockholm
	'British Soundworks', Franklin Furnace, New York
	'The Sculpture Show', Hayward Gallery, London Installation (flexi-disc in catalogue and broadcast)
	'Art Ink', Institute of Contemporary Arts, London
1984	The Orchard Gallery, Londonderry (LP record)
	Nova Scotia College of Art & Design
	'On the Wall/On the Air', Massachusetts Institute of Technology

1985	'British Art Show', Australia
	The Grapevine Arts Centre/SFX Centre, Dublin
	The Foksal Gallery, Warsaw
	'Alles', Kunsthalle, Berne
	'Sound/Vision', Plymouth Arts Centre & Spacex Centre, Exeter
	'Real Time', TV pilot programme: Institute of Contemporary Arts, London
1986	*0782 272121 Six Works for the Telephone*, National Garden Festival, Stoke-on-Trent (cassette publication)
	Arris, ICA Public Works, St James's Church, Piccadilly, London (boxed cassette publication)
1987	'U-Media', installation, Umeå, Sweden
1988	Interim Art, London (installation & 45 rpm record)
	Accent for a Start, Newcastle upon Tyne; Bradford; Manchester (performance and LP record)
	'State of the Nation', Herbert Gallery, Coventry
	'Media Exhibition', Stockholm
	Accent for a Start, Riverside Studios, London
	Soundworks exhibition, Triskel Arts Centre, Cork
1989	*Placement and Recognition*, installation and performance, Museum of Modern Art, Oxford
1990	*Radio Garden*, installation, Tyne International, part of the National Garden Festival
1991	New Irish Museum of Modern Art, Dublin, initial planning for permanent installation of *Radio Garden*
	Audio Arts/London, Weins Laden & Verlag, Berlin
	Process and Identity, a major new installation commissioned for 'Zone D' by the new Galerie of Contemporary Art, Leipzig
1992	*Crossings*, a 12-minute soundwork commissioned by BBC Radio 3 for live European broadcast in May
	Articles and Instruments, multiple published by Remmert & Richter, Berlin
	Documenta 9, Audio Arts presentation and booklaunch, Kassel
1993	RomaEuropa Festival, Rome, Electronic Arts Section, six soundworks
	'Audio Arts': half-hour radio programme broadcast on Bayerischer Rundfunk, Munich
	Time Garden, a new work for 'HA HA, Contemporary British Sculpture in an 18th-Century Park', Killerton Park, Devon
	Salon de Musique, Suite d'Automne, Galerie Lara Vincey, Paris, sound installation
1994	'Fragments of Purpose', a 'Topography of Errors/Terrors', Remmert & Richter, Berlin (new photo works)
	'Bronze Works', Burlington New Gallery, London

CASSETTE COVERS

AUDIO ARTS

Frank Stella, Marinus Boezem,
Marina Abramovic/Ulay, Gerhard Lischka,
Audio Arts at SFX Dublin,
New Records & Tapes.

AUDIO ARTS

Joseph Beuys in his installation Plight
at the Anthony d'Offay Gallery, October 1985

Joseph Beuys, Les Levine
Krzysztof Wodiczko,
Stephen Willats,
New Records & Tapes,
Turner Prize, Audie Awards

AUDIO ARTS

Julian Schnabel, Bruce McLean,
Nancy Spero, Kevin Atherton

AUDIO ARTS

John Latham, Andy Warhol,
Rasheed Araeen, Donald Judd,
Mona Hatoum, Nigel Rolfe,
Guillaume Apollinaire

AUDIO ARTS

ROY LICHTENSTEIN &
RICHARD HAMILTON
in conversation with
Marco Livingstone

AUDIO ARTS

VENICE BIENNALE
1988

AUDIO ARTS

GERHARD RICHTER
NAM JUNE PAIK

AUDIO ARTS

ILYA KABAKOV,
ERIC BULATOV,
ART London 89,
Magiciens de la Terre

AUDIO ARTS MAGAZINE

TALKING
ART

JEFF KOONS

AUDIO ARTS MAGAZINE

TALKING
ART

MICHAEL
CRAIG-MARTIN

AUDIO ARTS

VENICE BIENNALE
1990

Anish Kapoor, Andrew Graham–
Dixon, Peter Frank, Stuart Morgan,
David Mach, Gray Watson.

AUDIO ARTS MAGAZINE

Malcolm Morley
John Stezaker
Charlie Hooker

CATALOGUE

Volume 1 Number 1
CAROLINE TISDALL: AD REIN-HARDT'S Auto interview, read by Jack Wendler. CYRIL BARRETT: 'Art and Philosophy', interview by William Furlong. RICHARD SLADDEN: 'Systems approach to art and design education'. Extract from 'Art & Language proceeding', PHILIP PILKINGTON, MICHAEL BALDWIN, DAVE RUSHTON, CHRIS SMITH, 1973.

Volume 1 Number 2
MICHAEL CRAIG-MARTIN: 'The Oak Tree and the Glass of Water'. NOAM CHOMSKY interviewed by Dr Christopher Evans, recorded at the Massachusetts Institute of Technology, May 1973. NICE STYLE at The Hanover Grand, December 1973 (with songs 'Hoover Moover' and 'Mixer Trixter'). WYNDHAM LEWIS reading extracts from 'One Way Song', 'The Song of The Militant Romance', 'If So', 'The Man You Are', 'Enemy Interlude', recorded at Harvard University 1939. Mrs ANNE WYNDHAM LEWIS interviewed by William Furlong, February 1974.

Volume 1 Number 3
'A QUESTION OF JAMES JOYCE' by Margaret Henry, with readings from *A Portrait of the Artist as a Young Man, Ulysses, Finnegans Wake, The Letters of James Joyce Volume 1* edited by Stuart Gilbert, *James Joyce* by Richard Ellman, and various songs by John McCormack. JAMES JOYCE reading part of the Anna Livia Plurabelle extract from *Finnegans Wake*, recorded 1929. MARK HAYMAN interviewed by William Furlong, with recollections of CK Ogden and others, recorded August 1974.

Volume 1 Number 4
WB YEATS reads 'The Song of the Old Mother', from *The Wind Among The Reeds* (1899), with comment on 'Faery Song', recorded 1934. Mrs G Yeats: 'The Poet's Children', recorded 1949. Anne Yeats: 'Memories of her Father', interview by William Furlong, recorded 1974. ULICK O'CONNOR: 'The Swans of the Liffey'. Recorded 1974. OLIVER ST JOHN GOGARTY: 'Yeats and George Moore', recorded 1949. WB YEATS reads 'Coole Park and Ballylee' (verses 2 & 3) from *The Winding Stair and Other Poems* (1933), recorded 1937, and 'The Lake Isle of Innisfree' from *The Rose* (1893), recorded 1937.

Volume 2 Number 1
R BUCKMINSTER FULLER at Art Net, November 1974. JOSEPH BEUYS at the Institute of Contemporary Arts, London, November 1974.

Volume 2 Number 2
CARL ANDRE at the Lisson Gallery, London, June 1975.

Volume 2 Number 3
EDNA O'BRIEN talks of her life as a writer, January 1975.

Volume 2 Number 4
MARCEL DUCHAMP interviewed by George Heard Hamilton in New York and Richard Hamilton in London, recorded 1959. HERMANN NITSCH at the Basle Art Fair, June 1975.

Volume 3 Number 1
STEPHEN WILLATS: Extending the meaning in art, a basis for operation: 'West London Social Resource Project' and 'Meta Filter'.

Volume 3 Number 2
'RECENT ENGLISH EXPERIMENTAL MUSIC': HOWARD SKEMPTON, 'Waltz' (JOHN TILBURY piano); CHRISTOPHER HOBBS, 'Aran PTO' (ALEC HILL, CHRISTOPHER HOBBS, HUGH SHRAPNEL, JOHN WHITE); three piano duets (CHRISTOPHER HOBBS and JOHN WHITE); GAVIN BRYARS, 'Ponukelian Melody' (GAVIN BRYARS, cello, JOHN WHITE, tuba, CHRISTOPHER HOBBS, organ and orchestral bells); JOHN WHITE; Piano Duet 10,11,12 & 13. CHRISTOPHER HOBBS and JOHN WHITE, 'Photo Finish Machine', percussion/piano duet. MICHAEL PARSONS, Piano piece 5; JAMES LAMPARD, 'The Caterpillar', Majorca Orchestra; MICHAEL NYMAN, 'The Otherwise Very Beautiful Blue Danube Waltz' (ORLANDO GOUGH, JOHN LEWIS, BEN MASON, MICHAEL NYMAN, DAVE SMITH pianos). Produced in collaboration with *Studio International* and complementary to Art & Experimental Music, November/December 1976.

Volume 3 Number 3
'IDEOLOGY & CONSCIOUSNESS': CONRAD ATKINSON, 'Art & Politics', part of a two-day conference in London, April 1977. MARY KELLY and SUSAN HILLER discuss women's practice in art.

Volume 3 Number 4
DOCUMENTA 6: STATEMENTS AND SPACES, statements/interviews and sound environments/installations, with CLAUS BOHMLER, WOLF VOSTELL, ACHIM FREYER, ALBRECT D, ANTONIO MUNTADES, BRACO DIMITRIJEVIC, TAKIS, IAN BREAKWELL, JOHN LATHAM, BARBARA STEVINI, recorded in Kassel, June 1977.

JOHN CARSON: 'Radio Loughwork, Belfast', an artwork broadcast by Downtown Radio, Belfast. STEPHEN WILLATS, 'From a Coded World', including project operators Sandy Nairne and Roberta Graham.

Volume 4 Number 1
'FEMINIST ISSUES IN CONTEMPORARY ART': MARGARET HARRISON in conversation with LUCY LIPPARD, 1979.

Volume 4 Number 2
'IMPROVISED MUSIC & SOUND WORKS': ANTONIO RUSSOLO, Futurist Noise Machines, recorded 1921. IAN BREAKWELL and IAN McQUEEN: 'Breakwell's Circus', Third Eye Centre, Glasgow, including a collaborative sound version of the exhibition, November 1978. HUGH DAVIES and DAVID TOOP: 'Improvised Music', part of a concert at Riverside Studios, London in July 1978.

Volume 4 Number 3
'THE NEW YORK TAPES': INGRID SISCHY, LES LEVINE, MANHATTAN PROJECT, RONALD FELDMAN, HELEN WIENER, WILLOUGHBY SHARP, 1980.

Volume 4 Number 4
STUART BRISLEY: Double issue based on nine hours of recording made in four sessions during February and March 1981.

Volume 5 Number 1
'ARTISTS IN RESIDENCE': HELEN CHADWICK, MAGGI HAMBLING, IAN McKEEVER, chaired by Lesley Greene, final comment by Anthony Reynolds. Produced in collaboration with *Art Monthly* 51, November 1981.

Volume 5 Number 2
MARIO MERZ at the Whitechapel Art Gallery, London in January 1980, in conversation with Mark Francis, William Furlong, Martin Rewcastle and Nicholas Serota. THE VISUAL ARTS IN TOWER HAMLETS: a series of recordings made with artists and organisations: Peter Dunn and Lorraine Leeson, Ray Walker, The Basement Community Project, Dan Jones, Jeff Perks, Chris Orr, John Copnall, Eva Lockey, Half Moon Photography Workshop and Liz Allen, comments by the local community and the Russ Henderson Steel Band.

Volume 5 Numbers 3 & 4
LIVE TO AIR: 3 cassettes + 12pp booklet of international artists' soundworks. 'Rock Idioms': BRUCE McLEAN, JULIA HEYWARD, ROD SUMMERS, ART &

LANGUAGE, BARBARA ESS, DAN GRAHAM, CLIVE ROBERTSON, YURA ADAMS, DAVID GARLAND; 'Images & Narrative': TINA KEANE, JACKI APPLE, ADRIAN HALL, ARLEEN SCHLOSS, RICHARD LAYZELL, IAN BREAKWELL, BOB GEORGE, IAN MURRAY, HANNAH O'SHEA, ROSE GARRARD, GERALD NEWMAN, SILVIA C ZIRANEK; 'Technological & Audial Space': LAWRENCE WEINER/PETER GORDON, CONNIE BECKLEY, CHARLIE HOOKER, ANTI MUSIC/JOHN NIXON, MAURIZIO NANNUCCI, HANK BULL, DAVID CUNNINGHAM, JACK GOLDSTEIN, TOM MARIONI, DAVID TROOSTWYK, DIETER ROTH; 'Urban Reference': KERRY TRENGOVE, HELEN CHADWICK, JOHN CARSON, VITO ACCONCI, STUART BRISLEY, LES LEVINE, F UWE LAYSIEPEN/MARINA ABRAMOVIC, ROBERTA M GRAHAM, STEVE WILLATS, ELSA STANSFIELD/MADELON HOOYKAAS.

Volume 6 Number 1
Cassette + 12pp booklet. RICHARD HAMILTON at the Institute of Contemporary Arts, London, November 1982. Soundworks by DENIS MASI, SONIA KNOX. Interviews with PHILIP GLASS, KRISHEN KHANNA, VIVAN SUNDARAM, JUDY RIFKA. Music: RHYS CHATHAM, WINSTON TONG with TUXEDO MOON and Art School Bands. Performance by ERIC BOGOSIAN.

Volume 6 Number 2
2 cassettes + 16pp booklet. Interviews with: ROSE GARRARD, MAGGI HAMBLING. Music and comment by GLENN BRANCA. Soundworks by SUSAN HILLER, LILIANE LIJN, SHARON MORRIS, SONIA KNOX. Music: RICHARD STRANGE, AR PENCK, Art School Bands. 'Sound on Sound': new tapes and records received.

Volume 6 Number 3
'NEW YORK REPORT': Soundworks by WENDY CHAMBERS, JOAN LA BARBARA, ANNEA LOCKWOOD; interviews with JOHN CAGE, STEVE ROGERS, MARY TIERNEY, EDWARD KOCH, CHRISTOPHER PRICE, ROSELEE GOLDBERG, BOB GEORGE; music by KAZOOPHONY and ads by CHARLIE MORROW.

Volume 6 Number 4
'LOCATIONS & STRATEGIES': NEIL KINNOCK MP; WIESLAW BOROWSKI/Galeria Foksal, Warsaw; SIMON CUTTS/Coracle Press, London; GRITA INSAM/Modern Art Galerie, Vienna; DAVID KERR/Experimental Arts Foun-

dation, Adelaide; ROBIN KLASSNIK/ Matt's Gallery, London; DECLAN McGONAGLE/Orchard Gallery, Londonderry; ANTONIA PAYNE/Ikon Gallery, Birmingham. BARBARA STEVENI/APG; Artworks and performance: NAN HOOVER, DAVID TOMAS, CHARLIE HOOKER. New tapes and records received.

Volume 7 Numbers 1 & 2
Double issue. 'ACTUALITY', Audio Arts at the Venice Biennale, 1984, with: JULIAN ANDREWS, CONNIE BECKLEY, DR WILLI BONGARD, FLAVIO CAROLI, CHRIS CARRELL, HELEN CHADWICK, WILLIAM FEAVER, ROSE GARRARD, THERESA GLEADOWE, HEIDI GRUNDMANN, CLAIRE HENRY, HOWARD HODGKIN, WALDEMAR JANUSZCZAK, DECLAN McGONAGLE, MAURIZIO NANNUCCI, ANTHONY REYNOLDS, JOHN ROBERTS, KERRY TRENGOVE, SHELAGH WAKELY, JOHN WALTERS, SILVIA C ZIRANEK; with extracts of works by: MARINA ABRAMOVIC/ ULAY, GERALD NEWMAN, GIULIO PAOLINI, CARLO TATO, SILVIA C ZIRANEK.

Volume 7 Number 3
Comments and reactions from the second International Contemporary Art Fair at Olympia, London, 17–20 January 1985: MARISA CARDINALE/DEAN SAVARD/Civilian Warfare, New York; ELAYNE KING/The Fun Gallery, New York; A RAHIM SHARIF/The Bahrain Art Society, Bahrain; SIMON CUTTS/ Coracle Press Gallery, London; EDWARD TOTAH/Edward Totah Gallery, London; URSULA KRINZINGER/ Gallery Krinzinger, Vienna; SUR RODNEY (SUR)/Gracie Mansion Gallery, New York; NICHOLAS LOGSDAIL/Lisson Gallery, London; NICOLA JACOBS/Nicola Jacobs Gallery, London. HANNAH COLLINS: 'Night Report Projectionist: Ronald Grant'. DENIS MASI, first artist in residence at the Imperial War Museum, London, 1984. MALCOLM MORLEY talking on the occasion of his retrospective exhibition, Whitechapel Art Gallery, June–August 1983. JOHN HILLIARD discussing his new works on canvas at the Institute of Contemporary Art, London, November 1984. 'Sound on Sound': extracts from new art-related records and tapes. Report from Nova Scotia College of Art & Design: BRUCE BARBER, GERRY FERGUSSON, MICAH LEXIER, INGRID KOENIG; Artworks and additional material: DAN LANDER, MICAH LEXIER, DAVID BARTEAUS with WENDY GELLER and PHOLLOP WILLING P, ANDY JAMES, ANDY DOWDON, DOUG BARRON, Q104.

Volume 7 Number 4
FRANK STELLA, MARINUS BOEZEM, MARINA ABRAMOVIC/ULAY, GERHARD LISCHKA. AUDIO ARTS at SFX, Dublin: 'Music & Movement', ROBBIE, JOHN CARSON, ROBERT BALLAGH, JOAN FOWLER, PETER SHERIDAN, DOROTHY WALKER, MIKE ARCHER; MAX: CONOR KELLY, MARIAN WOODS, CIARAN BENSON,

AILEEN McKEOGH, JOHN MEANY, PAT MURPHY, NOEL SHERIDAN, WILLIAM FURLONG, ALANNA O'KELLY, LIAM WELDEN; REAL WILD WEST: CHARLIE RAFFERTY, PAUL MURTAGH, ROBBIE WARREN. New records and tapes.

Volume 8 Number 1
JOSEPH BEUYS talking on the occasion of his installation 'Plight' at the Anthony d'Offay Gallery, October 1985. LES LEVINE in conversation with William Furlong and Mike Archer during the presentation of his 'Blame God' series of public billboard works, September 1985. KRZYSZTOF WODICZKO discusses and passers-by respond to a projection onto the Duke of York's steps and monument, The Mall, London, August 1985. STEPHEN WILLATS and residents of Harvey House, Brentford on his latest interactive artwork, *Brentford Towers*, October 1985. The 1985 Turner Prize at the Tate Gallery with comments from: WILLIAM PACKER, RICHARD WENTWORTH, MELVYN BRAGG, JOHN ROBERTS, JON BIRD, ALAN HAYDON, PAUL JOHNSTONE, ALAN BOWNESS, SIR RICHARD ATTENBOROUGH, HOWARD HODGKIN, PETER TOWNSEND, JOHN HOYLAND, MICHAEL MOON, MARINA VAIZEY, JOHN McEWEN, JOHN WALTERS, MATTHEW COLLINGS, NORMAN ROSENTHAL, November 1985. 'AUDIO' AWARDS CEREMONY 1985: A grand gala benefit night for Audio Arts organised by BRUCE McLEAN and MEL GOODING at Riverside Studios, October 1985. Participants included: PATRICK HERON, PAUL RICHARDS, RICHARD CORK, ANTHONY D'OFFAY, RICHARD HAMILTON, WILLIAM FEAVER, KERRY TRENGOVE, BARRY BARKER, BARRY FLANAGAN, WALDEMAR JANUSZCZAK, RICHARD DEACON, NICK SEROTA, MARY KELLY, SUSAN HILLER, KATHY ACKER, MILENA KALINOWSKA, SILVIA ZIRANEK. New records and tapes.

Volume 8 Number 2
NANCY SPERO talking to Skye Holland on the occasion of her exhibition at the Institute of Contemporary Arts, London, March 1987. KEVIN ATHERTON discusses his public artworks on site at Brixton British Rail station, London, and in the Forest of Dean, August and September 1986. JULIAN SCHNABEL interviewed at Brown's Hotel on the day after the opening of his exhibition at the Whitechapel Art Gallery, September 1986. BRUCE McLEAN provides a 'guide' to his exhibition 'The Floor, The Wall, The Fireplace' at the Anthony d'Offay Gallery, 1987.

Volume 8 Number 3
JOHN LATHAM talks about his recent exhibition at the Lisson Gallery, April 1987. ANDY WARHOL interviewed at his exhibition of large self-portraits at the Anthony d'Offay Gallery, London. RASHEED ARAEEN comments on his works included in the exhibition 'Two Worlds' at the Whitechapel Art Gallery,

London, September 1986. DONALD JUDD discusses his works at the Waddington Gallery, London, March 1986. MONA HATOUM talking about her installation Hidden From Prying Eyes in 'At The Edge', an installation, performance and film event held in the Air Gallery, London, April 1987. 'Sound on Sound': New and archival records and tapes.

Volume 8 Number 4 & Volume 9 Number 1
Double issue. DOCUMENTA 8: GERMANO CELANT, TONY CRAGG, ANTONY GORMLEY, BILL WOODROW, HELEN & NEWTON HARRISON, EDWARD FRY, MARIA NORDMAN, ANDREAS BRANDOLINI, JASPER MORRISON, MICHAEL EHRLOFF, RICHARD DEMARCO, STUART MORGAN, RAY HUGHES. Audial reportage of works by: JOHN CAGE, FISCHLI/WEISS, FABRIZIO PLESSI, NAM JUNE PAIK, MARCEL ODENBACH, MARIE-JO LAFONTAINE, recorded in Kassel, September 1987.

Volume 9 Number 2
ROY LICHTENSTEIN and RICHARD HAMILTON in conversation with Marco Livingstone at the Museum of Modern Art, Oxford, May 1988.

Volume 9 Number 3
VENICE BIENNALE, 1988: TONY CRAGG, ROLAND BRENER, RICHARD CORK, HENRY MEYRIC HUGHES, SANDY NAIRNE, ANDREW NAIRNE, MAURIZIO NANNUCCI, NICHOLAS LOGSDAIL, MAUREEN O PALEY, KEIJU UEMATSU. With commentary by William Furlong and Michael Archer.

Volume 9 Number 4
GERHARD RICHTER discusses 'The London Paintings' at the Anthony d'Offay Gallery, London in 1988. NAM JUNE PAIK recorded during his exhibition 'Video Works 1963-88' at the Hayward Gallery, London in 1988.

Volume 10 Number 1
ILYA KABAKOV and ERIC BULATOV discuss their works presented at the Institute of Contemporary Arts, London in 1989. A report from Art London 89, the fourth international art fair, Olympia, London, with KARSTEN SCHUBERT, LESLIE WADDINGTON, HOLLY SOLLOMAN, ANNELY JUDA. MARK FRANCIS talks about the exhibition 'Magiciens de la Terre' in Paris.

Volume 10 Number 2
JEFF KOONS in conversation with Adrian Searle, part of the 'Talking Art' discussions at the Institute of Contemporary Arts, London, October 1989.

Volume 10 Number 3
MICHAEL CRAIG-MARTIN discusses his work with Michael Archer in November 1989, in the same month as his retrospective at the Whitechapel Art Gallery, London; part of the 'Talking Art' discussions at the Institute of Contemporary Arts, London.

Volume 10 Number 4
VENICE BIENNALE 1990: ANISH

KAPOOR, ANDREW GRAHAM-DIXON, PETER FRANK, STUART MORGAN, DAVID MACH, GRAY WATSON.

Volume 11 Number 1
MALCOLM MORLEY talks about his three-gallery exhibition at the Anthony d'Offay Gallery, London in September 1990. JOHN STEZAKER discusses recent collages exhibited at the Salama-Caro Gallery, London, February 1991. CHARLIE HOOKER: 'Wave – Wall/Dust and a Shadow', soundwork derived from two site-specific installations at the James-Hockey Gallery and ACAVA Central Space, June–December 1990.

Volume 11 Number 2
NANCY SPERO and LEON GOLUB in conversation with Adrian Searle, part of the 'Talking Art' discussions at the Institute of Contemporary Arts, London in April 1990.

Volume 11 Numbers 3 & 4
Double issue. ISSUES & DEBATES examines contemporary art in Europe. Recordings were made during July and August 1991 with artists, curators, critics and dealers in Nice, Cologne, Berlin, Leipzig, Dublin and London by William Furlong and Michael Archer. NICE: ERIC TRONCY, critic and curator; PHILIPPE PARRENO and PIERRE JOSEPH, artists; XAVIER MORGANA, artist; HENRY BOND and LIAM GILLICK, artists; CHRISTIAN BERNARD/Villa Arson; COLOGNE: DIEDRICH DIEDERICH-SEN/Spex; JUTTA KOETHER, artist and critic; SOPHIA UNGERS/Galerie Sophia Ungers; ISABELLE GRAW/Texte Zur Kunst. BERLIN: MARIUS BABIAS, critic and curator; THOMAS WULFFEN, critic; BARBARA WEISS/Galerie Wewerka & Weiss; BRUNO BRUNNET/Galerie Fahnemann; BORIS GROYS, writer; LEIPZIG: DR KLAUS WERNER/Leipzig Gallery of Contemporary Art; JUDY LYBKE/Eigen + Art; RUDOLPH REMMERT/Reclam-Verlag; BERLIN: MARIA EICHHORN, artist; CHRISTOS JOACHIMIDES, curator; DUBLIN: JOHN HUTCHINSON/Douglas Hyde Gallery; FINOLA JONES/Kerlin Gallery; PATRICK GRAHAM, artist; DECLAN McGONAGLE/Irish Museum of Modern Art; LONDON: KARSTEN SCHUBERT/Karsten Schubert Gallery; JON THOMPSON, critic; STUART MORGAN, critic; SIMON LINKE, artist; MAUREEN PALEY/InterimArt; IWONA BLAZWICK/Institute of Contemporary Arts. Produced in collaboration with *Artscribe*.

Volume 12 Number 1
RACHEL WHITEREAD talking to Michael Archer. MICHAEL LANDY interviewed at his exhibition 'Closing Down Sale', Karsten Schubert Gallery, London. LUCIA NOGUEIRA discusses her installation at the Anthony Reynolds Gallery, London, spring 1992. ZARINA BHIMJI in conversation shortly after her one-person exhibition at the Ikon Gallery, Birmingham.

Volume 12 Numbers 2 & 3
Double Issue. DOCUMENTA 9:

JONATHAN BOROFSKY, RICHARD DEACON, ROSE FINN-KELCEY, MARIO MERZ, STUART MORGAN, LARS NITTVE, KARSTEN SCHUBERT, RACHEL WHITEREAD, with sounds from installations including BRUCE NAUMAN, STAN DOUGLAS, recorded in Kassel, June 1992.

Volume 12 Number 4
RICHARD SERRA discusses his exhibition of drawings at the Serpentine Gallery, London, 1993. MIKE KELLEY during the installation of his show at the Institute of Contemporary Arts, London. ANYA GALLACCIO discusses her installation 'Red on Green' at the Institute of Contemporary Arts, London.

Volume 13 Number 1
ELLSWORTH KELLY in discussion at his exhibition at the Anthony d'Offay Gallery, London, October 1992. CHRISTINE BORLAND and CRAIG RICHARDSON in conversation with exhibition organiser Jonathan Watkins at their joint exhibition at the Chisenhale Gallery, London, March 1993. EUGENIO DITTBORN interviewed during his exhibition of 'Airmail Paintings' at the Institute of Contemporary Arts, London. THOMAS TREBSTEIN: 'Fifty-Fifty', sound montage. ANDREW SABIN discusses his large-scale 'The Sea of Sun' during its installation at Battersea Arts Centre, London.

Volume 13 Numbers 2 & 3
Double issue. VENICE BIENNALE 1993: Giardini section recorded by William Furlong: RICHARD HAMILTON, MICHAEL CRAIG-MARTIN, WILLIAM FEAVER, ANDREA FRASER (extracts from soundwork), RUDI FUCHS, JAN HOET, HANS HAACKE, LAWRENCE WEINER, YOKO ONO (via phone-link with New York), DAVID ELLIOT, JUDY ANNEAR, JENNY WATSON, MIRO-SLAW BALKA, ANDA ROTTENBERG, MAUREEN PALEY, ANNA KAMA-CHORA; Aperto section recorded by Liam Gillick: MATTHEW SLOTOVER, PHILIPPE PARRENO, CARSTEN HOL-LER, SIMON PATTERSON, CARTER KUSTERA, KIRSTEN OPPENHEIM (sound piece), MEG CRANSTON, HIRSCH PERLMAN, GIORGIO VER-ZOTTI, SYLVIA FLEURY (video piece), CHRISTINE BORLAND, NICHOLAS BOURRIAUD, FRANCESCO BONAMI, SEAN LANDERS, RIRKRIT TIRAVANIJA, DAMIEN HIRST, HENRY BOND (video piece), ANGELA BULLOCH, JULIA SCHER, GIANNI ROMANO, JULIE ROBERTS, SADIE BENNING (video piece), BENJAMIN WEIL, LOTHAR HEMPEL.

Volume 13 Number 4
JOSEPH KOSUTH interviewed by Michael Archer during preparation for the exhibition 'Symptoms of Interference, Conditions of Possibility', at the Camden Arts Centre, London, December 1993. MRINALINEE MUKHERJEE in conversation with Marjorie Allthorpe-Guyton and William Furlong, recorded in England in 1991 and published to coincide with her exhibition 'New Sculpture' at the Museum of Modern Art, Oxford, April–May 1994. TS

ENKHJIN interviewed by Colin Painter, recorded in England in 1994. MONA HATOUM interviewed by Gray Watson, discussing works including 'Light Sentence' shown at the Serpentine Gallery, London, 1993 and 'Measures of Distance' and 'Plus and Minus' shown at the Arnolfini Gallery, Bristol, 1993.

SUPPLEMENTS

WALLPAPER
A collection of sound recordings by contributors and founders of the magazine *Wallpaper*: BILL SHEPHERD, reading; DAVID COXHEAD, 'The Collected Works'; RICHARD QUARRELL, 'Sum: up to One Hundred and Down'; SUE BONVIN, 'Method of revolving a continuous sound'; JOHN WELCH, 'Poems', ANTHONY McCALL, 'Film with Optical Sound'; ANTHONY HOWELL, 'Two Exercises'; RICHARD BERNAS, 'Tuning a Cymbal (E Flat minor)'; SUSAN HILLER, 'Symmetrical Notes from the Dream Seminar' (Sept–Dec 1973), ANDREW EDEN, reading; AMIKAM TOREN, Untitled. (1975)

NICE STYLE
Sound catalogue for the much acclaimed performance at the Garage Gallery by Nice Style, The World's First Pose Band, featuring BRUCE McLEAN and DUNCAN SMITH. (1974)

RICHARD QUARRELL
A collection of readings: 'Four sums with the same answer'; 'Sum for the thirty-first triangular number of twos'. (1974)

RICHARD CORK
'Sculpture Now: Dissolution or Redefinition?', Lethaby Lecture delivered at the Royal College of Art, 14 and 21 November 1974.

R BUCKMINSTER FULLER
A two-hour lecture at Art Net, London, November 1974.

BIJOU O'CONNOR
In recordings made during June 1974 and May 1975 in Hove, Sussex, Bijou O'Connor recalls her short but intense friendship with F Scott Fitzgerald, and her friendships with Picasso, Gertrude Stein and Ernest Hemingway. HUMPHREY BOGART and LAUREN BACALL in 'To Have and Have Not', from the radio adaptation broadcast by CBS on 14 October 1946.

DAVID TROOSTWYK
Advertisement of an Idea, 1976, soundwork. A condensed recording of the original transmission on Capital Radio, London.

BRUCE McLEAN with SILVIA C ZIRANEK
Sorry: A minimal musical in parts. Soundwork comprising 'A National Anthem' and 'Sorry', presented at Battersea Arts Centre, London, 1977, and Hayward Annual, London, 1979.

IAN BREAKWELL
Continuous Diary: A series of descriptions in words and sound based

on a live reading by Ian Breakwell at the Whitechapel Art Gallery, London during the Audio Arts presentation there in September 1977.

RICHARD HAMILTON and DIETER ROTH
Collaborations: Readings. The programme comprises readings by the artists recorded at the Haags Gemeentemuseum, The Hague, and the first performance of their play *Die Grosse Bockwurst* with: KEVIN ATHERTON, JOAN HILLS, MARK BOYLE, MARY KELLY, SUSAN BOYD-BOWMAN, RON KITAJ, IAN BREAKWELL, ROBERT MEDLEY, MARIA BROODTHAERS, BRUCE McLEAN, DAVID BROWN, JANE MORANT, MARVIN BROWN, SANDY NAIRNE, MARC CHAIMOWICZ, RUTH PEIRCY, MICHAEL CRAIG-MARTIN, BARBARA REISE, RITA DONAGH, MARTIN REWCASTLE, WILLIAM FURLONG, NORMAN ROSENTHAL, GILBERT & GEORGE, DIETER ROTH, PETER GREEN, NICK SEROTA, NIGEL GREENWOOD, DUNCAN SMITH, RICHARD HAMILTON, JONATHAN WILLIAMS, MARGARET HENRY, recorded at the Whitechapel Art Gallery, London, 20 October 1977.

BRACO DIMITRIJEVIC
Including a read version of Dimitrijevic's work 'Interview' and a series of interviews recorded between 1975 and 1978.

GEORGE BUCHANAN
Song for Straphangers: The poet reads 35 of his poems including: 'Office Women', 'The Cabinet', 'They Govern us on Paper', 'A Woman of the World', 'The Time of our Lives', 'Against Nature', 'The Girl Editors', 'Song for Straphangers' and 'Dinner Party'. TED HICKEY: 'Beneath the Green Tree', the Keeper of Art at the Ulster Museum sings a unique collection of Irish traditional songs including: 'The Emigrant's Farewell', 'The Week Before Easter', 'In Praise of the City of Mullingan', 'The Wicklow Murder Ballad', 'The Night Before Larry was Stretched', 'James Connolly', and 'The Green Banks of Yarrow'. The programme also includes reels and jigs, with Donal Lunny, Andy Dickson and Oliver Brown. (1978)

JAMES COLEMAN
Box: An installation at ROSC, an international exhibition of contemporary art held in Dublin, 1977.

BRUCE McLEAN and PAUL RICHARDS, soundscore by MICHAEL NYMAN
The Masterwork Award 'Winning Fishknife': Extracts from the soundscore of a performance sculpture for the theatre, premiered at Riverside Studios, London, November 1979.

'AUDIO SCENE 79', MODERN ART GALERIA, VIENNA
Five cassettes. An unedited sound document of a three-day symposium with performances recorded in Schloss Lenenfeld, Krems in July 1979. Per-

formance: ARLEEN SCHLOSS, JOACHIM DIEDERICHS: JOHN CAGE; PETER FRANK: 'Fluxus and Music'; ANTJE VON GRAEVENITZ: 'Blank Out/ Music & Anarchy'; GEORGE F SCHWARZBAUER: 'Performance & Sound', performance: JANA HAIMSOHN; MAURIZIO NANNUCCI: Sound and Communication; Artists' soundworks, publishing and distribution, KOHLER, FURLONG and GEORGE; performance: APERQUE, Art on Radio: IAN MURRAY, HEIDI GRUNDMANN, HANS OTTO. (1979)

'THE STATE OF BRITISH ART': A DEBATE
16 cassettes. An unedited recording of the debates at the Institute of Contemporary Arts, London in February 1978: 'The Crisis in Professionalism': RICHARD CORK, PETER FULLER, ROBYN DENNY, MARY KELLY, RENE GIMPEL; 'Who Needs Training?': ANDREW BRIGHTON, RAY WATKIN-SON, DAVID HOCKNEY, MICHAEL FINN, PETER DE FRANCIA; 'The Multinational Style': JOHN TAGG, CAROLINE TISDALL (paper read), PATRICK HERON, ALAN BOWNESS, RASHEED ARAEEN; 'Why Not Popular?': PETER FULLER, ANDREW BRIGHTON, NASEEM KHAN, JAMES FAURE WALKER, PAUL WAP-LINGTON; 'Images of People': RICHARD CORK, TERRY ATKINSON, REG BUTLER, LISA TICKNER, JOSEPH HERMAN, VICTOR BURGIN and many others.

'DAVID BOMBERG . . . HIS LIFE & WORK'
The first of a series of tape/slide sequences produced by Audio Arts in conjunction with the Whitechapel Art Gallery, London, seen during the exhibition 'David Bomberg: The Later Years'. (2978)

DAN GRAHAM/THE STATIC
Audience/ Mirror/ Performers: Live performances at Riverside Studios, London, February 1979: Glenn Branca, Barbara Ess, Christine Hahn.

'LORELEI'
37 cassettes. 'The Long Distance Piano Sonata' by DIETER ROTH with BJORN ROTH (co-published with editions hans jorg mayer). Piano music, prepared radio cassette player and colour drawing by Dieter Roth. (1981)

NINE WORKS FOR TAPE/SLIDE SEQUENCE
71 slides + 2 cassettes. A continuous programme of works by: SALLY POTTER, PAUL NEAGU, DAVE CRITCHLEY, KEVIN ATHERTON, ROSE ENGLISH, REINDEER WERK, BRUCE McLEAN, MARC CHAIMOWICZ, JACKY LANSLEY. (1978)

PATRICK GALVIN
'The Mad Woman of Cork': Poetry. (1980)

JOHN HEWITT
'Substance and Shadow': Reading by the 'father of Northern Irish poetry'. (1980)

DIETER ROTH
'Harmonica Curse', comprising a cassette and polaroid photograph for each day of the year (from 14 February 1981 to 13 February 1982). Each day Dieter Roth plays a small accordion for half an hour and then takes a colour polaroid photograph of the location. (1982)

IAN BREAKWELL
'Dialogues': A cassette work by the artist, writer and film maker Ian Breakwell, which explores the nature of verbal communication in a provocative and entertaining manner. (1981)

LAWRENCE WEINER
'Concerning Twenty Works': Cassette work made by the artist on the occasion of his exhibition at the Anthony d'Offay Gallery, London, October–November 1980, with Miranda Frawley and William Furlong. (1980)

STEPHEN WILLATS
'Vertical Living': C60 + 4 slides. A series of interviews made by the artist during his work 'Vertical Living' carried out in a tower block in Hayes, West London, with project operators: Lewis Biggs, Mike Archer, and visitors: Richard Cork and Fenella Crichton. (1980)

TADEUSZ KANTOR
C60 + 8pp book. Interview recorded at Riverside Studios during his highly successful production there of *Wielopole Wielopole*. (1981)

ROGER DOYLE
Rapid Eye Movements: With 'Rapid Eye Movements' and 'Fin-Estra'. Doyle uses sound recorded from everyday life to build complicated 'walls of sound'.

JEAN-PAUL CURTAY
'Body Music': Jean-Paul Curtay outlines his body music concept and performs 'Body Music', 'His Manner was Striking', 'It was Intense and Somewhat Alarming', 'It was not a Lullaby',

Institute of Contemporary Arts, London, 1980. (1981)

LAURIE ANDERSON
An interview recorded at Riverside Studios, London, 19 October 1981.

'ANTI MUSIC'
A cassette sampler of music and performance groups who work and live in Australia, compiled by John Nixon, 1982.

JEAN TINGUELY
'Sculpture at the Tate Gallery': Recordings of thirteen of Tinguely's sculptures made during his retrospective at the Tate Gallery, 1982; with an 18-minute performance by Meta-Harmonie 11.

DENNIS OPPENHEIM
'The Diamond Cutter's Wedding': An interview with Oppenheim on the occasion of his exhibitions at the Ikon and Lewis/Johnstone Galleries, 1982.

'EVERYBODY'S DOING IT'
Sections of an interview with BRUCE McLEAN from a 'Walters Weekly' radio broadcast, BBC Radio 1, 'cut up' and with added music by Bill Johnson. 1982.

JOSEPH BEUYS
Two interviews with William Furlong and Michael Newman recorded at the opening of his exhibition at the Victoria and Albert Museum, 1983.

FRANCESCO CLEMENTE
The artist talks about his concurrent exhibitions in London 'The Midnight Sun' cycle at the Anthony d'Offay Gallery, London, and 'The Fourteen Stations' at the Whitechapel Art Gallery, London, 1983.

STEPHEN WILLATS
'Inside the Night': A montage of music and statements from the denizens of London's alternative club scene, 1983.

SILVIA C ZIRANEK
'Cooking with G*D (I(H)ate Solitude)': Eight recipes in pink and gold by performance artist Silvia C Ziranek, September 1983.

Readings at Coracle Press
Published by Audio Arts: GLEN BAXTER, BASIL BUNTING, THOMAS A CLARK, ROY FISHER, THOMAS MEYER, JONATHAN WILLIAMS, recorded 1981/2, published 1984

RICHARD LONG
In conversation with William Furlong with readings of eight works, recorded 1985.

TERRY ATKINSON and JON BIRD
Conversations on art and cultural politics, 1985.

BOW GAMELAN ENSEMBLE
Nine works performed by ANN BEAN, RICHARD WILSON, PD BURWELL, including 'Water/Iron', 'Pyrophones', 'Tumble Dryer with Mixed Contents', 'Motorised Metal Percussion', 'Arc Welder', 'Whistling Worm Fan/Bagpipes with Dinghy Pump/Hooters and Horns', 'When I Grow Rich', 'Steam Whistles/Blow Torches/Siren', 'Solos and 1 Trio', 1985.

CHARLIE HOOKER & PERFORMERS
Excerpts from live performances 1981–1984: 'Restricted Movement', 'Closedown', 'Transitions 3', 'Undercurrents 2', 'Oxo', 'Accordions Afloat', 'Night in Bike City'.

GEORG BASELITZ
'The Painter's Equipment': A lecture/event in German and English presented by Georg Baselitz and Richard Stokes at the Royal Academy of Arts, London in December 1987 to coincide with the Baselitz exhibition 'Sculpture and Early Woodcuts' at the Anthony d'Offay Gallery, December and January 1988.

'ART PROJECTS BEYOND THE GALLERY'
A conference organised by the Institute of Contemporary Arts, London to consider recent public artworks both in Britain and Europe, with: SANDY NAIRNE (chairman), JAMES LINGWOOD, JAN HOET, KASPER KONIG, SUTAPA BISWAS, SASKIA BOS, JEAN DE LOISY, DEANNA PETHABRIDGE AND ANTONY GORMLEY. (1989)

STUART BRISLEY and MAYA BALCIOGLU
The artists discuss their collaborative three-part work which comprised two full pages published in the national and international *Guardian* newspaper in March 1989 and an installation at the Air Gallery titled 'Bourgeois Manners No 3: Insight Unseen'.

JOHN CAGE
'Art is Either a Complaint or do Something Else': Texts from statements by Jasper Johns taken from Mark Rosenthal's *Jasper Johns' Works since 1984*, Philadelphia Museum of Art 1988. This reading took place during the exhibition 'Dancers on a Plane' at the Anthony d'Offay Gallery in 1989, featuring the work of John Cage, Merce Cunningham and Jasper Johns.

ANDRES SERRANO
In discussion with Simon Watney following an exhibition of his work at the Saatchi Gallery, London in 1991/2. (1992)

AUDIO ARTS SOUNDWORKS
Object & Spaces (1983)
Audio Arts/Orchard Gallery LP (1984)
Arris, ICA Public Works (1986)
0782 272121 (1986)
Head Low/The Difference (1987)
Accent for a Start (1987)
Vinny (1989)
Crossings (1992)

William Furlong, Mute, bronze, 1994
'There is no pretence here, no reproduction. The distance betwen the artwork and its subject is maintained. It is within that space that the bronze sculpture speaks and is heard.'

INDEX